The Triumph of Modernism

THE *Triumph* OF *Modernism*

THE ART WORLD, 1987–2005

Hilton Kramer

Ivan R. Dee
CHICAGO 2006

www.ivanrdee.com

Library of Congress Cataloging-in-Publication Data:
Kramer, Hilton.
 The triumph of modernism : the art world, 1987–2005 / Hilton Kramer.
 p. cm.
 Includes bibliographical references and index.
 ISBN-13: 978-1-56663-708-4 (cloth : alk. paper)
 ISBN-10: 1-56663-708-2 (cloth : alk. paper)
 1. Modernism (Art) 2. Art, Modern—20th century. 3. Art, Modern—21st century. I. Title.
N6494.M64.K73 2006
 709.04—dc22 2006017584

To Roger Kimball

Contents

Preface

In *The Triumph of Modernism* I have collected a selection of my writings on art from 1987 through 2005. Doubtless many readers, reflecting on the curious vicissitudes of cultural life over the last few decades, will regard the title of this book as a provocation. Modernism? Triumph? If there have been any cultural triumphs in the last twenty years, have they not been primarily at the *expense* of modernism? Have we not lately witnessed the triumph of postmodernism—a knotty, perhaps an incoherently knotty, term that nonetheless bespeaks the failure or disintegration of the entire modernist enterprise?

Perhaps. But it is worth stressing that the dynamics of what we have come to call postmodernism are neither as novel nor as revolutionary as its champions seem to believe. More than thirty years ago, in an essay called "The Age of the Avant-Garde," I wrote what was in effect an obituary for the avant-garde. Among other things, that essay was an attempt to distinguish the career of the avant-garde from the larger, more vital imperatives of modernism. The central issue, the central distinction, has to do with seriousness, with the allegiance art maintains to the pulse of lived experience. To a large extent, I argued, the avant-garde had repudiated that fundamental seriousness. Its idols were figures like Duchamp, its governing institution was the museum—conceived less as a repository of cultural achievement than as a terminus in which the monuments of the past could be subjected to the dissolving bath of irony and historical dislocation. "Duchamp's legendary assault on the work of art as traditionally conceived," I wrote, "demonstrates that there is no such thing as an object or gesture that, within the magical museum context, cannot

be experienced as art, and this demonstration has the effect of consign-
ing both the idea of tradition and the museum itself to a limbo of
arbitrary choices and gratuitous assertions. Which is exactly what our
culture has now become."

I believe that the experience of the past thirty-odd years has amply
confirmed that judgment—though I would add that our culture has be-
come something else as well. The aftermath of the avant-garde has not
been the sole province of "arbitrary choices and gratuitous assertions"—
the sole province, that is to say, of forces dedicated to disintegration.
There have been countervailing movements and oppositional figures,
though the specific gravity of our cultural life today dictates that gen-
uinely oppositional figures appear chiefly as proponents of recuperation.
This is one of the signal ironies of this age of irony and institutionalized
subversion: that the pressure of human experience should finally work to
subvert the ethic of subversion and erase the grinning rictus of
Duchampian frivolousness. We have not, perhaps, traveled very far down
that road of recuperation. But I remain convinced that the chief critical
task facing us is the task I identified at the end of "The Age of the
Avant-Garde": the task of "renegotiating our pact with the past and re-
examining all those restrictive clauses that have so often rendered our
commerce with 'tradition' simply foolish and parochial."

Properly understood, modernism is not only the ally, it is also the
spearhead of that renegotiation. For modernism denominates not a par-
ticular "stance" or style—it is by disposition neither figurative nor ab-
stract, for example—but rather a discipline: the discipline of truthfulness,
the rigor of honesty. *The Triumph of Modernism* is intended as a contri-
bution to that open-ended process. The book records my assessment of
a wide range of artistic endeavor and critical intervention. To be sure, it
minutes a variety of aesthetic failures, wrong turns, and outright depre-
dations. But its guiding ambition is to discriminate between the genuine
and the fraudulent in cultural life. Many of the artists, critics, and insti-
tutions I discuss in these pages have been more or less witting collabo-
rators in this effort. This book is a testament to their story—the story of
the triumph of modernism.

Earlier versions of most of this material appeared in *The New Criterion*,
Commentary, and the *New York Observer*. I am grateful to the editors
for permission to include that work here. I am also grateful to my

colleagues at *The New Criterion* for their help in the preparation of this manuscript.

H. K.

Damariscotta, Maine
July 2006

The Triumph of Modernism

I
Modernism and Abstraction

Kandinsky and the Birth of Abstraction

For me, the province of art and the province of nature thus became more and more widely separated, until I was able to experience both as completely independent realms. This occurred to the full extent only this year.—Vasily Kandinsky, in 1913

The birth of abstract art—art that makes no direct, immediately discernible reference to recognizable objects—has long been recognized as a fateful event in the history of art. Yet the intellectual origins of this event, which promptly established abstraction as one of the central traditions of twentieth-century painting and sculpture, have remained a vague and little-understood subject for the vast public that now takes abstract art for granted as part of the familiar scenery of modern cultural life. That the emergence of abstraction early in the second decade of this century represented for its pioneer creators a solution to a spiritual crisis; that the conception of this momentous artistic innovation entailed a categorical rejection of the materialism of modern life; and that abstraction was meant by its visionary inventors to play a role in redefining our relationship to the universe—all of this, were its implications even dimly grasped, would no doubt come as a shock to many people who now happily embrace the history of modern art as little more than a succession of styles, or art fashions, which may have something to do with the history of taste but do not have much to tell us about life.

As for the academic study of modernism, Professor Rosalind Krauss no doubt spoke for many of her colleagues in the universities when, in

the 1980s, she declared that she found it "indescribably embarrassing to mention *art* and *spirit* in the same sentence." Yet the artists who first created abstract painting—Vasily Kandinsky and Piet Mondrian preeminently among them—did not share that embarrassment. They really did conceive of their artistic endeavors as serving a spiritual mission, and if, some eighty-plus years after the birth of abstraction, we still take an interest in the art of its progenitors, we are obliged, I believe, to examine the ideas that shaped it, however odd or alien those ideas may look to us today.

This is certainly the case with Kandinsky, whose work is the subject of a current exhibition at the Museum of Modern Art that takes the birth of abstraction as its principal focus. Organized by Magdalena Dabrowski, *Kandinsky: Compositions* is a small exhibition about a very large subject. Yet it has the virtue of concentrating our attention on one of the pivotal moments in modern cultural history: the years 1910 to 1913, when Kandinsky was deeply engaged in painting the pictures that led him into the realm of abstraction and, at the same time, formulating the theories that supported this audacious endeavor. The exhibition includes some of the most beautiful paintings that have ever been created in the name of abstraction, and the greatest of them—*Composition V* (1911), from an unidentified private collection; *Composition VI* (1913), from the Hermitage Museum in St. Petersburg; and *Composition VII* (1913), from the Tretyakov Gallery in Moscow—have the additional interest of being relatively unfamiliar to the American public. The many studies that are also included in the exhibition give us a vivid account of the inspired, painstaking pictorial thought that Kandinsky lavished on this crucial turn in his artistic development. If only because of the masterpieces of lyric abstraction the show contains, it would have to be considered an important occasion. What may not be so apparent is that it also marks an event in modern intellectual history.

Kandinsky was very much a man of ideas—a cosmopolitan artist and intellectual straight out of the emancipated bourgeois intelligentsia that dominated the life of art and social thought in Russia in the last decades of the nineteenth century and the early years of the twentieth. His keen interest in music, theater, poetry, philosophy, ethnology, and myth was an essential element in his thinking about art. So was his deep interest in the occult—an interest that he shared with Mondrian and certain other creators of early abstract art. The character of Kandinsky's mysticism was

different from Mondrian's, however—more socially and emotionally engaged, and less inclined to take refuge in strategies of withdrawal from the trials of life. Kandinsky relished intellectual combat and critical controversy. Even his celebrated treatise *On the Spiritual in Art*, which he published in the period covered by the current exhibition, bristles with argument, assertion, and polemical heat.

The paintings that Kandinsky first produced in his pursuit of abstraction, culminating in the *Compositions* he created in 1913, are likewise very different in character from Mondrian's. Whereas Mondrian's aesthetic of abstraction derived from the "logic" of Cubism, Kandinsky's had its origin in the more disorderly, emotion-charged conventions of Expressionism. While Mondrian's mode of abstraction found its ideal in a pictorial style of straight lines, primary colors, and rectangular structures, Kandinsky's abounded in graphic improvisation, coloristic invention, "hidden" images, and a tumult of painterly dynamism—in other words, lyric inspiration. Whereas everything in Mondrian's abstraction seeks fixity and order, Kandinsky's embraces the fluidity and flux and thus the sensuality of the mind's impressions as an essential ingredient of his art.

For both Mondrian and Kandinsky, the artistic base from which they made their fateful leap into abstraction was landscape painting, but their respective approaches to landscape were, again, very different. Whereas Mondrian's was that of an ascetic determined to strip nature of its mutable attributes, Kandinsky's was that of a mystical lyricist for whom nature is an enchanted realm of poetry and symbolism. Yet for both, the leap into abstraction was at once guided and sanctioned by their faith in the metaphysics of the occult, which in the end emancipated them from the mundanity of the observable world.

Kandinsky enjoyed a distinct advantage, however, in coming from a vastly richer intellectual and cultural milieu—one in which all artistic issues were subjected to intense analysis and informed argument by artists and critics who, in many fields, were energetically engaged in advancing new ideas. The Symbolist movement in Russian literature, music, and philosophy in the 1890s, itself deeply immersed in mystical systems of belief, had already disposed Kandinsky to look beyond the boundaries of naturalism and materialism for the foundations of his art. Munich, where he established himself at the turn of the century, was also the scene of a good deal of avant-garde activity that devalued any abject dependency

on the imitation of nature in favor of stylized and symbolic representations of it. Compared to the pinched and provincial cultural atmosphere that Mondrian experienced in Amsterdam in the nineties, Munich was a veritable hotbed of modernist thought, much of it addressed to imaginative departures from academic convention and the canons of realistic depiction in the arts.

In his pursuit of abstraction, moreover, Kandinsky was, if anything, even more directly indebted to the doctrines of theosophy than Mondrian, himself a confirmed acolyte of the occult. There are many pages of *On the Spiritual in Art*, as well as other writings by Kandinsky during the period of his turn to abstraction, that are barely intelligible without recourse to the ideas of Madame Blavatsky and Rudolf Steiner. Both are briefly mentioned in *On the Spiritual in Art*, but their influence—and that of two other theosophical writers, Annie Besant and C. W. Leadbeater—on Kandinsky's artistic thought was far greater at this crucial juncture in his development than the artist could bring himself to disclose at the time. His entire *Weltanschauung*, his worldview of life itself, was shaped by their philosophy of the occult.

On the Spiritual in Art takes as its point of departure a religious crisis that Kandinsky describes in terms virtually paraphrased from these theosophical writers. "Our souls, which are only now beginning to awaken after the long reign of materialism, harbor seeds of desperation, unbelief, lack of purpose," he writes in the Introduction, echoing the theosophists' diagnosis of the spiritual malaise that had overtaken mankind in the modern world. He continues:

> The whole nightmare of the materialistic attitude, which has turned the life of the universe into an evil, purposeless game, is not yet over. The awakening soul is still deeply under the influence of this nightmare.

Owing to the nature of this spiritual nightmare, Kandinsky writes, the artist's whole world of feeling has been radically altered. In an apparent reference of the "decadent" art movement of the 1890s, Kandinsky declares that "coarser emotions such as terror, joy, sorrow, etc., which served as the content of art during this period of trial, will now hold little attraction for the artist."

What, then, was to take the place of this failed artistic content? Kandinsky speaks of the artist's yearning "to awaken as yet nameless feel-

ings of a finer nature." He invokes the possibility of an art that "also has an awakening prophetic power," and links this to "the spiritual life, to which art also belongs and in which it is one of the powerful agents." Yet because it is an essential part of Kandinsky's purpose in *On the Spiritual* to discredit alternatives to the "spiritual" program he envisions for the art of the future, he inveighs against a number of the reigning artistic orthodoxies of the period before outlining the terms of his agenda.

The primary target of his criticism is, of course, naturalism in all its materialist manifestations. Scorn is lavished upon the social radicals in the art world who favor naturalism—the "atheists" and "socialists of various shades," as Kandinsky calls them, given to quoting from Marx's *Capital* and announcing that "God is dead." Yet the aestheticism which, with its credo of *l'art pour l'art*—"art for art's sake," had itself rebelled against materialist orthodoxy is also denounced as a "dissipation of the artist's powers." For Kandinsky, this soulless aestheticism, which attempted to make a religion of art itself, was as much a threat to the "spiritual in art" as the most orthodox forms of the materialism it opposed.

It is at this point in *On the Spiritual in Art* that Kandinsky invokes the name of Madame Blavatsky. He cites theosophy as "one of the greatest spiritual movements" of the new century, and commends its mystical "path of inner consciousness" as the proper approach to "problems of the spirit." He then reminds his readers of Madame Blavatsky's prophecy that "in the twenty-first century this earth will be a paradise by comparison with what it is now"—a prophecy that, in Kandinsky's view, the new art of abstraction was destined to play a crucial role in fulfilling. For in Kandinsky's conception of the artist's new vocation, he was destined to become a spiritual leader of mankind—still another idea he derived from theosophical doctrine. Other than a brief footnote reference to Rudolf Steiner, no further direct mention of theosophy occurs in *On the Spiritual*, yet the entire work is based on theosophical ideas.

It wasn't only in his conception of the artist as a spiritual leader, moreover, that Kandinsky drew upon occult doctrine. *On the Spiritual in Art* is, after all, a treatise on the aesthetics of painting, and a good many of what appear to be purely aesthetic observations—about form, about color, about spatial relationships—are similarly derived from theosophical pronouncements. In this respect, *Thought-Forms*—the theosophical classic by Annie Besant and C. W. Leadbeater that was translated into German in 1908—seems to have been of capital importance. When, for

example, in the chapter of *On the Spiritual* devoted to "The Language of Forms and Colors," Kandinsky sets about the task of assigning specific meanings to specific colors, he is clearly appropriating an occult practice.

Thus about the color blue Kandinsky writes that "the deeper the blue becomes, the more strongly it calls man toward the infinite, awakening in him a desire for the pure and, finally, the supernatural"—an obvious echo of the assertion in *Thought-Forms* that "the different shades of blue all indicate religious feeling." When he writes about green that "pure green is to the realm of color what the so-called bourgeoisie is to human society: it is an immobile, complacent element, limited in every respect," this description, too, bears a distinct resemblance to the statement in *Thought-Forms* that "green seems always to denote adaptability; in the lowest case, when mingled with selfishness, this adaptability becomes deceit," etc. And while it is true that Kandinsky takes certain liberties with this theosophical practice, deviating from some of the meanings assigned to colors in *Thought-Forms* and other occult writings, he nonetheless follows the practice of conferring upon each color a significance that is finally metaphysical.

So, too, with Kandinsky's conception of pictorial form. In *The Sounding Cosmos*, the definitive study of the place occupied by occult doctrine in Kandinsky's theory and practice of abstraction, the Finnish scholar Sixten Ringbom reminds us that "thoughts and feeling, theosophy taught, have direct formative powers, and in *Thought-Forms* there is an important passage which only required an artistic application in order to serve as a manifesto for non-objective art." In this passage there are said to be "three types of form-producing thought, of which the first two take the image of persons or material objects, and the third takes a form entirely its own, expressing its inherent qualities in the matter which it draws round it." In this third category, wrote the authors of *Thought-Forms*, "we have a glimpse of forms natural to the astral or mental planes"—in other words, abstract form. To which Ringbom adds: "If, as theosophy maintained, there was a world of form and color independent of material objects, then such forms could be exploited artistically and provide the content replacing the object."

In his pursuit of abstraction, Kandinsky similarly divided his paintings into three categories—Impressions, Improvisations, and Compositions—and while they are not in every respect congruent with the division of form outlined in *Thought-Forms*, they nonetheless trace a similar course.

As Magdalena Dabrowski writes in the catalogue accompanying the current exhibition at MOMA:

> Impressions were the pictures stimulated by "direct impressions of external nature," expressed in "linear-painterly form." Works that were intended to convey "impressions of internal nature" and that represented "chiefly unconscious, for the most part, suddenly arising expressions of events of an inner character" were called Improvisations. [Kandinsky] described the most ambitious of these categories, Compositions, as "the expressions of feelings that have been forming within me in a similar way (but over a very long period of time), which, after the preliminary sketches, I have slowly and almost pedantically examined and worked out. Here, reason, the conscious, the deliberate, and the purposeful play a preponderant role. Except that I always decide in favor of feeling rather than calculation."

In a long career that was copious in production, Kandinsky reserved the term Composition for only ten paintings between the years 1910 and 1939. The first three Compositions were, alas, destroyed during the Second World War, and so we know them today only from preliminary studies and photographs. The last three, though they are included in the current exhibition, fall outside the period that is its principal focus— the period that saw the birth of abstract painting. It is therefore in *Compositions IV* through *VII* and their related studies that we can follow Kandinsky's development as he struggled to formulate his artistic ideas and create the pictorial language that enabled him to produce his first abstract paintings.

But did Kandinsky really succeed in these works in creating an art of pure abstraction? I believe he did; but early on in the history of abstract painting, as its champions divided into factions and each upheld an orthodoxy that precluded the admission of any rival version of abstraction, questions were raised as to whether Kandinsky's *Compositions* could be accepted as authentic examples of abstract art. No less a critic than Mondrian himself was one of the first to express some doubts on the matter. In the September 1918 number of the magazine *De Stijl*, five years after Kandinsky painted his first abstract paintings, Mondrian published an essay called "The New Plastic in Painting." With that essay he reproduced two pictures, Picasso's Cubist masterpiece *Le Violin (Jolie Eva)* (1912) and Kandinsky's *Composition VI* (1913), and insisted that the

Cubist painting, even though it still "represents particular things," came closer than Kandinsky's in expressing "the human spirit" because it "introduces the straight line where it is not directly seen in the object." Then, confining Kandinsky to a footnote, Mondrian wrote as follows:

> Kandinsky too broke the closed line that describes the broad contour of objects, but as he did not sufficiently tense the natural contour, his work remained predominantly an expression of natural feeling. Comparing the works of Picasso and Kandinsky . . . one sees clearly how important are the tension of curved line and use of the straight. Kandinsky's generalized expression, like Picasso's, came about through the abstraction of naturalistic form and color: but in Kandinsky's line still remains a vestige of the contour of objects, whereas Picasso introduces the free straight line. Although Picasso still uses fragments of the contour of things, he carries them to determination, whereas Kandinsky leaves somewhat intact the confluence of line and color found in nature.

Mondrian was certainly right in claiming to find in Kandinsky's *Composition VI* some trace of a "confluence of line and color found in nature," but his argument with Kandinsky cannot be understood entirely in terms of the aesthetics of abstraction. It was because Mondrian had come to believe that the spiritual mission of abstract art could not be fully realized except by means of straight lines that he condemned Kandinsky's lyrical abstraction as "predominantly an expression of natural feeling." Among theosophists, which Mondrian and Kandinsky both were, this was a pronouncement of spiritual failure. Needless to say, this was not the way Kandinsky saw the matter. By 1913 he believed he had arrived at a stage in his development when he was able, as he wrote, "to experience both [the province of art—meaning spirit—and the province of nature] as completely separate realms." Within a decade after 1913 he would, to be sure, abandon the Expressionist component in abstraction and make use of straight lines. But the straight line never became for him, as it did for Mondrian, either a sign of his spiritual mission or an exclusive component of his aesthetic. Yet for both of these masters of abstraction, theirs was an art born of this strange alliance of aesthetics and mysticism.

[1995]

Mondrian and Mysticism: "My Long Search Is Over"

> *The irrational bears the same relation to the rational that the unknown bears to the known. In an age as harsh as it is intelligent, phrases about the unknown are quickly dismissed. I do not for a moment mean to indulge in mystical rhetoric, since, for my part, I have no patience with that sort of thing. That the unknown as the source of knowledge, as the object of thought, is part of the dynamics of the known does not permit of denial. . . . We accept the unknown even when we are most skeptical. We may resent the consideration of it by any except the most lucid mind; but when so considered, it has seductions more powerful and more profound than those of the known.*—Wallace Stevens, circa 1937

What was the nature of the quest that moved the Dutch painter Piet Mondrian (1872–1944) to abandon the representation of nature in favor of an art of pure abstraction? What, exactly, did Mondrian *believe* he had achieved? In any attempt to address this question, we are obliged to deal with the fact that abstract art—and not only Mondrian's—was born of an alliance of aesthetics and mysticism. We are obliged to examine the ideas that shaped the artist's search for the absolute in art. Ideas, of course, are no substitute for the experience of art, and in Mondrian's case are certainly not to be taken to be the "subject matter" of his painting. Yet without some grasp of the intellectual history that led the artist to make his fateful leap into abstraction, the spiritual imperative that

governed Mondrian's art is unlikely to be understood. This is a subject that takes us into the mind of modernism at one of the key turning points of its history. It therefore seems an appropriate subject to explore on the occasion of the great Mondrian exhibition that opens next month at the Museum of Modern Art in New York—and all the more so since the exhibition itself, as it was presented at the National Gallery in Washington this summer, gave the subject scant attention. In Professor Yve-Alain Bois's essay for the catalogue accompanying the exhibition, for example, the author seems vaguely embarrassed that an artist of Mondrian's stature might be seen to be seriously implicated in a system of ideas and beliefs which for most of us cannot claim a very persuasive intellectual provenance.

It won't do to dismiss the issue with condescending references to Madame Blavatsky or attempts to substitute the ideas of more respectable thinkers like Goethe and Hegel in examining the intellectual origins of abstraction. For the problem posed by the relation that obtains between mystical belief and artistic innovation in the creation of abstraction is one that goes beyond Mondrian himself. In the period that saw the genesis of abstract art—roughly the decade beginning in 1910—what is particularly striking about the outlook of the artists primarily responsible for creating abstraction is their espousal of occult doctrine. So prevalent was a steadfast belief in the occult among the pioneers of abstract art—not only Mondrian but also Kandinsky, Malevich, and a good many of their disciples—that we have no alternative but to regard such doctrine as a basic component of their artistic vision.

It should be understood, however, that the particular school of mystical thought that exerted the greatest influence on the creation of abstract art—the system of occult belief generally known as theosophy—was in this period a widely established component of Western cultural life. While deliberately esoteric and by no means a popular creed, theosophy was not an interest limited to coteries of avant-garde painters and sculptors. Still less was it an interest confined to a circle of intellectual cranks and charlatans, though it did indeed attract a large number of crackpots and crazies. (It still does.) As Wallace Stevens was to observe some years later, "There are, naturally, charlatans of the irrational. That, however, does not require us to identify the irrational with the charlatans."

Still, it was an odd group of savants and mystagogues that shaped the course of modern theosophical thought, thereby exerting a decisive in-

fluence not only on the origins of abstract art but on other key devel-
opments in twentieth-century art and culture. The high priestess of the
movement was indeed the Ukrainian-born adventuress Helena Petrovna
Blavatsky (1831–1891), known to her followers the world over as H.P.B.
She was said to have commanded occult powers from an early age. She
certainly possessed a magnetic personality, making her way in the
world—which in Blavatsky's case meant Europe, America, and Asia—as
an emancipated woman without apparent means, yet always attracting (it
seems) a circle of admiring men and women who believed in her spiri-
tual gifts, supported her occult endeavors, propagated her theosophical
doctrines, and remained undaunted by her scandalous reputation.

In New York, in 1875, H.P.B. founded the Theosophical Society and
promptly produced two large tomes—*Isis Unveiled* (1877) and *The Secret
Doctrine* (1888)—that became the sacred scriptures of the movement. The
claim advanced by this movement, which came to be called the Univer-
sal Brotherhood of Humanity, was that theosophy had triumphantly
resolved the conflict between science and religion caused by the Dar-
winian theory of evolution. "It was the genius of H.P.B.," writes the
historian James Webb in *The Occult Underground*, "to apply Darwin's the-
ory to produce a *hopeful* resolution to the human condition." Webb con-
tinues:

> Whereas others saw only the destruction of the sustaining myth of
> man's divine origins, H.P.B. discovered that evolution could apply also
> to the "spiritual" aspects of existence. Man had evolved from apes—
> perhaps; but he had a noble destiny. Just as *homo sapiens* had evolved
> from a lower form of animal life, and that form in its turn from a
> lower—a vegetable, protoplastic, or unicellular existence—man as at
> present constituted was on his way to higher and better things.
> Evolution continued on a cosmic scale, with each individual born and
> reborn thousands of times until he had achieved earthly perfection.

To achieve the exalted goals that theosophy now invoked as a spiri-
tual imperative for art, it was nonetheless necessary for art itself to re-
main firmly within the realm of aesthetic experience. An art born of an
alliance of aesthetics and mysticism was still obliged to traffic in material
objects, and thus remain accessible to visual perception, if its spiritual
function were to be realized. It could not—or not yet, anyway—so com-
pletely dematerialize itself as to become invisible if it were to continue

to function as art. When the Epoch of the Great Spiritual was finally attained in some faraway future existence, no doubt this last concession to material contingency would be dispensed with; and art, too—to the extent that it continued to be needed—would become pure spirit.

But meanwhile, in the spiritually imperfect present, an art that aspired to make itself the instrument of pure spirit—to align itself with what Kandinsky described in *On the Spiritual in Art* as "the struggle toward the non-naturalistic, the abstract, toward inner nature"—had no alternative but to make its case as an earthly cultural enterprise. It thus remained subject, in this respect, to the "laws" and conventions and material conditions governing the medium in which the artist worked. It was for this reason that even the most mystical of the pioneer creators of abstract art found themselves engaged in a dialectic that embraced two very different aspirations—on the one hand, that of advanced artistic thought, with its headlong drive to discover new modalities of pictorial expression, and, on the other, that of a spiritual ideal that looked upon art as a means to an end that transcended art itself.

For observers who mistakenly tend to identify mysticism with a retreat from the practical affairs of the world, it must sometimes seem a paradox, if not an outright contradiction, that artists of a mystical temperament are perfectly capable of pursuing their worldly ambitions with the kind of uncompromising zeal that we observe in the careers of the early abstractionists. But the truth is that in every realm of high endeavor in which we find mysticism serving as a spur and an ideal—in movements of political revolution and campaigns for sexual emancipation, for example, no less than in avant-garde art movements—this loyalty to occult doctrine has proven to be a powerful incentive to practical achievement. Within the imaginative faculties there is nothing that so stirs the will to accomplish extraordinary things as the conviction that one is possessed of absolute knowledge about the ultimate destiny of human affairs. This was precisely the kind of mystical conviction that the pioneer creators of abstraction brought not only to their own innovations as artists but to the formation of avant-garde movements that changed the direction of modernist art and greatly expanded the place it would come to occupy in modern cultural life.

It is this belief in the absolute that accounts for the speed as well as the confidence which the pioneers of abstraction brought to their break with what they saw as the last vestiges of representation in art, and for

the success they achieved in winning converts to their radical view of artistic expression. These artist-acolytes of the occult really did believe they were fulfilling a unique spiritual mission in this fateful act of artistic innovation, and they persuaded a great many others to join them in that belief. Theirs was, in this sense, a religious movement as well as an artistic one, and they brought to it the kind of intensely felt faith that we associate with spiritual yearning and religious conversion.

Yet it was as artists first of all, and only secondarily as exponents of the occult, that they exerted their deepest influence on art itself. In the latest developments of the art of their time, which in the case of Cubism had already brought painting to the very verge of abandoning representation, they shrewdly discerned a "logic" that cried out for completion. This gave to abstraction a powerful sense of purpose—a kind of ontological imperative—that was all the more compelling when combined with the promise of a spiritual vocation. As artists, the pioneers of abstraction had largely mastered in their earlier paintings the rapid succession of styles that had moved from Realism and Impressionism to the Post-Impressionist, Fauvist, Expressionist, and Cubist art which dominated the European avant-garde in the last decade of the nineteenth century and the first decade of the twentieth. Because it was from inside this fast-paced arena of pictorial revision that Mondrian, Kandinsky, and Malevich made their historic assault on what remained of traditional representation in art, their views as well as their example carried a special authority—particularly for the younger members of the avant-garde who harbored an intense appetite for the absolute and a headlong impatience to see it realized. For them, everything that had occurred in the history of painting from Courbet to Picasso was suddenly relegated to the past by this unexpected leap into abstraction. In their very different ways—for Mondrian, Kandinsky, and Malevich, despite similar convictions about abstraction and the occult, were distinct individualists with quite separate programs for their art—the pioneers of abstraction opened up a new artistic world to their contemporaries. It was a world vastly different in its metaphysical and artistic outlook from that of the avant-garde movements which immediately preceded the emergence of abstraction.

Indeed, from the perspective of the modernist movement in Paris, where the prehistory of pictorial abstraction had largely taken place and which continued to command an unrivaled authority and influence as

the capital of the international avant-garde, the new abstractionists signified something alien and suspect. The modernism of the School of Paris had been anything but monolithic, of course. Its cosmopolitanism was legendary, and it was justly famous for its receptivity to a wide range of advanced ideas and personalities. Theosophy and other theories of the occult were well known there, too, though they did not lead to a movement advocating abstraction. In fact, none of the ideas contending for attention in the world of the Paris avant-garde openly advocated as *a matter of principle* the total rupture with representation then beginning to be championed by the pioneers of abstraction. Parisian modernism was, by and large, far too attached to the things of this world to forgo their pictorial representation as a permanent imperative. The Paris avant-garde was, in this respect, invincibly materialist in its outlook on life—still closely tied to observable sensation, and thus ineluctably earthbound in its basic character. However hermetic its allusions to the things of this world might at times become, Parisian modernism was nonetheless steadfast in its allegiance to them as an indispensable point of departure.

It was this allegiance to the things of this world that the mystagogic convictions of the new abstractionists now put into question for the first time, and it was for this reason, above all, that they were either ignored, rejected, or consigned to a marginal status by the Parisian avant-garde. (Even the quintessentially French color abstractions of Robert Delaunay, which the poet Apollinaire dubbed "Orphic Cubism" and which derived from the color theories of the Neo-Impressionists, were more sympathetically received in Germany than in Paris.) The doctrinaire abstraction that was rooted in theosophical ideas was therefore seen to constitute, in the early years of its development, a counter-avant-garde opposed to the mainstream artistic interests of the School of Paris. It was, as far as Paris was concerned, virtually an underground movement that did not enjoy the critical acclaim, or even the kind of critical scandal, that had marked the emergence of Fauvism and Cubism before the First World War and would again mark the emergence of Dada and Surrealism in the years following the war.

It was in advanced artistic circles outside of Paris—in Russia, Germany, and the Netherlands—that the new vision of the pioneer abstractionists met with the most combustible and consequential response. Of the vanguard figures who set out to create an abstract art based on a visionary synthesis of aesthetics and mysticism, only Mondrian lived and

worked in Paris for extended periods of his development, first in the years between 1912 and 1914 and then again from 1919 to 1938. It was in the first of these periods, when he remained virtually unknown to the Paris avant-garde, that Mondrian created his earliest abstract paintings.

Mondrian had made the decision to dedicate his life to art long before he turned to the occult, but it was as a dedicated theosophist that he created his first abstractions. After a strict Dutch Calvinist upbringing, he found in theosophy a refuge from the religious turmoil of his youth and early manhood. For a time he even kept a portrait of Madame Blavatsky on the wall of his studio—an icon of his spiritualist endeavors. (As Yeats later recalled, "To [Madame Blavatsky's] devout followers she was more than a human being.") In later life Mondrian's friends often spoke of his "priestly air," and there was no question that for him the artistic vocation would never be entirely separable from his intense religious feelings.

Born in Amersfoort, Utrecht, the Netherlands, in 1872, Mondrian was educated at the Calvinist Primary School in Winterswijk, where his father—a stern disciplinarian—was headmaster. This was the only formal schooling Mondrian received before enrolling in the Academy of Art, in Amsterdam, in 1892. In his adolescence he was given some informal art instruction by his father, an amateur draftsman, and by an uncle, who was a professional painter in The Hague. His own development as a draftsman was sufficient to enable him to qualify, at the age of twenty, for the modest post of teacher of secondary-school drawing. This was his situation when he entered the Academy.

Nothing in Mondrian's early life as an art student or as a young exhibiting artist gives us any hint of the gifts that would one day make him a leader of the international avant-garde. He was anything but precocious. He attended the Academy off and on until 1896, and began exhibiting in Amsterdam the following year. But the pictures he then produced—at a time, it should be remembered, when Van Gogh and Seurat had already completed their work, when Cézanne was painting some of the greatest pictures of his late period, and Art Nouveau was the fashion—still consisted of naturalistic landscapes and still lifes in the Dutch academic tradition. Even by provincial academic standards, moreover, Mondrian's early career was anything but promising. In 1901, at the age of twenty-nine, he failed to qualify for the Dutch *Prix de Rome*, owing to a lack of proficiency in rendering the figure. Henceforth, until his turn to abstraction,

Mondrian's principal subject matter was landscape. He was also devoted to painting flowers, a practice that provided him with a living of sorts even after he had turned to abstraction.

Following the *Prix de Rome* fiasco, nearly a decade elapsed before any significant trace of modernist influence made itself felt in Mondrian's landscape painting. This was slow in coming for several reasons. Holland in the nineteenth century had remained something of an artistic backwater as far as modern painting was concerned. News of avant-garde developments in Paris and other cosmopolitan capitals did not easily penetrate the provincial art life of Amsterdam in Mondrian's student days. ("Van Gogh was dead," wrote Michel Seuphor of this period in Amsterdam, "but still unknown.") Shut off from such developments in a very conservative cultural milieu, Mondrian himself did not awaken to the implications of modernism until he was well into his thirties. This awakening occurred, as it happened, coincidentally with his formal commitment to theosophy.

It was thus around 1909—the year that Mondrian officially joined the Theosophical Society of Amsterdam, with a certificate of membership signed by Annie Besant—that he belatedly developed the rudiments of a modernist pictorial style. It began with a modified version of Seurat's Pointillist method, combined with a Symbolist attitude toward color, that was applied to the rendering of Dutch landscape motifs—haystacks, windmills, tree forms, and seaside dunes. This initial approach to an independent style was already a step in the direction of abstraction, for nature was not so much described in these pictures of haystacks and dunes as made the point of departure for more emphatically articulated pictorial structures that relegated their subjects to a secondary status. Such pictures were, in any case, quickly succeeded by the artist's determination to submit these same landscape motifs to the even more radical Cubist innovations of Braque and Picasso, a few examples of which Mondrian saw for the first time in an Amsterdam exhibition in the fall of 1911. Those few proved to be enough to change everything.

Mondrian's encounter with Cubism was clearly the critical turning point of his artistic development. While it would be another year or two before he finally expunged the last traces of traditional representation from his painting, what can only be called his conversion to Cubism—now abetted by the anti-materialist imperatives of his theosophical faith—put Mondrian's life as an artist on an entirely new footing. Ap-

proaching his fortieth birthday, released at last from the tethers of academic tradition, philistine taste, and the provincial culture of his youth, Mondrian was ready to enter the ranks of the avant-garde. Artistically and spiritually, the obscure Dutch artist who finally quit Amsterdam for Paris in the last days of December 1911 was on his way to a new life—a life that in the coming decade would change the face of Western art.

"We may say," wrote Michel Seuphor in his study of Mondrian, "that it was in Paris in 1912 . . . that the life of the great painter began." It was, from the outset, a life of personal isolation, artistic dedication, and mystical reflection. The evidence suggests that it was also a life devoid of erotic engagement. Upon his arrival in Paris, where he lived and worked in a studio borrowed from a Dutch acquaintance, Mondrian had few friends, knew little French, and allowed himself almost no distractions. His first—indeed, his sole—priority was to come to terms with the Cubist ideas he had only just discovered.

To this task he now brought a sense of purpose that was entirely new to him. Quickly mastering the ambiguities that were central to the Cubist aesthetic—ambiguities that set the need for a recognizable motif dialectically at odds with a method of pictorial composition designed to eliminate its distinctive features—Mondrian painted with a confidence and drive he had never before enjoyed. His mission was at once exalted and implacable. Cubism became the battleground on which the artist who had been nurtured on the specifications of Dutch landscape painting fought his last protracted conflict with nature. In this struggle, Mondrian produced his first masterpieces—the series of *Compositions* based on tree forms in which the last remnants of naturalistic detail are no sooner evoked than all but extinguished in favor of pure painting.

Technically, Mondrian's tree *Compositions* of 1912–1913 may not qualify as pure abstractions, for the presence of the fractured motif, while diminished almost to the point of extinction, is still minimally discernible. (This tends to be true of nearly all the earliest abstractions.) Yet aesthetically, in the way such pictures are experienced as integrated structures of pictorial form, they have unquestionably crossed the boundary separating abstraction from representation. And during the remainder of this first period of residence in Paris, Mondrian eliminated virtually all association with nature from his pictorial vocabulary. By imposing upon each successive painterly composition of soft-edged Cubist forms an increasingly insistent network of hard vertical and horizontal

lines, he left no trace of—and finally no space for—an observed object or remembered motif.

The result was a series of paintings dominated by an irregular, improvised, and as yet unsystematic version of the abstract "grid" that, a few years hence, would become a compelling principle in Mondrian's classic geometrical abstractions. These first abstractions were not yet governed by any kind of absolute rule. They were not painted according to a theory. Mondrian was following the dictates of his sensibility—a sensibility that was then more confident, perhaps, about what it wished to eliminate than about what it wished to retain for painting—as he worked his way toward what he took to be "the logical consequences" of Cubism. Still, the artist who reluctantly returned to the Netherlands in the summer of 1914, on the eve of the First World War, had nonetheless succeeded in transforming the "logic" of Cubism into an art of abstraction. If he was not yet a recognized leader of the avant-garde—for abstraction was not itself a widely recognized artistic "cause"—he was already producing the kind of art that would serve as a foundation for a new movement. As Theo van Doesburg, the ideological leader of De Stijl, afterward acknowledged: "Mondrian was the first to realize, in 1913, by a consistent elaboration of Cubism, this new plasticism as a painting."

What role did Mondrian's belief in the occult play in this headlong pursuit of abstraction? The notebooks in which he began, in 1914, to keep a record of his ideas about "Art and Reality" clearly establish the centrality of his quest for "the spiritual" in all of his artistic endeavors at the time. This is the key passage:

> Art and Reality. Art is higher than reality, and has no direct relation to reality. Between the physical sphere and the ethereal sphere there is a frontier where our senses stop functioning. Nevertheless, the ether penetrates the physical sphere and acts upon it. Thus the spiritual penetrates the real. But for our senses these are two different things— the spiritual and the material. To approach the spiritual in art, one will make as little use as possible of reality, because reality is opposed to the spiritual. Thus the use of elementary forms is logically accounted for. These forms being abstract, we find ourselves in the presence of an abstract art.

Careful attention must be paid to the way Mondrian invokes the concept of "reality" in his writings, for in a very short time it would

come to signify something very different—the exact opposite, in fact—from his identification of reality, in this passage, with the material world of "our senses." This is, of course, what most of us mean by reality. As he refined his philosophy of art, however, bringing it into stricter alignment with occult doctrine, "reality" became a term wholly reserved in Mondrian's later writings for the realm of "the spiritual." But this terminological revision does not reflect any change in the essential direction of his thought about abstract art. Fundamental to its creation, in his case, was a steadfast metaphysical belief in the division that separated "the spiritual and the material," and, as an artistic corollary to this, a further belief—which he was not yet ready to act upon to the fullest degree—in "the use of elementary forms" as the most expeditious means of achieving "the spiritual" in art.

We cannot know what immediate course Mondrian's painting—as distinct from his ideas about painting—would have followed if the war had not disrupted his artistic pursuits in the summer of 1914. Summoned to his father's bedside in July of that fateful year, he was not expecting this duty visit to his family to amount to anything more than a brief interlude. As it happened, of course, he soon found himself trapped in the Netherlands for the duration of the war. As the country was neutral in the war, Mondrian was never in any danger from the military operations that were devastating other parts of Europe. Yet he felt painfully cut off from the important work he had started. Separated from his paintings, which had been left behind in Paris, and from the milieu in which they had been produced, Mondrian lost some of his artistic momentum. Nevertheless, in this period of enforced repatriation he devoted a great deal of thought to formulating his future artistic program.

In this pursuit he soon discovered that he was by no means as isolated in his new artistic and philosophical outlook as he had believed himself to be. "The war," writes the Dutch historian H. L. C. Jaffé, "had brought many Dutch artists who had been working abroad, back to their native country, and these came back to the Netherlands charged with the results of their studies and full of new and promising ideas. In the Netherlands they found an atmosphere of spiritual tension, generated by the fact of the country's being a neutral enclave, an oasis in a continent at war." It was thus in the war years that Mondrian came to know, among others, the painters Theo van Doesburg and Bart van der Leck, the architects J. J. P. Oud and Robert van't Hoff, the designers Vilmos Huszar

and Gerrit Rietveld, and the Belgian sculptor Georges Vantongerloo—
the artists who, with Mondrian, founded in 1917 the avant-garde move-
ment called De Stijl (the Style). This was to have an immense influence
not only on the future of abstract art throughout the Western world but
also on modern architecture and design and on the aesthetic, social, and
pedagogical theories that supported them.

De Stijl was, from the outset, something more than an art move-
ment. It was a social and cultural program, based on a visionary amalgam
of idealist aesthetics, industrial mechanics, and utopian politics. Its ambi-
tion was to redesign the world by imposing straight lines, primary col-
ors, and geometric form—and thus an ideal of impersonal order and
rationality—upon the production of every man-made object essential to
the modern human environment. Rejecting tradition, it envisioned the
rebirth of the world as a kind of technological Eden from which all trace
of individualism and the conflicts it generates would be permanently
banished. Its goal was to liberate European culture from the "archaistic
confusion" of its past in order to create an entirely new and completely
harmonious civilization.

In this ambition, notwithstanding its rationalist claims, a belief in the
occult was to play an important role. In 1915 the Dutch writer M. H. J.
Schoenmaekers published a treatise called *The New Image of the World*, de-
scribed by its author as a work of "positive mysticism." This and a sub-
sequent volume, *Plastic Mathematics* (1916), exerted a crucial influence on
Mondrian and the other founders of De Stijl. According to Jaffé, "Both
Mondrian and Schoenmaekers lived, at the time, in Laren and . . . saw
each other frequently and had long and animated discussions." Schoen-
maekers's ideas were directly incorporated into the De Stijl program
from 1917 onward, as well as into Mondrian's later theoretical writings.
The very term that Mondrian adopted for the geometrical abstractions
of his later years—Neo-Plasticism—was borrowed from Schoenmaek-
ers's wartime writings.

Schoenmaekers was a Neo-Platonist in quest of a reality more ab-
solute than any that could be discerned in the natural world without
the aid of mystical illumination. Nature, from the perspective of this
"positive mysticism," was looked upon as a mystery to be scrutinized
and penetrated—a view that was more or less in accord with theo-
sophical doctrine, and that also bore a distinct resemblance to the Sym-
bolist philosophy of Mallarmé. Truth was defined as the reduction of

"the relativity of natural facts to the absolute, in order to recover the absolute in natural facts." What was especially important in this theory was that art, if sufficiently awakened to its mystical role, was accorded a central place in the metaphysical process. "In art," Schoenmaekers wrote, mysticism "creates what we call, in the strictest sense, 'style.'" Style in art is characterized as "the general in spite of the particular" and the means by which "art is integrated in general cultural life." Thus the joint task of the artist and the mystic is "to penetrate nature in such a way that the inner construction of reality is revealed to us."

It was not only for its philosophical affirmation of the mystical view of "reality," moreover, nor for the role it envisioned for art in divining its "inner construction," that Schoenmaekers's theories were important for Mondrian in his thinking about abstraction. Schoenmaekers also specified the nature of the forms (rectilinear structures of the horizontal and the vertical) and the colors (the primaries: red, yellow, and blue) to be used in this artistic quest for the absolute, and then elaborated upon their cosmic significance. "This new plastic expression," Schoenmaekers wrote in *The New Image of the World*, "is of this world. . . . But it is a new earthiness, an earthly heaven." And an "earthly heaven," or some artistic analogue thereof, was indeed what the artists of the De Stijl group, Mondrian most conspicuously, were determined to create in their abstract art.

It must not be supposed, however, that Schoenmaekers's ideas triggered an abrupt or immediate break in Mondrian's pictorial practice. The purely geometrical, or Neo-Plasticist, abstractions, with which Mondrian came ultimately to be identified, were never painted according to a theoretical formula, and there was certainly no sudden conversion to the purely geometrical as the result of his response to Schoenmaekers's philosophy. On the contrary, Mondrian seemed at first somewhat daunted by the vision of an art that might jettison all the variations in tone and contour that had remained a staple of his painting even when he abandoned conventional representation in the most highly developed of his "Cubist" abstractions. In later years, with his painting confidently entrenched in Neo-Plasticist principles, he might dismiss such residual signs of painterly tradition as a throwback to "Impressionism" or even naturalism; but during this difficult period of transition to a more absolute mode of abstraction, when every mark on the canvas was an exploration of the unknown, Mondrian nonetheless held fast to such vestiges of tradition even as he

was inching his way toward a conception of painting that would finally do without them.

Thus the pictorial means traditionally associated with the depiction of observable objects and the space they occupy—shifts of tone and color value, and the variations in drawing that serve to hold them in place—survived a while longer in Mondrian's painting even when their representational function had already been forfeited. Clearly it was not an easy matter for a painter of Mondrian's background and experience, even at this relatively advanced stage of his development, to bid an irrevocable farewell to such a fundamental pictorial practice. The depth of the perturbation caused by this radical option may be inferred from the fact that only one painting by the artist survives from the year 1916. This was the crucial period in which Mondrian was struggling to reconcile the demands of his art with the appeal of Schoenmaekers's ideas. The abstraction that he produced that year—*Composition: 1916*, now in the collection of the Guggenheim Museum—is at once a summation of the "old" painting and a partial preview of the new. Its forms are predominantly rectilinear but still soft-edged, "open," and irregular. Its black lines hold firmly to right-angled verticals and horizontals, but at the side edges of the painting they shade off into veiled greys. Its colors—blues and blueish greys, pinks and greyish pinks, yellowish ochres that in places turn brown—are cousin to the primaries but remain equivocal, impure, and atmospheric. There is no discernible subject in *Composition: 1916*, but for anyone who knows the *Pier and Ocean* drawings by Mondrian that preceded it there is an unmistakable visual echo, or memory, in its fragmented grid structure. This is painting with a pronounced appetite for an absolute it does not yet command the means of realizing.

The breakthrough came the very next year. "For the moment at least," Mondrian wrote to a friend in September 1917, "my long search is over." While he had produced little new painting during the previous year, he had devoted much time and thought to the writing of a treatise of his own—"The New Plastic in Painting"—which van Doesburg began serializing in the inaugural issues of *De Stijl*. At the same time, Mondrian painted his first geometrical abstractions—the series of pictures entitled *Compositions in Color* or *Compositions with Color Planes*. These "flat" pictorial compositions of rectangles in primary colors on a grey ground closed the door on the kind of illusionistic space—the space of

representation—that the artist had been struggling to transcend since his first encounter with Cubism six years earlier. In 1917, Mondrian had at last brought both the theory and the practice of pure abstraction into a satisfactory alignment.

"The New Plastic in Painting" owed a good deal to Schoenmaekers's mystical philosophy, of course, but it was more directly addressed to the problems of painting. It was at once a manifesto for a new pictorial aesthetic—an aesthetic of pure abstraction—and a restatement of the occult, anti-materialist doctrines that supported its creation. "The new plastic," Mondrian wrote in the introduction to this historic treatise, "cannot be cloaked in what is characteristic of the particular, natural form and color, but must be expressed by the abstraction of form and color—by means of the straight line and determinate primary color." What is remarkable about "The New Plastic in Painting" is not only its triumphal affirmation of pure abstraction as an aesthetic "absolute"—a word that was repeatedly sounded throughout the manifesto—but the anxious attention that is lavished on the need to emancipate painting from the thralldom of what is variously called "nature's appearance," "naturalistic representation," "naturalistic form," "naturalistic color," and so on. Nature haunts the pages of "The New Plastic in Painting" like a specter that can be neither exorcised nor appeased. It can only be resisted by an act of transcendent artistic conscience that makes the pursuit of the "universal" a quest so absolute that all the contingencies of nature are stripped of their importance.

Implicit in this view of what Mondrian also called "the style of the future" was an idea of evolution—the evolution of art in the service of the evolution of spirit—akin to the theosophical doctrines of Madame Blavatsky and Rudolf Steiner. According to this conception of evolution, mankind had once "lived in harmony with nature's rhythm." With the development of human consciousness, however, "there automatically ensued a disharmony between man and nature." It was thus to be the function of the new abstraction, or what Mondrian sometimes called "abstract-real painting," to give us "the image of this regained harmony." This was to be achieved, Mondrian avowed, by the creation of a pictorial composition "more mathematical than naturalistic," an art of "pure relationships" that eschewed "all that was capricious" in nature in order to achieve "*the most constant, the most determinate plastic expression of equilibrated relationship*—composition in rectangular planes." (The emphasis is

Mondrian's.) Hence the *Compositions with Color Planes* that set him on his new course in 1917.

"The New Plastic in Painting" concludes by celebrating the emergence of "a purer and purer mode of expression in art" as a triumph of the modern era, and Mondrian was himself to live by this artistic faith for the rest of his life and make it a source of inspiration for others. All the same, an existential uncertainty about the role of nature—in art and in life—remained a vexing issue for Mondrian, and his philosophy of abstraction cannot be fully comprehended in isolation from it. Toward the end of "The New Plastic in Painting," his ruminations on nature suddenly take the form of an arcane discussion of the male and female principles transposed to the realm of mystical archetypes. Identifying nature with the female principle and spirit with the male, he concludes that "The female and male elements, nature and spirit, then find their *pure expression, true unity, only in the abstract.*" (Again, the emphasis is Mondrian's.) This is clearly the sheerest mysticism, and more the expression of a lingering anxiety about nature than a resolution of the problem it posed for a sensibility nurtured on the occult. Yet it was upon such an uneasy mystical foundation that Mondrian's absolutist aesthetic of abstraction finally came to rest.

In this amalgam of mysticism, anxiety, abstraction, and a search for the absolute, we are reminded, as we often are with Mondrian, of Mallarmé—especially of that passage in Mallarmé's prose in which the poet speaks so poignantly of "isolating oneself, disdainfully, in the serenity of abstraction." "Serenity appears as a quality both of the effect of the finished work," wrote one of Mallarmé's commentators, D. J. Mossop, "and of the artist's feelings during the act of composition. It is, in turn, inseparable from the idea of harmony. The poet achieves harmony and serenity in himself and in his work by withdrawing from too active a participation in the passions of his theme so as to abstract a perfect order from the disorder common to the impressions made by normal experience and the feelings of lyrical inspiration."

Such was Mondrian's outlook on art and life, too, as he finally achieved "the serenity of abstraction" and embarked upon the work that would shape the course of abstract art for decades to come.

[1995]

Art, Revolution, and Kazimir Malevich

There are careers in the arts that epitomize the spirit of their time in so many salient respects that they attain a kind of mythological status in the eyes of posterity. The life and work of the Russian painter Kazimir Malevich (1878–1935), whose art is currently the subject of an extraordinary exhibition, constitute a career of this sort. In every aspect of his endeavors—in his downfall as much as in his triumphs—Malevich was the very archetype of the avant-garde artist in the age of revolution. Embracing without qualm or limit every extreme of belief and aspiration offered up by the tumultuous era in which he pursued his radical ideals, Malevich looked upon art as at once an absolute and an instrument—as pure spirit, on the one hand, and a means of imposing a new social order, on the other. In this view of art and its functions, the work of art was thought to encompass and affect every sphere of life and thought—and to do so, moreover, through the suppression of all visual reference to earthly existence. So total was the mission of art to be in Malevich's conception of it that it was only through the most complete abstraction that both its transcendent and its earthly goals were believed to be fully realizable. Upon abstract art there was thus conferred a burden and a status that in more traditional societies were considered the province of religion, politics, education, philosophy, and culture itself. No wonder Malevich called the movement that he founded Suprematism, for the role that he envisioned for art was nothing less than a universal supremacy in all fields of human endeavor.

That such a conception of art might harbor some profound contra-diction, not to say a fundamental delusion; that it might deceive the artist himself as to what was central to his art and what merely circumstantial and peripheral; that in the end it was founded on a misconception not only of what art was capable of achieving but what the realities of life itself consisted of—about none of this does Malevich appear to have been even vaguely concerned while he was riding high as a leader of the Russian avant-garde in the years immediately preceding and following the Bolshevik Revolution of 1917. Though more of a mystic than a po-litical thinker, more indebted to the doctrines of P. D. Ouspensky than to those of Marx or Lenin, Malevich seems nonetheless to have truly be-lieved that the ideas governing his conception of art—ideas that are in-separable from the spiritualist, anti-materialist tenets of theosophy—were in perfect agreement with the ideological imperatives of the new Soviet state.

Malevich was by no means alone, of course, in his conviction that some ideal harmony united a belief in the occult with a commitment to Communism. Theosophy commanded a significant following among artists in many fields at the turn of the century, and not only in Russia; and it was often the case that an allegiance to theosophical doctrine in-clined these believers in the occult to seek earthly salvation in utopian or otherwise extreme political positions. Figures as different as the Irish poet William Butler Yeats and the Dutch painter Piet Mondrian followed quite similar courses at the time, Yeats combining his belief in the occult with an attachment to fascism and Mondrian seeking to unite his theosophical faith with some vague notion of an ideal utopian future. What made Malevich's situation so special was the opportunity that the Revolution of 1917 gave to the entire Russian avant-garde to make their dreams of a new world come true. In the vast upheaval of the Revolution, it hardly mat-tered for the moment that the romance of the occult was not finally rec-oncilable with the imperatives of a Communist society. In the short term, at least, the occultists and the Communists were agreed in wishing to overturn every tradition and destroy every remnant of the culture and the society of pre-Revolutionary Russia. The result was one of the most bi-zarre intellectual alliances in the annals of the modern era: an art move-ment that owed much to the irrationalist, anti-materialist doctrines of the occult was empowered by the Leninist leaders of the Revolution to cre-ate a new culture in the name of dialectical materialism.

We have long known about the tragic fate that overtook this misbegotten alliance of art and politics early on in its history. Even before Lenin's death in 1924, many of the stellar talents of the avant-garde had fled into exile—mainly to Germany and France—in order to avoid the catastrophe that was clearly on the way. By 1922 the process of systematically stripping the avant-garde of its powers, which in the first years of the Revolution had been enormous, had begun; and under Stalin modernism was categorically condemned as "bourgeois"—a charge likely to lead directly to the Gulag, if not to the firing squad. The dreams of the avant-garde were quickly supplanted by the long dark night of the Stalinist terror.

It was not the least of Malevich's distinctions that he survived this ordeal, even managing to die of natural causes in his own bed—itself something of an achievement for a figure of his eminence in the Soviet Union in the year 1935. That the price of survival was a fundamental betrayal of his own artistic ideals is made plain for us to see in the current Malevich retrospective—the most complete account of the artist's work we have seen in this country. When we come to the last room in this exhibition and find the painting called *Reapers* (circa 1929–1932), which depicts in a more or less realist manner three robust peasant women harvesting the grain, the only appropriate response is a feeling of utter revulsion. Not only does the painting represent an abject surrender to Stalin's newly proclaimed doctrine of Socialist Realism, but its very subject matter—those well-fed peasant women harvesting the grain in what looks like a pastoral idyll—is the most cynical propaganda. For it was precisely at this moment in history that Stalin was carrying out his program of collectivization, which caused the deaths of millions of peasants and resulted in the destruction of Russian agriculture.

Even if we knew nothing of Stalin's murderous policies, however, this painting would be difficult to take in purely artistic terms, for it marks a return to everything Malevich had categorically rejected in his art. In the development that is clearly and beautifully traced in this retrospective exhibition, we follow an immensely gifted and adventurous painter as he makes his way through the various styles—from Impressionism and Symbolism to Fauvism and Cubism and Futurism—that have defined the course of modernist art, until the moment arrives when he takes off into a realm entirely his own with the invention of a special form of abstraction. There is something very moving about this exhibition, for Malevich

was in many respects a far better painter—once he hit his stride, anyway—than he has generally been thought to be in the past. Certain of his Cubist and Cubo-Futurist pictures are undeniable masterpieces of their kind. They owe much to the precedents of the School of Paris, but it was in the nature of the Russian avant-garde to seize upon the most radical of these precedents and then carry them a step further—and to do so, moreover, with a speed and confidence and inventiveness that were often unrivaled elsewhere. Malevich was particularly audacious in this respect. In the Suprematist abstractions he produced in the decade beginning around 1915, he created not only some of the most original abstract paintings of the age but certain pictorial conventions that have continued to serve as guidelines for the more austere varieties of abstract art down to the present time. Compared with the works Malevich produced between 1915 and 1926, much that was acclaimed for its originality and audacity in the Minimalist art of the 1960s, for example, seems distinctly secondhand. Malevich created the aesthetic territory that the Minimalists later colonized and expanded.

I doubt if there has ever been a more beautiful presentation of Malevich's work than the one that Angelica Rudenstine has given us at the National Gallery in Washington, where this retrospective opened its current American tour. The emphasis in the installation and layout of the exhibition in Washington is decidedly—and properly, in my view—on the *art,* rather than on the ideas governing the art; and this emphasis has the salutary effect of establishing Malevich as an aesthetic sensibility, as the successful exponent of certain aesthetic strategies and devices, and thus tends to minimize the politics, the mysticism, and the rest of the ideological baggage that occupied such an important place in the artist's life and thought. This seems to me exactly the right emphasis, for it is *only* as an artist of considerable distinction and originality that Malevich continues to make a major claim on our attention. As a thinker he was quite hopeless. His copious writings, maddeningly repetitious and replete with every kind of mystification about art, politics, history, and the life of the spirit, now can have only a documentary and historical interest for us. There was also in Malevich what can only be described as a certain nuttiness. In no other member of the Russian avant-garde was the confusion of religion and politics quite so complete. He was given to comparing Lenin to Christ, and in what was, perhaps, the most extreme avowal of his irrational conflation of art, religion, and politics, he

recommended to his Soviet comrades that Lenin's body be placed "in a cube, as if in eternity," and urged that "Every working Leninist should have a cube at home, as a reminder of the eternal, constant lesson of Leninism," etc. "The cube," writes Robert C. Williams in *Artists in Revolution* (1977), "would symbolize Lenin's immortality. . . . In painting, the cube moving through two-dimensional space at an angle had created the patterns of Suprematism; in life, it would now help to build a new Soviet culture." One hardly knows whether to laugh or cry at the intensity of Malevich's conviction in such matters. Yet it was this same kind of conviction that led to the creation of such an extraordinary body of paintings.

We shall be a long time separating the art of the Russian avant-garde from the political tragedy that encloses it, but it is now more important than ever before that we do so, and this exhibition marks an important step in that direction. Because politics plays such an important role in the life of art today—such a destructive role—there is a tendency to sentimentalize and idealize the political circumstances in which Malevich and his Russian contemporaries produced their art; a tendency, in other words, to make a romance of revolution in its relation to the art of the avant-garde. To do so, however, requires a large measure of historical amnesia. When we come to that last room in the Malevich retrospective and encounter *Reapers,* we find that Malevich, too, was finally devoured by the Revolution he had so ardently supported. He survived by dishonoring the art that won him his place in history. We should not contribute to that dishonor by making a romance of the politics that was finally so murderously at odds with the art often produced in its name.

[1990]

Abstraction and Utopia

I. *From Theosophy to Utopia*

> *[Suprematism] will liberate all those engaged in creative activity and make the work into a true model of perfection.*—El Lissitzky, 1920

> *Abstract art, I thought, creates new types of spatial relationships, new inventions of forms, new visual laws—basic and simple— as the visual counterpart to a more purposeful, cooperative human society.*—László Moholy-Nagy, 1928

> *In the future, the realization of pure plastic expression in palpable reality will replace the work of art. But in order to achieve this, orientation toward a universal conception and detachment from the oppression of nature is necessary. Then we will no longer have the need of pictures and sculpture, for we will live in realized art.*—Piet Mondrian, 1942

> *To construct a utopia is always an act of negation toward an existing reality, a desire to transform it.*—Leszek Kolakowski, 1968

Abstract art—painting and sculpture that makes no direct, immediately discernible reference to recognizable objects—was born of an alliance of modernist aesthetics and the occult doctrines of theosophy in the second decade of the twentieth century. Its first masterworks were produced by Vasily Kandinsky in Germany, Piet Mondrian in the Netherlands, and Kazimir Malevich in Russia. Yet no sooner was this new

artistic convention established as an influence on the European avant-garde than it was quickly appropriated by still another mode of thought—utopianism—which similarly rejected commonly held conceptions of "reality" in the name of a visionary ideal. This utopian ideal, while no less mystical in some respects than that of theosophy, nonetheless differed from it in locating the realm of future perfection in the material world. Toward the material world utopian ideology adopted an attitude as radical—and, in fact, as otherworldly—as any to be found in occult doctrine, but it did not question the existence of the material world. Its goal was to change it—to eliminate its imperfections in order to establish an ideal harmony, at once social and spiritual, in every sphere of earthly human endeavor.

Whereas theosophical belief is essentially religious in nature, utopian thought is fundamentally political, for it seeks to realize its model of human perfection by bringing about a radical transformation of society and its institutions. While both envision an ideal future, it is in the nature of utopian thought to imagine that the particular "heaven" it hypothesizes can be created on earth.

It should not be supposed, however, that an allegiance to mysticism precludes a commitment to utopian ideology. On the contrary, these apparently contradictory doctrines have proved to be highly compatible systems of belief. Both refuse to acknowledge either the limits of human nature or the legitimate conflicts of interest that characterize virtually every form of human society. Both are attempts to transcend the contingencies of history for the purpose of achieving an eternal order so perfect as to lie beyond the need of dissension or modification. Yet utopian ideology departs from occult belief in a fierce yearning to effect a sweeping transformation of material life by means of political action.

The political models to which the pioneers of abstract art attached their utopian dreams, though generally of a socialist character, were by no means uniform, however much they may have been thought to resemble each other in the eyes of their adversaries. The leading figures of the Russian avant-garde—Malevich, Tatlin, Rodchenko, Lissitzky, Popova, et al.—were fervent supporters of revolution, and welcomed the Bolshevik seizure of power in 1917 as the dawn of a new millennium. And it was in Russia, in the immediate aftermath of the Revolution of 1917, that these champions of abstraction came to enjoy an unprecedented authority over the conduct of cultural life.

The utopian impulses of the De Stijl movement in the Netherlands, which also dates from 1917, were more restricted, and certainly less strident. While no less militant than the Russian avant-garde in its artistic objectives—and initially sympathetic to the Bolshevik cause—the De Stijl group remained aloof from any organized involvement in revolutionary politics. De Stijl was a movement confined to avant-garde artists, architects, designers, and art theorists. While in some respects an anti-war movement that took the horrors of the First World War to represent everything that was moribund in the European past, it never came under the jurisdiction of political commissars or party functionaries. Its primary influence—its primary achievement, too—would always be aesthetic. Its concept of utopia had more to do with ideas about painting and a redesign of the man-made environment than with programs of political action. It helped, of course, that the Netherlands itself remained neutral in the war.

In Germany, and in Central and Eastern Europe, where both Russian modernism and the De Stijl movement wielded immense influence in avant-garde circles, the relation that obtained between the aesthetics of abstraction and the utopian impulse varied from group to group—and sometimes from year to year—in the wake of the Bolshevik Revolution and the termination of the First World War.

The most celebrated citadel of avant-garde design to be established in Europe in the period between the two world wars—the Bauhaus, founded by the German architect Walter Gropius in Weimar in 1919—initially billed itself as the "Cathedral of Socialism," and from the outset was imbued with a radical fervor that was believed, especially by its enemies on the political right, to reflect revolutionary goals. Yet the radicalism of the Bauhaus, while generally socialist in its announced ideals, was in practice a more volatile and bizarre amalgam of artistic, mystical, and collectivist ideas than its socialist reputation suggests. Its ranks were rife with the followers of occult sects, bohemian lifestyles, food cults, and sundry other manifestations of a freewheeling counterculture.

At the same time, practical considerations required the Bauhaus to collaborate with industry and commerce, for its principal endeavors were addressed to the theory and practice of architectural, industrial, and graphic design, not to the production of fine art. In its early years its contribution to abstraction was more theoretical than practical. It wasn't until the late 1920s, when the Bauhaus had entered upon the crisis that

preceded its shutdown in 1933, that the most distinguished artists on its teaching staff—Vasily Kandinsky and Paul Klee—were first permitted to offer studio instruction in abstract painting.

It was in Russia, far more decisively than elsewhere, that abstraction was first drawn into the orbit of utopian thought in ways that determined its fate. In no other country did its peculiar combination of aesthetic radicalism and metaphysical yearning so quickly impel abstraction in the direction of political revolution. And in no other country did a triumphant revolution go so far in embracing abstraction as an instrument of cultural and political change. It was therefore in Russia, in the decade following the Revolution of 1917, that a new alliance of abstract art and utopian ideology was put to its severest historical test.

The artistic momentum that set the Russian avant-garde on this radical course was already well established before the Revolution itself. The roots of Russian modernism—abstract art included—are to be found in the cosmopolitan culture of the pre-Soviet Russian liberal intelligentsia that was in close touch with the latest artistic and intellectual developments in France, Germany, and Italy. The ideas of the Expressionist movement in Germany, including Kandinsky's *Blue Rider* group in Munich, and those of the Futurist movement in Italy were well known in Moscow and St. Petersburg, but it was the art of the Paris avant-garde that dominated the thinking of the Russian modernists in their accelerating quest for the absolute.

Crucial to this development were the great collections of the modernist School of Paris that had been amassed by two remarkable Russian businessmen, Sergei Shchukin and Ivan Morozov. With their immense holdings in the most advanced painting of the Paris school—especially the works of Matisse and Picasso—these collections played a central role in acquainting the artists of the burgeoning Russian avant-garde with splendid examples of the new Fauvist and Cubist art long before such objects were exhibited in significant numbers in the museums of the Western world. Then, too, a number of the artists who would shortly be counted among the early creators of abstract art in Russia made their personal pilgrimages to the French capital. Mikhail Larionov, who in 1913 issued a manifesto on behalf of Rayonist painting—a more or less abstract pictorial style claiming to be based on "forms chosen by the will of the artist"—had visited Paris as early as 1906 in connection with the Russian exhibition organized by Sergei Diaghilev for that year's Salon

d'automne. (It was in the Salon d'automne a year before that the Fauvist paintings of Matisse were first exhibited.) Liubov Popova, one of the stars of the early Soviet avant-garde, served an apprenticeship to Cubism in Paris in 1912–1913.

Around that time, too, Vladimir Tatlin, who would win lasting fame for his *Monument to the Third International* (1919), wangled his way into Picasso's Paris studio, where he had his first glimpse of the artist's constructed Cubist reliefs—a new mode of sculpture not yet known to the public. This led, in 1915–1916, to the creation of Tatlin's even more radical Corner Counter-Reliefs, abstract constructions made of metal and other materials that, unlike Picasso's constructed sculpture, no longer made any discernible reference to recognizable objects. Similar pilgrimages to Paris were made by Naum Gabo, Ivan Puni, and others, and key documents of the Paris avant-garde, like the writings of Albert Gleizes and Jean Metzinger on Cubism, were promptly translated into Russian.

Russian modernists were by no means alone, of course, in submitting to the influence of the Paris avant-garde in this period, but what they made of that influence was nonetheless remarkable even in an era known for its artistic audacities. For it was in the nature of Russian modernism to seize upon every innovation imported from abroad and propel its development in an even more radical direction than its originators had envisioned. As a result, the pre-Soviet Russian avant-garde promptly created more extreme varieties of pure abstraction than could be found in the advanced art of any Western European or North American art capital.

In this headlong rush into pure abstraction, a volcanic mixture of occult doctrine, political fervor, futuristic fantasy, and incendiary dreams of cultural revolution acted as a powerful stimulus. However pure or simplified its forms, abstract art in Russia was seldom looked upon as art-for-art's-sake even by pronounced aesthetes. Whatever its roots in mystical doctrine, abstraction was conceived to serve social, historical, and other purposes larger than itself. In the years leading up to the Revolution of 1917, cultural life in Russia acquired an increasingly apocalyptic character that favored extreme solutions to all the problems of art, life, and thought. In this circumstance, abstract art—precisely to the extent that it eliminated all trace of or reverence for the world as it was—had the advantage of addressing its public as, in Leszek Kolakowki's

words, "an act of negation toward an existing reality." This in itself gave to the aesthetics of abstraction a utopian imperative.

II. *Theo van Doesburg and De Stijl's Utopian Aesthetic*

> *The creation of a new world has commenced.*—Theo van Doesburg, *De Stijl*, August 1921

To succeed in elevating its acts of negation to the level of a comprehensive and influential artistic program, every avant-garde movement requires, in addition to the achievement of a master talent to set its aesthetic course, the services of a robust *animateur*—an artist-activist capable of commanding attention, forging alliances, winning converts, and otherwise advancing the cause. Mondrian, while undoubtedly De Stijl's master talent and the only major artist to be closely associated with the group, was temperamentally ill-equipped to perform such worldly tasks. The role of the movement's *animateur* therefore fell to Theo van Doesburg (1883–1931), a determined avant-gardist painter, writer, and intellectual whose artistic ambitions often exceeded the scope of his talents but whose gifts as a cultural impresario and propagandist were irrepressible.

It was van Doesburg who organized De Stijl as a movement and established its presence in the European avant-garde in the 1920s. He wrote some of its key documents, he was the editor of its journal—called *De Stijl*—and he was its principal liaison with other avant-garde groups, particularly Dada and the Bauhaus. He became, in fact, something like the movement's Apollinaire or Marinetti—a tireless proselytizer of its radical aesthetic who was himself "the prototype of the anti-bourgeois," as the Dutch writer Joost Baljeu called him. As early as 1914, though he had yet to produce a significant work of art or anything like an artistic manifesto, van Doesburg imagined himself making, as he said, "a daring, spiritual crusade throughout artistic and intellectual Europe." His opportunity came with the founding of De Stijl in 1917.

The ideas and aspirations that Mondrian and van Doesburg brought to De Stijl were anything but identical, however. For Mondrian, painting was a spiritual vocation. Once established, the principles of his Neo-Plasticism—the reduction of pictorial form to the square and the rectangle, with a palette limited to black, white, and the primary colors—remained

inviolate. Anything that suggested a residual dependency on subjective expression was regarded as a failure to conform to the universal "reality" Mondrian believed he had achieved in his Neo-Plastic compositions. Hence the strict observance of a pictorial syntax based on the right angle. As Mondrian once observed to the American painter Carl Holty: "Curved lines are too emotional." "Curved lines," of course, was a reference to Nature. Even shades of grey had to be eliminated from the painter's palette as an impermissible compromise.

Whatever may have been his interest in some possible equivalent of Neo-Plasticism in the fields of architecture and design—he seems to have been content to consign such endeavors to some hypothetical future—Mondrian himself remained exclusively occupied with the "reality" of his own painting and the synthesis of aesthetic and occult ideas governing its creation. Yet under van Doesburg's leadership, De Stijl embraced a cultural agenda that went beyond painting to include not only architecture and design but literature, music, and indeed—at least in theory—all of cultural life. As a consequence, Mondrian's relation to De Stijl was bound to be more problematic than anyone, least of all van Doesburg, was willing to acknowledge at the outset of their collaboration. Mondrian was nothing if not candid in underscoring for van Doesburg the exact nature of his own artistic interests. "You must remember," he wrote to van Doesburg in February 1917, "that my things are still intended to be paintings, that is to say, not part of a building. Furthermore, they have been made in a small room." Which, at the very least, placed his painting at a certain distance from the architectural ambitions van Doesburg envisioned for De Stijl.

Yet the originality of Mondrian's achievement as a pure abstractionist was fundamental to the founding of De Stijl. The aesthetic that Mondrian was perfecting during the early years of the war was understood to be essential to the movement's success—so much so that van Doesburg agreed to postpone the publication of the journal that became *De Stijl* until Mondrian felt ready to participate. This proved to be a shrewd decision, for the treatise that Mondrian wrote for *De Stijl* at van Doesburg's instigation on "Neo-Plasticism in Pictorial Art," which was serialized in the issues of 1917–1918, did much to define the radical aesthetic character of the entire movement. For the moment, moreover, van Doesburg's own work as an abstract painter, though it still derived from the kind of representational subject matter that Mondrian had now permanently

abandoned, showed every outward sign of conforming to the master's prohibitions. So certain fundamental differences that separated their respective views not only of art but of the movement itself were left in abeyance.

Yet painting was never more than one of van Doesburg's many avant-garde interests, and not always the dominant one. He certainly did not share Mondrian's view of painting as a spiritual vocation. For the whole mystical element in Neo-Plasticism he seems to have felt little affinity. He was more interested in the social functions of abstract art than in its religious significance or its occult sources. He was thus just the *animateur* that was needed to bring De Stijl's mystical conception of abstract art into alignment with the aspirations of utopian politics. It is no easy task, however, to establish the exact character of van Doesburg's own political beliefs. He was anything but a stickler for ideological clarity or linguistic precision.

"Capitalists are deceivers," he wrote in 1921, "and so are the Socialists." And further: "The first, second and third Socialist Internationals constituted ridiculous nonsense," and so on. What he then called for as an alternative to this "nonsense" was an "International of the Mind," which he seems to have conceived of as something resembling De Stijl's ambition to transcend what was stigmatized as Europe's tradition of "intellectual and material individualism." In the utopian "International of the Mind" that van Doesburg envisioned, individualism in society was— like lyricism in art—rejected in favor of something more "universal." In practice, this might mean nothing more revolutionary than the effort of abstract artists like himself, who made an absolute of straight lines, geometric form, and unmixed color, to ally themselves with like-minded modernist architects in creating immaculate urban designs devoid of traditional decorative embellishments. Or it might signify something more political—the dream of a utopian collectivism in which the De Stijl aesthetic would inevitably be established as the final arbiter not only of art and design but of all cultural life. Van Doesburg's writings on the subject, while unmistakably collectivist in spirit, are consistently vague about particulars.

Lecturing on "The Will to Style" in Germany in 1922, for example, he insisted that "Only collective solutions can be decisive in the realms of both politics and art," which seemed to place his program squarely in the camp of the Bauhaus radicals and the Bolshevik loyalists in the Soviet

avant-garde. Yet van Doesburg himself turned out to be too much of an unreconstructed, ego-driven modern individualist to conform even to the very limited "collective solutions" of his comrades in the De Stijl circle—Mondrian in particular—never mind the more sweeping solutions advocated by his counterparts in the Soviet avant-garde.

By 1926 van Doesburg had openly broken with the principles of Mondrian's Neo-Plasticism in order to advance his own mode of abstraction. This was grandly dubbed Counter-Plastic Elementarism, which amounted to little more than the introduction of the diagonal into Neo-Plasticism's orthogonal orthodoxy. Then he compounded the heresy by ridiculing the concept of "spirit," which he now ascribed to "witches, fortune-tellers and Theosophists"—in other words, charlatans. This was, of course, a calculated affront. Theosophy was the philosophical foundation on which Mondrian had based his entire abstract *oeuvre*. It was one of the core doctrines on which De Stijl had been founded. The very terms "De Stijl" and "Neo-Plasticism" were derived from the mystical writings of Mondrian's philosophical mentor, M. H. J. Schoenmaekers. This was heresy indeed. It was also a sign that van Doesburg, having established relations with Dada and the Bauhaus, now saw himself as the *animateur* of a much larger project—a Europe-wide, if not worldwide, avant-garde in the service of a utopian aesthetic.

In retrospect, van Doesburg can be seen to have been preparing himself for this larger role for some years. A man much given to adopting pseudonyms—even "Theo van Doesburg" was a pseudonym; his real name was Christiaan Emil Marie Küpper—van Doesburg had established a separate identity as a Dutch Dadaist poet, calling himself I. K. Bonset, as early as 1918 when he began a correspondence under that name with Tristan Tzara, one of the original instigators of Dada. (Mondrian, who was at first unaware of the deception, actually cautioned van Doesburg not to publish I. K. Bonset in *De Stijl*.) "There is little doubt," writes Joost Baljeu, "that van Doesburg saw Dada's revolutionary character and its engagement in the destruction of an old culture as a necessary preparation for the realization of De Stijl's utopian aims." Be that as it may, van Doesburg was clearly attracted to the anarchist-nihilist element in Dada even as he was promoting the principles of utopian order as the leader of De Stijl. Under still another pseudonym—Aldo Camini—van Doesburg also adopted the stance of a Dada anti-philosopher, drawing his inspiration from Tzara's *Manifesto of Mr. Aa the Anti-philosopher* (1918), to attack Kant,

Hegel, and the whole school of German idealist philosophy (for which other members of the De Stijl circle felt a close affinity) as well as Schoenmaekers, De Stijl's resident philosopher.

Meanwhile, van Doesburg was also busily at work establishing his bona fides with the leadership of the Bauhaus. He later claimed that Gropius had invited him to join the Bauhaus faculty, but this, like so many of van Doesburg's boasts, turned out to be something of a fiction. According to Gropius,

> I have never invited van Doesburg to the Bauhaus. He came there of his own initiative because he was attracted by our courses. He hoped to become a professor here at the Bauhaus, but I did not give him a position, since I judged him to be aggressive and fanatic and considered that he possessed such a narrow, theoretical view that he could not tolerate any diversity of opinion.

The latter point isn't quite correct, however, for van Doesburg wasn't at all averse to a "diversity of opinion" so long as he was free to claim every one of the diverse ideas he espoused as wholly his own.

In the end, it remains difficult to know what, if anything, van Doesburg really believed in beyond a vague, idealized utopian future from which the "old culture" of Europe had at last been expunged—a project in which the aesthetics of abstraction was seen to play a key role, and in which van Doesburg himself would be the intellectual leader. It was not to be, of course. By the end of the 1920s the modernist avant-garde was already in retreat in the Soviet Union. In Western Europe, Dada was succumbing to the blandishments of Surrealism, which rejected the aesthetics of abstraction, and the Bauhaus was heading toward political disaster. As it was, van Doesburg was probably fortunate to die when he did—in 1931, at the age of fifty-eight—with his utopian dreams intact and his megalomania undiminished. Had he lived another decade, he would probably have ended up as a university professor in capitalist America, which, while not a fate worse than death, would not have borne much resemblance to that "daring, spiritual crusade throughout artistic and intellectual Europe" that he had imagined for himself in 1914. But then, the entire character of "artistic and intellectual Europe" was altered when Hitler came to power in 1933 in ways that van Doesburg had never imagined, and, in that altered Europe, De Stijl's vision of a utopian future was one of the many avant-garde dreams that died of inanition.

Mondrian, however, proved to be a hardy survivor of De Stijl's demise and illusions. Working in Paris in the heyday of Surrealism's dominion in the 1930s, he went his own way, secure in his convictions, confident of his goals, never wavering in the faith that supported an art untouched by adverse circumstance; and in the end, in New York City of all places, found his final inspiration in the closest thing to the utopian future he had ever encountered.

III. *Abstraction and Revolution*

> *Utopias are an expression of aspirations that cannot be realized, of efforts that are not equal to the resistance they encounter.*
> —Alexander Bogdanov, Red Star (1908)

> *A revolution strengthens the impulse of invention. That is why there is a flourishing of art following a revolution. . . . Invention is always the working out of impulses and desires of the collective and not of the individual.*—Vladimir Tatlin, *International Iskusstv* (1919)

> *The reality principle*—la force des choses—*will, in the end, always prevail over utopian passions.*—Irving Kristol, "The Adversary Culture of Intellectuals" (1979)

The fate of abstract art in Russia in the decade following the Revolution of 1917 proved to be one of the most tragic chapters in the annals of twentieth-century modernism. Its only near rival among the political calamities that beset the modernist movement in the early decades of the century occurred in Germany in the 1930s with the unleashing of Hitler's war on "degenerate" art. There was this important difference, however, between the Nazi campaign to abolish modernist art in Germany and that of the Soviet Union under Lenin. Hitler never pretended to set up as a patron of modernist art. However grudgingly, Lenin—or the regime over which he presided as dictator, anyway—did so pretend for a very short but crucial period, thus inducing the illusion among members of the Russian avant-garde that modernism in the arts would be embraced by the Bolsheviks as a privileged coefficient of their political revolution.

The fragility of this ill-fated misalliance between modernist art and political revolution was signaled by the fact that the Bolshevik loyalist to

whom Lenin entrusted authority over the arts in the early years of the Soviet regime—Anatoly Lunacharsky, named People's Commissar for Public Enlightenment in 1917—was not himself exactly an enthusiast for avant-garde art. He was, to be sure, far more closely acquainted with the modernist movement than Lenin and far more tolerant of its innovations, having come to know some of the émigré Russian modernist painters in Paris before the First World War. Yet, while not as paranoid about the avant-garde as Lenin, who regarded it—not wholly incorrectly, alas—as a refuge for "escapees from the bourgeois intelligentsia," Lunacharsky clearly harbored serious doubts about the modernists he officially supported. To direct the Visual Arts Section of Narkkompros, the huge bureaucracy in his charge, Lunacharsky appointed not one of the militant advocates of Russian abstraction but David Shterenberg, a modernist painter he had met in Paris who was more amenable to welcoming a broader range of artistic loyalties than was common among the doctrinaire abstractionists. (Shterenberg, though a supporter of the Revolution, was not himself a Bolshevik.) Lunacharsky also named Marc Chagall, another of the modernist painters he got to know in Paris, as Commissar of Art in the artist's home town of Vitebsk. Abstract art, which in retrospect remains the most significant achievement of the Soviet avant-garde in this period, was never a branch of cultural life to which either Lunacharsky or his comrades in the Bolshevik hierarchy felt any personal or ideological commitment. On the contrary, abstraction was often under attack in the official Soviet press as a development inimical to the goals of proletarian culture even while the abstractionists enjoyed the official support of Lunacharsky's bureaucracy.

From the outset, then, the relation that obtained between an avant-garde that made an orthodoxy of abstraction and the firebrands of what, in the period from 1917 to 1921, was called War Communism, was highly problematic. Within the ranks of the dedicated abstractionists, moreover, loyalty to the Bolshevik regime was similarly riddled with doubt and suspicion. Vasily Kandinsky, the most accomplished of the abstract painters to enjoy official support, was never a true believer in the Revolution. Forced by the outbreak of the world war to leave Germany for his native Russia, where he was living when the Revolution erupted, Kandinsky married the daughter of a Russian general, and in 1922, having correctly perceived that the avant-garde would have no future in the Soviet Union, he decamped for the Bauhaus in Weimar.

Artistically, however, Kandinsky's period of repatriation in Russia brought a major change in his work. Under the influence of Malevich and his Suprematist circle, Kandinsky abandoned the painterly expressionist manner that had marked his first abstract paintings for the geometric and other hardedge forms now favored by the Russian abstractionists. Indeed, he became enough of a militant in his pursuit of this newly adopted pictorial orthodoxy to join Malevich in ousting Chagall from his official post in Vitebsk on the grounds that the latter's work was insufficiently abstract—and thus, in the minds of the abstractionist militants, insufficiently revolutionary. In 1921 a disillusioned Chagall departed once again for Paris, where he had made his first reputation as a member of the European avant-garde before the Revolution. He thus preceded Kandinsky into permanent exile in Western Europe by a year. Whatever differences divided Kandinsky and Chagall in the realm of pictorial aesthetics, they turned out to be very much alike in rejecting the political control of art that was already in progress in the Soviet Union.

Another prominent defector from the Soviet avant-garde was the sculptor Naum Gabo (1890–1978), who left Russia for Germany the same year as Kandinsky. Gabo was one of the pioneers of the kind of open-form abstract sculpture that, somewhat confusingly, has come to be called Constructivist. What lends confusion to the term in relation to sculpture like Gabo's is that while the latter is literally a construction of thin, sheetlike materials—first painted cardboard, then wood and metal and transparent plastics—that are cut and joined to shape three-dimensional "volumes" consisting of space rather than mass, Constructivism as a movement in the Soviet avant-garde represented a philosophy of art diametrically opposed to Gabo's. Gabo regarded his constructions as works of art conceived in a spirit that reflected new scientific thinking about space and matter. This was why he called his constructed sculptures "Realist" rather than Constructivist. For, in the Soviet context, Constructivism was one of the names given to a movement that repudiated fine art—art that was now stigmatized as mere "speculative activity"—in favor of the kind of functionalist art that was more explicitly designed to serve the practical and propaganda interests of the Revolution: posters, photography, book illustration, even the design of clothing, tableware, and furniture. It was mainly in the West that sculptures like Gabo's came to be called Constructivist, and Gabo

himself eventually accepted the name when he came to live first in England and then in the United States.

What adds still another layer of confusion to the issue is the fact that many of the leading advocates of Constructivism in the Soviet Union—Tatlin, Rodchenko, and Lissitzky, among them—first distinguished themselves as votaries of abstractionist fine art. Then, to advance the cause of Constructivist applied art, they adapted the formal vocabularies they had themselves invented for their fine-art abstraction to the design of useful objects, while at the same time declaring in the absolutist political spirit of the time that the fine arts, as traditionally conceived, must now be permanently rejected as a useless and harmful relic of a reactionary bourgeois culture. In a manifesto written in May 1921, Alexander Rodchenko (1891–1956), one of the most gifted abstract artists of his generation, thus repudiated all of his past artistic accomplishments when he announced that "up to now we did not see this simple thing called life, we did not know that it was so simple, clear, which has to be organized and purged of all kinds of adornment."

Having succeeded in purging painting and sculpture of everything but their most minimal abstract forms, Rodchenko and his Constructivist cohorts then undertook the much larger task of redesigning the objects of daily life for the Soviet masses along similarly minimalist lines. This was yet another utopian endeavor bound to fail—and fail it largely did in a very short time. Whatever small success this Constructivist initiative could make claim to was largely confined to the VKhUTEMAS, the government-sponsored design workshops where revolutionary theory enjoyed a distinct priority over the actual production of makable objects. This is one of the reasons, incidentally, why theory-obsessed academics in our own day feel such a strong affinity for the failed experiments of the Soviet Constructivists: they exist mainly in the realm of theory.

Given the conditions of Soviet society in the immediate aftermath of the Revolution of 1917, it was the very nature of the Constructivist enterprise that doomed it to failure. For one thing, the Bolshevik commissars on whose support these experiments in modernist design depended were, if anything, even more philistine in their aesthetic tastes than the pre-Revolutionary bourgeoisie the Constructivists scorned. Then, too, the faltering Soviet economy was simply not equipped to produce most of the projects that were proposed. As a consequence, most

of these projects remained on the drawing board. And needless to say, the Russian masses weren't exactly clamoring for modernist design, and it certainly wasn't in order to drink out of Suprematist teacups or buy their daily copies of *Izvestia* at a Constructivist kiosk that the Bolsheviks had fought a bloody civil war.

The ultimate historical irony of the whole Constructivist misadventure is that what survives of its endeavors—Rodchenko's brilliant photographs, Popova's extraordinary textile designs, and Alexandra Exter's sets and costumes for certain theatrical productions—are now admired for precisely the aesthetic, which is to say, the formal, ideas they embody rather than for the political motives that prompted their creation. What also needs to be noted about this failed utopian venture is the role it played in terminating one of the most remarkable chapters in the entire history of abstract art. Years before Stalin was in a position to demonize abstraction as "bourgeois formalism," the campaign to condemn the creation of abstract painting and sculpture as a cultural activity politically at odds with the goals of the Revolution and thereby to render abstraction officially insupportable was initiated from within the ranks of the Soviet avant-garde itself. Stalin only codified and criminalized what Constructivist militants like Tatlin and Rodchenko had first proposed in rejecting abstract art, and then promptly condemned Constructivism as well.

IV. *Abstraction and the Bauhaus*

> *"Art and Technology, a New Unity" is the slogan on our Bauhaus poster at the railroad station. Oh dear, will there really be no more art than the technology necessary to become profitable from now on? Since times are bad, art has to give in, and authority is granted it by associating with usable things—a hateful conception.*—Lyonel Feininger to Julia Feininger, 1923

> *Our aims are becoming more and more clear and have been expressed very precisely in an article by Moholy. They go against my grain in every respect, distress me terribly. What has been "art" for ages is to be discarded—to be replaced by new ideals. There is talk only about optics, mechanics and moving pictures. . . . Klee was very depressed yesterday when we talked about Moholy. He called it the "prefabricated spirit of the time."*—Lyonel Feininger to Julia Feininger, 1925

> *The concepts of mechanics, dynamics, statics and kinetics, the*
> *problem of stability, of balance, were examined in terms of three-*
> *dimensional forms and the relationship between materials was*
> *investigated as were methods of construction and montage. . . .*
> *Today's sculptor knows scarcely anything about the new fields in*
> *which the engineer works.*—László Moholy-Nagy, 1928

> *It took quite a while to get under way the kind of work which*
> *later made the Bauhaus a leader in designing for the lighting*
> *fixture industry.*—László Moholy-Nagy, 1938

It is one of the paradoxes of the legend of the Bauhaus, which the German architect Walter Gropius founded in Weimar in 1919 to reform and revitalize modern architectural practice, that it is often thought to have been one of the principal citadels of abstract art in Europe in the 1920s. The fact is, however, that no instruction in abstract painting—or, indeed, painting itself—was permitted at the Bauhaus until the last five years of its fourteen-year existence, and even then it was accorded a very low priority. Gropius disliked easel drawing, and his aversion to it was shared by Mies van der Rohe, who presided over the school in its final years. Traditional instruction in drawing and painting was never part of the Bauhaus curriculum.

The legend of the Bauhaus as a citadel of abstraction nonetheless persisted because a number of distinguished artists who have passed into history as masters of abstract art—Kandinsky, Klee, Albers, and Moholy-Nagy—were among the best-known members of the Bauhaus faculty. Then, too, an even larger number of lesser painters who had been students at the Bauhaus in the 1920s went on to acquire reputations as abstract artists working in what came to be recognized as a Bauhaus style. Most important of all was the fact that the basic course of instruction at the Bauhaus was designed to comprehend the entire range of visual experience in ways that eliminated from consideration all but its most universal and axiomatic attributes. As a consequence, abstraction of a certain kind—geometrical, Constructivist, and depersonalized—came to look as if it had been conceived to illustrate the theoretical principles of Bauhaus pedagogy.

The *Vorkurs*, or required preliminary course at the Bauhaus, was concentrated on theories of form and perception, on the one hand, and on the nature of materials, on the other, as a preparation for training in crafts and design. "What made the Bauhaus preliminary course . . . unique,"

writes Frank Whitford, "was the amount and quality of its theoretical teaching, the intellectual rigor with which it examined the essentials of visual experience and artistic creativity."What this meant in practice may be seen in a passage from an essay written in 1916 by the Austrian artist Johannes Itten, who three years later was brought to Weimar to create the original *Vorkurs* for the Bauhaus:

> The clear geometric form is the one most easily comprehended and its basic elements are the circle, the square and the triangle. Every possible form lies dormant in these formal elements. They are visible to him who sees, invisible to him who does not.
>
> Form is also color. Without color there is no form. Form and color are one. The colors of the spectrum are those most easily comprehended. Every possible color lies dormant in them. Visible to him who sees—invisible to him who does not. . . .
>
> Geometric forms and the colors of the spectrum are the simplest, most sensitive forms and colors and therefore the most precise means of expression in a work of art.

By the time Itten arrived at the Bauhaus in 1919 to set up its *Vorkurs*, such ideas were already well established in the De Stijl group in the Netherlands and the Suprematist circle in Russia, and in fact both De Stijl and Suprematism were to exert a profound influence on Bauhaus theory and practice as well as its disposition to think of both in utopian terms. It was certainly not the purpose of the *Vorkurs* to prepare its students for careers as abstract artists. Its goal was to prepare students for a much more ambitious task: the application of such theories of abstraction to a redesign of the entire man-made universe. In this respect, Bauhaus pedagogy had much in common with that of the VKhUTEMAS in the Soviet Union, especially after 1923 when the Hungarian artist László Moholy-Nagy (1895–1946) was appointed to replace Itten as director of the preliminary course.

Itten, who was more of a mystic than a political ideologue, had derived some of his ideas about color and form from Kandinsky's *On the Spiritual in Art*, published in 1912. (It was to teach in Itten's version of the *Vorkurs*, to which his own ideas had already contributed a good deal, that Kandinsky was invited to join the Bauhaus in 1922.) Spiritual matters were not of compelling interest to Moholy, however. In politics he was a radical who had supported Bela Kun's short-lived Soviet in his native

Hungary in 1919, and was still identifying himself as a Communist in the early 1920s. As a radical he was inevitably drawn both to the *révolté* art and politics of the Dadaists and to the authoritarian absolutism of the Russian Constructivists. (Whatever differences may have divided Dada from Constructivism, both had formed an alliance against the despised bourgeoisie.) In some respects, Moholy took the Bauhaus's commitment to socialism more seriously than Gropius himself—though Gropius had been a supporter of the ill-fated German revolution in 1919 and designed a *Monument to the Fallen of the March Insurrection* in 1920–1921.

What Moholy's arrival at the Bauhaus signified was a change in the atmosphere as well as the ideas that would now govern the Bauhaus. "Even Moholy's appearance," writes Frank Whitford, "proclaimed his artistic sympathies"—and his political sympathies, too, as Whitford's further account makes clear.

Itten had worn something like a monk's habit and had kept his head immaculately shaved with the intention of creating an aura of spirituality and communion with the transcendental. Moholy sported the kind of overall worn by workers in modern industry. His nickel-rimmed spectacles contributed further to an image of sobriety and calculation belonging to a man mistrustful of the emotions, more at home among machines than human beings. His dress stamped him as a Constructivist, as a follower to Vladimir Tatlin and El Lissitzky, who rejected all subjective definitions of art and were scornful of the idea of the artist as the inspired maker of unique objects stamped by his personality.

Like Rodchenko, to whose example he was also strongly drawn, Moholy was a man of remarkably versatile talents, excelling as a painter, photographer, graphic designer, product designer, sculptor, and visual theorist. Unlike Rodchenko and the Soviet militants, however, he was not prepared to reject the art of painting in order to concentrate exclusively on the applied arts. Nor, for that matter, did his radical sympathies prevent him from allying himself with capitalist industry in the realm of the applied arts. In this respect, Moholy's career—first in Germany, and then in America, where he later founded the so-called New Bauhaus in 1937—marked the demise of the utopianism which had prompted the creation of the Bauhaus as the "Cathedral of Socialism" in the immediate aftermath of Germany's defeat in the First World War. The hope of redesigning the man-made universe did not entirely fail, to be sure, but whatever successes were realized proved to be peculiarly dependent

upon the least utopian of all economic and social systems: capitalism. It was as a handmaiden to capitalist enterprise and corporate competition in the marketplace that many of the Bauhaus's modernist design ideas enjoyed their greatest prosperity and influence. It was a happier fate than that suffered by modernism in the Soviet Union under Stalin, but it was no less a refutation of the utopianism to which the founders of the Bauhaus had initially aspired.

All utopian endeavors derive their moral force from a firm belief in the perfectibility of man. It was one of the purposes of the original *Vorkurs* at the Bauhaus to achieve this radical transformation of the human species by, in effect, creating the conditions for a radical revision of human consciousness. The late Reyner Banham put it very well when, in a discussion of the *Vorkurs* in *Theory and Design in the First Machine Age* (1960), he cited "the determination to cleanse every incoming student's mind of all preconceptions and to put him, so to speak, back into Kindergarten to start again from scratch" as one of the defining innovations of the Bauhaus preliminary course. This, as Banham further observed, was clearly designed

> to return incoming students to the noble savagery of childhood. To
> have gone so far against established precedent without moving
> forward into a mechanized culture, meant that Itten had to go right
> outside the general body of Western, rational thought and under his
> influence Bauhaus students involved themselves in the study of
> mediaeval mystics like Eckhart, and Eastern spiritual discipline such as
> Mazdaznan, Tao and Zen.

Thus the socialist utopianism to which the Bauhaus dedicated its fortunes at the outset contained a large admixture of occult belief that was not to be exorcised until the arrival of Moholy, a man "more at home among machines than human beings." Under the guidance of this radical materialist, it was no longer the perfectibility of man that occupied the Bauhaus agenda but the perfectibility of machines, and that effectively closed the book on the utopian aspiration.

[1997]

Abstraction in America:
The First Generation

A work of art is an abstract or epitome of the world.—Ralph Waldo Emerson, in "Nature," 1849

Let us look at this American artist first. How did he ever get to America, to start with? Why isn't he a European still, like his father before him?—D. H. Lawrence, 1923

Abstract art made its debut in America at the same time as it initially emerged in Europe—which is to say, in the two or three years preceding the outbreak of the First World War in 1914. Yet the earliest achievements of American abstract art were not destined to have an impact comparable to that of the European masters of abstraction. No artists of the stature of Kandinsky, Mondrian, or Malevich appeared on the American art scene to galvanize a movement in favor of abstraction, and nothing was produced in the realm of theory that came even close to the urgent appeal that was sounded in Kandinsky's *On the Spiritual in Art* or the Supremalist manifestos of Malevich. American abstraction in this period was essentially the creation of isolated talents operating in a lonely and leaderless intellectual environment. What the American critic Sadakichi Hartmann had observed in 1898 still described the generation of Arthur Dove, Marsden Hartley, and John Marin a dozen years later. "Many of our American painters, particularly the better ones," wrote Hartmann, "have, in strange contrast to French artists who move in the midst of life and society, a peculiar trait in common: they love solitude and shun life."

53

Unlike its more robust counterparts in France, Germany, and Russia, moreover, the American avant-garde in the second decade of the century was deeply afflicted with a sense of its own provincialism and powerlessness. As a consequence, its efforts to achieve a modernist art that was authentically American tended to be more a matter of individual aspiration than of group endeavor or shared ideals. Added to this was the nature of the relation that obtained between the modernist artist in America and the dynamism of the society in which his work was created. Nowhere else in the world was the material progress of society so far advanced as it was in the United States. Yet the innovative spirit that animated technological change and capitalist enterprise in America met with firm resistance in the realm of culture and the arts, which, unlike the world of business and politics, remained a citadel of the genteel tradition.

In Europe the avant-garde mind saw itself as the coefficient of a modernity which society at large had not yet achieved. In America, however, modernity of the sort that the European avant-garde envisioned for its future—skyscraper architecture, high-speed locomotion, assembly-line production, electrified advertising, and similar feats of technological innovation—was already commonplace. What was missing—and thus left to the individual talent to invent for itself—was an artistic milieu that was open to a comparable level of radical innovation. Such attempts as there were to create a milieu of that kind were greeted with a philistine response so adamant and so uninformed that it inevitably had the effect of confirming the modernist's profound sense of alienation from the mainstream interests of American life.

The solitude that Hartmann characterized as the condition of the American artist was a direct consequence of this alienation. What also contributed to it was the influence of well-established American tradition—the Emersonian tradition of free-thinking mysticism, which elevated solitude to the status of a moral vocation. Compounded of French utopian thought, German metaphysics, and Unitarian liberalism, this was a tradition that made of individual consciousness a sovereign of all it surveyed in the life of the times. It set the soul in opposition to the institutions of society while allying itself with the beauty and beneficence of nature. It was thus a tradition that conferred an exalted spiritual sanction on any expression of individualism or isolation.

For the American modernists who came of age in the decade preceding the First World War, this Emersonian tradition, which embraced

the kindred radicalisms of Whitman and Thoreau, defined the very atmosphere in which they committed themselves to the life of art, and the ideas it fostered—especially its peculiar combination of mysticism, independence, and rebellion—remained the substratum of their artistic thought even as they looked to artistic developments abroad for the means of implementing them.

It certainly did much to shape the ethos of the first generation of avant-garde art in America—the embattled coterie of painters, photographers, and writers who sought refuge from the regnant philistinism of their day in the Photo-Secession Gallery, which Alfred Stieglitz had founded in New York in 1902. One of their number—the painter Marsden Hartley (1877–1943)—was given Emerson's *Essays* to read by his drawing teacher in art school in Cleveland, and it became for him, as he later wrote, the text "I was to carry in my pocket for at least the five ensuing years—reading it on all occasions as a priest reads his Latin breviary on all occasions, it seemed so made just for me." Emerson provided, he said, "the religious element in my experience." Soon thereafter, Whitman's *Leaves of Grass* acquired a similarly high place for him as a sacred text, and in the volume of his own essays, *Adventures in the Arts*, which Hartley published in 1921, Whitman was coupled with Cézanne—the ultimate standard of excellence for an American modernist of Hartley's generation—as "the two most notable innovators" of their times.

It was hardly surprising, then, that when Hartley wrote a letter to Stieglitz in 1913 from Munich, where Vasily Kandinsky and his circle of *Blaue Reiter* painters had come to talk to him about his abstract paintings at the Goltz Gallery, Hartley hastened to compare this momentous encounter to Emerson's historic meeting with Whitman to discuss *Leaves of Grass*. In Hartley's greatest moment of triumph as an abstract painter, it was from the annals of the Emersonian tradition that he still derived his touchstone of distinction.

Abstraction and the Stieglitz Circle

> In the little gallery of the Photo-Secession, where Mr. Stieglitz
> and his disciples hold forth for months together, there is never so
> much as a lead pencil sketch in the little exhibitions which may
> be properly said to have so much as a shred of a subject, and

the word of all other words that may be constantly overheard in
the discussions there is the word "pure."—Henry McBride
(1913)

It has to be understood that it was never the specific purpose of the
Photo-Secession Gallery—or 291, as it was commonly called (after its
address on Fifth Avenue)—to foster the development of abstract art. 291
was founded by Alfred Stieglitz, who was himself a photographer of im-
mense distinction, to promote an interest in photography as a fine art.
Beginning with a Matisse exhibition in 1908—the artist's first in the
United States—Stieglitz also took up the cause of the European mod-
ernist masters. By 1913, when the Armory Show in New York gave the
American public its first comprehensive account of the modernist move-
ment, Stieglitz had already exhibited Cézanne, Picasso, Brancusi, Nadel-
man, and Picabia, and was thus well established as the country's unrivaled
champion of modernism. In that role he published an excerpt from
Kandinsky's *On the Spiritual in Art* in the gallery's magazine, *Camera Work*,
in 1912. Yet abstraction was not the aesthetic absolute for the painters of
the Stieglitz circle that it was for Kandinsky himself.

If the word "pure" was often heard in that quarter to describe the
modernist ideal toward which the painters were striving, its precise mean-
ing nonetheless remained ambiguous—as ambiguous, indeed, as the paint-
ings themselves. It might be as easily applied to John Marin's landscapes
and cityscapes, in which recognizable motifs remained distinctly dis-
cernible within a pictorial structure that was highly abstract, as to the more
hermetic abstract paintings from nature by Arthur Dove (1880–1946),
which the artist actually called *Abstractions* as early as 1910–1911. At times
the word "pure" was merely a synonym for "modern," and at others it de-
noted the complete absence of a recognizable subject. At all times it was a
way of distinguishing the modernist idea of pictorial form—form that was
no longer tethered to a strict description of the observable facts—from
what were regarded as the "impure" varieties of academic realism that
were in thrall to such facts and still dominated the American art scene.

This whole notion of pure painting recalls the similarly ambiguous
Symbolist concept of pure poetry, and there is a parallel to be observed
between Mallarmé's call for artists "to paint, not the object, but the ef-
fect which it produces," and certain strains of Emersonian thought. In
writing about Thoreau in 1862, Emerson claimed that "His [Thoreau's]

power of observation seemed to indicate additional senses. . . . And yet none knew better than he that it is not the fact that imports, but the impression or effect of the fact on your mind. Every fact lay in glory in his mind, a type of the order and beauty of the whole."

Something akin to this attitude toward the observable facts of nature, which are taken to represent the "order and beauty" of something larger than the facts themselves, is what governed the early abstractions of Arthur Dove. The exact status to be assigned to Dove as a pioneer of abstract painting remains an unsettled question. We know for a certainty that he created some of the earliest abstract paintings, yet we also know that abstraction was never for Dove the single-minded pursuit of the absolute that it was for the acknowledged pioneers of abstract painting. Dove's abstractions are not the kinds of paintings that categorically separate themselves from the experience of nature. Their imagery is more like an Emersonian "epitome" of nature than a repudiation of it. Their light is an earthly light—the light of the sun and the moon as it is experienced in daily life. Their forms and their color, too, evoke the organic forms and colors of the natural world.

Dove's was an essentially pastoral sensibility. He was not a man of wide cosmopolitan culture. Farming was an occupation that sustained him in hard times, and boats were one of his passions. As a young man he had gone to Paris and even showed in the Salon d'automne in 1908 and again in 1909, and it was on his return to the United States that he earned a precarious living as an illustrator in New York. But cities held no romance for him. He belonged to that class of abstractionists who are totally devoted to nature, totally dependent on it for their visual inspiration and eager to wrest from it something permanent and quintessential. What the critic Paul Rosenfeld said of him in 1924—"There is not a pastel or drawing or painting of Dove's that does not communicate some love or some sensuous feeling of the earth"—defined his quality. So did Georgia O'Keeffe's more specific observation that "Dove comes from the Finger Lakes region. He was up there painting, doing abstractions that looked just like that country, which could not have been done anywhere else."

The modernist conventions Dove learned in Paris and helped to domesticate in America were straightaway placed at the service of this communion with nature. His primary interest was in a certain abstract visual rhythm—elusive, organic, and irregular, constantly changing and

constantly enchanting—to be discerned in the diurnal life of the land-scape and the seasons and in those objects (both natural and man-made) that nature transforms by its vivid orchestration of light and shadow. It was no doubt for this reason that he moved without qualm or com-punction between abstraction and representation in his painting, allow-ing his inward response to nature to determine the terms of his pictorial style. He was, in this respect, anything but an ideological acolyte of ab-straction, which remained for him a contingent option in art rather than an absolute commitment. It is for this reason, perhaps, that his influence on the history of abstract art rarely made itself felt beyond the bound-aries of the Stieglitz circle itself.

Marsden Hartley's "Cosmic Cubism"

> It is not like Picasso—it is not like Kandinsky not like any
> "cubism"—it is what I call for want of a better name
> subliminal or cosmic cubism—It will surprise you—
> —Marsden Hartley to Alfred Stieglitz (1912)

Marsden Hartley's brilliant, short-lived career as an abstract painter traced a very different course. Although he was reared in provincial and impoverished circumstances in northern New England, Hartley became a man of wide cosmopolitan culture—not only a brilliant painter but a self-educated poet and critic who contributed to *The New Republic*, *Seven Arts*, *Poetry*, and other leading literary journals of his day. Despite his penchant for solitude and the personal problems caused by his ho-mosexuality, especially in America, his friendships and connections in the years immediately preceding the First World War extended beyond the Stieglitz circle in New York to include Gertrude Stein's salon in Paris and the *Blaue Reiter* painters in Munich. It was, in fact, in Europe that Hartley made his most significant contribution to abstract art. Yet the misfortunes of history—in this case, the eruption of the war in Europe in 1914—had the effect of limiting that contribution to a very few years, 1912–1915, in a career that was otherwise to be devoted to representa-tional painting of an equally high order. In those few years, however, Hartley produced some of the masterpieces of early abstraction.

They were not the work of a young or untried artist. Hartley was in his mid-thirties when he went to Europe for the first time in 1912. He

had already had two solo exhibitions of his New England landscape paintings at 291, and that was where, before his departure for Paris, he also had his first opportunity to study the work of Cézanne, Matisse, and Picasso. All were to have an immense and immediate impact on his pictorial development. What ignited the spark that accelerated Hartley's headlong plunge into abstraction, however, was his unexpected discovery in Paris that his deepest affinities—both in art and in life—might not be there, despite the support he received from Gertrude Stein, but with the German avant-garde and Germany itself. For while the Picassos and Matisses in the Stein collection confirmed for Hartley his initial turn to an art more radical than anything he had attempted in the past, it was the German connections he made in Paris, and which then developed into the great romance of his life in Berlin, that provided the existential impetus for the painting that was to be his most distinctive contribution to abstraction.

In Paris, where the French had made Hartley feel like an outsider, his German friends offered encouragement and were eager to acquaint him with artistic developments in Munich and Berlin. One of those friends was a young sculptor, Arnold Rönnebeck, who was accompanied by his American fiancée, a singer. He promptly made a bust of Hartley that was exhibited at the Salon d'automne. (Some years later, Rönnebeck emigrated to America where he became the director of the Denver Art Museum.) Another was Rönnebeck's cousin, Karl von Freyburg, whose early death in the war inspired one of Hartley's finest abstract paintings, *Portrait of a German Officer* (1914). The third was a handsome Swiss poet, Siegfried Lang, with whom Hartley seems to have established an immediate romantic attachment—a devotion subsequently transferred to von Freyburg when Lang returned to Switzerland and Hartley settled in Berlin.

With these German comrades acting as translators, Hartley was introduced to the *Almanach* of the *Blaue Reiter* group, an anthology of pictures and essays launched by Kandinsky and Franz Marc in Munich in 1912, and was also able to make his way through Kandinsky's *On the Spiritual in Art* for the first time. Being of a mystical temperament himself, Hartley proved to be an eager convert to Kandinsky's call for an art of spiritual transcendence that would manifest itself in abstract forms, and he straightaway set about the task of creating paintings of this persuasion himself.

Although Kandinsky was already deeply committed to this spiritual mode of abstraction in his own work, the *Blaue Reiter* program embraced a far wider range of aesthetic affinities and possibilities. In the pages of its *Almanach*, illustrations of Kandinsky's abstractions shared attention with the modernism of the School of Paris—the Cubism of Picasso, the Fauvism of Matisse, and the so-called Orphism of Robert Delaunay, in addition to the less classifiable paintings of Henri Rousseau—as well as a miscellany of European folk art, medieval woodcuts, and primitive tribal art. (The latter no doubt reflected the ideas of Wilhelm Worringer, whose *Abstraction and Empathy* [1908] exerted a considerable influence on the *Blaue Reiter* circle.) Yet all of these disparate interests were seen to serve the same overarching mystical purpose. Cézanne, too, was drafted into service as a precursor of the *Blaue Reiter's* spiritual mission, and so was El Greco, a recent discovery of the German critic Julius Meier-Graefe, who was also a champion of Cézanne. "In their views of life," wrote Franz Marc in an *Almanach* essay called "Spiritual Treasures," "both [El Greco and Cézanne] felt the *mystical inner construction*, which is the great problem of our generation."

Nothing could have been better calculated to win Hartley's allegiance at that juncture in his career. The *Blaue Reiter's* alliance of modernism and mysticism was irresistible. He saw it as the invitation to join the European avant-garde that he believed had been denied him in Paris. And his German friends offered Hartley something else as well—a comradeship in which his homosexuality proved not to be an obstacle. That was something he seems never to have felt confident of in America, even in the relatively permissive atmosphere in the Stieglitz circle. The fever of inspiration in which Hartley hastened to join the German avant-garde was thus fueled by a fusion of sexual passion, aesthetic daring, and intellectual ambition unlike anything he had felt in the past.

Yet it was in fact in Paris, before his departure for Germany in January 1913, that Hartley produced the initial attempts at the "cosmic cubism" that constituted his first significant series of abstract paintings. Always a quick study, Hartley seems to have grasped the essential point about abstraction upon his initial contact with its sources. As to exactly what those pictorial sources were in his case, Hartley himself was not inclined to be entirely forthcoming. If the "cosmic" element in these abstractions owed much to his encounter, in Paris, with *Blaue Reiter* mysticism, their formal language still owed even more to Picasso's Cubism,

and, in all probability, to Delaunay's Orphic variations on Cubism, which were more adventurous in their use of color than Picasso's. About his debt to Delaunay, Hartley may have had personal reasons for remaining silent. He clearly felt an intense dislike for the man himself, whom he had met in Paris, but he seems nonetheless to have taken some cues from his work. Certainly the disklike forms in Hartley's early abstractions and their color-driven dynamism are traceable to Delaunay, who in this period, not incidentally, was more highly esteemed in Germany than in Paris.

Hartley's response to Kandinsky was far more complicated. His prior immersion in Emersonian mysticism had naturally disposed him to respond with enthusiasm to Kandinsky's advocacy of the occult as the basis for an abstractionist aesthetic. About Kandinsky's paintings, however, he expressed some serious doubt. While hard at work on his own abstract paintings in Paris in December 1912, Hartley wrote to Stieglitz—in the very letter in which he announced his venture into "cosmic cubism"—that "In Kandinsky's own work I do not find the same convincing beauty that his theories hold—He seems to be a fine theorist first and a good painter after." And writing to his niece at the same time, Hartley was even more negative: "he is a pure theorist and his work is quite without feeling—whereas I work wholly from the intuition and the subliminal."

Whatever Hartley may have meant by this criticism, it is to a large extent belied by Kandinsky's discernible influence on his own early abstractions. Like many of Kandinsky's *Improvisations* and *Compositions* of 1911, Hartley's 1912 "cosmic" abstractions have the look of imploded landscapes reconstituted on a celestial scale, and they are similarly dependent upon heavily marked black outlines for their basic pictorial structure. It may be, however, that Kandinsky's paintings were thought by Hartley to be too impersonal to satisfy the kind of emotion that Hartley himself was endeavoring to bring to his own abstractions. For what Hartley seems to have found missing in Kandinsky was precisely the kind of erotic fervor that was then impelling his own creative life.

It wasn't until Hartley himself went to live in the German capital, however, that he was fully able to give expression to this erotic impulse in his work. Berlin was clearly the great romantic idyll of Hartley's life. The sexual freedom he experienced in Berlin, which centered upon a young German officer he had met in Paris, was never entirely distinguishable in his own mind from either his mystical beliefs or his aesthetic

aspirations, all of which disposed him to find in the colorful pageantry of German military life both an imagery ideally suited to the artistic imperatives of abstraction and a pictorial correlative for its erotic subtext. It was in this sense that Hartley's "cosmic cubism" made of abstract painting the vehicle of a sexual romance.

In that endeavor, Kandinsky was indeed less important to Hartley than Franz Marc, who, though not himself either an abstractionist or a homosexual, proved to be a devoted artistic ally. In Marc's highly colored, folkloristic Expressionism, which encompassed a pictorial romance of another kind, Hartley found a Northern, mystical, modernist sensibility akin to his own, and Marc responded to this aesthetic kinship with the kind of encouragement, criticism, and useful contacts that Kandinsky could never bring himself to offer. It was largely owing to Franz Marc that Hartley was invited to exhibit with the *Blaue Reiter* group in Munich and become, in effect, a bona fide member of the pre–World War I German avant-garde.

One important consequence of this was an invitation to exhibit his work in the 1913 Berlin Herbstsalon, in the company of Kandinsky, Klee, Arp, Léger, Chagall, Boccioni, Delaunay, and other luminaries of the European modern movement. Five paintings by Hartley were hung between pictures by Kandinsky and Henri Rousseau. As he was the only American artist in the exhibition, Hartley was quick to entertain the illusion that he had at last "found [his] place in the art circles of Europe."

This short-lived idyll was decisively shattered by the war, which had the paradoxical effect of inspiring Hartley's most important contribution to abstraction while denying him the possibility of its continued development. Writing to Stieglitz from Berlin in 1913, Hartley had already indicated a "desire—to make a decorative harmony of color and form," which was his way of talking about abstraction, in his paintings of German military subjects. The outbreak of the war, though it brought him immense personal grief, initially accelerated Hartley's determination to pursue this pictorial project, and with the death of Karl von Freyburg in October 1914 it was transformed into a series of memorials for the great love of his life. For Hartley, this encompassed not only the fallen von Freyburg but also everything he had come to cherish about his life in prewar Germany.

About the political ramifications of the war, Hartley remained invincibly unconcerned. He seems to have had no faculty whatever for

understanding the political situation in which he found himself. While he acknowledged to Stieglitz that he was dealing with "teutonic" themes in these pictures, he never gave a thought to the way the war might affect their reception in the United States, where anti-German sentiment was already running high. (The United States did not officially enter the war against Germany until 1917.) Hartley saw the war entirely in terms of his personal loss, and it was as an expression of love and loss that he created the abstract elegies of 1914–1915.

The problem was, of course, that by constructing his "decorative harmony of color and form" in the elegies around specific, highly legible symbols of German military glory—most conspicuously, the Iron Cross that had been posthumously awarded to von Freyburg—Hartley made it inevitable that his paintings would be taken to be pro-German political statements. It may have been for their perceived political character that they were favorably received when they were exhibited in Germany, first in Frankfurt and then in Berlin, in 1915. But such a reading of his work seems never to have crossed Hartley's mind. While nothing was sold in these shows, he nonetheless believed, again mistakenly, that he had achieved a considerable success with them solely on the basis of their artistic merits. The exhibition in Frankfurt had even caught the attention of a correspondent for the *New York Times*, who, though he may not have known much about modern painting, certainly understood that Hartley's pictures had been inspired by the war. He described them to *Times* readers as "a snarl of triangles, squares, rectangles, flags of all nations, in glaring, solid, primitive colors, shuffled together, [which] produces a picture puzzle that absolutely defies you to say it isn't a battle." In New York itself, to which Hartley had reluctantly returned at the end of 1915, the political consequences of the war could no longer be avoided.

Stieglitz had been warning Hartley about the difficulty of finding buyers for abstract paintings of any persuasion. Even among the small number of patrons who had an interest in modernist art, abstraction still met with firm resistance. Hartley's new abstractions would therefore have been a hard sell at 291 even if they had been free of Teutonic motifs. But abstractions that were seen to honor Germany's role in the war placed the whole matter even farther beyond the pale of acceptability.

When, despite his misgivings, Stieglitz gamely mounted an exhibition of Hartley's German abstractions at 291 in the spring of 1916, it was,

of course, a fiasco. Hartley's belated attempt to forestall censure by falsely denying the symbolic character of his abstractions—"There is no symbolism whatsoever in them; there is no slight intention of that anywhere," he wrote in the catalogue of the show—persuaded nobody. The symbolism was simply too blatant to be missed. And as the exhibition itself was not so much decried as snubbed, Hartley was denied even the satisfaction of causing a scandal. The net effect of the exhibition was to bury Hartley's hope of making his mark as an abstract painter whose work would rank with that of the leaders of the European avant-garde.

In the immediate aftermath of this debacle, Hartley made one last attempt to salvage his venture into abstraction. In a series of low-keyed, highly formalized compositions based on Provincetown motifs drawn from boats, houses, and still-life objects in the summer of 1916, he abruptly lowered the emotional temperature of his painting, eradicating all trace of Expressionist symbolism and high color in favor of muted tones and crisp, flat, neutered forms. Under more auspicious circumstances this radical change in style might well have served as the basis of a new development in abstract painting. Whatever they still owed to Picasso's Cubism, these cool abstractions were something new—an anticipation, in some respects, of the kind of close-valued, clean-edged abstract styles that would later be developed on both sides of the Atlantic. But Hartley's was not a sensibility that could sustain an impersonal style devoid of existential imperatives. By temperament an Expressionist, he would never find an art of pure form sufficiently compelling to satisfy his inflammable personality. So he abandoned abstraction, which had yielded him his first masterpieces, and entered upon his long quest for a representational style in which the demands of both life and art might be given their due.

[1999]

Was Rothko an Abstract Painter?

You might as well get one thing straight . . . I'm not *an abstractionist.*—Mark Rothko to Selden Rodman, 1957

It has long been one of the curiosities of abstract art that so many of its practitioners have denied that they were in fact abstract artists. To have created works of art that were seen to be "merely" a mode of abstraction has been, for these artists, a considerable vexation, and some have gone to great lengths to—in their view—set the record straight on this question. But whether they actually succeeded in this project of denial or only added further impediments to our understanding of abstract art—including their own—remains a matter of debate.

It is a debate, moreover, that is certain to acquire a renewed momentum now that abstract art has lost its radical status and has passed into the hands of the art historians as a subject for research and interpretation. It is when an art no longer commands the distinction of radical novelty, and therefore no longer serves as a model for a new generation of "advanced" artists, that the task of explaining its "meaning" becomes especially problematical. A change in taste occurs, and the old aesthetic loyalties no longer obtain with the force they once did. There is a need to understand what it was about this art that held so many gifted artists in its thrall and persuaded so many connoisseurs of its importance. At the same time, however, there is likely to be a revisionist impulse at work in this search for "meaning"—an impulse that seeks to align the old art under study with the interests of the new art that has displaced it. If, as happens to be the case at the present moment, these interests are more closely focused on the "content" of art than they are

on its form, then we can expect the new interpretations of abstract art to follow a similar course.

This is what I believe has now happened with the study of abstract art in general and Abstract Expressionism in particular. Abstraction continues to be copiously produced, of course—and sometimes at a significant level of aesthetic achievement. But it can no longer be said to set the agenda for new artistic developments. (This doesn't mean that it might not do so again at some future date, but that is a different question.) Hence the proliferation of attempts to explain what abstract art was really about in its heyday.

What makes the whole issue especially perplexing is the even more fundamental question of whether this debate about the "meaning" of abstraction, though initially prompted by the effort of certain abstract artists to deny that they *were* abstractionists, makes any discernible difference in our experience of the works themselves. When, for example, we find ourselves in the presence of Mark Rothko's *Number 22* (1949) in the permanent collection of the Museum of Modern Art, what is there in what we see in the abstract forms of this painting that can be taken to refer to, or to embody, the metaphysical "subject" which the artist himself claimed for the work? Is that claim to be taken literally? If not, then in what sense is it to be taken? If we cannot actually *see* the artist's metaphysical "subject" in the physical object he has created for the avowed purpose of giving it expression, how can that subject be said to be present in the work?

Questions of this sort have often been raised about Mark Rothko's abstract paintings—the paintings, that is, that he produced from 1949 until his death in 1970—and with good reason. For it is well known that Rothko himself spurned the very idea that he was in any sense an abstract painter, yet the paintings themselves have long been taken—both by those who love them and by those who do not—to represent a particularly pure and even extreme form of abstraction. In his lifetime, Rothko made this issue of denial a crucial test for his admirers, and as a result they tended, by and large, to support his claim without significantly clarifying it. On at least one occasion, however, the claim was upheld so zealously that even Rothko appeared to shrink from endorsing it. I refer to the catalogue written by Peter Selz for the Rothko exhibition he organized at the Museum of Modern Art in 1961. In the short essay that Mr. Selz wrote for that catalogue, he began by declaring that

"[Rothko's] paintings can be likened to annunciations," and invoked the example of Fra Angelico to support such a reading. He ended with a flight of interpretative fancy that, though it was obviously intended as lavish praise, the artist himself recoiled from. The relevant paragraphs of Mr. Selz's text are too long to quote here in their entirety, but the following excerpts will convey something of their flavor:

> Eventually as other images occur to the viewer the metaphor of the creation of some universe becomes paramount. And increasingly—in the mind of this writer—these "shivering bars of light" assume a function similar to that loaded area between God's and Adam's fingers on the Sistine ceiling. . . . Rothko has given us the first, not the sixth, day of creation.

> The open rectangles suggest the rims of flame in containing fires, or the entrances to tombs, like the doors to the dwellings of the dead in Egyptian pyramids, behind which the sculptors kept the kings "alive" for eternity in the *ka*. . . . Indeed, the whole series of these murals brings to mind an Orphic cycle; their subject might be death and resurrection in classical, not Christian, mythology; the artist descending to Hades to find the Eurydice of his vision. The door to the tomb opens for the artist in search of his muse.

This was surely less a case of an "artist in search of his muse" than of an art historian in search of something—anything—to say about an art he couldn't comprehend. Never mind that Rothko himself, with all his talk about myth and tragedy and timeless subjects, had been responsible for leading Mr. Selz astray. Artists are given license in these matters that art historians appropriate at their peril. What Mr. Selz wrote on that occasion was all the sheerest nonsense, and was perceived to be nonsense at the time. Sidney Geist wrote a hilarious and devastating analysis of the essay in a short-lived publication called *Scrap,* and Rothko himself then asked the museum to withdraw the essay when it sent his exhibition abroad. I followed these developments with a keen interest while they were occurring, and not only because Mr. Geist and his collaborator on *Scrap,* Anita Ventura, were friends and colleagues but because the essay that I had commissioned the late Robert Goldwater to write about the Rothko show for *Arts Magazine,* which I was then editing, was the one that Rothko selected for the catalogue accompanying the European tour of the exhibition.

Well, all of this happened a long time ago, and would scarcely be worth recalling now if not for the publication of a new book on Rothko that makes an even more elaborate attempt to illuminate the artist's "subject" than the one Mr. Selz undertook nearly thirty years ago. Given the changes that have occurred in the intellectual climate of the art world, it is my impression that this new book—Anna C. Chave's *Mark Rothko: Subjects in Abstraction*—is likely to meet with a more sympathetic response than Mr. Selz's essay did. And, of course, the artist is no longer around to register his objections and thereby discredit a fanciful interpretation of his work. We are indeed in a new period, and I have an awful feeling that Professor Chave's book may very well represent its spirit—at least as far as the study of abstract art is concerned.

Thus, where Mr. Selz spoke only of "images [that] occur to the viewer," which obliquely acknowledged that they were, after all, *his* images rather than Rothko's, Professor Chave seems to believe that the images—or "traces," as she sometimes calls them—that occur to *her* in studying Rothko's paintings are actually present (in some sense) in the work itself. At least she seems to believe this some of the time, and her professors at Yale, where the original version of this book was accepted as a doctoral dissertation in art history, were apparently persuaded that this represented a perfectly legitimate reading of the artist's classic abstract paintings. Yet Professor Chave also appears, at other times, to believe that Rothko was indeed an abstract painter, and that her principal "discovery" in this book—that the abstract paintings are filled with discernible references to entombment and nativity motifs (among much else)—in no way contradicts that belief. Which, at the very least, raises the whole question of what an abstract painting is. Is it an art in which we can find "traces" of whatever our hearts and minds and the fashionable methodologies of academic study may wish us to find, or does what can be seen—and not seen—in the paintings place a limit on what can be said to be present in the painting?

"No doubt Rothko," Professor Chave writes, ". . . did not consciously make all the quotations that may be discerned in his art, but that does not mean that they are not there." She then continues:

> The influence and the perpetuation of existing cultural forms is not something artists can fully escape, either by design or by ignorance. Tradition, as Harold Bloom wrote (following Freud), is "equivalent to repressed material in the mental life of the individual."

What, then, does the "repressed material" of Rothko's "tradition" consist of, according to Professor Chave?

The general answer she gives to this question is—well, almost everything that has been done in Western painting since the Renaissance. (Unlike Mr. Selz, she doesn't go back to the Egyptian pyramids, though in truth there is nothing in her method to preclude such an option.) "Landscapes" and "portraits" are discovered to abound in Rothko's abstract paintings—"Any of Rothko's classic paintings could be described as having a portraitlike aspect or as bearing a trace of portraiture," etc.— but it is in what Professor Chave calls their "vestiges or traces" of the figurative religious painting of the Renaissance that these paintings are claimed to be especially rich. Painful as it is for me to reproduce such nonsense in these pages, I am obliged to quote a representative passage from Professor Chave's book, lest the reader think that I am exaggerating the extreme—and extremely foolish—degree to which she has carried this bizarre project of interpretation:

> The pose of the sleeping infant Christ in Bellini's *Madonna and Sleeping Child* prefigures the martyred Christ in the "sleep of death," as found in Bellini's *Pietà,* for example. Those images of Rothko's that parallel the pictorial structure of a pietà, such as *White Band (Number 27)* and *Number 20,* 1950, might be said at the same time to parallel the structure of a conventional mother and child image. Further, and by the same logic, such tripartite pictures as the untitled yellow and black painting of 1953, which bear a relation to the pictorial structure of an entombment, also bear a relation to certain conventional adoration or nativity images; in the first instance the deceased is laid on the ground before its attendants, and in the second, the infant lies sleeping on the ground at its mother's feet. But because Rothko's abstract figures are far removed from human form, in any case, the specific scale of the supine or horizontal figure relative to that of the erect or vertical figure—the factor that explicitly tells viewers of a mimetic image whether they are looking at an entombment or a nativity—has no bearing in Rothko's work. This basic schema, with a narrow band sandwiched between or below two larger masses, could yield an icon for the entire "human drama," then, from the "tomb of the womb" to the "womb of the tomb." His abstract figures could do (at the least) a double symbolic duty, that is, even where the symbols involved were

opposing ones, such as birth and death. Rothko's image-sign enabled him to elide or dismantle such conventional binaries and present them not as polar opposites but as interconnected, two sides of the same process or phenomenon.

No doubt it was on the basis of interpretative feats of this kind that Professor Chave received her present appointment to the Harvard faculty. One hardly knows whether to laugh or cry.

"Viewers [of abstract painting]," Professor Chave writes, "are left in the tense and tantalizing position of feeling that they can almost but never quite grasp a message that they may sense as inhering in the pictures." And earlier on she observes that "The message of the abstract painting veers decisively away from the textual or narrative, the explicitly recognizable and specifiable, into a more indeterminate realm." Part of the problem with this kind of pictorial analysis, of course, is its crass assumption that an abstract painting is something like a telegram containing a "message" in a code we are called upon to crack. Professor Chave doesn't call Rothko's paintings telegrams, to be sure—she calls them "a palimpsest of traces," as any academic semiologist in good standing would, I suppose. "The larger purpose of this book," she writes, "is to show how Rothko's pictures function polysemically," which is as close as Professor Chave comes to acknowledging that the aesthetic issues in Rothko's paintings—and, indeed, the aesthetic experience they afford, or fail to afford—have little or no interest for her. Her method in this book obliges her to deal with Rothko's paintings as if they really are *texts* to be decoded. It is therefore no wonder that it is their alleged "message" that interests her, for there is nothing in her method that can account for anything else. And since the "message" itself is an invention of the author, the whole enterprise turns out to have remarkably little to do with Rothko or his art.

What it does have a lot to do with, however, is the current disfavor with which academic opinion views the aesthetics of abstraction and the priority that academic research now accords to the study of "content" in art even in cases, like this one, where the content has to be invented in order to serve as a subject suitable for study. I have to say that Professor Chave is quite brilliant at this kind of analytic invention; I am in as much awe of her powers of imagination as I am of her sheer intellectual effrontery. But the sad truth is, this book has nothing to tell us about

Rothko or about abstract painting. It is a book—one among many, alas—about the crisis that has overtaken the study of art history in the universities.

Mark Rothko was hardly alone in rejecting the idea that he was in any sense an abstract artist. Many of the most illustrious names in the history of abstract art are known to have made similar denials. That many abstractionists were uneasy about venturing into this new aesthetic terrain, that they harbored doubts about the "meaning" of what they produced as abstract artists, that they sometimes made claims for their work, especially for its "content," that defy easy understanding and sometimes even credulity—these and many related questions have long been familiar to anyone who has studied the subject. But the answers to such questions do not lie in the impulse to "interpret" abstraction or to allegorize it or decode it as if it were a hermetic text. A painting isn't a text, and to pretend that it is one is to denigrate the very idea of abstract art, and to add yet another chapter—given its academic provenance, a particularly awful one—to the history of philistine response to its existence.

[1989]

Jackson Pollock and the New York School

*The American artist with any pretensions to total seriousness
suffers still from his dependency upon what the School of Paris,
Klee, Kandinsky, and Mondrian accumulated before 1935. . . .
All excellence seems to flow still from that vivacious,
unbelievable near past which lasted from 1905 until 1930 and
which not even the First World War, but only Hitler, could
definitely terminate.*—Clement Greenberg, 1947

*Every intelligent painter carries the whole culture of modern
painting in his head. It is his real subject, of which anything he
paints is both a homage and a* critique, *and everything he says
a gloss.*—Robert Motherwell, 1951

*We Americans have the technique to bring something to
performance so well that the subject is left out. There is nothing
we throw away so quickly as our* données; *for we would make
always an independent and evangelical, rather than a
contingent, creation. . . . We throw away so much and make so
much of the meager remainder. We make a great beauty, which
is devastated of everything but form and gait.*—R. P.
Blackmur, 1958

Is it possible that the significance of the New York School has been mis-
construed? Is it possible that the much vaunted "triumph" of Abstract Ex-
pressionism in the 1950s—when, for the first time in our history, an en-
tire "school" of advanced American painting commanded international

attention and acclaim—might not, after all, have been the unqualified artistic success it is nowadays taken to be by all the organs of established cultural opinion? That the emergence of the New York School in the decade that followed upon the end of the Second World War brought an immense change in the fortunes of American art is certainly beyond dispute. That this momentous change was closely linked to a decline in the fortunes of modernist art in Europe—the art from which Abstract Expressionism derived its principal impetus and ideas—remains a far more contentious issue. That the implications of that decline did much to determine the scope of what it was possible for the New York School to achieve is a question that few chroniclers of the Abstract Expressionist movement have been willing to confront. From a critical perspective of this persuasion, however, the emergence of the New York School is best understood as at once an epilogue to and a quintessentialization and apotheosis of the great epoch of early-twentieth-century modernist painting in Europe.

Such a view is, of course, very much at odds with current critical orthodoxies. On the one hand, there is the citadel of institutional opinion that insists on celebrating the New York School as a grand departure from European tradition, quite as if Abstract Expressionist painting was to be seen as some sort of analogue to Whitman's poetry or jazz. On the other hand, there is a counterorthodoxy prevalent in the academy that holds to a belief that the American avant-garde somehow "stole" its artistic ideas from their legitimate European custodians under the malign auspices of the cold war. The first attempts to aggrandize the New York School by exaggerating its originality and uniqueness, while the second attempts to demonize it for purely political purposes. (To this demonizing political agenda, moreover, the academic left has lately added equally irrelevant charges of racism and sexism.) Yet neither of these critical orthodoxies seems true either to our experience of the art itself or to the historical circumstances in which it was created.

What is essential to understand about the historical origins of the New York School is that it emerged from a world in which the political geography of modernist art had suffered a severe contraction. Even before the Second World War brought the public life of art in Europe to a virtual standstill, modernism had been outlawed in two of its vital centers—first in Russia under the Soviet regime of Stalin, and then in Germany under the Nazi regime of Hitler. This malevolent fate had

particularly grievous consequences for the votaries of abstraction, which was everywhere seen—by its champions no less than by its enemies—to represent the most extreme manifestation of the modernist spirit in art, and was thus even more vulnerable to hostile opinion than its figurative counterpart.

What is also important to understand about the fate of modernist art in the decade prior to the Second World War is that even in those countries where it was more or less accepted as a legitimate, though still controversial, component of modern cultural life—which was largely the case in France, Britain, and the United States—abstraction continued to meet with fierce institutional resistance. In France, except for Léger and Delaunay, the masters of the School of Paris were hostile to pure abstraction. In the 1930s, moreover, the dominance of Surrealism on the Paris art scene had the effect of marginalizing even abstract artists of the stature of Mondrian and Kandinsky. (That the abstract art of Kandinsky had exerted a crucial influence on Miró, the greatest painter to receive the imprimatur of André Breton, hardly mattered. Kandinsky remained excluded from the Surrealist canon.) In Britain, too, despite a spirited campaign mounted in the critical writings of Herbert Read on behalf of Henry Moore, Barbara Hepworth, Ben Nicholson, and Naum Gabo, abstraction was generally regarded by both the cognoscenti and the public as something alien and absurd. Even a modernist critic as enlightened as Roger Fry had harbored serious doubts about its aesthetic efficacy.

The situation in America was somewhat different, however. While mainstream critical opinion in the United States was similarly hostile or indifferent to the achievements of abstract art in the 1930s, there was nonetheless some significant institutional support for its European masters. The Museum of Non-Objective Art—later to be better known as the Solomon R. Guggenheim Museum—was founded in New York in 1937 as a kind of shrine to Kandinsky and his followers. (Jackson Pollock worked there, doing odd jobs, in 1943.) Even earlier, in 1927, A. E. Gallatin had opened his Gallery of Modern Art, a collection that favored abstraction, at New York University, and earlier than that, in 1920, Katherine Dreier had founded the Société Anonyme, which was also sympathetic to abstraction. Most important of all was the founding in 1929 of the Museum of Modern Art, where in 1936 Alfred H. Barr, Jr., organized a major exhibition of *Cubism and Abstract Art*, which gave the

public of its day its first comprehensive account of the history of abstract art in Europe.

Yet not a single American painting was included in the *Cubism and Abstract Art* exhibition, though Alexander Calder was represented by his mobile sculpture. This implicit downgrading of American abstraction deeply embittered our embattled native modernists, who in the 1930s were fighting a lonely struggle for recognition against the popularity of reactionary Regionalist and Social Realist painting. This led to a public protest in 1939 when a group called the American Abstract Artists, which had been organized in 1936 to advance the cause of abstract art in the United States, issued a broadside that asked the question, "How Modern Is the Museum of Modern Art?" It was signed by fifty-two artists and caused the museum a good deal of embarrassment. It did not, however, prompt any immediate change in policy.

The reason, though never publicly avowed, was nonetheless clear. American abstract art in the 1930s was not deemed sufficiently powerful or original to merit more vigorous support. As one of the museum's curators, James Thrall Soby, confided on another occasion: "You cannot possibly present twentieth-century American painting as we have presented School of Paris painting. The revolutionary impact is not there." This is a judgment that posterity has somewhat modified—for there was more going on in American art in the 1930s than the museum quite appreciated—but not essentially altered. Even the most advanced American art of the time was still largely tethered to European initiatives.

This was a situation that the eruption of the Second World War radically changed. The fall of Paris to the Nazi army in June 1940 marked the end of an era in European modernism. If the modernist movement in art was to have any immediate future, it would be left to artists in the United States—both native modernists and European émigrés—to create that future. Almost overnight, then, New York became the sole remaining outpost of the modernist movement, and thus the de facto capital of the international avant-garde. This was as much of a shock to the Americans as it was to the Europeans, for modernist art was essentially a European creation and American artists were used to regarding themselves as the underdogs of the movement. That its future might now be in American hands was a daunting prospect for which few American talents had prepared themselves. Yet it was in this atmosphere of shock, dislocation, and worldwide crisis—a crisis in the very civilization that had

produced the modernist movement—that the New York School emerged in the early years of the war.

Like so many of the other American painters who constituted that first generation of New York School painters, Jackson Pollock (1912–1956) was abysmally ill-prepared, by training or temperament or intellect, to respond to this daunting challenge. That he succeeded to the extent that he did— which was for a very brief period between 1947 and 1950—was itself a re- markable feat, a triumph of ambition and short-lived inspiration over a se- verely handicapped and unruly personality. The figure he most resembles in American cultural history isn't Walt Whitman but Hart Crane, whose horrific career traced a similar course of self-destructive combat with ex- treme circumstance to wrest from the conventions of European mod- ernism an authentic statement of American experience.

In September 1939, when the war in Europe commenced, Pollock was a twenty-seven-year-old painter whose accomplishment was negli- gible and whose personality was already showing signs of fracture and disarray. For two years he had been under psychiatric treatment for al- coholism, and would remain under treatment—mostly of a Jungian persuasion—for some years to come. As an artist he was still very much under the influence of his teacher and mentor, Thomas Hart Benton, one of the leaders of the Regionalist school. He had also taken a keen interest in the Mexican muralists, especially José Clemente Orozco and David Alfaro Siqueiros, who in the 1930s were very much in vogue in the United States. (They indeed enjoyed more favor at the Museum of Modern Art than most American modernists.) It was from Siqueiros in the 1930s that Pollock acquired an interest in the use of enamel paint and some of the techniques for dripping and pouring it, though it would be another decade before he put them to significant use in his own paint- ing. It was not until 1940 that, as his brother Sande wrote at the time, Pollock had "finally dropped the Benton nonsense."

What seems to have changed everything for Pollock was seeing Pi- casso's *Guernica* at the Valentine Gallery in New York in the spring of 1939, and then, later that year, the mammoth exhibition *Picasso: Forty Years of His Art* at the Museum of Modern Art. It was his intense en- counter with Picasso that marked Pollock's entry into the arena of mod- ernist painting, which Benton had famously repudiated—an arena in which Picasso would presently be submerged, in Pollock's case, by the impact of Kandinsky, Miró, Masson, and Matta. It was to a large extent

the therapeutic ethos of Jungian psychoanalysis, however—an ethos that conferred immense metaphysical authority on so-called archetypes, which were believed to lie buried in the recesses of unconscious memory but were waiting to be magically summoned for conscious purpose—that determined the way Pollock performed in that arena.

What ignited this heady amalgam of modernist pictorial aesthetics and Jungian psychology in Pollock's painting was the Surrealist doctrine of automatism, which was itself derived from the Freudian concept of the unconscious. This isn't the place to explore the central role played by psychoanalytic theory and practice in the art and culture of the 1940s in this country. Suffice it to say that it was enormous. It effectively supplanted the role played by Marxist thought in the 1930s, and exerted an even greater influence on the conduct of life. Neither the art of the New York School nor the poetry of the same period—the poetry of the generation of Delmore Schwartz, John Berryman, Randall Jarrell, and Robert Lowell—can be fully understood or seriously assessed in isolation from the culture of psychoanalysis. Nor, for that matter, can any other area of American cultural life in the years between the Second World War in the 1940s and the Vietnam War in the 1960s, a subject that still awaits a social historian to do it justice.

Be all this as it may, it was the doctrine of automatism that emancipated Pollock from the morass of modernist eclecticism and pastiche in which his painting remained mired during the war years when his art was just beginning to attract serious attention. His conversion to automatism also liberated him from the bogus mythification of those tacky Jungian "archetypes" that identify paintings like *The Moon Woman*, *Male and Female*, *Guardians of the Secret*, and *The She-Wolf* (all from 1942–1943) as the work of an artist whose raw command of the painterly medium, while still pretty crude, was more impressive than his muddled attempts to deal with symbols ostensibly dredged up from the unconscious—but actually acquired from the intellectual hearsay of the period—as his principal subjects. It wasn't until Pollock got rid of his subjects—or what R. P. Blackmur called "*données*" in the passage I have quoted above—that he was able to achieve an art that, as Blackmur wrote, "is devastated of everything but form and gait." It was his total embrace of automatism in the "drip" paintings of 1947–1950 that made the breakthrough possible.

It is one of the many problematic aspects of the retrospective *Jackson Pollock*, which Kirk Varnedoe has organized at the Museum of Modern

Art this winter, that it treats the artist's oeuvre as if it were a consistently sublime achievement rather than what it is: a highly uneven body of work which, even in its rare moments of original accomplishment, is scarcely comparable to the greatest painting of the modernist era. This approach to the Pollock problem seems to have been dictated by a mistaken belief that Pollock's life constitutes one of the master myths of twentieth-century American life. This belief is baldly stated in the opening pages of Mr. Varnedoe's essay for the catalogue of the exhibition, an essay whose very title—"Comet: Jackson Pollock's Life and Work"— puts us on notice that we are invited on this occasion not merely to examine an artist's work but to participate in an historical romance. "The span from Elvis Presley's first record in 1954 through Jasper Johns's first show in 1958 formed a key divide in American life," Mr. Varnedoe writes, "and Pollock's car crash (like the actor James Dean's the year before) was one of its benchmarks. In retrospect, that accident says 'end' as surely as Sputnik (launched the next year) says 'beginning.'" And further:

> Pollock now looms as a central hinge between the century's two halves, a key to how we got from one to the other in modern art. As the pivot on which prologue and coda balance, he has become in history, still more than he was in life, a legitimator: validation accrues to the lineage fertile enough to have spawned him, or to followers clever enough to have properly read his message; and competing claims abound. Even more broadly, any theory of cultural modernity has to claim the summit he occupies before it can assert dominion on the territory; and in this way accounts of Pollock also become litmus tests for broader philosophical and political positions about the meanings of his epoch. Trying to write his history inevitably broaches larger queries about our own.

In the presence of such claims to world-historical importance, then, Mr. Varnedoe embraces the notion that "normal critical criteria" are still beside the point in discussing Pollock's art, for how can mere art criticism hope to account for a phenomenon like "a central hinge" of an epoch that goes back a hundred years? Even in the vast literature devoted to Picasso, I cannot recall anything to equal this bizarre exercise in museological hyperbole. It makes even William Rubin's misguided attempt to place the paintings of Frank Stella in the company of Shakespeare and Dante seem almost modest by comparison. In the end it is a

testimony not to Pollock's artistic achievement but to something far more mundane—a curator's anxiety that a claim to anything less than the colossal and world-shaking will fail to bring in the crowds needed to justify an exhibition mounted on a blockbuster scale.

Alas, it is in the interest of museum marketing and mythmaking that war has been declared on so-called normal critical criteria in the organization of this retrospective and its accompanying catalogue, and not because such criteria are no longer relevant to what the artist accomplished or failed to accomplish in the course of a very troubled life.

What "normal critical criteria" amount to on this occasion turn out, for the most part, to consist of the critical observations made by the late Clement Greenberg in the course of his close involvement with Pollock's painting. While paying a kind of pro forma lip service to Greenberg's accomplishments as a critic, Mr. Varnedoe mounts a major assault on just about every aspect of his critical thought. Not only are we treated to the now familiar reference to Greenberg "as a tyrant of taste in the early 1960s" but to a summary attack on Greenberg's pessimistic views of American society in the immediate aftermath of the Second World War and the sense of "alienation" with which he identified both the New York School and the vicissitudes of high cultural aspiration in that period.

Taking what can only be called a *Saturday Evening Post* cover view of this postwar period, Mr. Varnedoe evokes a jolly time "when a world war against totalitarian powers had just been won, when prosperity had returned after the bitter years of the Depression, and when an enormous boom in new births apparently signaled a groundswell of confidence and relief." Apparently he is unacquainted with W. H. Auden's *Age of Anxiety* (1947), or the ballet later based on it, or with the pervasive influence in these years of such unjolly writers as Kafka and Kierkegaard and Sartre and Camus and Maritain—but why go on? About the spiritual temper of that postwar period Mr. Varnedoe remains as innocent—or ignorant—as one of those newborn babes he cites as evidence of a "groundswell of confidence." Can he really have no idea of the spiritual disarray and psychological breakdown that the war and the Holocaust and the atomic bomb brought in their wake?

There is certainly plenty to take issue with in Clement Greenberg's criticism, and with Greenberg himself, but on this subject—the moral and cultural temper of the period in which the New York School

emerged—his pessimism was both accurate and prophetic. He wrote as follows in 1947:

> The morale of that section of New York's Bohemia which is inhabited by striving young artists has declined in the last twenty years, but the level of its intelligence has risen, and it is still downtown, below 34th Street, that the fate of American art is being decided—by young people, few of them over forty, who live in cold-water flats and exist from hand to mouth. Now they all paint in the abstract vein, show rarely on 57th Street, and have no reputations that extend beyond a small circle of fanatics, art-fixated misfits who are as isolated in the United States as if they were living in Paleolithic Europe.

Although Pollock's principal critical champion, Greenberg didn't write as a cheerleader—and it is for that reason, I suppose, that a curatorial cheerleader like Kirk Varnedoe is concerned to discredit him. While Greenberg did not hesitate to describe Pollock in 1947 as "the most powerful painter in contemporary America and the only one who promises to be a major one," he also said of Pollock's painting that "its paranoia and resentment narrow it; large though it may be in ambition—large enough to contain inconsistencies, ugliness, blind spots, and monotonous passages—it nevertheless lacks breadth." It is for judgments like this that Greenberg has had to be demonized once again on the occasion of this retrospective.

For the entire premise on which this retrospective has been organized is the belief that Pollock ushered in a new golden age in American art—a golden age represented by the likes of Cy Twombly, Jim Dine, Roy Lichtenstein, Claes Oldenburg, Carl Andre, Frank Stella, Lynda Benglis, Richard Serra, and Brice Marden, among many others. One can only say that golden ages aren't what they used to be. On this matter, too, what Greenberg wrote about the Museum of Modern Art in 1947 remains amazingly relevant, for some things haven't changed in the last fifty years. "Pusillanimity makes the museum follow the lead of the powerful art dealers. . . . But it cannot be blamed too much, since it reflects rather accurately the prevailing taste in American art circles." If there really was "a tyrant of taste in the early 1960s" on the New York art scene, it was Leo Castelli, not Clement Greenberg—but to acknowledge that would capsize the premise on which this Pollock retrospective has been organized.

A more reliable key to our understanding of Pollock's painting is, in any case, to be found in Greenberg's observation that it "lacks breadth." But to reflect on that realm of aesthetic actuality is to remove Jackson Pollock from the romance of history and return our attention to what the artist accomplished and failed to accomplish in the only important pictures he ever created.

> *Somewhere deep in every American heart lies a rebellion against the old parenthood of Europe.*—D. H. Lawrence, 1923

Until well into the 1940s, Jackson Pollock's painting remained locked in a struggle to master and overcome the influences of the European modernist painters he took as his models—primarily Picasso, Kandinsky, and Miró. That he was not himself an artist in their class was more or less taken for granted even by his most ardent admirers at the time. It is doubtful that Pollock himself believed he was an artist in their class. Yet what he brought to his encounter with these European masters was a fierce determination to produce an art that would somehow carry him beyond the styles and conventions he was wrestling with. Among much else, this meant that traditional easel painting had to be abandoned in favor of something the European masters of modernism had not yet attempted to place at the center of their art—a mode of mural-scale wall painting of a radically subjective character.

Pollock seems to have understood that as an easel painter he would never be able to trump his European masters. Not only did they bring to the tradition of the easel picture a richer and more complex command of experience than any that was within his own reach, but they had effectively transformed the content of the easel picture to conform to the imperatives of that experience. Mural-scale wall painting of a certain persuasion—painting that would be tethered not to the service of some social cause but to the only subject that governed the artist's will: his own troubled psyche—offered a way to circumvent the tradition to which Pollock could not finally make a significant contribution.

It was in the interest of circumventing that tradition that the influence of the Mexican muralists, the public art of Thomas Hart Benton, and Pollock's own response to Picasso's *Guernica* all played a crucial role in determining his leap into mural-scale wall painting in the late 1940s. It was in the scale and ambition of such painting, not in its ethos

or imagery, that Pollock saw the possibility of a radical artistic opportunity. For the social content of 1930s mural painting Pollock felt no affinity whatever. Indifferent to politics and fundamentally anti-social in his personal behavior, Pollock had only one subject that commanded his loyalty: his own appetites, ambitions, and compulsions, which years of Jungian psychoanalysis had elevated in his own mind to the status of a cosmological imperative. (Hence his megalomaniac assertion that "I *am* nature!") It wasn't until he was able to bring those appetites and ambitions into alignment with a pictorial technique allowing them unfettered expression—unfettered, that is, by the traditional tools and constraints of easel painting—that Pollock was able to achieve an art uniquely his own.

It is for this reason that the "drip" abstractions of the late 1940s and early 1950s are inevitably the central focus in any comprehensive account of Pollock's oeuvre. It is one of the distinctions of the *Jackson Pollock* retrospective which Kirk Varnedoe has organized at the Museum of Modern Art that it assembles a larger number of these abstract paintings than has ever before been seen in a single exhibition. This, in my view, is also one of the principal liabilities of the exhibition, for what has come to be regarded as "classic" Pollock is not, after all, an art of infinite variety. It is maddeningly repetitious in its formal rhythms. It is paltry in its command of color, for classic Pollock is largely based on light-dark contrasts rather than chromatic structure. Classic Pollock also lacks breadth, as even Clement Greenberg acknowledged, in its range of feeling and invention.

Given these limitations, such paintings are best seen in isolation from each other. They actually gain something from being viewed in the company of abstract paintings unlike themselves in method and imagery— which is generally how we do see these Pollocks in museum collections— for the contrasts to be observed in such contexts have the effect of underscoring the element of furious, headlong energy in Pollock. When a large number of Pollock's abstract paintings are seen in close succession, however—as they are in the MOMA retrospective—their much-vaunted energy tends to deflate and flatten into decorative tedium. The more we look, the less we find. What may strike us initially as random and reckless in the labyrinthine traceries of dripped and poured pigment soon reveals itself to be involuntarily governed by an ineluctable and compulsive monotony. Pollock's unconscious, to the extent that it was called upon by his

automatist methods to supply him with images, forms, and ideas, turned out to be a very limited resource. But then, so too was the element of conscious control in Pollock. Which may be why classic Pollock turned out to have a lifespan of less than five years.

Even so, the paintings produced in the early stages of this short-lived period are more interesting than those that came at the end. If we take *Cathedral* (1947) as marking its beginning, then it was pretty much over by 1950, the year in which Pollock produced *Lavender Mist, Autumn Rhythm*, and a number of similar paintings in which he seems to have been able to effect a more workable equation between uncertainty and control than either before or after. That there remained a large element of uncertainty in Pollock's own view of what he was doing in the drip abstractions even in his best years is evident in his introduction of Miróesque cut-out figures in 1948–1949. In the eight-foot-wide *Out of the Web* (1949), for example, the figures actually dominate the weblike traceries of pigment. By the time we get to *Blue Poles* (1952), uncertainty has been supplanted by predictability. *Blue Poles* is the Abstract Expressionist version of Salon painting. Classic Pollock had become its own cliché. And in the few years that remained, Pollock is seen to be attempting something like a return to easel painting.

No one has given us a better account of the artistic implications of the shift from easel painting to wall painting in Pollock than the late William C. Seitz in his early study of *Abstract Expressionist Painting in America.*[1] Until 1946 [wrote Seitz] Pollock's paint surfaces were passionately molded with brush and knife in what Thomas Hess characterized as a "heavy, dark Expressionist idiom." The irreducible unit of his style, despite rectilinear structure, was the individual stroke, though its identity was apt to be lost in the total textural maelstrom and the optical pulsation effected by variegated color. Out of this "total textural maelstrom," according to Seitz, came "Pollock's identification of passion with nonobjective brush tracks," and this in turn led him to a pictorial method in which "tools seldom touched the painting surface"—the method Seitz described as "the flow or drip of enamel from brush, stick, or can."

1. Originally written as a doctoral dissertation at Princeton University in 1955, Seitz's *Abstract Expressionist Painting in America* was not published as a book until 1983, when Harvard University Press brought it out with a forward by Robert Motherwell and an introduction by Dore Ashton.

Seitz then addressed the crucial question of "the degree and nature of the control that the artist intentionally or unconsciously exerts over his medium." While reminding us that "The idea of accident is deeply entrenched in modern tradition," Seitz went on to observe that Pollock had

> demonstrated that direction can be given to even so fluid and willful a medium as poured enamel. Control here applies not to the exact track and shape of each brushstroke [sic] to be sure, but to the types of relationship inherent in the process. Individual passages . . . at no point evidence the direct touch of the painter. Rather, it is his entire bodily activity that from a distance influences, but by no means determines, his configuration. Accident, gravity, and the fluid response of the paint combine with human gesture to form a structure that is the result of their interaction.

About the pictorial structure that results from this interaction, Seitz also offered some cogent observations.

> It is easy to see three-dimensional structure in Pollock's pictures; and as one's consciousness moves, in exploring his endless space of cellular division, time is involved as well. Finally, following the perceptual jolt by which one's impression of a visual field shifts, hollow space becomes flat surface. What was open structure is seen as a network of lines that weave above and below each other across the canvas, and the spectator is excluded. The picture, still vital, becomes a wall decoration.

Now the possibility that it might be the fate of mural-scale abstract painting to be experienced as wall decoration—"wallpaper," as Harold Rosenberg derisively characterized it in "The American Action Painters"—was an issue that was deeply troubling to virtually all of the painters of the New York School. That is why there was so much heated discussion lavished on the importance of the "subject" from the earliest days of the Abstract Expressionist movement in the 1940s. It was believed—some of the time, anyway, by some of the artists—that a compelling subject would forestall abstraction's descent into wall decoration. There were New York School painters—Mark Rothko prominently among them—who insisted that the only legitimate subject for abstract painting was some mythic or mystical vision of human tragedy, yet few observers of his art could find any hint or suggestion of such a subject in the paintings he actually created. Willem de Kooning, on the other

hand, downgraded the very notion that "content" might play an impor-
tant role in painting—"It's very tiny—very tiny, content," he said—but
his own argument was undermined by the series of *Women* paintings that
placed him in a direct line of descent from Picasso, for whom a subject
had always been crucial. There was never any consensus on the subject
of a "subject" in the New York School, nor could there be—for it was
in the very nature of Abstract Expressionist painting for each of its prac-
titioners to conduct a radically subjective dialogue with the art of the
European modernists they aspired to supplant.

In this respect, certainly, Robert Motherwell was far more candid
than most of his colleagues in the New York School when he observed
that "Every intelligent painter carries the whole culture of modern
painting in his head. It is his real subject, of which anything he paints is
both a homage and a *critique*, and everything he says a gloss." Yet the idea
that "the whole culture of modern painting" might in fact be the unac-
knowledged subject of Abstract Expressionist painting—which I firmly
believe to be the case—was deeply distasteful to many painters in the
movement, who regarded it as an affront to their high-risk, existential
ambitions as members of an embattled avant-garde. It was an idea that
for many people in the art world conjured up discredited notions of art-
for-art's-sake and "significant form"—theories that were believed to give
priority to art over life, and thus inevitably put in question the ambition
of the New York School painting to produce an art so radical that it
would at some level challenge the life of the time.

It was for this reason that Harold Rosenberg's theory of "action
painting" scored such an immense success when it was first promulgated
in 1952. In a single bold stroke, Rosenberg's essay "The American Action
Painters" appeared to remove the entire Abstract Expressionist move-
ment from both the history of modern painting and the pettifogging
distinctions of aesthetic discourse by situating it instead in some exalted
realm of existential "action," where, as the author claimed, "what matters
always is the revelation contained in the act," and such mundane matters
as "Form, color, composition, drawing . . . can be dispensed with." This
was the key passage in what amounted to a declaration of independence
from what D. H. Lawrence had called "the old parenthood of Europe":

> At a certain moment the canvas began to appear to one American
> painter after another as an arena in which to act—rather than as a

space in which to reproduce, re-design, analyze or "express" an object, actual or imagined. What was to go on the canvas was not a picture but an event.

It was further claimed by Rosenberg that "The new American paint-ing is not 'pure' art, since the extrusion of the object was not for the sake of the aesthetic." On the contrary, Rosenberg wrote, "The new painting has broken down every distinction between art and life." From this per-spective, then, "The critic who goes on judging in terms of schools, styles, form—as if the painter were still concerned with producing a cer-tain kind of object (the work of art), instead of living on the canvas—is bound to seem a stranger."

If "every distinction between art and life" had been eliminated in this painting, what it called for wasn't art criticism or aesthetic judg-ment but some existentialist version of psychoanalysis. Since the painter has become an actor, the spectator has to think in a vocabulary of ac-tion: its inception, duration, direction—psychic state, concentration and relaxation of the will, passivity, alert waiting. He must become a con-noisseur of the gradations between the automatic, the spontaneous, the evoked.

The notion that "What was to go on the canvas was not a picture but an event" was the sheerest nonsense, of course. But it proved to be very seductive nonsense. For its effect was to provide the Abstract Ex-pressionist movement with an exciting new dramaturgy in which the artist now emerged as an existential hero and his painting was to be seen not as an aesthetic endeavor but as the cynosure of a heroic private ac-tion that was not to be judged by aesthetic standards. It was, alas, a very "European" theory, which derived from ideas to be found in Breton's surrealism, Freud's psychoanalysis, and Sartre's existentialism, yet it proved to be so appealing that it was somehow exempted from any neg-ative association with "the old parenthood of Europe."

There was, however, a dirty little secret involved in the promulgation of Rosenberg's theory. For it was well known at the time that Jackson Pollock was the artist upon whose recent work—the mural-scale "drip" abstractions of the late 1940s and early 1950s—Rosenberg had based his theory of "action painting." And it was also well known in New York art circles that Rosenberg actually despised Pollock's paintings and had a very low opinion of the man himself. Yet because Pollock was the only

painter then at work whose pictorial practice—especially as it was recorded in the photographs by Hans Namuth—seemed to lend itself to Rosenberg's existential "action" scenario, he shamelessly exploited Pollock's notoriety without according him appropriate recognition or even mentioning his name. There was thus at the very core of this famous essay on "The American Action Painters" an act—one might even call it an existential act—of unconscionable bad faith. Yet because Rosenberg was so enamored of his own theory and saw that its publication would bring him a celebrity he had never before enjoyed—which, of course, it promptly did—he turned his private mockery of Pollock's painting into a bogus manifesto for the entire Abstract Expressionist movement.

The unhappy history of this episode in critical legerdemain is now worth recalling not only because it became so inextricably involved in public perceptions of the art of the New York School for so many years but also because something akin to Harold Rosenberg's bad faith in promoting his "action" theory seems to have governed the very conception of the *Jackson Pollock* retrospective at MOMA. Unlike Rosenberg, Mr. Varnedoe cannot be accused of despising Pollock's painting, yet implicit in the atrocious way he has presented the artist's drip abstractions to the public—and without the drip paintings there would be no Pollock retrospective—is an assumption that these are not works of art that can be expected to sustain our attention without recourse to the mythology surrounding their creation.

Hence the unforgivable decision to install a life-size replica of the interior of the Long Island barn that served as Pollock's studio in the exhibition itself. That studio interior is, of course, the *mise en scène* of the media-generated legend of "Jack the Dripper" and all the other nonsense written about Pollock's antics as an artist. Owing to the photographs of Hans Namuth that documented Pollock's "performance" in that studio, it has become a space almost as famous as the paintings that were created in it. At MOMA, moreover, the replica of this studio space is adorned with a copious selection of the Namuth photographs of Pollock at work, and on a video monitor at the entrance there is a film version of the same subject. This replica of the Pollock studio turns out to provide the climactic moment in what is a large and at times a very wearying exhibition, and its function in the retrospective is clearly to give the public something other than Pollock's paintings to look at. To an understanding of Pollock's painting this replica of his studio space

contributes nothing. Its purpose is purely dramaturgical. By evoking the legend of the painter performing in the studio, it succeeds in shifting attention from the paintings to the artist himself as he has passed into the mythology of modern cultural life. It certainly succeeds as show biz but is finally very damaging to the public's understanding of the art.

What the conception of the Pollock retrospective owes to Rosenberg's "action" theory, and what both owe to the folklore generated by Namuth's studio photographs and films, is made explicit by Pepe Karmel, Mr. Varnedoe's collaborator on this exhibition, in his essay for the catalogue accompanying the retrospective. This essay on "Pollock at Work: The Films and Photographs of Hans Namuth," which runs to some 45 large pages plus 102 footnotes—roughly two-thirds as long as Mr. Varnedoe's own essay on the life and work of the artist—is something of a museological phenomenon in itself. I, at least, cannot recall another museum text of this length in which the most mind-numbing pedantry is so seamlessly combined with such shameless legend-mongering to produce such a negligible critical result. For what momentous discovery does Mr. Karmel come up with after his protracted study of Namuth's negatives and the outtakes from the Pollock film project? "Pollock's achievement, in his pictures of 1947–50," writes Mr. Karmel in conclusion, "was to transform graphic flatness into optical flatness—to show that by piling layer upon layer, sign upon sign, you could generate a pictorial sensation equivalent to that of the primordial vision field." He acknowledges that "The impact of this discovery is evident in Pollock's painting," and then adds: "But only through the films and photographs of Hans Namuth can we understand the technique that made it possible."

Yet in this pedantic endeavor Mr. Karmel is guilty of engaging in the very same critical strategy he takes Harold Rosenberg's "action" theory to task for. "Rosenberg's rhetoric encouraged artists and critics to focus on Pollock's actions rather than on the images resulting from them," Karmel correctly observes, and then at much greater length than Rosenberg attempted does exactly the same thing. But since the whole conception of this retrospective is to exploit the Pollock myth rather than to give the public a disinterested account of the artist's accomplishment—which really doesn't require an exhibition on this scale—it was essential for MOMA, too, to concentrate on "Pollock's actions" rather than his art. So the paint-splattered floor of the artist's studio is given a full-color re-

production in the catalogue, and the studio itself has been replicated as a shrine where not the paintings of Jackson Pollock but the photographs of Hans Namuth documenting their production may be pondered as the sacred relics of the artist's legend. All of which has less to do with the life of art than with the current business practices of the art-museum industry.

[1999]

I I
Modernism and Its Critics

Clement Greenberg
in the Forties

With the publication of the first two volumes of Clement Greenberg's *Collected Essays and Criticism*, we are at last on our way to having a comprehensive edition of the most important body of art criticism produced by an American writer in this century. The two volumes now available—*Perceptions and Judgments, 1939–1944*, and *Arrogant Purpose, 1945–1949*—bring together for the first time Mr. Greenberg's critical writings from the decade in which he emerged as the most informed and articulate champion of the New York School as well as one of our most trenchant analysts of the modern cultural scene. The two additional volumes promised for the future will presumably bring his remarkable critical oeuvre up to date. John O'Brian, the editor of the series, has so far carried out his duties with an exemplary scholarly tact—both of the new volumes contain useful notes, interesting biographical chronologies, and appropriate bibliographies—and the books have been produced by the University of Chicago Press in a very readable format. Under any circumstances the publication of Mr. Greenberg's *Collected Essays and Criticism* would have to be considered a capital intellectual event; but in the present climate, when so much that passes for serious criticism is in reality some form of academic twaddle, commercial hype, or political mystification, the appearance of these volumes also has a wonderfully bracing effect. For this is criticism that does not require us to surmount some impenetrable rhetorical barrier in order to discover what it is actually up to. It is plainly written, cogently argued, and admirably precise in the many discriminations and formulations it is concerned to make.

For anything remotely comparable in intellectual quality or aesthetic intelligence, one would have to turn to the most illustrious of Mr. Greenberg's predecessors—to Julius Meier-Graefe in Germany and Roger Fry in England. In his own generation he stands alone.

It is one of the many virtues of the present edition of Mr. Greenberg's writings that it places them firmly in the context of the history which prompted them in the first place. When, some twenty-five years ago, Mr. Greenberg published a selection of his essays under the title of *Art and Culture,* he was frank to say that that book was "not intended as a completely faithful record of my activity as a critic." Although drawn from the first twenty years of Mr. Greenberg's production, many of the essays in *Art and Culture* had been substantially revised in order to give the reader a clear account of the author's current views. "Not only has much been altered," as Mr. Greenberg noted in his preface to *Art and Culture,* "but much more has been left out than put in." *Art and Culture* was certainly a very distinguished book. Indeed, for a quarter of a century it has remained without rival as the premiere work of art criticism in our time. Yet the emphasis that *Art and Culture* placed on the present inevitably had the effect of foreshortening our understanding of the past—both the critic's past, with all of the shifts in emphasis and perspective that any full-scale critical career is bound to encompass, and that of the art he was attempting to come to grips with in a succession of discrete encounters. It is only with the publication of *The Collected Essays and Criticism* that we have now begun to have placed in our possession a complete account, month by month and year by year, of this crucial critical history.

It is another of the virtues of this edition that it illuminates—and with a fullness and candor that was no doubt inappropriate to the purposes of *Art and Culture*—the broad range of literary, artistic, and political interests that did so much to shape Mr. Greenberg's outlook as a writer. The first entry in Volume I is a review of Bertolt Brecht's *A Penny for the Poor.* The second is the author's now classic essay "Avant-Garde and Kitsch," written at the age of thirty and as much concerned with literature as with art. The third is an equally important but not so well-known essay, "Towards a Newer Laocoon," which attempted to explain in historical terms how it happened that modern art, in its "revolt against the dominance of literature"—the dominance, that is, of "subject matter at its most oppressive"—came to place "a new and greater emphasis

upon form" and upon the physical medium. "Towards a Newer Lao-coon" was, as Mr. Greenberg acknowledged, "an historical apology for abstract art," and may thus be considered something of a manifesto for the "formalist" view of art which he has steadfastly maintained through-out his subsequent career as a critic.

Interestingly, he was writing in these early years as a Marxist—an anti-Stalinist Marxist of the Trotskyist persuasion, to be sure, but a Marx-ist all the same. In this phase of his career Mr. Greenberg was *very* much a fan of the *Partisan Review* circle that looked to Trotsky as a political guide in attempting to "save" the Revolution from what was looked upon as Stalin's "betrayal" of it. In the fourth entry in Volume 1 of *The Collected Essays*—an essay called "An American View," written for Cyril Connolly's magazine *Horizon* in 1940 and published in London during the Blitz—we are given a clear statement of the political folly that this ideological outlook entailed. "Hitler realizes this much, that in order to keep capitalism there must be fascism," Mr. Greenberg wrote; "Trotsky realizes that in order to keep democracy there must be a socialist revo-lution. . . . We must choose: either capitalism or democracy. One or the other must go. If we insist on keeping capitalism then we cannot fight Hitler. He must win."

Cyril Connolly promptly and correctly responded to this mistaken analysis by writing an article in the same issue of *Horizon* which firmly rejected Mr. Greenberg's claims. "It is obvious that this view," Connolly wrote, ". . . rests on an over-simplification of the facts, and if put into practice would lead to disaster." (Mr. O'Brian quotes Connolly's re-sponse in a footnote.) Before the end of the forties Mr. Greenberg had more or less come to agree with Connolly, describing himself in a *Par-tisan Review* symposium in 1948 as an "ex- or disabused Marxist." And as an editor of *Commentary* from the late forties to the end of the fifties, he was, of course, in the forefront of those ex-radicals who played a role in articulating the case for what came to be characterized as anti-Commu-nist, or cold war, liberalism—a position from which, I believe, he has never since deviated.

What needs to be borne in mind about the role of Marxism in Mr. Greenberg's early writings is that 1) it did much to shape his view of history, and 2) it was never allowed to distort his judgment of particu-lar artists. The extent to which a Marxist-influenced teleology came to be subsumed in his reading of art history is another matter. It can be

argued—I have argued it myself—that some residue of the Marxian dialectic disposed him to find in art history, and most particularly the history of modern art, something in the realm of aesthetics ("subject matter at its most oppressive") that is more or less akin to the Marxist notion of class struggle as an iron law of historical development.[1] Something of the sort is certainly to be found in such essays as "Avant-Garde and Kitsch" and "Towards a Newer Laocoon," and it persists as a kind of leitmotif in a great many other essays, too. Yet it must be said that Mr. Greenberg's response to particular works of art is, more often than not, remarkably free of the ideological strictures to be found in his more theoretical pronouncements. And even in "Towards a Newer Laocoon," he was at some pains to underscore the limit that he placed on his own theoretical imperative:

> My own experience of art has forced me to accept most of the standards of taste from which abstract art has derived, but I do not maintain that they are the only valid standards through eternity. I find them simply the most valid ones at this given moment. I have no doubt that they will be replaced in the future by other standards, which will be perhaps more inclusive than any possible now. And even now they do not exclude all other possible criteria. I am still able to enjoy a Rembrandt more for its expressive qualities than for its achievement of abstract values—as rich as it may be in them.

This is not the observation of a closed mind, and the application of "other possible criteria" occurs more frequently in Mr. Greenberg's criticism than one expects from a writer so given to theoretical absolutes.

There is much discussion of poetry as well as of politics in these first two volumes of *The Collected Essays;* and fiction, philosophy, criticism, and even on one occasion the ballet—Anthony Tudor's *Dim Luster*—are likewise given some interesting attention. The forties was also a period in which Mr. Greenberg was much occupied with his translations of Kafka, and Volume 2 contains the first of his essays on Kafka, written in 1946. There is little question, I think, that Mr. Greenberg had both the resources and the sensibility to become a first-rate literary critic. But it was the art rather than the literature of his time that claimed his primary

1. See "A Critic on the Side of History: Notes on Clement Greenberg," in my book *The Age of the Avant-Garde* (New York, 1973).

allegiance, and it is, of course, as a chronicle of his art criticism that this new edition of his writings makes its principal claim on us.

During the period under review Mr. Greenberg was writing most regularly for *Partisan Review* and for *The Nation*. As Mr. O'Brian points out in his introduction to Volume 1, "His longer, justly celebrated essays were written primarily for *Partisan Preview*, while his shorter, until now mostly unrecovered articles, appeared mostly in *The Nation*." Read now in sequence, these articles give us an amazingly detailed, close-up view of the art life of the time—not only in their account of the new art that was being shown in New York for the first time, but also in their response to the work of the established masters.

In regard to the former—Mr. Greenberg's account of the new art of the forties—this new edition of his writings amply confirms his reputation as the preeminent critic of the New York School. In this first decade of its emergence he seems to have missed very little. As early as 1943 he wrote of David Smith: "Smith is thirty-six. If he is able to maintain the level set in the work he has already done . . . he has a chance of becoming one of the greatest of all American artists." About Jackson Pollock that same year he wrote: "Pollock has gone through the influences of Miró, Picasso, Mexican paintings, and what not, and has come out on the other side at the age of thirty-one, painting mostly with his own brush." About Robert Motherwell's first one-man show in 1944: ". . . he has already done enough to make it no exaggeration to say that the future of American painting depends on what he, Baziotes, Pollock, and only a comparatively few others do from now on." In 1945, on the occasion of Pollock's second one-man show: "the strongest painter of his generation and perhaps the greatest one to appear since Miró." And so on. It isn't at all the case that Mr. Greenberg was especially easy on the artists he admired, either. He could be severely critical—as he was, for example, with Arshile Gorky. Yet when Gorky's *The Calendars* was shown in the Whitney Annual in 1948, he did not hesitate to pronounce it "the best painting in the exhibition and one of the best pictures ever done by an American." That same year—"a remarkably good one for American art," as he noted—he spoke of Willem de Kooning as "one of the four or five most important painters in the country" on the basis of the artist's first one-man show. One could go on quoting from other reviews as well, and we are talking only about the period that ended in 1949—the terminal date of Volume 2.

The figure who looms behind a good many of these judgments—not in the sense of dictating them, for it was never a case of that, but by way of providing a reading of modern art that gave one the essential clues to its further development—is the painter and teacher Hans Hofmann, about whom there are fewer references in Mr. Greenberg's writing in this period than we might have expected. Hofmann is first mentioned in a footnote to "Avant-Garde and Kitsch" in 1939, but his own painting is not discussed until 1945, the year of his second one-man show in New York. When, on that occasion, Mr. Greenberg spoke of Hofmann as "a force to be reckoned with in the practice as well as in the interpretation of modern art," it was an acknowledgment of an influence that had already played an important role in the critic's thinking—an influence duly celebrated two years later in an essay written for *Horizon* on "The Present Prospects of American Painting and Sculpture":

> Hofmann will in the future, when the accomplishment of American
> painting in the last five and next twenty years is properly evaluated, be
> considered the most important figure in American art of the period
> since 1935 and one of the most influential forces in its entire history,
> not for his own work, but for the influence, enlightening and
> uncompromising, he exerts. . . . Hofmann's presence in New York has
> served to raise up a climate of taste among at least fifty people in
> America that cannot be matched for rigor and correctness in Paris or
> London.

Clearly the critic included himself among the beneficiaries of this influence, and so must we. It may even be that much that we still admire in Mr. Greenberg's writings about art in this period owes something to the fact that as Trotsky's influence—and the influence of Marxism generally—steadily waned, that of Hofmann's "formalist" reading of modern painting continued to cast its powerful spell.

It would be a mistake, however, to suggest that it is primarily as a sort of retrospective tip-sheet on the emerging eminences of the New York School that this critical chronicle is of interest now. What has kept Mr. Greenberg's criticism alive is the quality of the thought that he lavished not only on individual artists as he encountered their work for the first time but on the larger artistic and historical issues that their work was found to raise. In this collected edition of the criticism one can see more clearly than before how the famous longer essays—"The Decline of Cu-

bism," "The Crisis of the Easel Picture," "The New Sculpture," and "Our Period Style," all written in the years 1948–1949—grew out of the individual encounters with specific objects. However generalized, Mr. Greenberg's observations on individual artists, on art history, and on history itself may sometimes appear to be, they were always firmly anchored in concrete aesthetic experience. It is another of the strengths of *The Collected Essays* that it makes this internal connection between apodictic judgment and aesthetic actuality far more explicit than it has been hitherto. One may still want to quarrel with the judgment, but one knows better now on exactly what basis it has been arrived at.

Another large interest of these volumes is to be found in Mr. Greenberg's writings on European art, and specifically on the School of Paris. The forties was, of course, the decade in which the decline of Paris as the art capital of the West and the emergence of New York as its successor became an undeniable fact of international cultural life. In Mr. Greenberg's critical chronicle of this fateful decade we do not find a celebration of the decline of Paris—and still less, any gloating over it—but there is no denial of it, either. If anything, his discussion of it—which, characteristically, takes the form of discussing individual artists—is marked by a tone of deep regret. For the art produced in the heyday of the School of Paris remained for him, even in the forties, a touchstone of aesthetic quality. Again and again in these essays he makes it clear that for him Matisse still loomed as "the greatest master of the twentieth century"—a judgment that was by no means commonplace even in Paris in the forties—and Cubism remained, as he wrote in 1948, "the only vital style of our time, the one best able to convey contemporary feeling, and the only one capable of supporting a tradition which will survive into the future and form new artists." The intensely serious attention given as a matter of course to Picasso, Bonnard, Chagall, Leger, Braque, Miró, and other luminaries of the School of Paris is itself a reflection of the central place Mr. Greenberg continued to accord these artists. The welcome he gave to Dubuffet in the late forties, moreover, makes nonsense of any notion that his was a criticism in any way governed by chauvinistic bias.

In this respect, it should be said that the campaign lately mounted by certain Marxist historians to suggest that in the 1940s New York somehow contrived to "steal" modern art from Paris by means of a government-sponsored conspiracy will find nothing in *The Collected Essays* to support what is essentially an exercise in political paranoia (if not indeed

an attempt to repeal history itself). To Mr. Greenberg, as to many others at the time, it came "much to our own surprise," as he wrote in 1948, that "the main premises of Western art have at last migrated to the United States, along with the center of gravity of industrial production and political power." His complaint was that Americans were still so piously attached to the prestige of the School of Paris that they could not bring themselves to recognize what was going on in their own country—but this was an aesthetic judgment, not a political one. And the fact that Paris still loomed so large in the eyes of the New York art world, that art produced in Paris still held such unbroken sway over what dealers showed, critics wrote, collectors bought, and museums acquired—all this, too, makes nonsense of the charge that some secret conspiracy was at work to elevate New York at the expense of Paris. The plain truth is, Paris *did* suffer a decline so irreversible that it has not recovered to this day. It is, in any case, against the background of this abiding piety about art in Paris and its corollary—a general disinclination to believe in the importance of American art—that Mr. Greenberg's writings in the forties about both French and American art need to be read.

Finally, it is worth pointing out that there is much in these volumes on a variety of other subjects that remains of great interest. About the paintings of Arnold Friedman, an American artist only now—forty years after his death—being accorded anything like the recognition he deserves, Mr. Greenberg wrote beautifully and repeatedly. His obituary of Mondrian is still a very moving document:

> [Mondrian's] pictures, with their white grounds, straight black lines, and opposed rectangles of pure color, are no longer windows in the wall but islands radiating clarity, harmony, and grandeur—passion mastered and cooled, a difficult struggle resolved, unity imposed on diversity. Space outside them is transformed by their presence.

About Edward Hopper, too, an artist one hardly expected Mr. Greenberg to have much interest in, he had some *very* sharp things to say. Also about Max Beckmann. Reviewing an exhibition of the paintings Beckmann produced in Holland during the Second World War, Mr. Greenberg wrote in 1946 that there were five or six pictures in the show that "warrant calling Beckmann a great artist, even though he may not be a great painter." He then went to say of Beckmann:

He is certainly one of the last to handle the human figure and the portrait on the level of ambitious, original art. . . . The power of Beckmann's emotion, the tenacity with which he insists on the distortions that correspond most exactly to that emotion, the flattened, painterly vision he has of the world, and the unity this vision imposes—so realizing decorative design in spite of Beckmann's inability to think it through consciously—all this suffices to overcome his lack of technical "feel" and to translate his art to the heights.

On visual art other than painting and sculpture there are likewise some brilliant perceptions. Here is Mr. Greenberg on the photographs of Henri Cartier-Bresson:

> The unusual photographs of the French artist Henri Cartier-Bresson . . . provide an object lesson . . . in how photography can assimilate the discoveries of modern painting to itself without sacrificing its own essential virtues. One thing that painting since Manet has emphasized is that a picture has to have a "back." It cannot simply fade off in depth into nothingness; every square millimeter of picture space, even if it represents only the empty sky, must play a positive role. This, Cartier-Bresson, like his fellow-photographer Walker Evans, has learned preeminently. At the same time, unlike Edward Weston and the later Stieglitz, he has not forgotten that photography's great asset is its capacity to represent depth and volume, and that this capacity's primary function is to describe, convey, and make vivid the emotional "use-value" of beings and objects. It is to anecdotal content that Cartier-Bresson, rightly, subordinates design and technical finish.

He writes well on the cartoons of William Steig and David Low, too. Notwithstanding the great variety of subjects that is dealt with in this critical chronicle, we are seldom in any doubt that it is one subject, above all—the emergence of abstract art, which Mr. Greenberg described in 1944 as "one of the most epochal transformations in the history of art"—that lies at the center of *The Collected Essays.* In these first two volumes Mr. Greenberg's response to this "epochal" event, while generally positive and welcoming, remains fluid and analytical. He is fully aware of the aesthetic costs entailed in the triumph of abstraction, and not reluctant to talk about them. If he can already be said to be writing here as a "formalist" critic, he also shows himself to be open to, and

even enthusiastic about, a good deal that the formalist criticism of a later generation has shut its eyes to. What *The Collected Essays* of the forties makes abundantly evident, moreover, is that he is a bigger and more various writer than he has generally been thought to be. This being the case, the future volumes in this series will be keenly awaited.

[1987]

Clement Greenberg and the Cold War

No art critic of our time has been the subject of more discussion than Clement Greenberg, who was born in 1909 and published the bulk of his critical writings between 1939 and 1969. Yet the nature of that discussion has at times been so contentious, not to say acrimonious, that the effect has been to obscure the virtues that made this criticism loom so large—and for so long a time—in the minds of both his admirers and his adversaries. It seems to me unlikely that the publication now of two further volumes of Mr. Greenberg's *Collected Essays and Criticism* will do much to alter this situation. The academy, the museums, the media, the art journals, and a good deal of the intellectual press, not to mention foundations, corporate sponsors, and the cultural agencies of government, are now in the hands of apparatchiks who have a vested interest in defending both the kind of art and the kind of writing about art that Mr. Greenberg has famously deplored, and it is not to be expected that they will surrender their animus on the present occasion.

On the contrary, opposition is likely to be intensified, for the discussion of the issues raised in Mr. Greenberg's criticism is even more adamantly politicized today than it was in the days when he was still a regular contributor to critical opinion. In a culture now so largely dominated by ideologies of race, class, and gender, where the doctrines of multiculturalism and political correctness have consigned the concept of quality in art to the netherworld of invidious discrimination and all criticism tends to be judged according to its conformity to current political

orthodoxies, even to suggest—as Mr. Greenberg's writings invariably do—that aesthetic considerations be given priority in the evaluation of art is to invite the most categorical disapprobation.

So rapidly has the radicalization of critical opinion accelerated in the past decade that in the seven years that have elapsed since the publication of the first two volumes of *The Collected Essays and Criticism,* the editor in charge of this otherwise exemplary edition of Mr. Greenberg's writings—John O'Brian, now professor of art history at the University of British Columbia—has clearly felt obliged to abandon the politically neutral tone he brought to the presentation of the earlier volumes and to adopt a more belligerent voice for the later volumes. No doubt this is due, in part, to the shift that occurred in Mr. Greenberg's own political views over the course of his critical career, and in even larger part to Mr. O'Brian's disapproval of that shift.

In his early years as a critic, Mr. Greenberg was a Trotskyist—which is to say, an anti-Stalinist Marxist—yet by the end of the forties he had already described himself as an "ex- or disabused Marxist," and by the fifties he had joined the ranks of the anti-Communist liberals. (Mr. O'Brian prefers to call the position of the latter "Kantian anti-Communism.") From the perspective of the academic Marxists who came out of the sixties, this put Mr. Greenberg on the wrong side of the cold war, making him politically suspect if not actually retrograde, and it is more or less from that perspective that Mr. O'Brian has written his introduction to the last two volumes of *The Collected Essays and Criticism.*

Hence the tremendous emphasis that Mr. O'Brian places on the cold war as the principal influence on Mr. Greenberg's criticism in the fifties and sixties. The main charge is that an "acquiescence to the *Pax Americana* and its policies was accompanied by a corresponding shift in [Mr. Greenberg's] stance as a cultural critic." To support this charge, Mr. O'Brian dwells at some length on the long essay that Mr. Greenberg published in *Commentary* in 1953 under the title "The Plight of Our Culture," which is now reprinted in Volume 3. This is indeed an important essay that ought to be better known. It is not only the best response to T. S. Eliot's *Notes Towards the Definition of Culture* that I know of, but also one of the most cogent analyses of the problem of democratic culture any critic has given us in the last forty years. Unfortunately, it is one of the odd features of this new edition of Mr. Greenberg's writ-

ings that Mr. O'Brian has allowed his own political animus to distort its meaning. My guess is that he was so concerned to bring his reading of Mr. Greenberg's later criticism into line with the political views of his friend and colleague Serge Guilbaut, the author of *How New York Stole the Idea of Modern Art,* that he scarcely noticed the degree of misrepresentation that such an effort required.

"In 'The Plight of Our Culture,'" Mr. O'Brian writes, Mr. Greenberg "revoked his earlier criticism of mass-circulation magazines and their blurring of distinctions between high and low culture." It is also claimed that "Greenberg deduced that the newly dominant culture of the middle classes had the capacity to resist dilution and adulteration by mass culture as well as produce what he still most desired: . . . 'formal culture with its infinity of aspects, its luxuriance, its large comprehension.'" For Mr. O'Brian, then, "the transformation in Greenberg's thinking was an about-face," and "in the space of a couple of years, pessimism about the culture of modernity had given way to optimism" for purely political reasons. "Thus Greenberg's Cold War politics and cultural optimism merged," he writes, and this "ex- or disabused Marxist" is now said to have joined other New York intellectuals in believing that "democracy and capitalism . . . already were demonstrating what might be accomplished in the realm of middlebrow culture."

All of this suggests, of course, that "The Plight of Our Culture" is a rousing, politically inspired apology for middlebrow culture, and hence a retreat from Mr. Greenberg's vigorous defense of high culture in his classic essay "Avant-Garde and Kitsch," first published in 1939 and reprinted in Volume 1 of *The Collected Essays and Criticism.* Yet, in fact, "The Plight of Our Culture" is one of the most thoughtful and categorical indictments of middlebrow culture any American has ever given us. Far from representing an "about-face" on the imperatives of high culture, this very dour analysis of its fate under the pressures of democracy and capitalism puts a good deal of the blame for its problematic condition on the corrupting force of middlebrow culture. What does make "The Plight of Our Culture" different from "Avant-Garde and Kitsch" is its refusal to formulate its subject in orthodox Marxist terms (though Marxist thought still exerts a considerable influence on its analysis of culture) and its acknowledgment of the changes that had lately occurred in the relation of middlebrow culture

to high art.[1] Yet to characterize this examination of middlebrow cul-
ture as "optimistic" requires a suspension of attention to its most salient
points, if not indeed a flight of ideological fancy.

"The Plight of Our Culture" occupies some thirty pages in the new
edition of Mr. Greenberg's writings, and cannot therefore be summa-
rized in its totality. But here, anyway, are some of the relevant passages
from Mr. Greenberg's analysis of middlebrow culture:

> The liberal and fine arts of tradition, as well as its scholarship, have
> been "democratized"—simplified, streamlined, purged of whatever
> cannot be made easily accessible, and this in large measure by the same
> rationalizing, "processing," and "packaging" methods by which
> industrialism has already made lowbrow culture a distinctive product
> of itself. Almost all types of knowledge and almost all forms of art are
> stripped, digested, synopsized, "surveyed," or abridged. The result
> achieved in those who patronize this kind of capsulated culture is,
> perhaps, a respect for culture as such, and a kind of knowingness, but
> it has very little to do with higher culture as something lived.

1. Still, there was much in "Avant-Garde and Kitsch" that did not belong to Marxism,
and much, too, that is perfectly consistent with the view of high art to be found in "The
Plight of Our Culture" and all the later criticism. For example:

> . . . it is true that once the avant-garde had succeeded in "detaching" itself from so-
> ciety, it proceeded to turn around and repudiate revolutionary as well as bourgeois
> politics. The revolution was left inside society, a part of that welter of ideological
> struggle which art and poetry find so unpropitious as soon as it begins to involve
> those "precious" axiomatic beliefs upon which culture thus far has had to rest.
> Hence it developed that the true and most important function of the avant-garde
> was not to "experiment," but to find a path along which it would be possible to
> keep culture *moving* in the midst of ideological confusion and violence. Retiring
> from public life altogether, the avant-garde poet or artist sought to maintain the
> high level of his art by both narrowing and raising it to the expression of an absolute
> in which all relativities and contradictions would be either resolved or beside the
> point. "Art for art's sake" and "pure poetry" appear, and subject matter or content
> becomes something to be avoided like a plague.
>
> It has been in search of the absolute that the avant-garde has arrived at "abstract"
> or "nonobjective" art—and poetry, too. The avant-garde poet or artist tries in effect
> to imitate God by creating something valid solely in its own terms, in the way na-
> ture itself is valid, in the way a landscape—not its picture—is aesthetically valid;
> something given, increate, independent of meanings, similars or originals. Content
> is to be dissolved so completely into form that the work of art or literature cannot
> be reduced in whole or in part to anything not itself.

The middlebrow in us wants the treasures of civilization for himself, but the desire is without appetite. . . . A sense of continuity with the past, a continuity at least of truth, of enduring relevance, belongs to a genuine culture almost by definition, but this is precisely what the middlebrow does not acquire. . . . He might be able to do so, eventually, by exerting humility and patience, but these he is somehow never able to muster in the face of culture. In his reading, no matter how much he wants to edify himself, he will balk at anything that sends him to the dictionary or a reference book more than once. (Curiosity without energy or tenacity is a middlebrow trait wherever and in whomever it appears.) Towards his entertainment, no matter how much he wants it to be "significant" and "worthwhile," he will become recalcitrant if the "significance" is not labeled immediately and obviously, and if too many conditioned reflexes are left without appropriate stimuli. What the middlebrow, even more conspicuously than the lowbrow, wants most is to have his expectations filled exactly as he expects to have them filled.

Middlebrow culture, because of the way in which it is produced, consumed, and transmitted, reinforces everything else in our present civilization that promotes standardization and inhibits idiosyncrasy, temperament, and strong-mindedness; it functions as order and organization but without ordering or organizing. In principle, it cannot master and preserve fresh experience or express and form that which has not already been expressed and formed. Thus it fails, like lowbrow culture, to accomplish what is, perhaps, the most important task of culture for people who live in a changing, *historical* society: it cannot maintain continuity in the face of novelty, but must always forget and replace its own products.

As for the relation that obtains between high culture and middle-brow "standardization," Mr. Greenberg can hardly be said to take an optimistic view. "High culture, however—authentic, disinterested culture—has so far suffered more than it has gained in the process," he writes. And his characterization of popular culture doesn't offer much of a basis for optimism, either:

At the same time lowbrow, "machine," commercial culture is there everywhere to offer its relief to all those who find any sort of higher

culture too much of an effort—lowbrow culture being powerful not only because it is "easy" and still suits the majority, but also because it has replaced folk culture as the culture of *all* childhood, and thereby become our "natural," "autochthonous" culture. (And, unlike folk culture, lowbrow culture neither contributes—at least not fundamentally—to high culture nor effaces itself in its social presence.)

You may, if you like, call this optimism or an "about-face" or—what is really implied by the charge—cold war propaganda, but it sounds both pretty grim and pretty accurate to me, and not exactly a cheerleader's view of either capitalism or democracy.

It is also true that Mr. Greenberg acknowledges that "like lowbrow culture, middlebrow culture is not all of a piece," that "the good and the bad are mixed," and that middlebrow art "is not wholly adulteration and dilution." This, too, strikes me as true, at least for the time in which it was written, but not to offer much solace. Really, the only thing that Mr. Greenberg found to admire in "the middlebrow's respect for culture" was, as he wrote, that "it has worked to save the traditional facilities of culture—the printed word, the concert, lecture, museum, etc.—from that complete debauching which the movies, radio, and television have suffered under lowbrow and advertising culture." Yet anyone reading this passage in the 1990s must be aware of how much more has been surrendered by these "traditional facilities of culture" to the demands of lowbrow, popular culture over the last forty years. But even forty years ago, when our institutions of high culture had not yet sunk to their present levels, Mr. Greenberg's view of even this development was anything but rosy:

> But doesn't the damage still outweigh the gains [he asked], and can any amount of improvement at the lower levels compensate for deterioration at the highest, where the most authentic manifestations still have their being, where the forms and values of every other level originate—no matter how perverted subsequently—and where our experience is still most significantly and enduringly preserved?

As the passages I have quoted from "The Plight of Our Culture" attest, this is an essay that raises fundamental questions about the fate of high art in our society. They are the kinds of questions, moreover, that have acquired an even greater urgency today when the middlebrow culture described by Mr. Greenberg in 1953 has been largely gutted of

whatever virtues that could once be claimed for it and, for both political and commercial reasons, is now effectively supplanted by something much worse. (See, for an egregious example, Tina Brown's *New Yorker.*) For Mr. O'Brian to reduce these questions to a highly simplified scenario of cold war politics not only misrepresents the content of "The Plight of Our Culture" but renders it irrelevant to our current cultural concerns—which is, to say the least, a curious policy for the editor of these books to pursue.

What Mr. O'Brian clearly cannot forgive is that Mr. Greenberg had taken the anti-Communist side in the early stages of the cold war, and, as he writes, "remained committed to the Cold War agenda of the U.S. government." This is the "original sin" that for Mr. O'Brian has left an ineradicable taint upon everything that has been gathered in Volumes 3 and 4 of this *Collected Essays and Criticism,* right down to its last pages. For "in 1969," he writes, in what turns out to be the closing item in Volume 4, Mr. Greenberg "conducted a lengthy interview with Lily Leino for dissemination by the U.S. Information Agency, the umbrella organization for the Voice of America." I frankly rejoice that someone in the USIA bureaucracy had the brains to ask a writer of Mr. Greenberg's distinction to speak on the Voice of America broadcasts, but for Mr. O'Brian it remains a mark of the writer's contract with the Devil.

And what sort of thing was Mr. Greenberg broadcasting for the Voice of America in 1969? Recalling a period twenty-five years before, "when everybody was so sure that Americans couldn't produce art of any consequence—and that included Americans themselves," Mr. Greenberg was, among other things, complaining that

> a lot of inferior art is taken seriously all over the world. It's a paradoxical situation when someone like Rauschenberg—who's nowhere nearly as good as Eakins, Homer, Ryder, or the early John Sloan, or Milton Avery, not to mention Marin—is viewed a major figure because of the credit American art in general now enjoys in the world.

He also had some praise for Andrew Wyeth! But it was probably this sort of thing that Mr. O'Brian found particularly offensive:

> I've seen some contemporary Soviet art, and as far as I can tell, art in the Soviet Union is controlled by Philistines. The same appears to be

true in China and in every other place where Bolsheviks are in power. I call them Bolsheviks instead of Communists because I feel that that's more accurate, more specific. "Socialism" in backward countries means Bolshevism—Stalinism, if you want—and that means something barbaric, because "socialism" in a backward environment becomes, among other things, an aggressive expression of backwardness.

Some of us knew that all this was perfectly true when Mr. Greenberg made his broadcast in 1969, and now all the world knows it was true. Yet because he spoke the truth under U.S. government auspices, Mr. O'Brian apparently finds it tainted. That is indeed the triumph of ideology over veracity.

There is no question that the cold war played a significant role in shaping American cultural life in the decade and a half that followed the end of World War II, and that ex-radical intellectuals of Mr. Greenberg's generation made an important contribution to the formulation of that role. I said as much more than thirty years ago when Mr. Greenberg's first book of essays, *Art and Culture,* was published, and Mr. O'Brian accurately quotes me to that effect. "To understand *Art and Culture* is to understand a great deal about the artistic values that came out of the war and the Cold War years," I wrote in *Arts Magazine* in October 1962; "to question it is to question some of the salient achievements and aesthetic beliefs of those years."

What is so curious and distorting about Mr. O'Brian's characterization of Mr. Greenberg's role in this intellectual history is that he leaves the "salient achievements" of the cold war period—which means, in this context, the Abstract Expressionist movement—unquestioned while at the same time endeavoring to reduce the "aesthetic beliefs of those years" to a purely political scenario. It is in this respect as well as others that he reveals his loyalty to the radical politics of the sixties, with its anti-American paranoia, its sentimentalization of Marxist ideology, and its adamant refusal to acknowledge the moral superiority of American democracy over Soviet tyranny.

For what, after all, was the cold war about if not the conflict between American (and Western) democracy and Soviet tyranny? Mr. O'Brian is not, to be sure, one of those nut cases who attempt to demonstrate that the fame and influence of Jackson Pollock was the creation of Nelson Rockefeller and John Foster Dulles and that even Harry Truman had

somehow contrived to promote the interests of American abstract painting even while going through the motions of condemning it. He leaves the ideological dirty work to Serge Guilbaut and the cadres of radical art historians who have now succeeded in portraying the achievements of the New York School as nothing but a tainted product of America's role in the cold war. Yet what he has given us in a large part of his introduction to Volumes 3 and 4 of Mr. Greenberg's *Collected Essays and Criticism* is a somewhat more respectable and respectful version of the same ideological narrative.

There is no way to understand what in 1962 I spoke of as "the salient achievements and aesthetic beliefs" of the war and the cold war period without some acknowledgment of the lethal effects that Stalinist influence had on American art and culture in the 1930s. The Stalinist-inspired Popular Front culture of the thirties was, in all its essentials, an irredeemably philistine and middlebrow culture, and it laid upon the arts in this country a curse of mediocrity and sentimentality from which it did not begin to recover until the 1940s. (That is the reason why William Faulkner and Wallace Stevens were dismissed as reactionary eccentrics in the thirties while Grant Wood and Thomas Hart Benton were acclaimed as geniuses.) If there is a serious criticism to be made of Mr. Greenberg's essay "The Plight of Our Culture," it would have to do with his failure to acknowledge the extent to which the middlebrow culture of the forties and early fifties had been fashioned in the Popular Front culture of the thirties.

In its artistic and cultural interests, this was one of the things that Trotskyism set out to combat in the thirties, and it was out of that conflict that Mr. Greenberg wrote his essay "Avant-Garde and Kitsch" in 1939. But even stripped of its Stalinist distortions, the Marxism of the thirties proved to be a poor guide to what was actually happening in American art in the forties, and it is much to Mr. Greenberg's credit that he recognized the change for what it was. (By the same token, it is much to Mr. O'Brian's discredit that he still doesn't.) This was the political drama that was made manifest in virtually every area of postwar American cultural life. Whereas in the early plays of Arthur Miller, for example, you see the middlebrow sentimentalism of the Popular Front mind reenacted with a vengeance, in the criticism of Lionel Trilling you see the attempt to liberate literary and social thought from its corrupting influence. It is in that context that Clement Greenberg's criticism of the

fifties and sixties needs to be understood, and it is a sad commentary on the intellectual life of the 1990s that the editor of this fine edition of *The Collected Essays and Criticism* still doesn't get it. Hence his determination to reduce every aesthetic idea, if not aesthetics itself, to a suspect political datum.

[1993]

T. J. Clark and the Marxist
Critique of Modern Painting

The question is, finally: how could there be an effective political art? Is not the whole thing a chimera, a dream, incompatible with the basic conditions of artistic production in the nineteenth century—easel painting, privacy, isolation, the art market, the ideology of individualism? Could there be any such thing as revolutionary art until the means existed—briefly, abortively— to change those basic conditions: till 1919, when El Lissitzky puts up his propaganda poster outside a factory in Vitebsk; or 1918, in Berlin, when Richard Huelsenbeck has the opportunity, at last, to "make poetry with a gun in his hand"?
—T. J. Clark, in *The Absolute Bourgeois: Artists and Politics in France, 1848–1851*

"It turns out we are part of the superstructure," M. said to me in 1922, after our return from Georgia. Not long before, M. had written about the separation of culture from the State, but the Civil War had ended, and the young builders of the new State had begun—for the time being in theory only—to put everything in its proper place. It was then that culture was assigned to the superstructure.—Nadezhda Mandelstam, in *Hope Against Hope: A Memoir*

There are times when, owing to its larger ramifications, a single academic appointment at a leading university very quickly acquires the status of an historical event for those alert to its meaning. The appointment

of T. J. Clark as professor of art history at Harvard University in 1980 was for some observers an event of this kind. For what it signified was a decisive shift in the way the study of art history—and most particularly, of course, the history of modern painting, which is Professor Clark's academic specialty—would henceforth be pursued as an intellectual discipline at this venerable seat of learning.

In an earlier generation the Harvard art history department, together with its illustrious museum-training program at the Fogg Art Museum, had won a high reputation among the *cognoscenti* of the art world as a citadel of humanistic scholarship and aesthetic connoisseurship. There had indeed developed a distinctive Fogg tradition at Harvard. It was a tradition based, above all, on the close, comparative study of individual art objects, and one of its goals was to produce a certain kind of expert intelligence—aesthetic intelligence. In the perspective of this tradition, it was assumed that for the mastery of such intelligence the cultivation of sensibility—a sensibility for objects—was quite as essential as the acquisition of historical knowledge; that, in other words, aesthetic intelligence was virtually meaningless if separated from the disciplines of connoisseurship.

This, in any event, appears to have been the ideal that once governed the Fogg tradition at Harvard, and from the influence it exerted on the museums and the universities, on art collecting and on art scholarship, there can be no question that the art public in America had over the course of many years reaped some significant benefits. There are certainly more than a few masterpieces to be seen in our public collections today which owe their presence there—and thus their place in our experience—directly or indirectly to precisely the kind of connoisseurship that concentrates its principal interest on aesthetic quality. For this reason, the Fogg tradition may be accurately described, I think, as an example of cultural elitism that serves the public interest.

If there was also something to be said against the Fogg tradition—that it tended to be snobbish and clubby; that it was often condescending to outsiders, operating in the world of money, jobs, appointments, and preferments, as something of an old-boy network; and that it produced its full share of duffers who had all the appurtenances and pretensions of the connoisseur without any discernible trace of the sensibility or knowledge essential to the connoisseur's task—well, that too may be taken as a measure of how far the ideal often fell short of being

realized in an imperfect world. The ideal itself, however, was not only a noble one, but one that had the merit of addressing itself to something at once central and indispensable to our aesthetic experience.

By the time Professor Clark came to Harvard in 1980, this Fogg tradition was already on the wane. If its demise was not quite complete, its days were nonetheless clearly numbered. The cultural insurgency of the sixties had done its work at Harvard, no less than elsewhere in the academic world, and a new administration at the university was obviously prepared to welcome not only radical change but a change in the direction of an avowedly left-wing radicalism. Art history was by no means the only field in which this new direction made itself felt at Harvard. Its successful penetration of the law school faculty was sufficiently dramatic in its consequences to cause articles to be written about them in *The New Yorker,* the *New York Times,* and other publications. For those who understood what was happening to the study of art history at Harvard, the change represented by Professor Clark's appointment was seen straightaway to be no less fateful.

What this change entailed, moreover, could never have been in doubt. Harvard certainly knew what it was getting. Professor Clark, a British scholar trained at Cambridge University and the Courtauld Institute, had in 1973 published two works—*The Absolute Bourgeois: Artists and Politics in France, 1848–1851,* and *Image of the People: Gustave Courbet and the 1848 Revolution*—which spelled out his philosophy of art history in unmistakable terms. They had instantly established him as one of the most programmatic and plainspoken Marxist writers then concentrating on the field of nineteenth-century French art. The author of *The Absolute Bourgeois* and *Image of the People* was not one of your new-style, hermetic Marxists, given to employing an esoteric jargon and an impenetrable syntax. There was nothing arcane in Professor Clark's vocabulary and nothing obscure or ambiguous in his ideology. The opening chapter of *Image of the People* had been devoted to a disquisition "On the Social History of Art," which made the flagrantly political character of the inquiry altogether explicit; and lest there remain any lingering doubts on this score, Professor Clark wrote a new preface for inclusion in both volumes when these were reissued in paperback editions by the Princeton University Press in 1982.

In this preface he underscored the fact that both *Image of the People* and *The Absolute Bourgeois* "were written for the most part in the winter

of 1969–70, in what seemed then (and still seems) ignominious but unavoidable retreat from the political events of the previous six years. Those events haunt the books' best and worst pages, and provide throughout the main frame of reference for the history of a distant revolution and its cultural dimension." The main purpose of the preface was thus to provide a summary of what Professor Clark called "the books' chief problem"—which is to say, their principal political objective.

> So I owe it to the reader, confronting these relics of a slightly better time, [he wrote] to state again what I took to be the books' chief problem. They wished to establish what happened to art when it became involved, however tangentially, in a process of revolution and counter-revolution: in other words, when it lost its normal place in the machinery of social control and was obliged for a while to seek out other spaces for representation—other publics, other subjects, other idioms, other means of production. As my Jamesian title [The Absolute Bourgeois] was meant to imply, one could hardly have expected the story, in an order already irredeemably capitalist, to be other than one of failure to find such space. Bourgeois society is efficient at making all art its own. The conditions for a rendezvous between artistic practice and the only class which henceforth could produce and sustain alternative meanings to those of capital did not exist in 1850, and have only existed in botched and fragmentary form in the century since—against the grain of the Bolshevik Revolution, around the edges of the Workers' Councils in Berlin, Barcelona or Turin, and nowadays [1981] perhaps in the struggle of the Polish working class to reimpose soviet rule.

There is much that could be said about the outlook that is revealed in these observations. One notes, for example, the easy, unargued assumption that the primary "meanings" to be gleaned in a work of art are those which derive from the economic and political situation in which it is produced. Then, too, there is the implacable hatred of capitalism and its corollary detestation of the institutions of bourgeois society (except, perhaps, where appointments to the Harvard University faculty are concerned). There is the inevitable—for a Marxist—glorification of revolution, and the cynical—indeed sickening—reference to "the struggle of the Polish working class to reimpose soviet rule." From these and other attitudes so emphatically avowed in the preface to the new editions of

Image of the People and *The Absolute Bourgeois,* as well as in the books themselves, it will be evident that Professor Clark not only approaches the study of art history from the perspective of a doctrinaire Marxist, with everything this implies about the primacy given to politics in his entire intellectual enterprise, but that he wishes to be clearly understood to be doing just that. Somewhat less evident, perhaps, at least to the uninitiated, is what follows from this: that in the perspective of this politicized history of art, art itself is definitively consigned to what in classic Marxist parlance is called the "superstructure"—a subject to which we shall return in due course.

Now Professor Clark has given us a new book, his first since joining the Harvard faculty. It is called *The Painting of Modern Life,* and it bears the subtitle, "Paris in the Art of Manet and His Followers." Once again the ostensible subject is nineteenth-century French painting. The names of Manet, Monet, Pissarro, Degas, Seurat, and other artists of the Impressionist era appear frequently, and reproductions of their works, both in color and in black and white, adorn its pages. Yet it will come as no surprise to any reader acquainted with *Image of the People* and *The Absolute Bourgeois* to discover that the real focus of *The Painting of Modern Life* is not on the history of *art.* What interests Professor Clark is something else.

In this new book it is mainly, but not exclusively, the issue of *class.* In its fundamental concerns, *The Painting of Modern Life* is yet another contribution to the propagation of that mythic phenomenon which lies at the heart of the Marxist conception of history: class conflict. This is Professor Clark's real subject in this book. Everything else—certainly everything involving aesthetics—is placed in a subordinate relation to that subject. And while Professor Clark is shrewd enough not to insist on the fact that this is his principal subject in this book, he doesn't deny that it is, either. He even offers us some ruminations on the concept of class at the outset of the discussion, but at the same time cautioning the reader that these may appear to be "very general, not to say banal, propositions on the nature of society as such." He is anything but a fool. He knows exactly what he is doing. But he is also somewhat fearful—as he has every reason to be—of being seen to be an exponent of what he himself dismisses as "the worst pitfalls of vulgar Marxism." Rather than dwell on the "vulgar" concept of class conflict, then, he avails himself of the more sanitized and eminently more fashionable nomenclature of semi-

otics. Thus the new revised standard version is: "Society is a battlefield of representations." Behind this semiotic smokescreen, however, the same old Marxist scenarios remain firmly in place. Nothing has changed but the words.

The truth is, there are no instruments fine enough to measure the difference between the vulgar Marxism that Professor Clark professes to scorn and the particular variety of Marxist dialectics that governs every page of *The Painting of Modern Life.* In the one variety of Marxism, as in the other, neither the creation nor the experience of art is believed to enjoy the slightest degree of aesthetic independence from the iron laws of history. Everything in art is seen to be determined by the economic "base" and what are now called its "representations." As a result, art is simply—and sometimes very simply indeed—treated as a kind of epiphenomenon of the historical process, of interest mainly as a reflection of the depredations of bourgeois society and the strategies that have been devised to conceal or compensate for their outrageous moral consequences.

In keeping with this view, Professor Clark writes of Seurat's *La Grande Jatte* that "it attempts to find form for the appearance of class in capitalist society" and "that the forms it discovers are in some sense more truthful than most others produced at the time; and that it suggests ways in which class might still be painted." (There is thus an assumption here that "ways in which class might still be painted" is, or ought to be, an important item on the agenda of contemporary art today.) And just as "the intermingling of classes" is said to be "Seurat's subject," and hence the basis of his appeal for us, the real interest of Manet's *Olympia* is said to be "that class was the essence of Olympia's modernity and lay behind the great scandal she provoked." Of Manet's *La Musique aux Tuileries,* moreover, Professor Clark writes that it is "hardly a picture of modernity at all, as it is sometimes supposed to be, but, rather, a description of society's resilience in the face of empire." Class is thus assumed to be the key to every aspect of painting by Manet and his followers, and Professor Clark is sometimes quite cross with those painters whose work fails to support him on this point.

Much of *The Painting of Modern Life* is devoted not so much to painting itself as it is to the work of Baron Haussmann in redesigning and reconstructing the city of Paris in the nineteenth century and to the ways in which painters depicted the life of the city as the result of this work.

Professor Clark is very concerned about those artists who are deemed to have failed to grasp the real—which is to say, the class—meaning of this phenomenon. Monet and Renoir, for example, are among those who are given failing grades on this score.

> It should go without saying that this situation—Haussmann's work and its aftermath—[Professor Clark writes] presented painting with as many problems as opportunities. Naturally it offered occasions for a meretricious delight in the modern, or proposals in paint that the street henceforth would be a fine and dandy place. (I cannot see, for example, that Monet's two pictures of *Le Boulevard des Capucines* in 1873 do more than provide that kind of touristic entertainment, fleshed out with some low-level demonstrations of painterliness. Where Monet went, Renoir inevitably followed; his image *of the grands boulevards* in 1875 is untroubled by its subject's meanings, and not helped by this innocence.)

Now it needs to be pointed out, I think, that when Professor Clark writes the words *I cannot see* in this passage, he isn't kidding. He sees only what he wants to see, and he clearly cannot find anything worth looking at in a painting if it fails to denote signs of class distinction, or other evidence of social conflict, with the requisite degree of documentary explicitness. To the extent that he can be said to have an "eye" for anything in painting, it is an eye for "its subject's meanings." But these "meanings" are rarely, if ever, those determined by the painter. They are entirely predetermined by Professor Clark himself and his "method." Which is to say that he has eyes only for the meanings he has gone in search of, and no other meanings—least of all those which are known to have been of primary interest to the painter in question—have any reality for him.

As for the matter of how painters see their subjects, Professor Clark turns out to be a curious (and sometimes comical) guide. Consider, for example, the famous question of *flatness* in Manet's painting. Professor Clark does not deny, of course, that it is an issue in Manet, but he insists that it is not so much an aesthetic issue as an ideological and social one. Thus the very term is rejected in the discussion of *Olympia,* for it is deemed insufficient to account for the "circuit of signs" that is held to be responsible for the radical nature of the painting's subject. Yet in speaking of Manet's *Argenteuil, les cantiers,* flatness is accepted because it

is found to serve a documentary function in the painting. Taking note of "the unlikely construction of the black straw hat" in this picture, Professor Clark writes: "it has to be said . . . that Manet *found* flatness more than invented it; he saw it around him in the world he knew."

On the other hand, what Monet's eye—the most celebrated "eye" in Impressionist painting—found in the world *he* knew is judged to have little or nothing to do with visual observation and everything to do with the presuppositions of political ideology.

> There is a rule to these paintings [by Monet], and it might be stated roughly as follows [Professor Clark writes]: Industry can be recognized and represented, but not labour; the factories have to be kept still, as if that were the guarantee in an art which pretended to relish the fugitive and ephemeral above all else. Industry must not mean *work;* as long as that fictitious distinction was in evidence, a painting could include as much of the nineteenth century as it liked. The railway, for instance, was an ideal subject because its artifacts could so easily be imagined as self-propelled or self-sufficient. The train went discreetly through the snow. . . .

And so on. Nor was Monet's eye the only one to be governed primarily by social considerations of this sort. Why did Pissarro, at a crucial phase in his development as a painter, turn to the Neo-Impressionist methods of Seurat? Not, according to Professor Clark, for aesthetic reasons—which are never mentioned in this book. What prompted Pissarro's interest in Seurat's pictorial innovations was, it turns out, the burning issue of "leisure in class conflict." (Here the "battlefield of representations" is abandoned in favor of the more familiar Marxist terminology.) Of Neo-Impressionism Professor Clark writes:

> I do not believe that its vehemence (or its appeal to Pissarro) can be understood unless it is seen as deriving from an altered view of leisure, and of art as part of that leisure—which in turn derived from a new set of class allegiances.

I await with interest the monograph which either Professor Clark or one of his students must surely now be preparing for the purpose of tracing the relationship of every one of Pissarro's changes of style to the artist's shifting perception of "class allegiances" in the society of his day. Who knows? In the magical world of Marxist dialectics it might even be

disclosed to us that it is in this issue of *class* that the key to Pissarro's influence on Cézanne—and perhaps on Matisse, too—is finally to be found. No doubt all will be revealed to us in the fullness of time.

It would be unrewarding to dwell further on Professor Clark's treatment of particular artists or particular works of art in *The Painting of Modern Life*. The field of inquiry which it is the purpose of this book to explore and enlarge upon contributes nothing to our understanding of painting *as art*, and is not meant to. On the contrary, its purpose is to destroy—or, as we say nowadays, deconstruct—the very idea that art is in any sense an autonomous enterprise or that its highest achievements often add up to a good deal more than the sum of the social and material circumstances of its creation. (Also deconstructed in the process—and thrown, as it were, onto the ash heap of history—is the concept of aesthetic intelligence that once governed the Fogg tradition at Harvard.) There is a striking irony in this, of course. For in denying to art the spiritual freedom that it has sought for itself and very often achieved in the modern era—most notably, of course, in precisely those bourgeois capitalist societies which Marxist criticism is most eager to condemn—writers of this persuasion inevitably exhibit a kinship with the kind of reactionary and philistine taste which led so many benighted critics to condemn modernist art in the first place.

I wonder if it isn't, after all, a sense of this kinship that has prompted Professor Clark to devote so much of his intellectual energy, in this book as in his others, to disinterring a great many of the articles and reviews that attacked Manet and his contemporaries in their own day. Professor Clark's devotion to this "lost" critical literature, which he has culled from the annals of nineteenth-century French journalism, amounts at times to an obsession. He can hardly set down three consecutive paragraphs of his own prose without inserting into them some lengthy passage from an obscure review of the exhibitions in which Manet, Seurat, and others showed their work. Excerpts from this vast reservoir of critical writing, usually given in English in the main body of Professor Clark's text and in the original French in the voluminous notes, actually make up a sizable part of *The Painting of Modern Life*—by far the more valuable part, in my opinion. Professor Clark's real gifts are those of a researcher, not a critic. Documents, not art objects, are his forte—which is yet another reason, I suppose, why he is inclined to deal with art objects as if they, too, were little more than social documents.

Given his interest in nineteenth-century French art criticism, one rather regrets that Professor Clark hadn't settled for producing an anthology of critical writing along the lines of the collections given us in recent years by Elizabeth Gilmore Holt.[1] But of course it is not in the interest of his political scenario to do so. His quotations from French art criticism, like his "readings" of French paintings as sociological reports, are made to serve a purpose. Both are part of the indictment he has drawn up for the purpose of unmasking modernism itself as a failed revolutionary impulse. What is intolerable to a Marxist like Professor Clark is that modernist art, despite its many and famous conflicts with bourgeois society, has proved in the end to be an essential component of bourgeois culture, and accepted as such. For that reason alone modernism must now stand condemned as a coefficient of capitalism—than which, from a Marxist perspective, no worse crime in the realm of cultural life is conceivable. It must therefore now be discredited and deconstructed to make way for that future "rendezvous," as Professor Clark has called it, between artistic practice and "the only class"—the proletariat, of course—capable of ushering in a new golden age.

It is no wonder, really, that Professor Clark is haunted by the specter of "vulgar" Marxism. Some forty-one years ago, in the aftermath of the radical movement of the thirties, Arthur Koestler wrote an essay called "The Intelligentsia"—it was published in *Partisan Review* and then reprinted in *The Yogi and the Commissar*—in which he discussed the falsity of this Marxist mode of historical analysis. He spoke of "the fatal short cut [taken by Marx and Engels] from Economy to 'Superstructure': that is, culture, art, mass-psychology"—a shortcut that has been endlessly retraced by Marx's intellectual heirs ever since. "Marxian society," Koestler wrote, "has a basement—production, and an attic—intellectual production; the staircase and the lifts are missing." Koestler went on to point out that "it is not as simple as that: the triumphant class creating its own philosophic superstructure to fit its mode of production like a tailored suit." Now despite everything that has happened in the last four decades, and despite the new terminology that is invoked to give this famous "short cut" a new currency, this image of a basement and an attic

1. Holt's two major works on the history of art in nineteenth-century Europe are *The Triumph of Art for the Public* (New York, 1979) and *The Art of All Nations* (New York, 1981).

with the staircase and the lifts missing is, as it happens, a very accurate description of the historical method employed by Professor Clark in the writing of *The Painting of Modern Life*. For much of this book, he rummages around in the basement of nineteenth-century French society, retracing and reinterpreting events in the economic life of the period. To make his ascent from this basement of "production" to the attic, where the form of "intellectual production" called painting is to be found, he is obliged to avail himself of that magic carpet he calls historical materialism. No wonder, then, that when he arrives at his destination he has some difficulty discovering—to use Koestler's other image—a "tailored suit" that entirely pleases him. History is not, after all, a fertile field for the discovery of miracles.

The question to be asked about *The Painting of Modern Life,* and indeed about Professor Clark's entire intellectual enterprise, is: Why? Why now? What accounts for its governing animus, which is a profound and unappeasable hostility to modernist art, and why has it won such a favorable response both inside the academy and out? In attempting to answer such questions, it is no longer sufficient to say that a phenomenon like Professor Clark is part of the price we continue to pay for the political upheavals of the sixties. This is true as far as it goes—it is indeed the basic truth of the historical situation in which we find ourselves today— but it does not entirely account for the place which this Marxist critique of modern painting now occupies in contemporary cultural life or for its reception among people who believe themselves to be interested in art, people who believe art to be vitally important to their lives.

The answer, I think, lies in the sense of keen disappointment—a disappointment that amounts at times to a feeling of rage—among people of a generally liberal and leftist outlook over recent changes in our relation to the achievements of modern art. Brought up to believe that the essence of the modern movement was to be found in its *révolté* impulses, that in some sense modernism *was* revolutionary in its ultimate goals as well as in its technical and expressive innovations, these people feel betrayed by their discovery—which history has now made all but unavoidable—that they were mistaken, or at least misinformed, about the thing they loved so much and placed so high a value on.

Modernism not only did *not* turn out to be, as they were for so long led to assume it was, coextensive with the impulses of political revolutionism, but was in some respects deeply hostile to those impulses and

incompatible with them. Modernism really did turn out to be an essen-
tial component of bourgeois culture. And to this fact of history, which
they now recognize *as* a fact of history, they cannot reconcile themselves.
It leaves them bereft of a sense of cultural purpose. Never mind that
these disappointed acolytes are the same people, for the most part, whose
embrace of modernism has confirmed its central place in bourgeois cul-
tural life. Such paradoxes of history do little to assuage the bitterness of
their disappointment. They were brought up, after all, to believe that they
could have the cake of revolution and eat it too, and now that they have
discovered otherwise there is no consoling them. Their grief is great, and
it has disposed them to welcome any and all attempts to discredit the
achievements of the very thing in which they once placed their fondest
hopes.

There remain, of course, for the people I speak of, certain sacred mo-
ments in the history of modern art that are exempt from the general
condemnation. The Russian avant-garde in the early years of the Bol-
shevik Revolution, the German Dadaists in the upheaval of the First
World War and the German revolution—these, above all, have not lost
their luster. For true believers in the doctrine that modernism must
remain synonymous with revolutionism if it is not to be despised and re-
jected, these remain the exemplary episodes in the history of artistic pro-
duction (as they call it). Hence the loving references to these episodes in
Professor Clark's writing. (Hence, too, the whole program of a critical
journal like *October,* by the way, which draws its name and indeed its
Weltanschauung from a similar reading of history.) Hence, above all, the
need to discredit the idea of *aesthetic* achievement in art and replace it
with scenarios claiming to represent an authentic *social* history of art.

Professor Clark is only one exemplar of this movement which has
made such headway in the academy and the art journals (including such
eminently bourgeois journals as *Art in America* and *Artforum)* in recent
years, and Harvard's is by no means the only department of art history
to have felt its influence. Yet precisely because Harvard for so long rep-
resented a philosophy of art that has now been made a special object of
ideological deconstruction, T. J. Clark's appointment to that faculty has
inevitably acquired a significance that reverberates far beyond the groves
of academe.

[1985]

Rembrandt as Warhol: Svetlana Alpers's "Enterprise"

From time to time we are given a new book that so vividly illuminates the intellectual ground we stand on that it instantly acquires the status of an emblematic event. As far as the study of art history is concerned— and more particularly, what has gone wrong with it—I believe we have now been given such a book in Professor Svetlana Alpers's *Rembrandt's Enterprise: The Studio and the Market.* Professor Alpers is one of the leading representatives of the kind of art history that now dominates the profession, and is widely recognized as an academic eminence of considerable power and influence. Occupying a senior position on the art history faculty at the University of California at Berkeley, she is the author of an earlier and much-praised study of seventeenth-century Dutch painting, *The Art of Describing* (1983), and serves as an editor of two academic journals, *Representations* and *The Raritan Review.* She is also, I believe, an adviser to the Getty operations that now play such a conspicuous role in the funding of art historical research. She has been a fellow of the Center for Advanced Study in the Behavioral Sciences at Stanford, a fellow at the Institute for Advanced Study in Princeton, and the recipient of numerous other fellowships and awards. *Rembrandt's Enterprise* is itself based on the Mary Flexner Lectures delivered at Bryn Mawr College in 1985—though, as we shall see, it was the more academic rather than the political parts of the book that were mainly vouchsafed to the audience at Bryn Mawr.

Clearly, we have in Professor Alpers one of the brightest stars now traversing the academic firmament. This makes it all the more imperative

that we understand the nature of *her* enterprise, which I believe to be a wholly destructive one. To understand what she has set out to accomplish in this book, it is essential, however, that we have some sense of the intellectual situation of which *Rembrandt's Enterprise* is so important an expression. Only then will it be possible to see why her book is indeed an emblematic event—emblematic, that is, of the catastrophe that has overtaken not only the study of art history but much else that we prize in the life of the mind.

Is it an exaggeration to speak of a catastrophe in these matters? I think not. For it is one of the truly horrifying characteristics of the present age that so many of its most gifted scholars and intellectuals—especially in the fields of art history and literary study—are nowadays almost exclusively engaged in systematic and politically inspired demolition projects. In this respect they differ so greatly from even the most critical and contentious of their predecessors as to constitute a separate profession. To say that they no longer belong to the tradition of humanistic study is hardly sufficient to describe what it is they are actually doing, for it is precisely this humanistic tradition and its accomplishments that all their intellectual energies are mobilized to "deconstruct"—which is to say, destroy. They may, perforce, still feel themselves obliged—as Professor Alpers does in her study of Rembrandt—to lavish attention upon the achievements which this tradition has elevated to a position of the highest esteem; but if so, it is only for the purpose of nullifying that esteem and placing those accomplishments in question.

It needs to be emphasized that there is much more involved in this phenomenon than a mere revision of received opinion. The greatest scholarship, like the greatest criticism, has always had a revisionist effect upon our thinking, for new research and new ideas in any field of study are bound sooner or later to dislodge established beliefs, topple entrenched intellectual authority, and introduce new interpretations and judgments. It is one of the purposes of new knowledge, after all, to alter our understanding, and it is all the more to be welcomed when it puts us more deeply in touch with the spirit as well as the substance of the objects of our study.

The academic projects I speak of, however, are different in purpose and in spirit from the scholarship and criticism of the past. It is the unmistakable goal of this new learning (as I suppose it must be called) not to bring us a deeper appreciation of the achievements of the past but, on

the contrary, to discredit them in some fundamental way and thereby render the whole idea of achievement—in art or in anything else having to do with aesthetic or moral distinction—highly suspect if not indeed completely fraudulent.

Projects of this kind may take a variety of forms—or, as they say in the academy, may employ a variety of methodologies—but fundamental to all of them is the attempt to make the study of art a branch of the social sciences. By effecting this change of intellectual venue, these scholars hope (as they see it) to demystify their subject, strip it of its claims to any sort of aesthetic or spiritual achievement, and thus reduce it to a level where it is no longer to be differentiated from any other form of material culture. The very idea that a work of art may be thought to transcend the material conditions of its creation is an anathema to this new learning, which is rigidly deterministic in its entire outlook on art and life. The particular mode of determinism deemed most appropriate to the subject under study will *vary*, of course, according to the special ideological goals to which the study is tethered. The feminists and "gender" specialists will naturally favor a purely biological determinism; the Marxists (of whatever stripe) will similarly favor a purely economic or "class" determinism; and so on, as the emergence of sundry hybrid or crossover ideologies prompts the creation of ever new methodological instruments. But the fundamental goal remains the same: art must be categorically removed from the realm of aesthetics and placed firmly in a realm where the only legitimate questions are those that can be asked about the material—which is to say, the political and economic—conditions of its production.

In the field of art history, this movement—in which Professor Alpers plays a major role—now commands the greatest academic prestige and the greatest academic patronage. Books by its leading practitioners and their many acolytes flow from the presses—especially the university presses—in ever greater numbers, and academic appointments are governed by its followers with a degree of control that old-time union leaders would have every reason to envy. The movement's hegemony—to borrow the atrocious term that is so often on the lips of its representatives—is becoming so nearly complete that newcomers to the field can no longer hope to have much of a career in art history if they are so rash as to register their dissent from its fundamental premises. Young art historians—and many who are no longer young—now face the choice of joining the herd or

seeking employment elsewhere (meaning, of course, outside the academy). Under the circumstances, it is no exaggeration at all to speak of a catastrophe.

It is one of Professor Alpers's distinctions as a writer to make this fateful turn in the outlook of art history—and indeed, in the whole notion of what art is—sound at times as if it were a weighty and even disinterested enterprise. Less obviously strident than many of her political colleagues and often more diligent in her research, she is remarkably adept at mimicking the tone of the old-style scholar when it serves her purpose, and thus at giving us the impression—at first glance, anyway— that there is nothing of the vulgar ideologue to be found in her arduous historical labors. The learned references accumulate with the requisite density, and there is even a show of civility (of a sort) toward one or another of her illustrious predecessors. Writing, for example, about Julius Held's assertion that Rembrandt's is "the work of a man who never compromised, who never permitted himself to be burdened with a chain of honor, and fiercely maintained both the integrity of his art and his freedom as a man," Professor Alpers observes (characteristically) that "this is not wrong, but the terms which are brought together here are unexamined." What she means is that they are not sufficiently political, and she then hastens to apply her own, more explicitly political terms to the question at issue here, which is Rembrandt's "individualism" and which is said in her account, not surprisingly, to be "a function of the economic system in which he lived."

Rembrandt's Enterprise is not a long book. The text consists of only 122 pages divided into four chapters, and there are 32 pages of notes. But it sometimes reads like a long book while one is trying—especially in the first three chapters—to figure out exactly where it is going and to what purpose. The observation I have quoted about Rembrandt's individualism, for instance, does not turn up until page 114, in Chapter IV, which is entitled "Freedom, Art, and Money"; and by that time, of course, we know where we stand—or rather, where Professor Alpers has been standing from the beginning. (The reference to Rembrandt as a man who "loved only three things: his freedom, art, and money," comes from J. B. Descamps's *La Vie des Peintres Flamandes, Allemands et Hollandois,* published in Paris in the eighteenth century.) But in the first three chapters of *Rembrandt's Enterprise,* though they are not without some in-

teresting observations on the life of art in Rembrandt's time and on his own working methods, the gravamen of the argument is often elusive. As one makes one's way through the twists and turns of these first three chapters, one more and more has the sense of an indictment being drawn up, and while there is never any question in one's mind that the culprit—namely Rembrandt—will be found guilty, the crime with which he is to be charged nonetheless remains obscure for pages at a time. It is only in Chapter IV that it is openly stated. Interestingly, it was this Chapter IV, which contains the substance of Professor Alpers's political charge, that was omitted from the Mary Flexner Lectures at Bryn Mawr. Which leads one to wonder what it was that the students in the audience at Bryn Mawr understood Professor Alpers to be talking about.

It must be said, too, that as a writer Professor Alpers has an extremely irritating habit of setting out to make a point, or at least of inducing the illusion that a point is about to be established by means of all the learned references that are set before us with such a showy display of erudition, and then, without the point ever really being made, of looking back on what she has been saying as if an irrefutable conclusion had been reached. This rhetorical strategy, if it can be called that, has the effect of rendering a good deal of the scholarship in the book either completely redundant or simply pedantic. Certainly much of it, though not without interest, proves to be irrelevant to her principal theme. But as we don't know for certain what the principal theme is until we get to that crucial fourth chapter, we are left to savor the erudition for its own sake— which is harmless, I suppose, even though it suggests that Professor Alpers is not primarily a thinker at all but a pedant who is dependent upon ideology for the substance of whatever thought she wishes to convey. It is, in any case, only when she comes to make an ideological point that her writing acquires an unmistakable clarity.

What, then, is the charge that Professor Alpers is so concerned to make in this book? What, in fact, is Rembrandt's "enterprise" claimed to have been?

The very word *Enterprise* in the book's title alerts us, of course, to the fact that we are to regard Rembrandt as first and foremost an entrepreneur, and the book's subtitle, *The Studio and the Market,* underscores the extent to which we are being invited on this occasion to consider Rembrandt's art primarily as a business. But there is more to Professor Alpers's

charge than a mere description of the artist's role in marketing his pictures. She would certainly not want to be seen as one of those "vulgar" Marxists who see nothing in an artist's work but its economic function—although, in fact, when one has penetrated Professor Alpers's new-style academic jargon (Rembrandt's studio is described as "enabling," etc.) and waded through the 258 footnotes, it is quite apparent that her argument turns out to be far more dependent upon such crude Marxist formulations than she could ever bring herself to acknowledge.

It is in the very last paragraph of Chapter III that Professor Alpers gives us a first, brief, tantalizing glimpse of the case she means to bring against the artist she is writing about. (How frustrating it must have been for the Bryn Mawr audience to have the Mary Flexner Lectures conclude on a note that, in truth, marks their real beginning!) Writing in this chapter about *The Jewish Bride,* long considered one of Rembrandt's greatest works, she takes up the matter of the "universality" that has been traditionally attributed to so many of the artist's greatest works, and sets about the task of deconstructing the term. It isn't a true universality that can be claimed for *The Jewish Bride,* according to Professor Alpers, but only an *"effect* of universality" (her emphasis), and she then explains how this artificial "effect" is achieved:

> He makes a portrait more than a portrait *by* elevating the genre. [This, by the way, is not said in admiration.] But this *effect* of universality is achieved by masking or hiding the economic and social basis of the transaction between the painter and his sitters.

The suggestion of "individuality" in Rembrandt's subjects is likewise said to be something "imposed on them" by the "master's domination" of them. "One might say," she writes, "that rather than serving [his patrons], Rembrandt exercises his authority over them," and since we all know that for writers like Professor Alpers authority is always to be considered a very bad thing, this too figures in the indictment. Thus she concludes Chapter III with the following analysis:

> The nineteenth century credited Rembrandt with being uniquely in touch with something true about the individual human state. I would put it differently. It was something stranger and more unsettling. Rembrandt was not the discoverer, but one of the inventors of that individual state. And so his late works became a touchstone for what

western culture, from his day until our own, has taken as the irreducible uniqueness of the individual.[1]

When we turn to Chapter IV of *Rembrandt's Enterprise,* we are bluntly informed that Rembrandt was "a man of the market," and this is intended to mean something more than the mere fact that he sold his paintings for money. And it is not meant to mean anything good, of course. The fact that Rembrandt achieved both a personal and artistic freedom by means of the market is taken by Professor Alpers to be crucial to the indictment she draws up against him.

> He had a "propensity to truck, barter and exchange," in Adam Smith's famous phrase [writes Professor Alpers], and to make works suitable to such transactions. As a master in the studio he made himself a free individual, not beholden to patrons. But he was beholden instead to the market—or more specifically to the identification that he made between two representations of value, art and money.

In Professor Alpers's view, the market economy provided Rembrandt with his "models or definitions of self and art," and the market itself is said to have marked "the establishment of a system of representation." (It is at this point in the argument that Professor Alpers effects a marriage of sorts between the crude Marxist formulations that lie at the heart of her analysis and the familiar twaddle of poststructuralist academic jargon.) Since it was from the market that Rembrandt is alleged to have derived his "models or definitions of self and art," and the market was itself "a system of representation," it is no longer a mystery as to where Professor Alpers's argument is going. "Rembrandt was also a maker of representations," she writes, "hence the appropriateness of his making art into a commodity to be exchanged in a marketplace so perceived." And then, just in case we are in danger of missing the point, she writes: "One can say of this artist what Adam Smith said of mankind, 'Every man thus lives by exchanging or becomes in some measure a merchant.'" The next paragraph begins: "Let us consider Rembrandt's paintings as commodities . . ."

1. One notes with interest the lower-case "w" in this reference to "western" culture. Are we to take this as Professor Alpers's contribution to the current debate over the place to be accorded to courses in Western civilization in the liberal arts curriculum? It would seem so.

But what was it that Rembrandt was actually selling in the market—besides his paintings, that is? He was selling what Professor Alpers is fond of calling "the individuality 'effect,'" and this is said to be "a function of the economic system in which [Rembrandt] lived and in which he played such an active part." There then follows this remarkable passage:

> It was in Rembrandt's time that the individual came to be defined in what were then new, economic terms. Those familiar words from the American declaration of human rights, "life, liberty, and the pursuit of happiness," are a reworking of Locke's "life, liberty and estate" which constituted his definition of property: "By Property I must be understood ... to mean that Property which Men have in their Persons as well as Goods." On this view, to be an individual is defined by the right to property. And the most essential property right of each man, and hence the grounding of this notion of the individual, curious though it might sound put in this form, is the right to property in one's own person. Freedom, then, is defined as proprietorship in and of one's own person and capacities. It is the proprietorial quality of this notion of the individual to which I wish to call attention. It was Rembrandt who made this the center of his art—the center, even, of Art.

In reading this passage, it is important to understand—it does, admittedly, take some effort—that Professor Alpers is not lavishing any praise on either Rembrandt or liberty or the concept of the individual. Far from it. She is concerned to unmask the true nature of Rembrandt's enterprise. And what was that? Well, he stands charged with having commodified *himself* by virtue of having painted and marketed his own self-portraits. On page 118 we are finally given Professor Alpers's definitive judgment on the great self-portraits: "Rembrandt was an entrepreneur of the self."

All through the reading and rereading of this last, ghastly chapter of *Rembrandt's Enterprise,* I was overcome with a sense of having read it, or something very like it, before. It is a feeling one often has in reading the "new" art historians, and the new literary scholars, too. No matter what their subject, and no matter how "original" their treatment of it, there is a political scenario that tends to repeat itself over and over again, endlessly striking the same notes and leading to the same conclusions. In the case of *Rembrandt's Enterprise,* however, it wasn't of another art historian that (I came to realize) I was being reminded. It was of that eminent

Marxist literary theorist and academic, Professor Fredric Jameson. At the risk of depressing the readers of this article even more than I already have, I want to quote the relevant passage from Professor Jameson's essay on "Postmodernism and Consumer Society"—which, as a matter of fact, I have quoted once before in *The New Criterion*[2] but which I must return to once again because it explains so much about the nature of Professor Alpers's enterprise.

> The great modernisms [Professor Jameson wrote] were . . . predicated on the invention of a personal, private style, as unmistakable as your fingerprint, as incomparable as your own body. But this means that the modernist aesthetic is in some way organically linked to the conception of a unique self and private identity, a unique personality and individuality, which can be expected to generate its own unique vision of the world and to forge its own unique, unmistakable style.
>
> Yet today [we] . . . are all exploring the notion that that kind of individualism and personal identity is a thing of the past; that the old individual or individualist subject is "dead"; and that one might even describe the concept of the unique individual and the theoretical basis of individualism as ideological. There are in fact two positions on all this, one of which is more radical than the other. The first one is content to say: yes, once upon a time, in the classic age of competitive capitalism, in the heyday of the nuclear family and the emergence of the bourgeoisie as the hegemonic social class, there was such a thing as individualism, as individual subjects. But today, in the age of corporate capitalism, of the so-called organization man, of bureaucracies in business as well as in the state, of demographic explosion—today, that older bourgeois individual subject no longer exists.
>
> Then there is a second position, the more radical of the two, what one might call the poststructuralist position. It adds: not only is the bourgeois individual subject a thing of the past, it is also a myth; it *never* really existed in the first place; there have never been autonomous subjects of that type. Rather, this construct is merely a philosophical and cultural mystification which sought to persuade people that they "had" individual subjects and possessed this unique personal identity.

2. See "Modernism and Its Enemies" in *The New Criterion*, March 1986.

Professor Alpers does not tell us which of these "positions" she is espousing in *Rembrandt's Enterprise*. I suspect it is the first—but then it hardly matters. The point is, it is this political interpretation of the concept of the individual and of Rembrandt's role in fostering it that *Rembrandt's Enterprise* is really about. This, anyway, is its manifest subject. But I think the book is also to be taken as a political allegory about the relation of art to life in our time as well. Indeed, the more one thinks about *Rembrandt's Enterprise,* the more Professor Alpers's "Rembrandt" comes to resemble an artist like Andy Warhol, the most successful "entrepreneur of the self" in the art of our own era. Rembrandt as Warhol: such is the fate of even the greatest art when it is so categorically removed from the realm of aesthetics and made to do duty as just another counter in the dialectic of material culture. Such, too, is the dismal fate of art history when the study of art is no longer its primary concern.

[*1988*]

III
Modernism and After

ESSAYS

Richard Serra at MOMA

The Richard Serra exhibition which has come to the Museum of Modern Art this spring is an event bound to disturb—perhaps even infuriate—a great many more people than it pleases. In this respect, as in others, the exhibition is completely faithful to the spirit of Mr. Serra's work, which from the outset of his career—some twenty years ago—has been conceived of as a series of provocations. Yet it would be a mistake, I think, to allow this posture of provocation to set the terms of our response to the sculpture which we encounter in the MOMA exhibition. It would also, alas, be a mistake to discount it entirely. For the element of provocation is an integral part of Mr. Serra's artistic program. It would therefore be absurd to ignore it.

The problem, in Mr. Serra's case, is to determine exactly what *artistic* role the artist's posture of provocation plays in the creation of his sculpture. This is not an easy task, however, for the artist himself has done much to obscure the issue, and his many "activist" champions—no doubt taking their warrant from the artist's own attitudes and then raising the ante, so to speak, in their own political interests—have done even more. We need to be reminded, then, that it is as an *artist*—and not as something else—that Mr. Serra's primary claim on our attention rests. To see what that claim really amounts to, it is therefore essential that we separate the art from the artist's reputation. And this, in turn, means that on the occasion of the present exhibition at MOMA, we must separate the art from the texts describing it in the catalogue accompanying the show—texts which MOMA itself, in an extraordinary disclaimer, has all but disavowed but which it has obviously deemed politic to publish without interference.

There is no mystery, of course, as to how this unusual situation, in which the museum finds itself publicly at odds with its own publication, has come about. The museum had apparently intended for some time to devote an exhibition to Mr. Serra's work. Before much headway could be made in that endeavor, however, Mr. Serra suddenly emerged as a figure of considerable controversy. The large outdoor sculpture called *Tilted Arc,* which he created for the plaza of the Jacob K. Javits Federal Building in lower Manhattan on a commission from the General Services Administration, became the focus of a fierce debate. A great many people who work in the Javits building—people who have to live with the sculpture every working day—strongly objected to it. (The sculpture consists of a Cor-Ten steel wall, measuring 120 feet in length and 12 feet in height, which bisects the building's plaza.) This led to a hearing on the suitability of the work. As a result of the hearing, a decision was made to order the removal of *Tilted Arc* to another site, and this prompted further debate. (It did not cause the work to be removed, by the way. At this writing, it remains in place.) Naturally, given the current climate of opinion, the whole episode made of Mr. Serra something of an artist-hero and, owing to the fact that *Tilted Arc* was a government commission, something of a political martyr as well.

As I have elsewhere given my opinion on this work and the controversy surrounding it, I do not propose to go into the matter again in any detail here.[1] Suffice to say that I was not one of those who succumbed to the charms of *Tilted Arc,* nor was I persuaded that the decision to order its removal from the Javits plaza constituted a crime against art, society, or anything else. On the contrary, it seems to me that there are legitimate reasons for objecting to the work and that the entire controversy has done much to illuminate the deeply problematic nature of the project that has come to be called public art—a vast and expensive program upon which the government embarked with a great deal of naiveté and a woeful paucity of serious thought about its implications or indeed its essential purposes.

What is of more direct concern here, however, is the role that the *Tilted Arc* affair has played in the presentation of the MOMA exhibition. By its very nature, of course, *Tilted Arc* could not be included in the ex-

1. See "Art Since the War: Who Will Write Its History?" in *The New Criterion,* Summer 1985, pp. 7–8.

hibition. There is, to be sure, a photograph of the work in the show, as there are of the artist's many other immense public sculptures both here and abroad. But photographs are not sculpture, and the photographs in question are in many cases extremely misleading. This is certainly the case with the photograph of *Tilted Arc.* It does not in any sense suggest what it is actually like to experience the sculpture *in situ,* which is what the controversy is really about. *Tilted Arc* is by no means the only work photographically misrepresented in this way in the MOMA show. A sculpture I very much admire—the construction called *Carnegie,* which was erected last fall outside the entrance of the Museum of Art at the Carnegie Institute in Pittsburgh—is similarly misrepresented by an aerial view of a kind which is vouchsafed to almost no one but the birds (and professional photographers seeking bird's-eye views). We can hardly be surprised, then, that it is one of these aesthetically sanitized photographs of *Tilted Arc* that adorns the cover of the MOMA publication, which is not really a catalogue of the exhibition but a propaganda offering wholly devoted to exalting Mr. Serra in his role as artist-hero and political martyr.

The question which therefore most urgently needs to be asked about the sculpture of Richard Serra at this juncture is this: What is it we are left with when all the controversy and role-playing is put aside? With this question in mind, the MOMA exhibition turns out to be an event of exceptional artistic interest. By no means is everything in the exhibition an unqualified artistic success, in my opinion. But there is much that is. And there can be no question, I think, that Mr. Serra has taken sculpture in a direction that is new, however much his work may owe to the ideas of his contemporaries. What is original in his work may not always be to our liking, perhaps—but it nonetheless leaves the art of sculpture significantly altered.

Every artist is shaped to one degree or another by his moment of entry into the art scene, and Mr. Serra has proved to be no exception to the rule. His moment of entry came in the turmoil of the sixties, and in his work there are still to be discerned some of the characteristic forms of that period and some of its characteristic attitudes, too (not all of which found their way directly into art at the time). Much of the new art of that period—especially the new abstract art—was not only highly formalistic in spirit but cool and impersonal in feeling. Elementary shapes—geometric or at least straight-edged—predominated, and

in sculpture there was a distinct preference for outsize scale and for an industrial or fabricated look in the finish of the work. Such were the established characteristics of Minimal sculpture when Mr. Serra arrived on the scene in the sixties, and he very quickly made them his own. Minimalism became the "tradition" to which he attached himself.

To this tradition, however, was added something else: the notion that both the process by means of which the sculpture is executed and the specific space in which it is created must henceforth be regarded not merely as the circumstantial conditions of the work's realization but as essential, defining aspects of its artistic existence. Hence the emergence of so-called process art and site-specific sculpture, in both of which Mr. Serra played a much publicized role.

Not all of the influences that shaped Mr. Serra's outlook in the sixties were strictly aesthetic, of course. There was also the *révolté* ethos of the counterculture, which called for a programmatic resistance to whatever could then be regarded as established social practice. The innovations inherent in both process art and site-specific sculpture were born of this spirit of resistance, but in themselves they proved to be feeble as well as temporary challenges to the artistic status quo—and no challenge whatever to the established social order. With few exceptions, they were easily assimilated into the patronage system they were ostensibly designed to challenge, and have remained a permanent feature of an expanded art world ever since. What began as a radical attack on established artistic conventions was very quickly embraced as a new artistic orthodoxy. Which is why a "radical" artist like Mr. Serra could so swiftly become the darling of cultural bureaucrats, bourgeois collectors, and highly placed academics throughout the Western world. It was not that he had failed to produce something new, but that within a decade of his debut he was clearly seen to be taking sculpture in a direction which, although new and in some respects startling, was nonetheless consistent with what prior modernist practice had prepared the way for.

I have already observed that Minimalism was the tradition to which Mr. Serra attached himself at the outset of his career, and he remains very much a Minimalist sculptor today—but a Minimalist with a difference. To the purely formalistic attributes of Minimalism he has added something odd and unexpected—an element of dread, or what might even be called fear, which I do not recall ever before encountering in a sculptural work in quite the same way. In much of Minimalist sculpture, no matter

how elephantine the scale of the work may be, the highly simplified forms together with their impersonal surfaces and rigorously logical structures tend to have a rather benign, if not indeed a sedative, effect on any reasonably knowledgeable spectator. Just about the last thing in the world we expect to experience in the presence of these works is a sensation of dread. Far from posing either a physical or theoretical threat to our existence, Minimalist sculpture tends for the most part to relax the spirit and offer us the visual equivalent of nirvana—which is to say, deliverance from all sense of pain, anxiety, or trauma.

This is distinctly not the case with many of the steel constructions we encounter in the Serra exhibition at MOMA. For one thing, these sculptures occupy the museum's spaces with an authority that is all but indistinguishable from a certain mode of aggression. Their outsize forms tend either to impede or direct our movements in or around them; to take an interest in these works is, to some extent, to surrender to their scale, which is not so much a human scale as a scale designed to diminish our sense of autonomy and volition. I speak particularly of the room-size constructions which, by means of immense steel slabs, divide space in such a way as to hold us captive, direct our vision, and control our movements as a condition of seeing the work at all. I cannot speak for others, of course, but I doubt if I am the only spectator to find the experience of such works vaguely threatening. Enclosed in the vaultlike spaces that the sculptor has created, one naturally wonders—not continuously, but from time to time—what would happen if one of these weighty steel members were suddenly to topple. Or rather, one doesn't wonder—one knows for certain that in such an event one would be crushed to death. Of course nothing does topple. Everything remains securely in place, and one is free to explore the work in perfect safety. And yet the implied threat is there—and it persists in remaining a constituent element in the experience of seeing Mr. Serra's work for as long as one lingers in its presence. Even with the constructions that one cannot enter—which are roped off from the viewer and which we therefore see from a space we do not share with the work itself—the delicate balances sustained by the huge steel plates give the impression of a precariousness that reinforces this sense of an implied threat and thus surrounds us with an atmosphere of dread.

I at least know of nothing quite like this in the history of sculpture. As Dr. Johnson famously said of the prospect of hanging, it is an

experience that concentrates the mind. We leave this exhibition with a *very* vivid sense of having seen something and felt something we have never seen or felt before, and the memory of it is not soon dissipated. It remains fixed and unforgettable. Whether we like it or not—whether, indeed, we are meant to like it—is another question, and I *very* much doubt if this question of our "liking" the work is of compelling interest to Mr. Serra. I rather think he would believe he had failed in his mission if we were found to like it too quickly. (Which, if true, must make his current popularity among cultural bureaucrats something of a problem for him.) His *primary* aim (I gather) is to affect and manipulate our response, to impose a certain control on our perceptions, and thus to shatter our complacency in the face of the art experience, and in this he certainly succeeds. The marriage of Minimalist form and existential dread turns out to be a potent combination.

I note with interest, by the way, that neither of the two sculptures that MOMA has acquired for its permanent collection—*Cutting Device: Base Plate Measure* (1969), which is the first work we see on entering the exhibition, and *Modern Garden Arc* (1986), which reposes in the museum's elegant sculpture garden—can be said to generate this sense of dread. They belong to Mr. Serra's more purely formalistic works. Which is entirely understandable. Vastly more space would be required for one of Mr. Serra's room-size constructions than MOMA has, or will ever have, available in its permanent collection. And there are probably other reasons why the museum has settled for what is, in truth, only a token representation of the artist's work in its permanent collection. Mr. Serra is not, after all, primarily a museum artist. As that wall of photographs documenting Mr. Serra's many public commissions reminds us, his major works have mainly been created for large outdoor sites, and I very much doubt if MOMA is ever going to turn over its beautiful garden to something akin to the *Tilted Arc*. Were it ever to do so, the uproar likely to ensue would make the whole controversy that has raged over the commission for the Javits plaza look like a pastoral idyll.

Instead of this unpleasant and indeed unthinkable prospect, the museum has turned over its book on Richard Serra to two authors—Rosalind E. Krauss and Douglas Crimp, co-editor and managing editor, respectively, of *October* magazine—who, for the most part, completely ignore the exhibition that MOMA has mounted on this occasion and offer the museum's public absolutely nothing in the way of an intelligible

guide to the artist's work. In the customary *October* manner, the one gives us a poststructuralist disquisition of insurmountable opacity while the other rides his political hobbyhorse for a replay of the *Tilted Arc* melodrama, grandly announcing that we have now, as a result of this controversy, witnessed "the redefinition of the site of the work of art as the site of political struggle." No wonder, then, that William Rubin, the director of the museum's Department of Painting and Sculpture, felt obliged in his preface to this publication to declare that "The Museum of Modern Art disagrees with the rhetorical tone and historical polemic of much that has been written about *Tilted Arc* here as elsewhere." We can assume that Mr. Serra got the publication he wanted and that getting it was one of the conditions he laid down for agreeing to this exhibition. That is the way it usually goes nowadays with artist-heroes, especially those honored few who have also been elevated to the status of political martyrs. They get everything they ask for. But the fact remains that this MOMA exhibition is itself in no sense a "site of political struggle," nor is Mr. Serra himself of any outstanding interest as a political figure. He *is* of great interest as a sculptor, however, and it is a pity that an institution of MOMA's stature could not bring itself to offer its public even a hint about what the real nature of that interest might be. Its abject surrender in this matter has surely set a precedent it will live to regret, for the next time around the ante will be raised to a degree guaranteed to be even more unpleasant than anything the museum might have faced on this occasion.

[1986]

The Death of Andy Warhol

The death of Andy Warhol was bound to be a media event, and so it was. For the media, after all, it was like a death in the family. Here was a figure who was famous for being famous, for knowing the famous, and for serving as an avatar of fame, and nothing so pleases the media as an opportunity to celebrate one of their own creations. The front-page obituary in the *New York Times,* the special segment on the MacNeil-Lehrer News Hour, the cover story in *New York* magazine, not to mention the many pictures and news stories in the daily tabloids and on the network news programs—the coverage could hardly have been better (or worse) if Warhol himself had orchestrated it. Which, in a sense, he had. The most distinguishing characteristic of this prodigious outpouring of commentary, homage, and celebrity worship was the way it confined itself to the terms that Warhol himself had set for the discussion of his life and work. Even writers who, on other occasions, find it appropriate to apply more elevated standards to art (and life) proved ready and eager to suspend them in discussing Warhol and his significance. It was as if no language but Warhol's own—the language of hype—could be expected to have any meaning when it came to explaining just what it was that made him important.

All the same, it is my impression that Warhol's death caused some of these volunteer laureates of hype and celebrity a good deal of uneasiness. Suddenly they were on the spot. They couldn't in good conscience bring themselves to say that Warhol had been a great artist, even though they had often written about him as if he were. They couldn't, in many cases, even bring themselves to explain why he should be considered an im-

portant artist, even though they had long taken it for granted that he was. No one is under oath, of course, in writing obituary notices. Even so, there was a general tendency on this occasion to take refuge in the subject's fame, in his personality, in his business affairs and his entourage, even his wig, and leave the art more or less unexamined. Amid the expected encomiums, there was in fact a discernible hedge and wariness to be observed in the claims advanced for Warhol's artistic achievement. It turned out that almost no one could bring any conviction to the task of specifying what that achievement had consisted of.

The truth is, even among his friends and admirers it was widely recognized—even if seldom admitted—that, although being an artist was essential to his social position, Warhol was far more important as a social phenomenon than he ever was or could be *as* an artist. That was what gave him his special aura, after all—and his influence. *As* an artist he ended his career exactly as he began it—as a gifted *commercial* artist with a flair for the arresting graphic image and skillful layout. He was never much of a painter, and as a sculptor he didn't exist. (As for his movies, it is probably enough to observe that, having served their purpose—which was to propagate the Warhol myth—they had long ago predeceased their creator. Of aesthetic merit they had none whatever.) Warhol's "genius" (if it can be called that) consisted of his shrewdness in parlaying this essentially commercial talent into a career in an art world that no longer had the moral stamina to resist it: a career that would have been unthinkable, for example, ten years earlier.

To an extent that was unrivaled among his contemporaries in the Pop Art movement, if only because they knew so much less than he did about the dynamics of the fashion world, Warhol understood that something momentous had happened to the art scene in the late fifties—that the relation which had formerly obtained between art and fashion (and hence between art and publicity, and between art and money) had undergone a decisive change. Which is to say that he understood the success of Robert Rauschenberg and Jasper Johns better than they did. (Not that they were slow to catch on—but that is another story.) Their success owed much to the international acclaim that Abstract Expressionism, having passed through its avant-garde phase, was receiving for the first time and to their putative role as both the heirs and the rebels of that movement. Warhol understood that something else was involved; that with the success of Rauschenberg and Johns, the age of the avant-garde had drawn to a close.

Their success had been, initially, an art-world success, but it quickly developed into a much larger phenomenon. A *boundary* separating art and fashion had been breached, and never again would the really big successes of the art world be confined to that world. Henceforth success in that art world would be played on a much larger stage.

Rauschenberg and Johns came out of the school of Marcel Duchamp. They stood in relation to Abstract Expressionism very much as Duchamp had stood to Cubism—as plenipotentiaries to the world of publicity and chic, agents of "advanced" styles that offered just the right dash of scandal (the stuffed goat, the paint-splattered bed, the targets and flags, etc.) to excite a taste that had wearied of the rigors of abstract art. Warhol, on the other hand, belonged to the school of Condé Nast, where such "scandals" are recognized as marketable commodities and routinely processed as the materials of fashion. In moving from a career in fashion illustration to a career in this swiftly expanding art world, Warhol saw that the product needed only the most superficial modification to win attention and garner rewards—rewards far greater than any to be found in the realm of fashion illustration. Art, no matter how debased, still offered a kind of status that was denied to advertising, but otherwise there were now fewer and fewer differences separating the art world from the advertising world. The ethos was getting to be essentially the same. Success was the goal, the media would provide the means of achieving it, and what the media loved more than anything else—certainly more than art—was a product based on their own stock-in-trade. And that, from his "Marilyns" to his "Maos," is what Warhol mainly specialized in giving them. Considering the magnitude of his accomplishment in this respect, it would be churlish to deny that he did indeed have genius of a sort. No ordinary talent could have done it—but the talent, alas, was not primarily an artistic talent.

As everyone knows, the art world never really recovered from this fateful incursion. As a movement Pop Art came and went in a flash, but it was the kind of flash that left everything changed. The art public was now a different public—larger, to be sure, but less serious, less introspective, less willing or able to distinguish between achievement and its trashy simulacrum. Moreover, everything connected with the life of art—everything, anyway, that might have been expected to offer some resistance to this wholesale vulgarization and demoralization—was now

cheapened and corrupted. The museums began their rapid descent into show biz and the retail trade. Their exhibitions were now mounted like Broadway shows, complete with set designers and lighting consultants, and their directors pressed into service as hucksters, promoting their wares in radio and television spots and selling their facilities for cocktail parties and other entertainments, while their so-called education programs likewise degenerated into sundry forms of entertainment and promotion. The critics were co-opted, the art magazines commercialized, and the academy, which had once taken a certain pride in remaining aloof from the blandishments of the cultural marketplace, now proved eager to join the crowd—for there was no longer any standard in the name of which a sellout could be rejected. When the boundary separating art and fashion was breached, so was the dividing line between high art and popular culture, and upon all those institutions and professions which had been painstakingly created to preserve high art from the corruptions of popular culture. The effect was devastating. Some surrendered their standards with greater alacrity than others, but the drift was unmistakable and all in the same direction—and the momentum has only accelerated with the passage of time.

There was no more telling symbol of this surrender of standards than Warhol himself, the cheerful nihilist who became the unlikely culture hero of a new era. Anyone who was around at the time will remember exactly when it was that we were given our first taste of its lethal character. It came, of course, in the early sixties with the false dawn and specious glamour of the Kennedy administration—the media-fabricated glamour that in retrospect has turned out to be the perfect political analogue for what was occurring on the cultural scene. There is an important book to be written about the cultural fallout of the Kennedy years, and Warhol's would by no means be the only significant career that would require a place in the story. So, among many others, would Norman Mailer's and Arthur Schlesinger, Jr.'s and George Plimpton's, and so too, in their own spheres, would the history of *New York, The New Yorker,* and the *New York Review of Books,* not to mention less exalted branches of the media. Still, in any such study a special place would have to be reserved for the Warhol phenomenon, which gave to the art world—but not to the art world alone—a model that has proved to be so irresistible that it is now a permanent, and permanently disabling, component of

cultural life. It was really that ghastly model, rather than the man or his art, that the media celebrated so copiously in their obituary notices of Andy Warhol—a model that continues to exhibit a potency his art could never achieve.

[1987]

How Good Was Gauguin?

I. *The Gauguin Myth in the Age of Media Hype*

The process by means of which certain artists—certain modern artists particularly—attain a mythical status that transcends all aesthetic considerations is one that is so familiar to us that we hardly any longer pay it much attention. It is now taken for granted as one of the facts of modern cultural life. This does not mean that the myths themselves have lost their power to influence our thinking about art, but precisely the contrary. Both the myths and the process of mythmaking are now so firmly established in our consciousness that they continue to exert an influence even when the effort is made to discount their effect and rid our minds of their disfiguring fictions.

Yet it is only on a certain kind of artist that such a mythic status can be conferred. Great achievement in art is not itself a sufficient condition; at times, indeed, it is not even a necessary condition. It is life, not art, that confers the status I speak of, and not just any life, of course, but one in which an extreme degree of nonconformity or suffering or violence or saintliness or promiscuity or sheer human oddity is seen to be inseparable from the artistic vocation itself. Matisse, who was probably the greatest painter of the twentieth century, was never a suitable candidate for the role—too bourgeois in appearance, for one thing—whereas it fit Picasso to such a degree that he came finally to see his own life entirely in its terms. Cézanne, with his banker father and uneventful love life, was never a candidate either, though he was a greater painter than either Van Gogh or Gauguin, who now stand for us as the very archetypes of the mythic artist.

It was the writers of popular fiction who transformed the lives of Van Gogh and Gauguin into these archetypes, thereby changing forever—even for those who resist the fictionalization—the way their art would enter our lives. As the protagonists first of widely read novels— *Lust for Life* and *The Moon and Sixpence*—and then of the trashy movies based on them, these two painters acquired an aura that has lent itself to an ever increasing vulgarization with each passing decade. Moreover, it is this vulgarization and not their intrinsic artistic merits that has so greatly transformed the market value of their pictures. Now not even the art museums can any longer be counted upon to act as a bulwark against such a sweeping distortion of artistic values.

It is certainly owing to this mythic aura and the vulgarization it has brought in its wake that it has lately proved to be so easy to divide the short, tragic career of Van Gogh into a series of isolated agons, each of which could be packaged as a separate, highly promotable exhibition melodrama. And since it is now the tendency of the museums to market the materials of high art, wherever possible, as if they belonged to the realm of popular culture, we can probably expect to see even worse things in the future. Thanks, for example, to Mrs. Huffington's ghastly biography of Picasso, who can doubt that we shall soon see this artist accorded the ultimate degradation—a television docudrama mini-series certain to be the purest and most lurid soap opera.

Because of all this, it was with a certain feeling of dread that some of us greeted the announcement of a major Gauguin exhibition—a show destined to be mounted on the blockbuster scale—and there was nothing about the initial promotional atmosphere surrounding the announcement to allay our worst expectations. At a posh press luncheon in New York months in advance of the actual opening of the exhibition in Washington, the featured speaker—the one who caused, and was expected to cause, the biggest stir—wasn't a scholar or connoisseur who could shed new light on an artist already so familiar to us, though such experts were briefly heard from, but a movie actor, Donald Sutherland, who had been invited (hired?) to explain to the company assembled at Le Cirque—writers, publicists, museum officials, and AT&T executives (the sponsors)—what it had felt like to *play* Gauguin.

In the event, Mr. Sutherland conducted himself with exemplary dignity and tact, but the quality of the actor's presentation, however admirable, is not the point, of course. It was his presence on such a program

that struck entirely the wrong note—wrong because it was the responsibility of the art museums organizing the Gauguin retrospective not only to place their primary emphasis on the artist's aesthetic achievement but to make every effort to separate his name and his work from the kind of vulgarization that had already done so much to distort the nature of that achievement. By choosing instead to exploit the Gauguin myth at the very outset of their campaign to win maximum media attention for this exhibition, the museums made yet another contribution to undermining the standards that it is their primary function to uphold.

Was it even necessary for the museums to make this obeisance to crass commercial interests? Certainly not as far as the public was concerned. It is my impression, anyway, that nothing in the world—nothing short of a total news blackout, that is—could nowadays have kept a major Gauguin retrospective from being one of the most popular exhibitions of our time. The likelihood is that it was not the public but the sponsor of the exhibition—in this case, AT&T—who needed, or at least wanted, this approach in order to be certain that *its* costly role in the event would receive the requisite visibility. None of us is so naive as to believe that corporate sponsorship of art exhibitions—or any other cultural programs, for that matter—is ever entirely cost-free. But too little attention, I think, is given to what the actual cost might be both to the cultural institutions which receive the funding and to the public which is supposed to be the primary beneficiary of the sponsor's largess. In the case of public television, for example, we have seen the whole idea of a "noncommercial" medium give way to one in which it is now taken for granted that commercial messages—and sometimes quite elaborate ones—will now be the norm. We seem, alas, to be moving in that direction in the museum world, too. Hence the featured presence of Donald Sutherland at a press lunch for a Gauguin exhibition, for in the advertising business making use of show-business celebrities to plug a company name has long been a standard practice. For museums to lend themselves to this practice is not a happy augury.

II. *Separating the Art from the Legend of the Artist*

When we turn to the actual exhibition—the largest, apparently, ever to be devoted to the artist's work—we are reminded, alas, that it was Gauguin himself who was the first to set this process of mythification in

motion, and this makes the task of separating the art from the legend of the artist at once more difficult and more imperative. As Françoise Cachin writes in her splendid essay for the catalogue of the exhibition: "The hero of his own history, [Gauguin] also saw himself as the hero of painting of his age, which seemed to him decadent." It is important to keep this notion of the decadence of the age firmly in mind in thinking about Gauguin, for it is one of the keys to the artist's desperation as well as to his achievement.

It can be said, of course, that every great modern painter has seen himself as "the hero of painting in his age, which [seems] to him decadent," and to the extent that this is true, Gauguin was certainly one of the principal figures who created this role for the modern artist. It is a role, moreover, that manifests itself *in the work* as well as in the legend. For the pressure to make every painting—every drawing and print and sculpture, too—count as a radical revelation; the horror of backsliding into something merely familiar and already accomplished; the sense of engaging in a fierce competition not only with one's contemporaries but also with one's predecessors and one's posterity; above all, the determination to make of art something absolute and ideal, something from which all the chaff of common experience and conventional feeling has been once and for all time expunged, leaving only the purest aesthetic essence, or what Gauguin himself often called "the abstract," to be experienced in the created object: in all this we are made to feel not only the harrowing and all but impossible nature of the task that the artist set for himself but the role that each fresh assault on the creative enterprise was obligated to play in bringing that task to a triumphant realization.

Not every attempt at the task succeeded, to be sure—not in Gauguin's case nor in anyone else's; but the unremitting pressure is there, all the same, even in the paintings that aren't exactly masterpieces, the paintings that remind us, over and over again, that with Gauguin the will to *be* a certain kind of artist was at times even more important than either talent or vision in enabling him to accomplish what he did. In the work of almost no other modern painter of comparable stature, indeed, are we made to feel so emphatically or so often the presence of the artist's will in determining the momentum of his development, the audacity of his ideas, and the quality of even his greatest pictures. This, too, was a matter in which Gauguin served as a model for the future.

It is this sense we so often have in Gauguin of the creation of art as an act of will that leaves us wondering, even in the face of his greatest achievements, if there wasn't, after all, something rootless and self-determined and artificial in what this renegade from bourgeois life set out to accomplish. Of course it was in the nature of the Symbolist aesthetic that Gauguin so passionately espoused to embrace artifice and indirection as the instruments of revelation, and he was in this respect completely faithful to the spirit of Rimbaud and Mallarmé. Yet this impulse to accord to the artist's will a kind of sacred priority cost Gauguin something as a painter. It is only in an exhibition on this scale that we can see how much remained *un*developed and *un*resolved in his work—that we can see the profusion of ideas that were never pursued and the array of possibilities never explored. There are paintings here—and they tend to come earlier rather than later, from the *Quarry in the Vicinity of Pontoise* (1882) to *Fatata te mouà* (1892)—out of which other painters, and I mean other great painters, might have made entire careers (and in some cases actually did). That fear of lapsing into the kind of decadence he most despised won for Gauguin his many artistic victories, but did he entirely escape the shadow of the decadence he so greatly dreaded? As a painter, I don't think he did. Which is why, I suppose, that in the end painting alone could not satisfy his aspiration. The last paintings of Gauguin are by no means his best or most original work: that is another lesson of this vast exhibition. In the end he had to turn to words—and to the kind of printed images that are much akin to words—to make his final avowals. The sheer exertion of will could no longer make the art of painting its most direct or satisfactory instrument.

Still, Gauguin emerges from this exhibition as a greater painter than some of us, at least, had thought him to be in the past. He was not what I would call a natural painter. He never commanded the kind of fluency we find in Pissarro and Monet and Degas and Picasso and Matisse. He could take nothing for granted, and there was never anything relaxed or easy in his work—not even in the Impressionist pictures, which sometimes have the character of a lesson to be mastered, a test to be met before he could be released to pursue a vision of his own. He is also an artist who tends to look better and stronger when seen, as he is in this retrospective, in isolation and on a great scale than he usually does in the company of his contemporaries. While his ideas were sometimes profound and even prophetic, his art—dare one say it?—was sometimes

shallow, aesthetically shallow in a way that Cézanne's, for example, never was. All of which makes Gauguin an odd kind of classic—an artist who can never quite be relied upon to be great, but who was great often enough to make his place among the masters a persuasive proposition if not always an absolute conviction.

Is it finally possible to separate the art from the legend of the artist? I am not sure that it is. For Gauguin will always remain the painter laureate of all those members of the middle class, wherever they may be, who harbor the illusion that what is "primitive" or distant or alien— whether it is found in faraway islands and what is now called the Third World or in the underclass of our own society or in our own most cherished fantasies—is somehow more real and certainly less decadent than the common realities of bourgeois life. That this standard of the real is, in the end, itself an illusion does nothing to diminish its appeal, and while that appeal persists Gauguin will remain its poet.

[1988]

John Szarkowski's "History of Photographic Pictures"

A picture has been said to be something between a thing and a thought.—Samuel Palmer

Of the many things to be noted about the book and the exhibition that John Szarkowski has produced for the Museum of Modern Art under the title *Photography Until Now,* the first is this: the book is without doubt one of the best ever written on its subject, which is the history of photography, and the exhibition is one of the most beautiful that the museum has devoted to the medium. Neither is without significant flaws, to be sure, but given the scale of Mr. Szarkowski's project—which encompasses the prehistory of photographic thought, going back to Leonardo, as well as a century and a half of actual photographic production—such flaws as it has are not, for the most part, unduly disfiguring.

At least this is true as far as the historical material is concerned. When it comes to the contemporary pictures, however, the exhibition goes into something of a nosedive. While certain reasons for this conspicuous drop in aesthetic quality can be adduced from the way Mr. Szarkowski treats this period in his book—he speaks, for example, of a sense of "a diminished role for photography, even a kind of disenfranchisement"—what it comes down to, I think, is the same pattern of decline that has lately been discernible elsewhere in the visual arts.

That we are now in a fallow period in the visual arts, if not indeed a period of decadence, is not something that the curatorial mind can

generally be expected to acknowledge. Yet Mr. Szarkowski comes remarkably close to doing just this when, in the concluding chapter of his book, he says of contemporary photographers that "As with poets and composers, the relationship between their work and their lives has become casual and improvisatory"; and further, that the time has now passed when photographers could really believe that "they had a privileged access to truth and thus to power." Beside such doleful pronouncements, the claim that "a score or more of photographers are now doing work of vitality and original beauty, under conditions that do not seem propitious" sounds a little hollow, and the exhibition doesn't do much to support the claim, either.

It is, in any case, for its splendid account of what Mr. Szarkowski calls the "history of photographic pictures," rather than for its inventory or assessment of current accomplishment, that *Photography Until Now* commands our admiration. Yet it is important to make a distinction here between the book and the exhibition. About the book, Mr. Szarkowski writes that he has "attempted . . . to sketch out a history of photographic pictures, organized according to patterns of technological change." This interpretation of technological change is broad enough to encompass, as he notes, "not only . . . the chemical and optical issues often thought of as constituting photographic craft, but . . . methods of distribution of photographic imagery, economic constraints, and professional structures."

What this means, in effect, is that Mr. Szarkowski has written a social history of photography, and—in my view—a very good one. The exhibition, on the other hand, although divided into sections that conform to the organization of this social history, is more the work of a connoisseur of photographic art than of a social historian. This accounts for the remarkably high level of quality that is sustained throughout most of the historical sections of the exhibition. Where this high level collapses into something else, we can usually feel the intervention of the social historian who cannot resist the temptation to document a development that, whatever its other claims to our attention, is devoid of aesthetic interest. It is only in the interest of social history, for instance, that items such as a population chart from a New York newspaper in the year 1900 or a layout devoted to Mussolini in a 1934 issue of the London *Weekly Illustrated* have found their way into the company of so many photographic masterpieces.

It is, moreover, the connoisseur rather than the social historian who is responsible for the brilliant installation of the exhibition. Mr. Szarkowski has always had a keen sense of what might be called the dramaturgy of a large photographic exhibition, which in the wrong hands—and with the wrong eyes—can so rapidly degenerate into either an exercise in tedium or a riot of showy effects. In this exhibition he is very adroit at striking a balance between familiar and unfamiliar pictures in a way that illuminates both. He is very good at rhyming pictures that belong together and, where needed, coming up with striking juxtapositions that refresh the eye, foil expectation, and offer instruction as well as pleasure. Mercifully, there is no tendency here to treat the installation as, primarily, a problem in layout design, and thus to treat pictures as mere visual counters in some larger design strategy. In most cases the exact pictorial weight of a photograph is carefully calculated and given the space and the company that are appropriate to its character and its scale.

Again, this connoisseur's delicacy (if one may call it that) tends to break down in the contemporary section of the exhibition, but there it is often a case of trying to make bricks without the requisite straw. Pictures such as Robert Rauschenberg's, Andy Warhol's, and Cindy Sherman's are so fraudulent and crass in the use they make of the photographic medium that their sheer vulgarity is bound to capsize whatever company they are made to keep. The historical part of the show is not without its own episodes of misplaced emphasis—Mr. Szarkowski seems, for example, to have acquired a sweet tooth for anonymous pictures of early industrial plants that cannot always be justified by the photographic results—but by and large, it is his connoisseur's eye that remains in control. It was certainly the connoisseur's eye, by the way, that elected to omit Robert Mapplethorpe from this exhibition—a decision that renders a more salutary and unanswerable judgment on the whole Mapplethorpe controversy than any other I know about.

When we turn to the book Mr. Szarkowski has written to accompany this exhibition, we find it is the social historian who is mainly in command, with the connoisseur usually playing a more ancillary role. About the role of early photography in politics and in the lives of the lower classes, for example, Mr. Szarkowski has some interesting things to say. Writing about Mathew Brady's 1860 portrait of Abraham Lincoln, he tells us that Lincoln is thought to have considered the popularity of this picture, which was printed in huge numbers, one of the reasons for his

election. "The frontier lawyer," Mr. Szarkowski writes, "who was said to look 'half-alligator and half-horse' looks in Brady's portrait rather more like Gregory Peck. It is not known how many of Brady's portraits of Lincoln were sold in carte-de-visite form, but the one made by Alexander Hesler the following June was said to have sold more than 100,000 copies."

He reminds us that the daguerreotype, on the other hand, "found its special function in making pictures for the smallest and most private of audiences—the families of uncelebrated men and women. Daguerreotypists made portraits of millions of people who were unknown beyond their own village, people whose forebears had never before been portrayed as individuals. . . . It is poetically just that the daguerreotype belongs to the century that saw in Western countries a radical expansion of suffrage. After Daguerre the yeoman, and then the peasant and the proletarian, would also have visible ancestors and family histories."

In Mr. Szarkowski's account of the nineteenth-century interest in photographing ruins, however, the social historian is joined by the connoisseur of pictorial aesthetics in defining a major genre of early photography. "Of all the surprises that might persuade one to postpone one's journey," he writes, "a ruin was the delight that came most naturally to Talbot's mind." William Henry Fox Talbot (1800–1877) was, of course, one of the inventors of photography. Mr. Szarkowski continues:

> In this taste [Talbot] was altogether representative of the educated
> classes of his time and place. Ruins were revered both for their
> meaning and their aspect: both as documents to be read for what they
> told of the medieval or ancient past, and as embodiments of the
> picturesque, a word that resists precise definition, but that expressed a
> taste for the used above the new, the irregular over the geometric, the
> rough rather than the smooth. The ruin was a central icon to the
> Romantic imagination, and if, by 1850, the idea had been well worked
> over by painting and poetry, photography brought to it a new
> specificity and conviction. And the calotype, which itself tended
> toward the rough and irregular, and did not look too insistently new,
> was an excellent tool for the issue at hand.

About many subjects, indeed, Mr. Szarkowski writes with a critical clarity that is admirably unclouded by nostalgia. His judgment of the way

photography was used—and misused—in *Life* magazine properly explodes one of the abiding myths of photographic history:

> In 1972 *Life* closed its doors; many of the other magazines that had supported photo-journalists had already done so, or would shortly. The reason usually given for their failure is the rise of television. . . . But one might say that the magazines had failed on creative grounds before television became a competitor, and that if they had succeeded on those grounds they might also have survived. It is difficult to identify a photo essay from the best days of the experiment in which consistently superior photographs and rigorous writing augment and transform each other, to achieve that new means of expression to which editors, photographers, writers, and art directors paid continual lip service.

What is also a major part of this story, which Mr. Szarkowski does not go into, is the politics of photojournalism in its heyday. The most celebrated photojournalists of the thirties and forties belonged to the left, whereas the proprietors of the mass-circulation magazines they worked for were generally on the right; and this meant that an ideological civil war was endemic to the entire enterprise. I frankly doubt that the history of photojournalism can be entirely understood in isolation from this political conflict.

There is much more to *Photography Until Now* than can be described here, of course. And, it is also important to take note, it is a major event in John Szarkowski's own career. Mr. Szarkowski has been the director of the Department of Photography at the Museum of Modern Art since 1962, and in *Photography Until Now*—both the book and the exhibition—he has given us both a summary of his thought in this field and a quite specific sense of what he believes the canon (dare one use the word?) of great photography to consist of. There is no one better equipped to essay these tasks than he, and his achievement in *Photography Until Now* will itself stand as a landmark in the intellectual history of photography.

That it is an achievement attended by a certain air of melancholy is itself a reflection of the situation in which photography now finds itself. With his customary candor Mr. Szarkowski takes note of the degree to which photography has lately taken refuge in the academy and in the art world in the interest of survival, and while he doesn't offer any assessment of what losses this shift has entailed for photography—losses in

quality and in expressive power as well as fundamental purpose—he shows himself to be keenly aware of them. It was certainly bad luck for photography that it attached itself to the academy at the very moment when the academy was itself suffering a calamitous crisis of confidence in its own purposes, and it was a similar misfortune for photography to become so dependent on the art world at a moment when its standards, too, were in a tailspin. But perhaps this is just another way of saying that photography is now, for better or for worse—usually worse, I'm afraid— so much a part of the crisis that the institutions of our cultural life are passing through that it has virtually ceased to have an identity or a destiny of its own. If this is indeed the case, then *Photography Until Now* may serve to remind us of what this field of achievement consisted of in the halcyon years of its development.

[1990]

Reflections on Matisse

Sometimes it has been conceded that I have a certain technical ability but that all the same my ambition is limited, and does not go beyond the purely visual satisfaction such as can be obtained from looking at a picture. But the thought of a painter must not be considered as separate from his pictorial means, for the thought is worth no more than its expression by the means, which must be more complete (and by complete I do not mean complicated) the deeper is his thought. I am unable to distinguish between the feeling I have about life and my way of translating it.—Henri Matisse, in "Notes of a Painter" (1908)

Matisse first emerged as a leader of the School of Paris in the fall of 1905. That was the year the critic Louis Vauxcelles, who admired the thirty-six-year-old painter even if he did not understand him, coined the term *fauves*—wild beasts—to describe the work of Matisse and his followers in the Salon d'automne. However ironical or absurd this coinage may now seem to us as a description of Matisse's pictorial aesthetic, at the time it had the effect of conferring on his work the status of an avant-garde provocation.

The evidence suggests that this had never been Matisse's intention. The role of *peintre maudit* was not something he coveted. He had submitted his art to the lessons of the masters. He was forging a style based on the discoveries of Pissarro, Seurat, and Cézanne. Nothing about his experience or his temperament placed him in the line of those *révolté* personalities who specialized in uproar and anarchy. Yet in the fast-paced world of the Paris avant-garde, where radical innovation was a cynosure

of distinction and reputations were made overnight by coterie opinion while the public remained largely oblivious to what was really happening in art, Matisse was thrust into a position wholly alien to his sensibility. For a couple of years thereafter, until Picasso, twelve years his junior, emerged with *Les Desmoiselles d'Avignon* in 1907 to challenge his rival's leadership of the avant-garde, every negative opinion, whether academic or "advanced," only added to Matisse's preeminence.

After the impact of *Les Desmoiselles*, however, Matisse was never again mistaken for an avant-garde incendiary. With the bizarre painting that appalled and electrified the cognoscenti, which understood that *Les Desmoiselles* was at once a response to Matisse's *Le Bonheur de vivre* (1905–1906) and an assault upon the tradition from which it derived, Picasso effectively appropriated the role of avant-garde "wild beast"—a role that, as far as public opinion was concerned, he was never to relinquish.

Le Bonheur de vivre, owing to its long sequestration in the collection of the Barnes Foundation, which never permitted its reproduction in color, is the least familiar of modern masterpieces. Yet this painting was Matisse's own response to the hostility his work had met with in the Salon d'automne of 1905, a response that entrenched his art even more deeply in the aesthetic principles that had governed the Fauvist paintings which had caused such a furor and which did so on a far grander scale, too. Had it been better known, its role both in Matisse's development and in Picasso's, too, would have been more readily understood, and it is a great pity that it could not be secured for the marvelous Matisse retrospective that John Elderfield has now organized at the Museum of Modern Art. For it is a painting that stands at the crossroads of modern art. No sooner was this masterwork completed, elevating Matisse's art to a new level of achievement, than it was eclipsed—in avant-garde opinion, anyway—by Picasso's bombshell, and this, in turn, did much to determine the way modern art was comprehended from that day until ours.

Whereas Matisse had drawn upon a long tradition of European painting—from Giorgione, Poussin, and Watteau to Ingres, Cézanne, and Gauguin—to create a modern version of a pastoral paradise in *Le Bonheur de vivre*, Picasso had turned to the alien traditions of primitive art to create in *Les Desmoiselles* a netherworld of strange gods and violent emotion. As between the mythological nymphs of *Le Bonheur de vivre* and the grotesque effigies of *Les Desmoiselles*, there was no question as to which was the more shocking or more intended to be shocking. Picasso had

unleashed a vein of feeling that was to have immense consequences for the art and culture of the modern era while Matisse's ambition came to seem, as he said in his "Notes of a Painter," more "limited"—limited, that is, to the realm of aesthetic pleasure. There was thus opened up, in the very first decade of the century and in the work of its two greatest artists, the chasm that has continued to divide the art of the modern era down to our own time.

There can be little doubt, I think, that what might be called Matisse's "tradition," by which I mean not only Matisse's own accomplishment but his influence on other artists and the whole spirit of his aesthetic, has been less widely understood than that of Picasso, whose art and life have dominated so much of our thinking about art in this century. The fact that we have had to wait twelve years, since the great Picasso retrospective that was mounted at MOMA in 1980, for a comparable retrospective devoted to Matisse is only another reminder of this basic difference in our apprehension and valuation of their respective accomplishments.

Matisse seems to have understood the implications of the chasm that separated him from Picasso straightaway, and in the immediate aftermath of *Les Desmoiselles*, as the juggernaut of Cubism was launched upon the Paris art scene, he wrote his great defense of his artistic philosophy in the "Notes of a Painter," which was first published in *La Grande Revue* on December 25, 1908. Owing to a single, long sentence in this manifesto, however, Matisse seemed to incriminate himself as some kind of escapist, at least in the minds of the more *révolté* elements of the avant-garde, and as a result this beautiful avowal of his faith in pure painting made him the target of further hostility for many years to come. Certainly nothing could have made his distance from the spirit of *Les Desmoiselles* more vivid than the famous passage in which Matisse wrote:

> What I dream of is an art of balance, of purity and serenity, devoid of troubling or depressing subject matter, an art which could be for every mental worker [*travailleur cérébral*], for the businessman [*l'homme d'affaires*] as well as the man of letters [*l'artiste des lettres*], for example, a soothing, calming influence on the mind, something like a good armchair which provides relaxation from physical fatigue.

Yet what immediately precedes this passage in the "Notes of a Painter" is an observation about Giotto that is as essential to Matisse's aesthetic credo as his talk of balance, purity, and serenity.

> A work of art must carry within itself [Matisse wrote] its complete significance and impose that upon the beholder before he recognizes the subject matter. When I see the Giotto frescoes at Padua I do not trouble myself to recognize which scene of the life of Christ I have before me, but I immediately understand the sentiment which emerges from it, for it is in the lines, the composition, the color. The title will only serve to confirm my impression.

Which is why, of course, so large a part of "Notes of a Painter" is devoted to lines, composition, and especially color—to the "means" by which an artist expresses his "thought"—not only in Matisse's own work but in that of a great many other painters as well.

In his reaffirmation of this philosophy of art, Matisse made a definitive statement about his own artistic goals—goals that it must have seemed to him were imperiled by *Les Desmoiselles* and the response it instantly ignited. But he also enunciated one of the categorical statements of faith in modernist aesthetics—that belief in the power of "the purely visual satisfaction" of a painting to convey its meaning and spiritual value. This is the belief, whether consciously acknowledged or not, that draws us to the great works of the past even when the stories they retell are no longer of compelling interest to us, and it is what still draws us to many modern works—even, I daresay, *Les Desmoiselles d'Avignon*—long after their subjects have lost their power to excite our attention.

Matisse never abandoned this faith in what he called the painter's "thought." He restated it nearly thirty years later in the remarks he published in *The Studio* magazine under the title "On Modernism and Tradition" (1935). "A great modern attainment is to have found the secret of expression by color, to which has been added, with what is called Fauvism and the movements which have followed it, expression by design; contour, lines and their direction," he wrote, adding that "if I am not mistaken, only plastic form has a true value, and I have always believed that a large part of the beauty of a picture arises from the struggle which an artist wages with his limited medium."

Among "the movements" that Matisse had in mind in this statement, Cubism was undoubtedly the most important, and despite his initial recoil from *Les Desmoiselles*, he monitored the progress of Cubism with close attention to its great contribution to the "plastic form" he valued above all else in painting. He made ample use of it, too, which

the current retrospective documents in greater detail than any other Matisse exhibition we have seen. Matisse was never a dogmatist in aesthetic matters. He was open to every possibility except the abandonment of the painter's "thought" to something outside of the "means" used to express it.

It is one of the many strengths of the retrospective that John Elderfield has organized at MOMA that it has been conceived and executed with a very clear and subtle understanding of the arguments and counterarguments that have dogged Matisse's reputation since that fateful day in 1907 or thereabouts when he was effectively supplanted by Picasso as the leader of the Paris avant-garde. These, as Mr. Elderfield knows very well, are arguments and counterarguments about the nature of art itself, and not only about Matisse's and Picasso's. Yet the fate of Matisse's reputation, and thus of our understanding of what Matisse achieved as an artist, remains ineluctably joined to the ways in which Picasso has come to define the idea of modern art in this century, and it is Mr. Elderfield's distinction in this exhibition and in the great catalogue he has written to accompany it to have explored this relationship more thoughtfully than any of his many predecessors. The result of this critical endeavor is the best account of Matisse's art and thought that any writer has given us.[1]

That the "Evaluation of Matisse's importance is still tied to evaluation of Picasso's" is indeed the *donnée* of Mr. Elderfield's approach to his subject, and in the series of oppositions he cites—between the hedonist and the radical, between the artist "on holiday" and the artist "at war," between the champion of "harmony" and the exponent of "dissonance," etc., which in the end come down to an opposition between the artist as "French bourgeois" and the artist as "international bohemian"—he places Matisse's art in the historical framework that we can all instantly recognize as having dominated all discussion of these artists for as long as we can remember. No other writer has explored the implications of these facile oppositions so tellingly or related them so directly to the fact that, as Mr. Elderfield writes, "the very idea we have of modernism contains, if not indeed comprises, the idea of a protracted struggle for dominance

1. John Elderfield, *Henri Matisse: A Retrospective*, with contributions by Beatrice Kernan and Judith Cousins (New York, 1992).

between opposing systems, represented by Matisse and Picasso, each claiming for itself proprietary rights on an essential modernism."

Mr. Elderfield also gives us a very exact account of the reason why Matisse later emerged as the winner, so to speak, in the contest that he seemed for so long to have forfeited.

> Matisse's reputation as a radical artist was not to achieve its full height ... until after his death. It came as the result not only of broadening critical acknowledgment of his work ... it also, and more importantly, was the result of Matisse's influence on new art. His paintings of the 1930s and 1940s had been perceived as maintaining the vitality and innovative possibilities of that art in a period of great stylistic confusion, when the tradition of Picasso's Cubism decayed into mannerism and mediocrity. His example had certainly been critical to the development of American Abstract Expressionist painting in that way. But it was not until the 1960s, when so-called Color Field painters, Minimalists, and Pop artists could all, in their different ways, find inspiration in Matisse's work, that he fully recaptured the interest of the avant-garde, was acknowledged as a true radical, and again began to be described as the most important twentieth-century painter.

To which Mr. Elderfield promptly adds the questions that continue to haunt both the debate about Matisse and Picasso and the larger debate about art itself:

> But still, was not Picasso, perhaps, a more "serious" artist? And is he not a more influential one? For some, the old questions remain, especially now that the magnificent *Alterstil* of modernism itself—the American painting of the 1950s and 1960s that came so to value the purely visual, and therefore Matisse—is past.

This retrospective is undoubtedly the finest exhibition of its kind ever mounted, and insofar as it is possible to do justice to an artist of Matisse's stature in a single exhibition, this one certainly succeeds beyond cavil. And quite apart from what it does for Matisse, it also has the effect of making one feel a lot better about the century in which we live—a terrible century in so many ways, yet one in which we can nonetheless feel an immense sense of pride if, beside its unremitting record of suffering, bloodshed, and tragedy, it can also boast of an achievement as sub-

lime as Matisse's. Yet there is something about this wonderful event that induces a feeling of sadness and loss as well—a feeling that one of the great possibilities of the human mind may now have spent itself. When we exit this exhibition and return to the sordid cultural landscape of this last decade of the century, it is hard to believe that we shall ever again witness anything like it, now or in the foreseeable future.

[1992]

Philip Johnson's Brilliant Career

His wit all see-saw, between that and this,
Now high, now low, now master up, now miss,
And he himself one vile antithesis.
 —Alexander Pope, "Epistle to Dr. Arbuthnot"

There are certain figures in the arts who, although minor in accomplishment and equivocal in their aesthetic influence, are so completely representative of the spirit of their age that they come to occupy a historical position far greater than the intrinsic merits of their work could ever justify. Their function in cultural life is not so much to create as to incite and impersonate.

Such figures tend therefore to commence their careers as epigones of talents more radical than their own. Often they are drawn to extreme positions that promise deliverance from the conventionality of their origins, but they are not equipped by sensibility or conviction to distinguish between the appearance and the reality of the idols and ideals they choose to emulate. When they feel called upon at opportune moments to attempt originality or innovation—as they inevitably do—they lapse into parody and pastiche, sometimes deliberately, sometimes not.

The métier of such figures is not, in any case, either ideas or artistic creation. It is publicity, showmanship, and the exercise of power. Once they have captured the limelight, they become addicted to it, for the withdrawal of attention is tantamount to oblivion. Their careers thus become a succession of feints and assaults designed to command the public stage and add luster to their visibility—even at the price of obloquy

and scandal. In our time this usually means pleasing important people while pretending to offend established taste.

The American architect Philip Johnson is a particularly vexing example of this type. For more than sixty years—he was born in 1906—he has been a formidable presence on the American cultural scene. No other figure of his time—no other architect, certainly—has so successfully combined so many roles in the arts and their institutions. In addition to his work as an architect and architectural publicist, Johnson has been an eminent museum curator (at the Museum of Modern Art), an influential university professor (at Yale), a leading collector and promoter of contemporary art, and a tastemaker and reputation broker on a huge scale. He has also been an immensely successful businessman, and equally successful, too, as an adviser and mentor to people who are even richer and more powerful than he.

Yet Johnson's career, though undeniably brilliant, encompasses no single accomplishment that can be cited as a quintessential example of his ideas or his vision. In lieu of a personal aesthetic or a recognizable style or a definitive philosophy—or even, alas, a coherent development—what characterizes his work is a series of brilliantly performed charades in which other people's ideas, other people's tastes, and other people's styles have been appropriated, exploited, deconstructed, and repackaged to advance the prosperity of his own reputation and influence.

One consequence of that influence and the enormous power of patronage and preferment that it commands has been a notable reluctance among architectural critics and others to undertake the kind of frank and comprehensive assessment that is normally devoted to the work of famous figures on the cultural scene. Compared, for example, with the attacks that have been mounted in recent years on the accomplishments of Alfred H. Barr, Jr., the founding director of the Museum of Modern Art who launched Johnson's career as an architectural expert and art collector, or on the work of Mies van der Rohe, whose ideas exerted the single greatest influence on Johnson's early architectural thought, Johnson himself has remained remarkably exempt from searching criticism. It is indeed a measure of Johnson's power that despite the many really bad buildings he has created over the last thirty years or more, and the many ideological hostages to fortune he has given his enemies over the course of his career, he remains in nearly total control of his own reputation.

Although he is widely recognized as the bad boy of contemporary architecture—he once proudly proclaimed himself to be an architectural "whore"—an aura of artistic distinction and superior taste has nonetheless insulated Johnson from serious attack.

How is one to explain this odd situation? It is certainly not a question of his being a beloved figure; he is not. No doubt, fear of reprisal accounts for a good deal of the reluctance to challenge the basis of Johnson's artistic celebrity, but there are other reasons, too. One of them is that he has played an important role in launching the careers of many of those who would now be in a position to write the requisite critiques of his work, and who may well be hesitant to seem lacking in gratitude. Another is that Johnson has proved to be very adept at anticipating such critiques in his own frequent utterances about his work, making effective use of a combination of campy self-mockery and swaggering self-aggrandizement as a means of trivializing the case against him before others have had the opportunity to state it more cogently.

But a more fundamental reason than any of these has been the sweeping destruction of architectural standards which Johnson himself—both as an architect and as an architectural thinker—has made fashionable both within the profession and in the public perception of current architectural practice. This destruction of standards has advanced for a couple of decades now under the rubric of "postmodernism," which is less a movement than a collective agreement to reduce architecture to the level of kitsch and elevate kitsch to the status of art.

Johnson did not himself create the postmodernist phenomenon—creation, even of this sort, has never been his forte—but he was quick to identify himself with its fortunes and soon became its most prestigious representative. What made the move especially piquant for a sensibility as perverse as Johnson's was the contradiction it embraced. For in the first phase—the Miesian phase—of his architectural career, Johnson was an ardent champion of the very modernism that the postmodernists were busily maligning. But it is entirely characteristic of Johnson that the second half of his career should have been devoted to destroying the standards that served as a touchstone of quality in the first. Infidelity has long been a distinguishing feature of Johnson's character, and in this respect the promiscuous shifts of attachment and betrayal in his artistic tastes are an accurate reflection of the way he has lived his life in both the private and public realms.

Owing to the checkered character of that life, it was not to be expected that Johnson would ever authorize a frank, full-scale biography. Indeed, the original agreement that obtained between him and Franz Schulze, the author of *Philip Johnson: Life and Work,* stipulated that the book would not be published in its subject's lifetime. It was on this assumption that Johnson enthusiastically cooperated in the preparation of the book and encouraged intimate friends and professional associates to do likewise. Yet as the book approached completion and Johnson, despite the frailties of age, continued to command the limelight, he changed his mind about delaying publication. His appetite for publicity undiminished, Johnson gave Schulze the go-ahead, thereby assuring himself of what was likely to be his last sensational fling in the public eye.

Always a shrewd connoisseur of the *Zeitgeist,* Johnson understood very well that in the debased cultural climate of the 1990s, even the most scandalous revelations in Schulze's biography would not only have lost their power to cause him public embarrassment but would, on the contrary, contribute to the glamour of an invincibly chic reputation. And in this hardheaded assessment Johnson has been proved largely correct. For what emerges from Schulze's biography is, among much else, a portrait of the architect as an immoralist—precisely the kind of immoralist in whose mind a deep-rooted aestheticism combines with a remorseless nihilism to render everything but personal gratification and public approbation utterly meaningless. And that, rather than the admired or despised architect, is the figure who is now being celebrated as he approaches his ninetieth birthday.

Philip Johnson was born to wealth, privilege, and propriety in Cleveland, Ohio, the son of a successful, Harvard-educated lawyer and a reclusive, Wellesley-educated mother whose primary interests, according to Schulze, were "good manners and lofty ideas appropriate to her concept of [the Johnson family's] station and mission in life"—"a mother of majesty rather than intimacy." After the death of his older brother when Philip was two years old, he was subjected to what Schulze describes as "an uncommonly protected upbringing." Neither of his parents was young. When they married in 1901, his father was thirty-nine and already twice widowed; his mother, then thirty-two, had been, in keeping with the conventions of the day, well on her way to spinsterhood. Philip and his sister Theodate, the only member of the family to whom he was ever close, later believed their mother had had a lesbian attachment before her

marriage—but this was pure speculation and may have been, on Philip's part at least, a self-justifying belief.

Homer Johnson was remarkably generous to all of his children, and in the case of his single surviving son he lavished so much wealth upon him that by the time Philip graduated from Harvard he was richer than his father. Still, the father seems never to have known what to make of his brilliant, troubled son and was fairly obtuse about what he could not avoid knowing. When, for example, he discovered that Philip, while at Harvard, had consulted a Boston neurologist about his homosexuality, he simply declared that "Boys don't fall in love with boys" and advised his son to forget about it. Many years after Homer Johnson died, in his ninety-eighth year, the son's judgment on him was characteristically cold and dismissive: "He wasn't any use in the world."

His mother, however, was more interested in things of the mind, and although no more adept than her husband at understanding their son, she exerted a far greater influence on his development. "Since she understood more of the mind than of the heart," Schulze writes, "she looked upon Philip's special place in the family as an excuse, indeed an inspiration, to design his intellect first and worry over his psyche later, if at all." It was a recipe for disaster, and the disasters promptly manifested themselves in the form of violent tantrums, abysmal loneliness, and mental breakdown.

Yet however much he may have disliked his mother, she remained Johnson's principal intellectual confidante until well after his student years. "Their mutuality endured," Schulze writes, "and she became his favorite correspondent throughout his school years away from home and his early professional life." At Harvard one of his major concentrations was in Greek, which his mother had taught him as a boy, and her notion of the Johnson family's "station" in life, which placed them well beyond the mundane standards of ordinary folk, was one that the adult Johnson adopted as a personal credo.

This sense of a special station was greatly abetted by Johnson's en- thusiastic discovery of Nietzsche while he was studying philosophy—his other academic interest—at Harvard. According to Schulze, it was Nietz- sche who turned Johnson in the direction of art and politics, and whose ideas can be seen in retrospect to have shaped the immoralist impulses that governed the rest of his life and work.

During most of his undergraduate career at Harvard (protracted to seven years because of episodes of mental breakdown), Johnson seems

not to have been much interested in either art or architecture, and indeed he had no very specific notion of what he wanted to do. Except for study at Harvard and travel abroad, his life remained closely tethered to that of his family. (On one of his trips he took to wearing Arab dress and enjoyed what Schulze describes as "his first fullfledged, 'consummated' sexual experience" with a guard in the Cairo Museum.) The fortune that Johnson's father had already settled upon him did not make the choice of a vocation a pressing one, and his father's predictable suggestion that he study law was easily rejected. So was the offer to teach Greek at Oberlin, where his father was a trustee.

What chanced to give Johnson his first sense of a commanding purpose to which he could harness his considerable intellectual energies was a meeting in 1929 with the twenty-seven-year-old Alfred Barr, who later that year would be named director of the Museum of Modern Art in New York. Barr had given a series of five widely noticed lectures at Wellesley on the entire history of modernism, from Post-Impressionism to the Bauhaus and Russian Constructivism, and he was on the lookout for recruits to the cause. Johnson had only lately acquired a curiosity about modernist buildings in Europe, but at their first encounter at Wellesley, where Johnson's sister was a student, Barr appears to have converted him on the spot. Schulze helpfully illuminates the psychological process at work. Johnson, he writes,

> had a habit of seeking out authority figures ... who, as if reenacting [his mother's] role in his younger life, could take command of his emotional loyalties at the same time they nurtured his intellectual ambitions—could dominate him, that is, as they aggrandized him.

As discussions for the new museum in New York were already in progress, Barr apparently hinted that there might be a place for Johnson on its staff, and gave his eager recruit detailed instructions on what he should see on the European trip he was planning for the summer of 1929. Thus began Johnson's initiation into the modernist movement that was to dominate the whole first phase of his professional career.

While Johnson was abroad that summer, the announcement of Barr's appointment was duly made. Johnson could not immediately join the museum staff, however, because he had not yet completed the course requirements for his Harvard degree. This he did in the spring of 1930, meanwhile commuting to New York where he quickly became a

member of Barr's inner circle. By that time he had also teamed up with the architectural historian Henry-Russell Hitchcock, Jr., and together they planned a book that in 1932 was published under the title *The International Style: Architecture Since 1922*. This, as Schulze correctly observes, "went on to exert a tremendous impact on architecture worldwide."

Johnson was distinctly the junior partner in this collaboration, but it nonetheless established him as an authority on a subject that, three years earlier, he had barely been acquainted with. Even more important to his new career was the show "Modern Architecture: International Exhibition," which he organized at the Museum of Modern Art in 1932. This was a major event in the campaign to establish modernist architecture on the American scene, and it launched Johnson as a tastemaker in a field that was still highly controversial and in which he was himself still something of an amateur, neither a trained scholar nor a professional practitioner. He proved, however, to be a great showman, and this was an immense advantage in the new museology which Barr introduced to the public with the Museum of Modern Art—a museology in which installation, presentation, and propaganda were to be as important in shaping public response as the objects on display.

Johnson was clearly one of the rising stars in the constellation of talents that Barr was counting on to run the museum in the first decade of its activities. In Barr and his wife Marga, moreover, Johnson found a friendship unlike any he had ever known. They were more than mentors to him; they were "family"—the kind of cosmopolitan, uncensorious family Johnson preferred to his own. In Marga Barr, especially, he found a worldly confidante with whom he could frankly discuss anything, including the vagaries of his now very active sex life. Although more or less contemporaries—Barr was one year older than Johnson—Johnson became, in effect, the Barrs' adopted "son." They traveled together, they rented Manhattan apartments in the same building, and they were closely bound to the same mission—the museum and the modernism it espoused. Or so it seemed, anyway, to the Barrs and their circle.

Yet the museum, as it turned out, did not really satisfy Johnson's inchoate and unappeased Nietzschean ambitions for himself and the world. To fulfill those ambitions, art was deemed to be insufficient. Only politics would do—and politics, as it happened, of a particularly loathsome character.

The turning point came in 1933 with Adolf Hitler's assumption of power in Germany. Johnson adored Germany. He was fluent in the German language and well versed in the avant-garde cultural life that marked the last years of the Weimar Republic. He had taken full advantage, too, of the sexual opportunities it offered to a man of his tastes. That Hitler was the sworn enemy of everything Johnson seemed most to admire in Weimar Germany hardly seemed to matter. There is no other way to put it: Johnson fell in love with the Nazi regime.

The Barrs, who were in Germany when Hitler came to power, were horrified. When they met with Johnson in Europe shortly thereafter, their disagreement was total and intense.

Alfred deplored the takeover [Schulze writes]; Philip was exhilarated by it. Alfred foresaw a brutal repression of freedoms in all walks of German life, leading to an atrophy of national culture as a whole. Philip, remembering the Potsdam rally at which he found himself transfixed by the Nazi spectacle and transported by the charisma of Hitler, saw a *"nationale Erhebung"* (national resurgence), an amazing restoration of confidence among the German people, who only shortly before had seemed defeated by the Depression.

For Johnson, as Schulze shrewdly observes, "Hitler and the Nazis had color. . . . There was dash to these Nazis: the way they dressed and sang and marched and fought; their impudence, their bravado, the sexuality Philip could not help but project on them." And the Nazis also met the requisite Nietzschean standard. "He concentrated his attention on the Nietzschean text in *Der Wille zur Macht* and its thesis that 'the will to power' constitutes man's fundamental motivating force"—a doctrine, as Schulze also points out, that "must have appealed to the elitist view in which Philip had been nurtured since birth."

In the face of these attractions, which were as much aesthetic and erotic as they were political, the arts were no longer a priority for Johnson. "If in the arts [Germany] sets the clock back now, it will run all the faster in the future," he wrote at the time. Even the Bauhaus, which Johnson had acclaimed four years earlier as a new architectural ideal, he now condemned for bearing "irretrievably the stamp of Communism and Marxism." As for Hitler's racial doctrines, Johnson never allowed them to interfere with his sex life. In that respect, at least, he remained a follower of the Weimar ethos rather than the Nazi. Thus, writes Schulze,

"he took his first serious lover [in New York] in 1934"—at the very moment when he was committing himself to the fascist cause, to which racial theories were central. "Jimmy Daniels was a black café singer whom Philip later called the first Mrs. Johnson."

Still, as a consequence of Johnson's political conversion, when he returned to New York from Germany he resigned his post at the Museum of Modern Art to devote himself to politics. Then he did something really bizarre for a white homosexual with a black male lover. With a school friend who was working at the museum, Johnson attempted to join up with the Southern political machine led by the demagogic governor of Louisiana, Huey Long.

It was a move widely reported in the New York press at the time. The headline of a story written by Joseph Alsop in the *Herald Tribune* read: "Two Quit Modern Art Museum for Sur-Realist Political Venture." The *New York Times* reported of Johnson and his colleague that "Recently they became convinced that, after all, abstract art left some major political and economic problems unsolved. Consequently both have turned in their resignations [from the Museum of Modern Art] and will leave as soon as practicable for Louisiana to study the methods of Huey Long." Once again Alfred Barr was horrified, tried to change Johnson's mind, and failed.

Needless to say, Huey Long was not interested in Johnson's services. But Johnson's next attempt to attach himself to a homegrown version of a Nazi-type movement met with a more enthusiastic response. He discovered the Reverend Charles E. Coughlin, the Roman Catholic priest whose Sunday afternoon radio broadcasts from the Shrine of the Little Flower in Royal Oak, Michigan, commanded an audience of thirty million listeners. By February 1936, Johnson was in direct contact with Coughlin, and though he found the man himself a "crashing bore," he nonetheless enlisted in his political cause, which at that moment aimed to challenge President Franklin D. Roosevelt in the 1936 election. Johnson went to work for Coughlin's weekly paper, *Social Justice,* and was much involved in the single biggest rally of the priest's political campaign. Schulze writes:

> At Riverview Park [in Chicago], an enormous amusement complex
> on the city's North Side, a throng estimated by the *Chicago Tribune* at
> between 80,000 and 100,000 heard Coughlin speak from a huge

platform that Philip had taken special pains to design. It was modeled after the one he had seen used so effectively at the 1932 Nazi rally: "A special stand, bordering on the moderne," the *Tribune* reported, "had been created at one end of the field. It provided a glaring white background 50-feet wide and 20-feet high for the solitary figure of the priest."

Even though the campaign of Coughlin's Union party flopped, Johnson labored on, attempting to stimulate some kind of political youth movement along the same lines. That, too, flopped.

It was in the aftermath of the Coughlin debacle that Johnson returned to Germany. The highlight of his 1938 journey was the Nazi *Parteitag* in Nuremberg, marking the fifth year of Hitler's ascension to power. Johnson characteristically described the Nuremberg rally as "even more staggering" than Wagner's *Ring*. He remained unbothered, moreover, by the fact that Hitler had officially declared war on *Entartete Kunst*—"degenerate art" of precisely the kind he had so recently championed as a member of Alfred Barr's inner circle at the Museum of Modern Art. As Schulze observes, "the romance of the thing overpowered him."

When he returned to New York in the winter of 1938–1939, Johnson tried to buy the *American Mercury*, the monthly magazine founded by H. L. Mencken, complaining that "the Jews" had ruined it, and when that, too, fell through, he traveled once again to Europe—this time venturing as far as Poland. "The Polish tour," writes Schulze, "only reinforced Philip's preconceptions of the backwardness among the Poles and the Jews, while reminding him of the superiority of German society and the German military force." When the war started with Hitler's invasion of Poland, he therefore headed straight for Berlin in order "to prepare for the most exciting episode of his summer: the German Propaganda Ministry had formally invited him to follow the Wehrmacht to the front."

He owed this opportunity to Father Coughlin's *Social Justice*, for which he wrote five articles in the summer and fall of 1939, condemning England, praising the Germans, and dismissing the United States as "the best misinformed nation in the world." From Johnson's FBI file, which the Bureau began assembling during the war, Schulze has retrieved a letter, believed to have been written to a friend in December

1939 when Johnson was back in the United States. This is the key passage:

> I was lucky enough to get to be a correspondent so that I could go to
> the front when I wanted to and so it was that I came again to the
> country that we had motored through, the towns north of Warsaw. . . .
> The German green uniforms made the place look gay and happy.
> There were not many Jews to be seen. We saw Warsaw burn and
> Modlin being bombed. It was a stirring spectacle.

This is almost too much even for Schulze's studied detachment.
While he makes a feeble attempt at a psychological analysis of Johnson's
behavior—based on some ill-digested ideas out of William James—he is
clearly both appalled and bewildered by his own account of this crucial
period in Johnson's life, which is the most complete we have been given
so far.

In 1939, Philip Johnson's romance with Hitler and the Nazis had be-
gun to attract the interest of a journalist named Dale Kramer—no rela-
tion to the present writer—who in the October 1940 issue of *Harper's*
gave an account of Johnson's political affiliations in an article on "The
American Fascists." The magazine was on the newsstands in September
when, according to Johnson's FBI file, he had arranged a meeting at the
German embassy in Washington. It may have been pure coincidence,
but, writes Schulze, "three days after the alleged appointment at the em-
bassy in Washington Philip was back in Harvard, enrolled as a student in
the school of architecture." His affair with Nazism was over.

On his return to Harvard, Johnson, at age thirty-three, was no ordi-
nary student. He was older, richer, and more knowledgeable than other
students. Moreover, in the decade since he had received his undergrad-
uate degree, the university—or its Graduate School of Design, anyway—
had abandoned its traditional curriculum to embrace the modernism
which Johnson had championed in the early 1930s. The book that John-
son and Henry-Russell Hitchcock had published in 1932, *The Interna-
tional Style,* was now a required text.

This gave him an immense advantage, to say the least. And so did his
wealth, which enabled him to design and build for himself a Miesian
house in Cambridge while he was still enrolled as a student. To be sure,
Johnson could not entirely escape the consequences of his political past,
but in the end his fascist involvements proved to be more of a temporary

inconvenience and occasional embarrassment than a permanent bar to advancement. This was all the more remarkable in that the new Harvard design faculty was dominated by three refugees from Nazi Germany—Walter Gropius, the founder of the Bauhaus; his Bauhaus colleague Marcel Breuer; and Martin Wagner, the former director of planning for the city of Berlin. But the bad blood that existed between Gropius and Johnson, for example, had much more to do with the latter's loyalty to Mies van der Rohe than with the former's love affair with the Nazis. (Years later, when he was in a position to do so with impunity, Johnson dismissively characterized Gropius as "the Warren G. Harding of architecture.") Breuer, on the other hand, treated Johnson with cordiality and respect.

Meanwhile, Johnson was making some pro forma attempts at his own political rehabilitation. When he joined a Harvard Defense Group (a civil defense organization) in 1941, it fell to the young Arthur Schlesinger, Jr., to dismiss him from the organization on political grounds. An attempt to take a wartime job at the Office of Facts and Figures in Washington likewise failed as soon as the agency got a look at his FBI file. Still, Johnson weathered these and other travails—including a brief stint in the U.S. Army, into which he was drafted in 1943—with remarkable ease, given the strong anti-Nazi sentiments at the time.

When he got out of the army in 1945, with the country still waging war against Japan, he promptly set about mapping the course of his new career. Toward this end he opened his own architectural office in Manhattan (though he was unlicensed to practice in New York State); and, with the help of Alfred Barr, he insinuated himself into his old position in the architectural department of the Museum of Modern Art. The renewed MOMA connection proved indispensable to his new career as a practicing architect, restoring Johnson to a position of authority in the field even before he had built enough to earn it.

Then, as always, Johnson was not a man—or artist—to allow principle to interfere with opportunity. He straightaway designed a prefabricated house for a *Ladies' Home Journal* competition, and arranged for the house to be exhibited at the Modern. "Remarkably," writes Schulze, "it was a deep bow to the functionalism Philip had so long abhorred." Even his renewed campaign on behalf of Mies concealed a growing private doubt about the value of the Miesian aesthetic—which did not prevent Johnson from mounting an exhibition devoted to Mies at the Modern or from designing for himself the famous Glass House in New Canaan,

Connecticut, a house that is itself little more than a pastiche of the Miesian style.

That house promptly proved to be so egregiously uninhabitable even for an aesthete like Johnson that he at once undertook to build an alternative, *anti-Miesian* retreat on the same property that would afford him the privacy and amenity which the doctrinaire transparency of the Glass House precluded. In this regard I recall a lecture Johnson delivered at Harvard in the spring of 1951 (when I was a student there). Asked by a member of the audience if the Glass House was not fundamentally incompatible with the needs of family life, Johnson declared with his customary hauteur that the family should be abolished.

For Johnson, the Glass House of 1949 served a purpose far more important than domestic amenity. More than anything else he had done or would ever do, it established Philip Johnson the architect as a reputed master of the same modernist style upon which Philip Johnson the museum curator and author had conferred a renewed legitimacy and glamour. Whatever his doubts about the failings of the Miesian ideal, and despite the inevitable jokes about "Mies van der Johnson," the Glass House was a brilliant gambit that completely succeeded in its purpose. To this day it continues to be regarded as a classic of American modernist architecture, despite the fact that architects as eminent and as different as Frank Lloyd Wright and Mies himself dismissed it with contempt.

The payoffs came right on schedule. In 1950, Johnson was commissioned to design the MOMA annex on West 53rd Street—another exercise in Miesian pastiche—and in 1953 the Abby Aldrich Rockefeller Sculpture Garden. (It was the elder Mrs. Rockefeller who, when told something of Johnson's Nazi connections, reportedly said that "every young man should be allowed to make one large mistake." But it is doubtful that Mrs. Rockefeller ever knew the full extent of Johnson's involvement.) The sculpture garden may be the single most beautiful thing Johnson ever designed, but it is an essay in museum installation, not building design, and serves a strictly aesthetic function. In any case, these MOMA commissions set the stage from which Johnson's subsequent architectural career was launched.

Not everyone could be expected to be as forgiving as Mrs. Rockefeller, however. The experience of World War II and the impact of the Holocaust remained powerful moral and emotional issues, especially in the intellectual, cultural, and business worlds of New York. This obliged

Johnson to ponder, as Schulze writes, "the need . . . to be free of public perception of his kind of political taint." Success, in other words, required some public gesture of atonement if the stain of anti-Semitism were to be effectively neutralized.

When, therefore, Johnson learned that a Jewish congregation in the suburb of Port Chester, New York, was looking for an architect to design a new synagogue, he seized the opportunity with his characteristic bravado. "His proposal to design [the building] without fee," writes Schulze, "was hard for the potential clients to resist, coming as it did from an architect, and a New Canaan neighbor, whose professional reputation was growing at about the same rate his political past seemed to be receding in most people's minds." The building that Johnson designed was an architectural hodgepodge devoid of aesthetic distinction, but for the architect it served its purpose well enough. It was another brilliantly cynical move, and there was no way for his clients to know that the sculpture he selected for the interior—an abstract metal relief by Ibram Lassaw—was virtually identical with the one that already adorned his secluded New Canaan bedroom, the scene of rituals of a very different sort. Whether or not Johnson intended this as a private joke cannot be known; but it is not the kind of aesthetic irony that would have been lost on him.

It is worth reflecting, in this connection, upon the remarkably large number of prominent Jews who, in the course of Johnson's architectural career, have made major contributions to his reputation and success. Conspicuous on this roster of art patrons, intellectuals, businessmen, museum trustees, critics, and architects are such luminaries as Lincoln Kirstein, Edward M. M. Warburg, Ronald Lauder, Samuel Bronfman, I. S. Brochstein, Rosamond Bernier, Ada Louise Huxtable, Paul Goldberger, Robert A. M. Stern, and Peter Eisenman. To them should also be added Shimon Peres, who in 1960 arranged for Johnson to design the nuclear reactor at Rehovot in Israel, and Meyer Lansky—"one of the panjandrums of organized crime in America," as Schulze writes—for whom Johnson was planning to design a huge gambling casino–hotel in Havana when Fidel Castro's revolution altered their respective schedules.

This is by no means an exhaustive list, but it is sufficient to underline the extraordinary success Johnson achieved in his programmatic effort to induce a kind of collective amnesia or suspension of curiosity about his Nazi past, even among people who had every reason to be alert

to such matters. It was not until 1988, when Johnson was eighty-two and, as Schulze says, "probably the most famous figure in the American architectural world," that the critic Michael Sorkin attempted to awaken a new generation with a scathing article in *Spy* magazine. But the venue of Sorkin's attack was itself too disreputable for the article to have much of an impact. At the altitude of eminence which Johnson now occupied, with the press in his pocket, the *beau monde* at his feet, and the profession lavishing hosannas upon him, he was for all practical purposes beyond the reach of criticism or exposure.

What in retrospect is especially remarkable about these adroit historical maneuvers is that the man who effected them remained at best a very mediocre architect and at times a disgracefully bad one. The art museums he designed for Lincoln, Nebraska; Utica, New York; and both Corpus Christi and Fort Worth, Texas, are among the worst such buildings erected in this country in his lifetime—and all the less to be forgiven as coming from a connoisseur canonized by the Museum of Modern Art. None of these buildings is in the same league with a contemporary masterpiece like Louis Kahn's Kimbell Art Museum in Fort Worth or the building Edward Larrabee Barnes designed for the Walker Art Center in Minneapolis. The New York State Theater, which Johnson designed for New York City Ballet at Lincoln Center, is so undistinguished that many people find it hard to believe it was done by a reputable architect at all; it looks like pure developer's boilerplate.

These failed buildings, moreover, date from before the time when Johnson developed a conscious policy of socking it to his corporate clients with aggressive displays of imperious bad taste—before, that is, he perpetrated postmodern monstrosities like the AT&T Building and the so-called Lipstick tower in New York. For some two decades now, Johnson has been functioning—with what degree of deliberateness, one can only surmise—as the Andy Warhol of American architecture, "quoting" a bit of Gothic here, a bit of Chippendale there, and sporting a display of self-aggrandizing kitsch everywhere, in more or less the same manner in which Warhol famously "quoted" the Campbell Soup label.

Some of this has proved to be too much even for Johnson's most loyal admirers. The critic Ada Louise Huxtable spoke for many when, in an address to the American Academy of Arts and Sciences in 1980, she condemned buildings like AT&T and the Pittsburgh Plate Glass headquarters in Pittsburgh as "shallow, cerebral design," "bad pieces of archi-

tecture," and "clever cannibalism." But the most devastating judgment came in 1976 from an even more surprising quarter, the Museum of Modern Art, which rejected Johnson's bid to design the most ambitious expansion in its history. Johnson had been, in effect, MOMA's house architect for a quarter-century and its principal architectural authority for longer than that; he was now passed over for the commission that would give the museum its architectural identity for many decades to come. (The job went to Cesar Pelli.)

It was tantamount to a divorce, and Johnson suffered what may have been the single biggest disappointment of his career. "Hence his reaction," Schulze writes, "which was to reverse the intentions he had earlier had for the disposal of his estate and not to leave the museum his collection of painting and sculpture or even his country property in New Canaan." Still, even this has not quite ended Johnson's association with the museum, for MOMA is planning to mark his ninetieth birthday in 1996 with a publication and exhibition devoted to the paintings, sculptures, and design objects he has already given the museum since its founding.

What audacities Johnson may be preparing for that occasion is anyone's guess, but it is a mercy that neither Alfred nor Marga Barr will be around to witness them. On the last pages of *Philip Johnson: Life and Work,* Schulze brings us up to date on his subject's current views with an account of an address Johnson delivered last year (1994) at the Austrian Museum of Applied Arts in Vienna:

> The subject was Stalinist architecture, and Philip used the occasion not only to demonstrate again that his basic view of the world was as consistent as the styles of his architecture were not, but to affirm an opinion he had seldom had the opportunity to express: his admiration for a boulevard in the former East Berlin that had been the object of almost unanimous scorn among Western critics. It was the notorious Stalinallee, later renamed the Karl-Marx-Allee, still later, after the fall of the Berlin Wall, the Frankfurter Allee. Philip had long found a grandeur in it that others had dismissed as totalitarian pomposity. Now he called it "the new Champs-Elysées," a product of "romantic daring" and "the dream of the East for monumentality."

Schulze may well be correct in his observation that "At eighty-eight, [Johnson] was where he was always most comfortable, at the head of the

parade of contemporary taste." But given his history, there are other ways of reading his remarks in Vienna. Coming upon them in his biography, I was reminded of a conversation I had with Marga Barr in the last year of her life. I was then working with her on the preparation of a "Chronicle" of Alfred Barr's career for publication in *The New Criterion*. (It was published under the title, "Our Campaigns," in a special issue of the magazine in the summer of 1987.)

On one of the mornings we had set for a meeting in her apartment, the *New York Times* published Johnson's proposed designs for the rehabilitation of the Times Square–42nd Street area. I found them even more wretched than some of the awful things he had already built, and I was eager to know what Marga thought of them. In recounting to me the story of Alfred's career, she had had frequent occasion to speak of Johnson, and she always did so with fond affection—for the record, so to speak. That morning I asked if she had seen the paper, and she rather glumly acknowledged that she had. I then asked what she thought of the kind of buildings Johnson had lately been designing—and hastened to add that she was under no obligation to discuss the subject if she preferred not to.

In responding to difficult questions, Marga had a way of turning away for a few moments while she composed her thoughts and then facing her interlocutor with a very determined look. This is what she did that morning as she said to me: "I feel about Philip today the way I would feel about a beloved son who had gone into a life of crime."

It was a hard thing for her to say, but Marga Barr was not in the habit of shirking the truth. After reading Franz Schulze's life of Philip Johnson, I would say that she had gotten the matter exactly right.

[1995]

Duchamp and His Legacy

> *For Marcel Duchamp the question of art and life, as well as
> any other question capable of dividing us at the present
> moment, does not arise.*—André Breton, in *Littérature*, 1922

> *He approaches life as he does the chessboard: the gambits
> fascinate him without leading him to imagine that there is a
> meaning behind it all which might make it necessary for him to
> believe in something. . . . Duchamp's attitude is that life is a
> melancholy joke, an indecipherable nonsense, not worth the
> trouble of investigating.*—Hans Richter, *Dada: Art and Anti-
> Art*, 1964

What accounts for the immense intellectual prestige which the mystique
of Marcel Duchamp has enjoyed in this country—if only in certain cir-
cles, to be sure—for more decades than most of us can now remember?
I speak at the outset of the artist's mystique rather than of his art, for it
is not so much Duchamp's art as the penumbra of ideas and mystifica-
tions associated with it that has cast a spell over the minds of so many
otherwise intelligent people, both in the art world and beyond it. As an
artist, after all, Duchamp produced one of the smallest *oeuvres* in the
modernist canon. He was always a lazy revolutionary. His insouciance
was often a mask of indolence, his indolence a reflection of the accidie
or ennui he perfected as a way of life and somehow managed to endow
with an aura of sanctity. That it was a sanctity of negation only enhanced
its prestige.

How much that aura of sanctity owed to the effortless celebrity that
Duchamp achieved in America while he was still in his twenties is a

matter about which, of course, we can only speculate. What is a certainty, however, is that America was essential to the kind of career he elected to pursue once that celebrity had been thrust upon him in the Armory Show of 1913. The painting that made Duchamp an overnight sensation in that show—the *Nude Descending a Staircase*, painted in 1912—wasn't the masterpiece of audacity it was taken to be. As William S. Rubin observed in his "Reflexions on Marcel Duchamp" in 1960, "the *Nude* hardly compares in adventurousness with the great Analytic Cubist paintings of the same year"—the paintings of Braque and Picasso. Indeed, to place the artist who painted the *Nude Descending a Staircase* in the company of Braque and Picasso, never mind Matisse and Léger, is to define him as a minor figure. In the Paris avant-garde of the period before the First World War, Duchamp did not rank at all.

Only in America was he mistaken to be a major representative of the modernism that had been created by talents more robust than his. The truth is, the sensation that the *Nude* caused in New York in 1913 was more a reflection of *our* provincialism than of Duchamp's originality. Yet who can doubt that the entire career of the Duchamp who is now so admired, so solemnly studied and so widely emulated—the Duchamp of *The Large Glass*, the "Readymades," and the enigmatic notes and clues that accompany them—was determined by this early episode in mistaken identity? For that episode and the publicity it generated placed upon Duchamp's every subsequent artistic effort an obligation to come up with something that would prove to be equally provocative and controversial.

It is in this respect that Duchamp belongs to the history of the avant-garde in America rather than to its greater counterpart in Paris. It wasn't until the emergence of the Surrealist movement in the early 1920s that Duchamp secured an anchor to which he could attach himself in the Paris avant-garde. Even then, of course, it suited his temperament to use the Surrealist camp as a convenience, as it were, rather than be used by it. Mark Polizzotti, in his new biography of André Breton, gets the matter exactly right when he describes Duchamp as an "amiable fellow traveler" of both Dada and Surrealism who viewed the younger Breton "with a mixture of respect and sarcastic amusement." But then, of course, he viewed everything in life with sarcastic amusement.

With the Dada movement Duchamp had closer affinities, and many people still persist in portraying him as the very archetype of the Dada

spirit—a practice that Duchamp did nothing to discourage. He certainly shared the Dada taste for creating scandal, yet with neither of the two principal activities that occupied the Dada movement—art and politics— did Duchamp have much sympathy. He professed to scorn the creation of the first (though in private he continued to pursue certain projects), while about the second he refused to pay it even the compliment of rejection. Alongside the copious *oeuvres* of the leading artists of the Dada movement—Jean Arp, Kurt Schwitters, Max Ernst, and Man Ray— Duchamp's is little more than a provocative patchwork; and with the politics of a Dada militant like Richard Huelsenbeck, Duchamp had no affinity whatever. One can well imagine with what "sarcastic amusement" he might have observed Breton's tortuous attempt to establish an *entente cordiale* with the French Communist party in the 1920s, but it is doubtful that he paid the matter the slightest attention. The sheer solipsism that circumscribed Duchamp's mental universe precluded such interests.

It was this inviolate solipsism, to which his works, his utterances, and his public career made so many arch allusions, that combined with the glamour of Duchamp's peculiar fame to create his special mystique. By suggesting that he believed in nothing, least of all in art, while at the same time enjoying the status of an admired and controversial artist, Duchamp left it to others to discover and codify what, if any, might be the private pieties and proclivities that actually governed his life and thought. Has any other modern artist ever given so many interviews about such a small number of objects without revealing anything very definite about their meaning or intention?

Those interviews were often brilliant performances. They introduced just enough variation into Duchamp's account—or rather, nonaccount—of his thought to sustain the interest of his acolytes while disclosing little, if anything, that wasn't already established as a coefficient of his personal myth. It was in this sense that Duchamp may have been the greatest "performance artist" of his time—an artist, in other words, whose "works" are seen to be mere props for the ritual reenactment of a private destiny.

All through the later decades of his life, when it pleased Duchamp to beguile successive generations of artists and art-world functionaries as an eminence who had achieved a special status precisely because he had given up the mundane task of creating art, it was his historic act of negation that was assumed to be the basis of his moral authority—a moral

authority that depended, paradoxically, on the good opinion of the many other artists who treated him as a guru and hailed him as a master while they themselves refused, of course, to follow his example in abandoning the creation of art. These artists understood very well that giving up art *à la Duchamp* would get them nowhere. Duchamp had already done that to great acclaim, and it was not a gesture that could be repeated with anything like the same effect. Besides, these artists were eager to get on with their careers and achieve the kind of success that had come to Duchamp himself at an early age. They hadn't yet done enough in their art or achieved enough public notice to endow any decision they might make to abandon the creation of art with the requisite shock and significance.

Their problem—the problem of the Duchampian epigones—was indeed paradoxical: how to honor and participate in the spirit of the master's negation of art while continuing with the creation of art. The solution, of course, was the sham compromise that goes by the name of "anti-art," which may best be defined as a species of art that claims, if only provisionally, to be something other than what it is—namely, art—in order to be judged by criteria other than those currently in effect or, better still, not to be judged at all but simply embraced as a form of expression more imperative than mere "art."

Much of the art of the last fifty years—much, certainly, that belongs to what the art establishment believes to be "avant-garde"—is anti-art of this persuasion, and Duchamp is indeed its patron saint. He set this train on its course, after all, with the "Readymades"—the snow shovel, the urinal, the bicycle wheel, etc.—that mocked the very concept of artistic creation and were yet quickly accepted, albeit in quotation marks so to speak, as authentic and even profound works of art. Today, nearly eighty years after Duchamp perpetrated this bluff on the New York art world, his anti-art legacy fills our museums and in some other quarters, too—the academy and the media—commands an esteem that is often greater than any enjoyed by works of art created by more traditional means. All of which is a reminder, if we still need one, that the conventions of this anti-art legacy have themselves now come to constitute an academy of sorts.

It is a measure of this academic status that the study of Duchamp is now something of an academic industry—so much so, indeed, that in this last decade of the twentieth century it looks more and more as if the university will be the final resting place of Duchamp's reputation. This

may tell us more about the fate of the university at the end of the twentieth century than it tells us about Duchamp—for much of the academic literature on Duchamp amounts to little more than pedantry in the service of uncritical adulation—but it also suggests that the appropriation of Duchamp by the academy may be the ultimate Duchampian irony: a revolution in sensibility buried in a cemetery of scholarly footnotes.

To this vast literature on Duchamp there has now been added something new—an avowedly "humanistic" and "old-fashioned" historical approach to the subject called *The Private Worlds of Marcel Duchamp*. Its author—Jerrold Seigel—is not an art historian or art-world groupie but the William J. Kenan Professor of History at New York University. His aim in writing about Duchamp is, as he notes in the preface to this study, "to clarify certain features of the avant-garde and of modern cultural history more generally." In this respect, at least, his study of Duchamp may be considered a sequel to his earlier history of *Bohemian Paris: Culture, Politics, and the Boundaries of Bourgeois Life, 1830–1930*, published in 1986. And while in much of the book Professor Seigel doesn't write as a critic of Duchamp—on the contrary, he is clearly captivated by the audacity of Duchamp's performance and determined to give it the benefit of many doubts—in the end *The Private Worlds of Marcel Duchamp* is really a contribution to the demystification of his subject.

It is for this reason that one wishes the book had begun where it ends, with the chapter on "Art and Its Freedoms." For it isn't until the last page of *Private Worlds* that Professor Seigel explicitly raises the question that is now the principal reason for us to take an imperative interest in Duchamp and his legacy. This is the key passage:

> As the claim that dissolving the separate sphere of art would liberate
> energies capable of creating new forms of life loses what persuasive
> force it once bore, we realize more and more that art owes what
> power it has to enrich the rest of life to the very separation and
> independence against which many avant-garde projects were directed;
> what we gain by dissolving the boundaries between art and life turns
> out to be much less than what we risk losing.

This is immediately preceded by an observation that is even more devastating in its assessment of Duchamp's influence:

> As some recent critics have begun to argue, the consequences of
> merging art into life have not been what Breton and others hoped,

leaving life untransformed but art much weakened by the absence of criteria to decide whether any given object belongs within its sphere and, of those objects that do, which are good. The sovereignty of the artist who claims the right to declare that art is whatever he or she designates has clashed with the equal authority of audiences to accept or reject what is offered them; the result is only a higher level of mutual suspicion and confusion.

This is indeed where a study of Duchamp and his legacy ought now to begin, and it is one of the disappointments of Professor Seigel's book that the subject comes too late to be fully explored. There are some excellent things in this last chapter on "Art and Its Freedoms"—most notably, the comparisons that are made with Picasso, John Cage, Paul Valéry, Jean-François Lyotard, Michel Foucault, and Nietzsche—but even these are somewhat blurred in the final equivocations about what in Duchamp's legacy remains "vital and worth preserving."

As for what Professor Seigel means by those "private" worlds he alludes to in his title—in the end they amount to little more than the defeated desires of a Freudian family romance. Professor Seigel describes his study of Duchamp as "only mildly and partially psychobiographical," but in fact the book is regrettably "old-fashioned" in the way it accords intellectual priority to a quite conventional Freudian analysis of Duchamp and his *oeuvre*. Did Duchamp feel "neglected as a boy"? Did he suffer from "his mother's indifference"? Did he entertain fantasies of incest about his sister Suzanne? Did all this leave him sexually "deadened" in later life? Was he impotent or merely sexually indifferent to the many women with whom he was thought to have had affairs of a sort in his maturity? Or was he a secret homosexual? And was much of his art, in any case, some sort of masturbation fantasy?

About most of these questions we have no definitive answers. Professor Seigel's speculations are better informed than most others I have read, but they leave us wondering if he quite understands the extent to which they, too, contribute to the mystification of his subject's reputation. For what they add up to is a protracted case of voyeurism haunted by impotence, and they leave us with a distinct impression of Duchamp as a man whose relation to art was remarkably parallel to his relation to sex—an impression of total freedom won at the price of a bemused and self-absorbed sterility. And if Professor Seigel believes what he says about

Duchamp's damaged psyche, then what does it mean for him to invite us to "celebrate the courage and originality with which [Duchamp] explored those inner spaces" on the last page of this book?

The question is an important one, for what I have called Duchamp's mystique derives, above all, from the conception of radical freedom he brought to the artistic vocation—a conception of freedom so fundamentally inimical to the artist's vocation that it renders it impotent. For in art, as in life, there are only choices to be made, obstacles to overcome, contingencies to engage and accommodate. To "drop out" is to abandon effort and inspiration in favor of a radical passivity—which is what the Duchampian idea of total freedom finally comes down to.

Why, then, should we speak of "courage" when what we are dealing with is failure—a failure of spirit, certainly, and very likely a failure of talent as well? Failure in art, failure in life: isn't that the unacknowledged subtext of the story that is told in *The Private Worlds of Marcel Duchamp*? That Duchamp had the "genius" to turn that failure into a myth of success and superiority is an important part of the story, too, of course— maybe even the more important part, for it returns us to the American setting of his career and the role played by American provincialism and gullibility in the creation of the Duchamp cult. And to the study of that subject "psychobiography"—Freudian or otherwise—doesn't have much to contribute.

In the end, alas—and despite the demurrals of its last chapter—*The Private Worlds of Marcel Duchamp* is a study remarkably reluctant to face up to the implications of its own findings. Inside this book there is a better book waiting to be written, but the one we have been given leaves the subject of Duchamp and his legacy safely enclosed in the equivocations of the academy.

[1995]

Léger's Modernism

*If pictorial expression has changed, it is because modern life has
necessitated it. The existence of modern creative people is much
more intense and more complex than that of people in earlier
centuries. The thing that is imagined is less fixed, the object
exposes itself less than it did formerly. . . . The view, through the
door of the railroad car or the automobile windshield, in
combination with the speed, has altered the habitual look of
things. . . . The compression of the modern picture, its variety, its
breaking up of forms, are the result of all this.*—Fernand
Léger, 1914

I once had a student who wrote a term paper in which he compared the
forms in Fernand Léger's *Three Women* (1921), in the collection of the
Museum of Modern Art, with the forms of the engine room of the navy
submarine in which he had served during the Korean War. While older
and with more experience of the world than the other undergraduates
I was then teaching, this student was new to the mysteries of modern
painting. Mine was the first art history course he had ever signed up for,
and he had never before entered an art museum before I assigned the
class to study certain pictures at the Museum of Modern Art—not slides
or other reproductions but the actual paintings—as a preliminary to
reading anything about them. His reaction to Léger was instant and elec-
tric. He seemed to understand everything about the painting, including
its humor.

One of the things that were interesting about the immediacy of this
response to Léger was its relation to the student's wartime experience.

For there was no way, in that early stage of his study of modern painting, that he could have known of the role that Léger's own military experience in the First World War had played in the development of his art. About the effect of that experience on his artistic thought, Léger was nothing if not explicit and unequivocal. "During those four war years," he later recalled,

> I was abruptly thrust into a reality which was both blinding and new. When I left Paris my style was thoroughly abstract: period of pictorial liberation. Suddenly, and without any break, I found myself on a level with the whole of the French people; my new companions in the Engineer Corps were miners, navvies, workers in metal and wood. Among them I discovered the French people. At the same time I was dazzled by the breech of a 75-millimetre gun which was standing uncovered in the sunlight: the magic of light on white metal. This was enough to make me forget the abstract art of 1912–13. A complete revelation to me, both as a man and as a painter. . . . Once I got my teeth into that sort of reality I never let go of objects again.

It was not that Léger was ever inclined to glorify the violence of the war. Whatever his affinities with the Futurists in other respects, he did not share their cult of violence. Nor, for that matter, was his conversion to a modernism based on machine forms quite as sudden, perhaps, as his later account of it implies. He had, after all, reflected on the way machine technology had "altered the look of things" in 1914, prior to his wartime encounter with "the magic of light on white metal," and the abstract paintings he produced in the *Contrast of Forms* series in 1913 had already infused the Cubist aesthetic with a machinelike dynamism quite unlike anything to be found in Picasso or Braque.

Yet what John Golding has written about the effect of the war on Léger's artistic thought—that "no other artist of his generation was to extract such positive conclusions from its squalor and horror"—is certainly true. Léger came out of the war with a clear conviction that modern technology, both as an experience to be encompassed in art and as a determinant of its pictorial form, had something important to contribute to modern painting, and it was upon that conviction that all of his subsequent achievements were based.

It wasn't quite the case, however, that in the pursuit of those achievements in the decade following the war Léger had altogether forgotten

his interest in abstraction. Almost alone among the luminaries of the School of Paris in the early decades of the century, Léger understood the importance of Mondrian and the De Stijl group. In an essay on "Abstract Art" for *Cahiers d'Art*, in 1931, Léger said of these Neoplasticist painters that "they are right to say that Cubists' works cannot go as far as their own inquiries do," and hailed them as "the true purists." Abstract art, he wrote, "is the most important, the most interesting of the different plastic trends that have developed during the last twenty-five years," and predicted it would have staying power. Yet he readily acknowledged that as a painter "I have stayed at the 'edge' without ever involving myself totally in their radical concept."

Did he nonetheless derive something from their example? I think it is undeniable that he did. There would scarcely be such a preponderant use of black, white, and brightly colored geometric forms in Léger's paintings of the late teens and early twenties if not for the innovations of Mondrian and his circle. "They have daringly used as the 'main character' the *colored plane* which has obsessed painters since 1912," Léger wrote, adding that "the geometric shape rigorously limits it. . . . Color is locked in and must remain fixed and immobile." Even a painting as crowded with curvilinear forms as the *Three Women* contains much that answers to this description.

It is often said of Léger that, alone among the early masters of the School of Paris, it was he who took Cubism out of the studio and into the street—which is to say, into a fateful dialogue with the iconography of modernity. The nod to Futurism, just before the First World War, and the bow just after to its polar opposite—De Stijl—certainly bears this out. What he wanted for his painting was the dynamism of the former, minus its violence, and the order of the latter, minus its mysticism and metaphysics. Once Léger adopted Cubism as the key to his pictorial ambitions, moreover, he seems to have felt impelled to endow it with a more impersonal profile than would be possible in an art that drew its subjects from the intimate objects of the studio or the familiar haunts of an artists' bohemian milieu. Before the war he solved this problem most successfully by turning away from objects altogether in favor of Cubist abstraction in the *Contrast of Forms* pictures. During the war that was a solution that no longer commended itself to his chastened view of the place he wanted his painting to occupy in the social order to which he had been awakened by the war itself. Hence what looks like a retreat

into the quasi-Futurist figurative Cubism of *The Card Game* (1916). This is not to say that the latter isn't a terrific picture, but it has the period look of the prewar avant-garde.

This is why, in the "Fernand Léger" exhibition that Carolyn Lanchner has organized this spring at the Museum of Modern Art, our encounter with one of the first of the big postwar paintings—*The City* (1919)—has the effect of a clash of cymbals announcing a new era. This is a far more original picture than is commonly acknowledged, and not the least amazing thing about it is its buoyant affirmation of modernity. The modern city that is celebrated in this painting is, however, an entirely visual rather than an existential or social phenomenon. There is no throng, no traffic, no momentum that derives from the depiction of an urban mass enacting the grueling rituals of workaday life. There is no suggestion of urban anxiety, either. In Léger's *City*, "the *colored plane*," here given an insistently vertical accent, is indeed the "main character," while what traces remain of the city's shadowy inhabitants are reduced to the status of robots or silhouettes—in other words, abstractions. For that matter, Léger's entire conception of the modern urban scene in this painting is a variety of visionary abstraction—a syncopated gloss of impressions in which the painterly dabs and touches of, say, Pissarro's city pictures of the 1890s, with their grey weather and distant vistas, are cheerfully transmuted into the close-up, immaculate, highly colored, hard-edged, fragmentary forms of a twentieth-century metropolis. It was also, of course, a largely imaginary metropolis, for the actual city of Paris in 1919 was anything but the model of modernist geometric construction that is depicted in *The City*. . . .

In this respect it hasn't been sufficiently noted that *The City* was a remarkably upbeat painting for an artist in Léger's position to produce at that moment in modern history, scarcely a year after the armistice that ended the First World War. The war had been an immense trauma for the men of Léger's generation and the cause of widespread cynicism and demoralization in its aftermath. Compare the effect of the war on minds as different as Bertolt Brecht and Max Beckmann in Germany, T. S. Eliot in England, and Ernest Hemingway in America, and you might suppose, if you didn't know better, that the war had scarcely touched Léger in any adverse way. In neither *The City* nor in the pictures that Léger produced in the decade that followed—the decade in which he painted his greatest pictures—is there a hint of anything like the anguished disillusionment

and cynical detachment that we find in Brecht's *In the Jungle of Cities* or Beckmann's paintings of the 1920s or Eliot's *The Waste Land* or Hemingway's *In Our Time*. Nor is there the least suggestion of the kind of angst that permeated the work of the New Objectivity movement in German painting that is exactly contemporary with Léger's paintings of the 1920s. There is instead an almost utopian vision of a technological order in which models of beauty and perfection are drawn from the world of machine-made objects.

Underlying Léger's modernism in the 1920s, then, is a certain dissociation of sensibility—for his was a modernism accompanied by a rejection, which we must suppose to be deliberate, of everything that was dark and desperate and unresolved in the experience of modernity. It was not at all the case that Léger was himself indifferent to the failings of modern society, but he seems to have reserved his feelings about all that for his politics—the politics of a sentimental leftism that eventually brought him into the orbit of the French Communist party. In his art, however, he specialized in a kind of comic modernism, a modernism of happy endings. There is certainly a deadpan comic undercurrent in paintings like *The Mechanic* (1920), *Woman and Still Life* (1921), *Reading* (1924), and the delightful *Composition with Hand and Hats* (1927), which obviously owes a lot to the movie comedies of the 1920s. The *Three Women* is itself—among much else, of course—a comic masterpiece.

By the 1930s and 1940s, this comic vein in Léger's paintings lost some of its deadpan humor as the pictures got bigger and their subjects more traditionally satirical. From his version of *Adam and Eve* (1935–1939) to his not very amusing *Leisure, Homage to David* (1948–1949), Léger becomes a more problematic artist. The element of visionary abstraction that served as a kind of pictorial conscience in Léger's masterpieces of the decade following the First World War is largely gone, supplanted by a larky pictorial vaudeville that often degenerates into mural-scale cartoons. In this connection I think it is fair to say that Léger's interest in the movies contributed far more to his painting than his interest in modern architecture did. It was always a fallacy that modern painting would somehow achieve some sort of higher social redemption by placing itself at the service of modern architecture, and Léger—owing, no doubt to his political sentiments—was in his later years much tempted by that false prospect. In a lecture called "The Wall, the Architect, the Painter" (1933), Léger welcomed such collaboration with modern architecture. "The

simplified and rational architecture that is going to conquer the world must serve as a possibility for reviving this collective art that created immortal masterpieces before the Renaissance," he said. "The evolution of society may be tending toward this new order. Easel painting survives—and will always survive—but it can be broadened by the Renaissance mural."

But the "simplified and rational architecture" that did conquer the world proved to be deeply inimical to a modernist revival of the Renaissance mural. As late as 1950, Léger was still harboring the illusion that mural painting might still be revived, and now he saw it as a vehicle for abstract painting. "I believe and I maintain," he wrote, "that abstract art is in trouble when it tries to do easel painting. But *for the mural the possibilities are unlimited.* In the coming years we will find ourselves in the presence of its achievements." He was wrong on both counts, about abstract easel painting no less than about the possibilities of abstract mural painting. The net result for his own painting, however, was to render it more and more superficial, not only in its imagery but in its command of feeling. And it wasn't as if the result succeeded with the public, either. George Heard Hamilton was surely right when he wrote that "there is little evidence that Léger's efforts to create an art with wide popular appeal has met with much response from the people for whom he intended it." Léger's modernism remained an art of the museums.

It is interesting, in this regard, to see Léger's modernism in the 1920s in relation to the turn that Picasso's modernism took in the same period. On this subject, John Golding's essay on "Léger and the Heroism of Modern Life" must be regarded as the classic text.[1] Writing about what he calls Léger's "Neo-Classicism"—a term I should myself hesitate to apply to the artist's machine-form pictures of the twenties—Mr. Golding observes that "he avoided all the overtly classicizing attributes in which Picasso rejoiced; there are no white draperies; no garlands of leaves and flowers, and his figures wear a garb that is strictly contemporary and yet timeless in its simplicity." And further:

> The pitchers and the urns, which can transform a Picasso figure into a caryatid or a river goddess, become, in Léger's work, the implements

1. See John Golding, "Léger and the Heroism of Modern Life," in *Visions of the Modern* (Berkeley, 1994).

of domestic, workaday life. The latent sensuality of Picasso's nudes, and the languor that characterizes the contemporary work of Neo-Classicizing artists such as Derain or La Fresnaye, these were qualities completely alien to Léger's art. He treats his figures, not without an underlying compassion, but with a detachment that was fundamental to his vision of the modern world; his figures are geared to contemporary life, and it is as part of the mechanism of life in general that they achieve significance.

Yet the similarities are found to be just as striking as the differences:

Both adopt for their figures static, monolithic poses, and both make use of similar, heavy, generalized forms to render their limbs; the heads are composed of simple, almost geometrical shapes and the features are rendered in the same incisive, sculptural way. At times Léger's figures echo those of Picasso so closely that one cannot help suspecting him of consciously trying to inject a quality of contemporary slang into Picasso's Neo-Classical vocabulary.

Mr. Golding misses the comic element in Léger's parodies—if that is what they are—of Picasso's Neoclassicism, but he is otherwise correct about the parallels, and this raises the question of whether Léger's upbeat 1920s modernism was any less of an escape from the traumatic effects of the First World War than Picasso's fantasias on a classical dream world. In retrospect, both now seem to have been in flight from precisely the kind of ill-fated modernity that the war itself represented for an entire generation.

The exhibition that Ms. Lanchner has organized in "Fernand Léger" is not, alas, the full retrospective one had hoped it would be, but it is a splendid exhibition all the same. It is certainly odd that in an era that has witnessed the rise and fall of Pop Art and of so much machine-made Minimalist art, no New York museum thought to mount a retrospective of Léger's work as a relevant point of reference. But it may be that Léger himself, while still an undoubted classic of modern painting, no longer looms as the master artist he was once thought to be. In the absence of a full retrospective, the question remains open, but in this abridgment of Léger's *oeuvre* it looks more and more as if the Léger destined to survive is the Léger of the years 1910–1930.

[1998]

Bonnard and "the Stupidities"

*I agree with you that the painter's only solid ground is the
palette and colors, but as soon as the colors achieve an illusion,
they are no longer judged and the stupidities begin.*—Bonnard
to Matisse, 1935

*In short, there is something abject and sinister about Bonnard's
late bathers. . . . The metamorphosis may be gorgeous, but it is
also a kind of elegant* pourriture, *exquisite rot, canvases
shimmering with the iridescence of putrefaction, glowing with
the ooze of the* informe. *It is significant that Bonnard's work is
at its best when he kills off or mutilates his subject: Marthe
dismembered or floating in deathlike passivity is the heroine of
his most exciting canvases.*—Linda Nochlin, *Art in America*,
July 1998

*There is decadence that excites and decadence that enervates.
Bonnard's is the second sort: edgeless, nerveless, weird, fussy. He
isn't mindless, exactly, but he withholds his mind from his
transactions with painting. For thought, he substitutes
maundering on autopilot. His compass is a vague tastefulness.
This comforts people who dislike thinking. I submit that such
people are already comfortable enough, on their own lookout,
and should not be indulged.*—Peter Schjeldahl, *The Village
Voice*, July 28, 1998

Who could have imagined that in 1998, more than half a century after
the artist's death, the paintings of Pierre Bonnard (1867–1947) would still
be a subject of controversy? Yet in certain influential quarters of the art

world this season's Bonnard exhibition at the Museum of Modern Art has elicited a response at once so intemperate and so bizarre that at times it went beyond controversy to become a moral indictment. This may strike us as a very odd thing to happen to an artist as reclusive as Bonnard was in his life and as exclusively concentrated on the gravity of the painter's vocation as he remained throughout all the later decades of his long career. But it would probably not have surprised Bonnard himself. Responses of this kind were precisely what he had in mind when he spoke of "the stupidities" that painting of his persuasion—so radically entrenched in the language of "the palette and colors"—was likely to inspire in critics who regard such a pictorial practice as a wicked indulgence.

What is it, then, about Bonnard's painting that excites such a heated condemnatory response? Make no mistake: Bonnard really incites these critics to paroxysms of denunciation and ridicule. Linda Nochlin, the Lila Acheson Wallace Professor of Modern Art at New York University's Institute of Fine Arts, went so far as to say of Bonnard's late *Bather* pictures that "I am so repelled by the melting of flesh-and-blood model into the molten object of desire of the male painter that I want to plunge a knife into the delectable body-surface." (She is speaking of Bonnard's paintings of his beloved wife, Marthe.) Peter Schjeldahl, still in mourning over the lost illusions of the 1960s counterculture, adds to the indictment by speaking of these same paintings as "eye-candy," "trivial," the residue of "a masturbatory trace," and "an art that is on its last legs as a culture-changing enterprise." These writers clearly disapprove of Bonnard's marriage as well as the paintings that derived from his domestic situation, and are made wildly angry by the high reputation he has achieved as a modern master—a reputation that Mr. Schjeldahl dismisses as having "one foot in the museum and the other in among glossy-magazine perfume ads."

We are given an essential clue to the nature of this critical distemper in Mr. Schjeldahl's reference to an art that is seen to fail in its duty as "a culture-changing enterprise." Professor Nochlin's version of this charge is that Bonnard's later paintings mark "a retreat from the public world." In other words, Bonnard's paintings of his wife at her bath fail to meet what might be described as a politically correct, social activist quotient in art. And if this is indeed the charge, then it must be said that it is at once correct and utterly ludicrous. These paintings most certainly are in-

sufficiently *engagé* in the political sense to qualify as social activist art. They are definitely not what we used to call "avant-garde" either. They have not been conceived to give us a *nouveau frisson*. Yet because both Professor Nochlin and Mr. Schjeldahl are savvy enough to know that the age of the avant-garde is long past, they are obliged to recast their indictments to conform to a roster of socio-sexual offenses more appropriate to the postmodernist culture wars than to the old arguments over "advanced" art.

Professor Nochlin thus speaks of dismemberment and mutilation—terms more aptly applied, perhaps, to a discussion of *Les Demoiselles d'Avignon* than to an elucidation of such masterpieces of memory and desire as *The Bath* (1925), *The Bathroom* (1932), and *Nude in the Bath* (1936). Mr. Schjeldahl, too, writes as if Bonnard has violated some sort of social compact in failing to depict his wife as an aging senior citizen. "He painted her at least 384 times," Mr. Schjeldahl writes, "never with real attention to her face and invariably, even when she was 72 years old and dying, as a nubile young woman."

Alas, it isn't only in regard to the art of painting that such criticism may be relegated to what Bonnard called "the stupidities." Is it really necessary to explain to grownups like Linda Nochlin and Peter Schjeldahl that when a man and a woman have lived together in a conjugal relation over a long period of time they inevitably accumulate a reservoir of erotic memory that profoundly alters the ways in which they see and experience each other's physical presence? A gesture glimpsed in old age may evoke emotions tethered to a distant past that are far more vivid than the actualities of present experience. Couples who have lived together a long time do not meet each other as utter strangers upon awakening to the light of day. They tend to see each other through an involuntary scrim of memory, desire, familiarity, and regret. In such lives, the past lies close to the surface of all waking experience, ready at any moment to illuminate a gesture, an utterance, even a silence, with some freshly remembered simulacrum. A sudden look of delight, a cry of pain, or something as ordinary as the sound of a footstep on the stair—or the ablutions of the bath—may unexpectedly trigger feelings that, however brief in duration, wipe away the years to reveal a continuum of emotion, attachment, and association that is all the more precious for being unanticipated and unwilled. Does all this really have to be explained to writers claiming to be educated, sentient adults? Apparently it does, to judge

from "the stupidities" that have been addressed to Bonnard's *Bather* paintings on the occasion of the MOMA exhibition.

Something like this realm of experience was, in any case, central to Bonnard's project as a painter in all the later decades of his life. His word for it was "poetry"—a poetry of feeling that for Bonnard was the poetry of life itself—and he was indeed its unrivaled pictorial master in the art of the modern era. This "poetry" is not to be mistaken for a romantic idyll, however. There was little about the anxiety, melancholy, and despair of conjugal experience that Bonnard did not comprehend—and make the subject of his paintings—long before he embarked upon the late *Bather* pictures. In the early bedroom paintings—*Man and Woman in an Interior* (1898) and *Man and Woman* (1900), among others—we are given glimpses of a world of sexual melancholy more often associated with the paintings of Edvard Munch and the drama of Henrik Ibsen, both potent influences in the circle Bonnard frequented in this period, than with the *luxe, calme et volupté* of the Impressionist masters. When he does come to paint a version of the latter in *The Earthly Paradise* (1916–1920), he sets the autobiographical scene in Eden just before the fateful Fall—a fate Bonnard well understood to be his own in this central attachment of his long life.

Nor was there anything about the ravages that time inflicts on the frailty of human flesh that Bonnard did not understand and experience at firsthand. But this difficult subject was something he reserved for his own remarkable self-portraits, which are sometimes terrifying in their pitiless candor. To his obsessive depictions of the aging Marthe, however, Bonnard brought an unfailing moral delicacy that gives priority to an intensity of emotion that precludes the very possibility of the kind of pitiless candor the painter lavished on his self-portraits—a moral delicacy in which time is dissolved in favor of memory and feeling. Why this moral delicacy—and the exquisite painterly invention that is its exact pictorial correlative—should now be regarded as a personal and moral failure, if not something worse, rather than as a triumph of aesthetic sensibility, is a matter that has more to do with the vagaries of postmodern sexual politics than with the achievements of art.

Reading the criticism I have been quoting here—"decadence that enervates," "a masturbatory trace," "exquisite rot," and so forth—I am reminded of the fatuous way in which Marxist critics used to write about Proust. Comparisons between Proust and Bonnard have been made

many times, of course, but nowhere has the comparison done more to illuminate Bonnard's painting than in Timothy Hyman's new book *Bonnard*, which in my judgment is by far the best thing ever written about the painter. In calling our attention to what "aligns Bonnard's vision with that of his near contemporary Marcel Proust (1871–1922) in his vast novel *A la recherche du temps perdu*," Mr. Hyman writes:

> We know that the artist read *A la recherche* probably before 1925, and reread it after 1940. Proust's artist-character Elstir may contain a component of Bonnard (he may be Monsieur Biche, "Mr. Bitchy," at Madame Verdurin's *petit cénacle*, or little group), but the real identity is with the narrator, "Marcel"; just as Proust writes the book of himself, so Bonnard will paint the picture of himself. Bonnard's self, like Marcel's, is not that fixed and continuous character of our usual social being. What he has to record is a sudden stabbing involuntary vision of things, and of his place among them. Jean Clair writes of Bonnard being "giddy in the astonishment of the relived moment." He is a myopic spectator, moving through a "floating world," until arrested by a sudden focus. (The transition from blur to focus is essential to his painterly language.)

And further:

> Freud downgraded ecstasy, writing it off, along with daydreaming, as an aberration—as atavistic forms of mental life, and regressions to "primary process" thinking. But Bonnard's first-person art could be seen as a sustained argument for the validity of such modes of being, often in association with Marthe. Her bathroom at "Le Bosquet" was for Bonnard what the famous "cork-lined room" was to Proust: a place of incarceration, and the alchemical chamber in which the base metal of everyday was transformed to gold.

It is in passages like these that Mr. Hyman's *Bonnard* seems to give us not only a glimpse into the painter's creative imagination but also an authentic account of our own experience of the paintings themselves. It goes far in establishing Bonnard's greatness as a painter and the depth of feeling and thought upon which the paintings are based.

Yet the sad fact is that attacks on Bonnard are hardly a recent development, though I know of nothing in the past that quite matches the virulence of the criticisms I have mentioned here. The only thing

approaching it is Picasso's now legendary hostility to Bonnard—"That's not painting, what he does"—and the attack on Bonnard in *Cahiers d'Art* in 1947, the year of the painter's death, an attack that Picasso is believed to have inspired. This article asked the question, "Pierre Bonnard—est-il un grand peintre?" and answered with a resounding negative judgment: "It is evident that this reverence [for Bonnard] is shared only by people who know nothing about the grave difficulties of art and cling above all to what is facile and agreeable." As I wrote in 1984 on the occasion of the Bonnard exhibition at Beaubourg in Paris: "Some version of this judgment will always, I suppose, be the view of professional avant-gardists in every generation, and it is for this reason that Bonnard has survived, at least until now, as a kind of displaced person in the art of our time."[1]

Moreover, this attack in *Cahiers d'Art* was echoed, or at least paralleled, in avant-garde circles in New York at the time. Clement Greenberg, for example, wrote about Bonnard in 1947, on the occasion of an exhibition at the Bignou Gallery, and then again in 1948 when MOMA devoted its first exhibition to the artist. These were crucial years in the development of the New York School, and it was from the perspective of this American avant-garde that Greenberg made his curiously divided assessment of Bonnard's accomplishments. For while he clearly admired Bonnard and gave his readers a close account of his painterly qualities— qualities that, as he wrote in 1947, "led Bonnard to paint more and more abstractly; the greater the attention to pigment and brushstroke the less becomes the concern with the original idea of the subject in nature"— he couldn't quite forgive Bonnard for retaining his attachment to the object.

> Here . . . is a way of approaching abstract painting that makes a detour around Cubism and yet arrives at the same place in the end [he wrote in 1947]. But Bonnard never abandons the object, and never will—nor does he violate it as Picasso has done, while still retaining it. He holds on to the third dimension more tenaciously. He may simplify nature but he does not reorganize it with respect to anything except color; and so the world he shows us disorients no one familiar with that of Monet or Renoir.

1. See "Bonnard in Paris" in *The New Criterion*, May 1984.

Greenberg understood that what Bonnard "seems to want is a big *flat* picture with the massiveness and weight of Tintoretto or Veronese," and admired what he called Bonnard's "audacity" in this respect. Yet because the artist was still found wanting by the avant-garde standards of that particular moment in American painting, the final judgment is highly equivocal.

> But the intimacy of Bonnard's art, its concentration on gentle pleasures, and the fact that it smells permanently of the fashions of 1900–1914, expressing as it does the desire of the French middle classes to make history stop and stand still at 1912, and leave them undisturbed in the enjoyment of the modest but refined amenities that the Third Republic had permitted them to accumulate—all this should not mislead us into thinking that [Bonnard] lacks ambition as a painter.

When Greenberg returned to the subject in 1948, his assessment was equally equivocal:

> The question why an artist who painted as consummately as Bonnard should have failed quite to attain major quality is perhaps best explained by a certain aspect of French tradition. . . . He experimented within the limits set for him, but did not try very hard to break through them.

All of this is on a much higher level of critical discourse than what we have been getting in response to the current Bonnard exhibition at MOMA, but it is also a reminder of the degree to which judgments of Bonnard's achievements have been—and continue to be—hostage to whatever mix of avant-garde sentiment and radical political ideology happens to be rampant. The aesthete in Greenberg clearly responded with enthusiasm to Bonnard's painterly qualities, yet a certain residue of Marxist sentiment—by the late 1940s, Greenberg was speaking of himself as a "disabused Marxist"—combined with his vocation as a champion of the American avant-garde to render Bonnard finally unacceptable.

Outside the circles of that avant-garde, however, Bonnard became something of a hero and a model for a younger generation of painters— for Nell Blaine and Fairfield Porter and the painters upon whose work they were to exert an influence. And even in the circle of the Abstract Expressionist painters, at least one painter—Mark Rothko—found in that 1947 exhibition at the Bignou Gallery the foundation of the mode

of color abstraction that became his signature style. In the current Rothko exhibition at the Whitney Museum, you can see the results of his encounter with Bonnard in 1946–1947, and it would be a brave critic who pronounced Rothko a greater painter than Bonnard. For notwithstanding the "stupidities" that the current Bonnard exhibition has met with in New York, I believe that the artist's greatness is now beyond dispute, or ought to be. Still, Bonnard's own pessimism on this question cannot be ignored, either. "Speaking, when you have something to say, is like looking," he said. "But who looks? If people could see, and see properly, and see whole, they would all be painters. And it's because people have no idea how to look that they hardly ever understand."

[1998]

A GALLERY CHRONICLE

Mapplethorpe at the Whitney:
Big, Glossy, Offensive

In the Robert Mapplethorpe retrospective that is currently installed at the Whitney Museum of American Art, there is so much that is highly problematical and so much that is simply offensive—so much, indeed, that many people will still want to consider pornographic—that we have no choice but to conclude that it was precisely its air of scandal and provocation that commended the work to the museum's staff and made it seem not only a suitable but an irresistible subject for a large, glossy, sensational exhibition.

This impression—that it is Mr. Mapplethorpe's subject matter that is primarily, though not solely, responsible for this large-scale show—is reinforced, moreover, by the fact that he is in many other respects a photographer who contributes little that is new to the language of photography. The formal conventions within which he works clearly owe much to the style that Edward Weston and his many followers perfected years before Mr. Mapplethorpe was born, and this is not a style that in its original form could be expected to elicit much interest nowadays at the Whitney.

What Mr. Mapplethorpe has made of this style is certainly remarkable. While adhering to and intensifying the formalist conventions established by Weston, he has also transformed them into a vehicle for a highly specialized sexual vision. (Even this transformation was anticipated, of course, in Weston's many photographs of female nudes and in the famous picture of his son's naked torso.) Not every one of Mr. Mapplethorpe's pictures has a sexual subject, to be sure, but a great many of them do, and the exhibition as a whole has a very distinct erotic flavor. It encloses us in a realm where a certain kind of homoerotic taste is allied with and aggrandized

by a particular kind of purist aestheticism. If the aestheticism remains teth-
ered to the Weston style, the taste derives its imperatives from something
quite different—a homosexual subculture in which extremes both in
physical endowment and in the trappings and rituals of sexual practices
generally considered perverse are greatly idealized.

It is this taste for the idealization of the physical and erotic extreme
that gives Mr. Mapplethorpe's work its characteristic emotional charge.
What his admirers most enthusiastically respond to is the exceptional
candor as well as the exceptional craft he brings to this project of ideal-
ization. Especially where he concentrates his attention on subjects
heretofore considered "forbidden"—subjects, that is, usually confined to
porno publications—Mr. Mapplethorpe provides his adoring public
with the kind of gratifying *frisson* that, happily for the rest of us, it sel-
dom encounters elsewhere on the art scene.

Richard Marshall, the curator of the Whitney show, correctly iden-
tifies one of the most important of these subjects as the "sadomasochis-
tic theme," and duly notes—quite as if he were listing the components
of a landscape or a still life—"the elements of threat, danger, pleasure and
pain that often underlie [Mr. Mapplethorpe's] imagery." I shall spare the
reader any attempt to describe the really repulsive pictures on this sado-
masochistic theme, but there are several things to be said about them.
One is that they generally don't amount to much as examples of the art
of photography, and it is really not as outstanding works of art that they
are included in the Whitney show. No doubt the subject so absorbed the
photographer that he had little time to embellish the pictures on this
theme with his usual repertory of artistic effects. The most respectable of
them—the double portrait of "Brian Ridley and Lyle Heeter"—is noth-
ing but a second-rate imitation of Diane Arbus.

Then there is the problematic nature of the way these pictures are dis-
cussed in the exhibition catalogue—one of the most elegant publications,
by the way, that the Whitney has produced in some years. For Mr. Mar-
shall, who acknowledges that Mr. Mapplethorpe made these pictures "not
as a voyeur but as an advocate" and "sympathetic participant," and claims
that they "confirmed his position as an artist of strength, confidence and
talent," the SM photographs simply represent a happy confluence of the
"prevalent aesthetic issues of the 1970's" and "the dominant social and
sexual issues of the decade."

On the other hand, Ingrid Sischy, another contributor to the cata-
logue, writes as if the votaries of sadomasochistic sex constituted an op-
pressed ethnic minority in need of a UN resolution guaranteeing their
total and absolute freedom to do whatever they desire. Hers is surely one
of the oddest documents ever published in an art museum catalogue. It
is a cry of pain over the fate of sexual freedom in the age of AIDS—a
subject eminently worthy of examination but not one that belongs to
the province of an art museum.

The best of Mr. Mapplethorpe's pictures are those that are concen-
trated on the bodies of nude figures—mostly male figures. Some of
these—the frontal head and shoulders picture of "Ken Moody," for ex-
ample, and the "Lisa Lyon" pictures—bear a remarkable resemblance to
certain sculptures of Gaston Lachaise. By and large, however, these pho-
tographic celebrations of exemplary physiques, with their theatrical
lighting and arty poses, combine the familiar conventions of fashion
photography—especially that of Irving Penn and Richard Avedon—
with the formalist conventions of the Weston style.

What Mr. Mapplethorpe adds to this expertly crafted pastiche—it
constitutes, I suppose, his artistic signature—is an impulse that Richard
Howard, still another contributor to the catalogue, describes as the wish
"to restore aesthetic dignity to the [male] genitals." Mr. Howard is prob-
ably right in observing that in Mr. Mapplethorpe's photographs "the male
genitals are often presented . . . as surrogates for the face." Less admiring
observers might conclude that this, in effect, reduces the bodies of Mr.
Mapplethorpe's subjects to the status of impersonal sexual objects, but this
isn't the way Mr. Howard sees the matter. He concludes his homage to
Mr. Mapplethorpe by comparing his work to "the sonatas of Scarlatti
[and] the last paintings of Mondrian"—a comparison that would cer-
tainly have horrified Mondrian, and that I find utterly ridiculous.

But it is not inappropriate for Mr. Howard's extravagant praise to
adorn the catalogue of the Mapplethorpe exhibition, for it is just this
sort of hype and special pleading that has made it possible for the Whit-
ney to give us this bizarre exhibition. Alas, the work itself does not, in
my opinion, even begin to justify an exhibition on such a major scale.
Mr. Mapplethorpe is unquestionably an accomplished photographer, but
there remains much in his work that is not only derivative but second-
rate. And it doesn't lack, either, the kind of vulgarity and ostentation—I

am speaking of aesthetic vulgarity—that is only the other side of a pervasive sentimentality.

As for Mr. Mapplethorpe's famous framing devices—the use he makes of fabric, mirrors, etc., in order to turn his pictures into one-of-a-kind art objects—all one can say is that they represent a tacit recognition that the photographic images are often not in themselves of sufficient power or interest to stand on their own. If you have a taste for campy minimalism, you will probably love these devices. I find them pretty trashy.

The truth is, there are about a dozen pictures in this show that have some real artistic quality—but you couldn't mount a major retrospective on an accomplishment of that size. And so it has been left to the "forbidden" subject matter to carry the burden of the show. There is no denying that the result is a sensational exhibition—but the sensation in question doesn't add much to the experience of art.

[1988]

Kiefer at MOMA

No exhibition of an artist of the 1980s had been more eagerly awaited than the Anselm Kiefer retrospective that opened at the Art Institute of Chicago at the end of 1987. And on that occasion the Kiefer retrospective was, as expected, loudly acclaimed as an epochal event. This remarkable German painter, born in 1945, was heralded as the saint and savior of art in our time. Indeed, he was celebrated as something more than an artist. *Time* magazine spoke for many when its art critic announced that Mr. Kiefer was not only "the best painter of his generation" but that his work constituted "a victory for the moral imagination."

Yet this excessive judgment has very quickly receded into history, and is unlikely to be reaffirmed with the same unequivocal enthusiasm now that the traveling Kiefer retrospective has come to its last stop at the Museum of Modern Art. It is my impression, anyway, that feeling is no longer running quite so high in Mr. Kiefer's favor—that it has now become somewhat compromised by elements of doubt and disappoint-

ment. Last year the question seemed to be: What makes Anselm Kiefer so great? Now, less than a year later, the question one hears is: What was it that made Anselm Kiefer seem so important? It would be a mistake to conclude that the artist's spectacular reputation is already passé. It isn't. Mr. Kiefer continues to command immense respect and even adulation. Yet something has undeniably changed. A significant shift has occurred in the way his work is perceived, and it has occurred in a remarkably short time. How are we to account for it?

Speaking for myself, I can say that I, too, was immensely impressed and moved the first time I saw a show of Anselm Kiefer's paintings at the Mary Boone Gallery. The large, overscale images of landscape and architecture, with their melancholy allusions to Germany history—and most particularly German history in the Nazi period—were like nothing else to be seen in contemporary painting. The dour palette—all greys, blacks, and earth colors—seemed in itself a sober reminder of the death and destruction we associate with the Hitler era, yet there was also in the work a very clear attempt to evoke the kind of mythic grandeur we had come to associate with the classics of German romanticism. The artist was clearly attempting to deal with the tragedy and horror of the cultural tradition into which he had been born, and born in the very year that Germany itself had been reduced to the kind of rubble that was so movingly evoked in the physical quality of the paintings on view.

I returned to that exhibition several times, and on each of those visits I found what appeared to be a permanent company of young artists in attendance. They were clearly in a state of enchantment and awe over the artist's work, and not only, I believe, because of the unusual element of pictorial drama to be found in it but also because of the sense of moral gravity that it conveyed. I have to say that I was never again able to experience anything like that initial response to Mr. Kiefer's art. Yet I continued to admire it, and probably for some of the same reasons those awestruck artists did. In an art world that was rapidly becoming ever more vulgar, commercialized, and cynical, Anselm Kiefer seemed to be in possession of a vision that was infinitely more serious and thoughtful than anything to be found among his immediate contemporaries. When, a year or two later, I found myself serving on an advisory committee for the 1985 Carnegie International Exhibition, I did not hesitate to award Mr. Kiefer one of the top prizes, and in the context of that exhibition I still believe that he had earned it.

When I went to Chicago in the fall of 1987 to see the huge retrospective that has now come to MOMA, it was inevitably with mixed feelings about what I would find. I still counted myself among the Kiefer admirers, but I wasn't quite prepared for the way so many other members of the press—and I mean *in the exhibition* and not only in what they wrote—responded to the event. To describe that response as excessive and irrational hero-worship would scarcely begin to give an account of the kind of adulation that was so openly displayed on that occasion. There was an almost religious quality to the response. It was as if the press, whose members are normally so skeptical and impious in their general outlook on art and life, had found in Mr. Kiefer a redeemer in whose works it could at last truly believe.

This response was to some extent abetted by the highly dramatic installation that the show was accorded in Chicago. At MOMA, with its rather prosaic gallery spaces and bright lights, there is nothing akin to the cathedral-like heights and twilight-of-the-gods atmosphere that made the Art Institute a perfect setting for Mr. Kiefer's dark, oversize paintings. Under MOMA's bright lights, some of the magic has evaporated. The work simply doesn't cast the same spell. But for myself, the spell was already receding, if not completely gone, in Chicago. What struck me most forcefully on that encounter with Mr. Kiefer's work—one that lasted several hours—was the problematical nature of the artistic enterprise the artist was engaged in. And it is this question—the question of whether Mr. Kiefer has actually succeeded in his attempt to make the tragedy of history an integral and indispensable element in the art of painting—that must now be faced in any serious discussion of his achievement.

Our answer to this question is likely to depend on the degree to which we are inclined to accord to any artist's subject matter a radical priority over the aesthetic means employed in its expression. The question is rendered all the more moot in Mr. Kiefer's case because of the extreme difficulty many of us are likely to have in identifying his subject matter or motifs with any exactitude. I hasten to add that in the book-length catalogue that Mark Rosenthal, the curator of twentieth-century art at the Philadelphia Museum of Art, has written to accompany the exhibition we are provided with an expert guide to virtually every nook and cranny of Mr. Kiefer's complex iconography. Yet it is one thing to read about the artist's symbols and allusions in a book and quite another

to experience those symbols and allusions *as art*. Purely as a pictorial performer Anselm Kiefer remains a very impressive talent, but the longer I look at his paintings the more I come to feel that his subject matter has a way of dissolving—for the spectator, if not for the artist himself—into a generalized gloom that is not altogether untouched by something that can only be described as sentimentality.

Mr. Kiefer's sentimentality is itself a complicated affair, of course. It is a heavy, portentous sentimentality, a very Germanic and romantic sentimentality—but it is sentimentality, all the same. You can feel it with a special acuteness in one of the big, recent pictures that wasn't included in the Chicago version of the retrospective—a huge grey painting of many panels called *Women of the Revolution* (1986–1987). There are no female figures explicitly depicted in this painting. But its surface is covered with a great many small picture frames inside of which are dried flowers or leaves or other materials intended to evoke feelings of loss, memory, and death. The names of the departed women are inscribed on the picture surface to commemorate their spirits. I have to say that the sheer pathos of this picture came as something of a shock to me, for I hadn't expected Mr. Kiefer to go quite this far in surrendering to the sentimentality that elsewhere in his work remains under a tighter rein.

Anselm Kiefer's best paintings remain his visionary landscapes, and some of them—*The Mastersingers* (1981–1982), *Nuremberg* (1982) and the earlier *Cockchafer Fly* (1974)—are very fine indeed. But anyone who now comes to this retrospective—which was jointly organized by the Art Institute of Chicago and the Philadelphia Museum of Art—in search of an artist-redeemer is in for a disappointment.

[1988]

Frankenthaler at the Whitney

It is no secret in the art world that abstract painting has fallen on hard times. I do not mean economic hard times. The runaway prices commanded by Jackson Pollock, among the dead, and Frank Stella, among

the living, show no sign of declining, as far as I can tell, and many other big names in the field still enjoy immense prestige. But economic prosperity should not be mistaken for aesthetic vitality. There is a crisis in abstract painting all the same—an artistic crisis, which stems from a loss of faith in the aesthetic basis of art. You cannot have a vital movement in abstract painting without a strong belief in the efficacy of the aesthetic impulse, and that is what we seem for the moment to have lost. Not all of the troubles that beset the current art scene can be blamed on money matters. Ideas still count for something, too—and it is the very idea of abstraction in painting that is now in trouble.

The 1980s have witnessed a widespread revolt against abstraction, which many younger artists—not to mention critics, curators, and collectors—have come to identify with a modernism they believe to be moribund. I think they are wrong about this, woefully wrong, but a lot of people have nonetheless come to believe it. And in art, belief matters a lot.

Believing modernism to be moribund, a new generation of artists has put its faith in that curious amalgam of fantasy and philistinism that goes by the name of postmodernism. Whether this proves to be an enduring tragedy for our culture, or only a sterile and sometimes comic interlude, no one can yet say. What we can be certain about, however, is that there is no place for abstraction in this postmodernist scenario. Abstraction requires an absolute conviction in the power of pictorial form to speak directly to the mind and the emotions without recourse to adventitious "subjects" or easily identified symbols. Toward such a conviction the postmodernist attitude is one of mockery and derision. Rejecting the aesthetic impulse as an illusion and originality in art as a myth, the postmodernist camp—or should one say, Camp postmodernism?—relies instead on parody, allegory, and what is called "appropriation." It relies, in other words, on the recycling and repackaging of received images. Whereas it had been the abiding ambition of modernist art to "make it new," in postmodernism—as Calvin Tomkins wrote a few years ago— "nothing here is new, only 'neo.'"

In vivid contrast to the aesthetically degraded atmosphere that this postmodernist imperative has imposed upon the current art scene, the Helen Frankenthaler exhibition that has now come to the Museum of Modern Art recalls us to a very different attitude toward art—a point of view quintessentially modernist in its aesthetic ambition. Ms. Franken-

thaler is not only one of our best abstract painters; she has been one of our best and purest painters of any persuasion for a remarkably long time. She entered upon her professional career as a painter at an early age, having her first solo exhibition at the Tibor de Nagy Gallery in New York in November 1944, just before her twenty-third birthday. This made her the youngest member of the so-called second generation of the New York School. At twenty-four, in her second solo show, she exhibited *Mountains and Sea*, a painting that was to become a landmark in American art—a classic of abstract painting that did much to determine the course of her own artistic development and, owing to its influence, that of abstract painting itself.

Mountains and Sea (1952) is the first of the forty paintings we see in the current MOMA exhibition, which has been organized by E. A. Carmean, Jr., the director of the Modern Art Museum of Fort Worth, Texas. The show is called a "paintings retrospective," which means that it is not a comprehensive survey of everything the artist has done in the period under review (1952–1988). As Ms. Frankenthaler has been a prolific as well as a highly original artist, a true retrospective would require a much larger exhibition than the present one. Yet the decision to limit this show to a carefully selected succession of very individual pictures seems right.

I use the word "individual" advisedly, for Ms. Frankenthaler is not the kind of abstract painter who replicates a carefully designed trademark image from picture to picture. She is anything but an abstract serialist, remaking the same picture over and over again in cold blood, as it were. Each of her paintings is a separate conception, and it requires a certain space—a mental as well as a physical space—to be properly seen and felt. It is, moreover, painting in which the emotions are directly engaged. Ms. Frankenthaler works in what is essentially a lyric mode of abstraction, where the quality of feeling governing virtually every aspect of the painting's execution is crucial to the pictorial outcome. Paintings of this kind are not ideally seen in exhausting numbers, for each of them obliges the spectator to begin, so to speak, at the beginning with each encounter. Which is why I think this exhibition is the right size for the kind of aesthetic experience it offers.

Writing about her work some years ago, I said that Ms. Frankenthaler was the painter who had put Abstract Expressionism on a diet. The wonder is that she was able to effect this radical change in the Abstract

Expressionist aesthetic so early on, and at a moment when challenges to its authority were not exactly welcome. By thinning out her paint to the consistency of a wash and then pouring it directly onto the canvas, instead of applying it with a brush, the artist eliminated some of the heaviness and opacity—those weighty encrustations of pigment—that had already come to characterize certain aspects of the Abstract Expressionist school.

This was an innovation that allowed her to bring to large-scale abstract painting something of the fluency and transparency of watercolor. What resulted—first in *Mountains and Sea* and thereafter in such pictures as *Eden* (1956), *Round Trip* (1957), and *Winter Hunt* (1958)—still had something of the look of Abstract Expressionist painting. Its forms remained basically gestural and improvised, and there was a good deal of drip and splatter. Yet the whole quality of feeling was different—lighter, more lyrical, less earthbound. Something genuinely new had been added to the history of abstract painting, and it straightaway had an effect on that history, leading directly to what came to be known as Color-field painting.

I once half-jokingly described *Mountains and Sea* as "a sort of *Desmoiselles d'Avignon* of the Color-field school," and I see that Mr. Carmean quotes this remark in his catalogue for the present exhibition. What I had in mind, as I expected my colleagues to recognize, was André Breton's characterization of Joan Miró's great painting, *The Birth of the World* (1925), as "the *Desmoiselles d'Avignon* of the *informel*," the *informel* school of abstract painting being a sort of French counterpart to the Abstract Expressionist school in New York. Thinking abut it now, I see that there is even more of a connection between Miró's painting and Ms. Frankenthaler's than I realized at the time. Miró, after all, had similarly put the rhetoric of Surrealist painting on a diet, and by remarkably similar means—though there is no way that Ms. Frankenthaler could have seen *The Birth of the World* at the time she painted *Mountains and Sea*. Although Miró's masterpiece now hangs in the permanent collection of MOMA, it had never been shown in public before 1968.

If, in the 1950s, Ms. Frankenthaler succeeded in putting Abstract Expressionism on this radical diet, she went on in the 1960s to produce a remarkable series of masterpieces in the Color-field style she had in-

vented. The current exhibition has an especially rich representation of pictures from this period, a total of thirteen paintings, beginning with *Swan Lake I* (1961), that will be a revelation to those who have not had an opportunity to see them before. Neither then, nor since, has Ms. Frankenthaler succumbed to the temptation to repeat her successes. While remaining loyal to certain ideas, she has never allowed herself to become hostage to a method. I cannot honestly say that the latest painting in the exhibition—the very large *Casanova* (1988)—is one of my favorites, but I nonetheless admire the unflagging invention that she continues to bring to every picture. And the seven pictures selected to represent the 1980s in this exhibition give us only a cursory account of what she has been up to in this very productive decade.

One leaves this exhibition feeling more convinced than ever that Ms. Frankenthaler is a major artist, not only in the history of American painting or abstract painting but in the very rich history of modernist art itself. But one also leaves this show with a sad sense of how isolated painting of this kind and quality has become. The ideals that nourished it—the ideals of a modernism that gave an unquestioned priority to the authenticity of aesthetic experience over every other consideration in art—no longer occupy the place they once did. The fashions that have taken the place of those ideals have reduced whole areas of the art world—and this includes large parts of our museums— to a vulgarity and meretriciousness without parallel since the worst days of the official nineteenth-century salons. It is no wonder that abstract painting has suffered a crisis in an artistic environment that is so debased.

On a happier note, it should be observed that Ms. Frankenthaler has been unusually lucky in her critics and commentators. On this occasion, in addition to the fine catalogue written by Mr. Carmean, we have also been given a splendid new monograph on the artist's work by John Elderfield, the curator at MOMA responsible for the very beautiful installation of this show. Mr. Elderfield's has the additional interest of providing us with a fairly detailed account of the New York scene in which Ms. Frankenthaler came of age as an artist—one of the best accounts of New York in the fifties I have read.

[1989]

The Citadel of Modernism
Falls to Deconstructivists

Pity the poor curators at the Museum of Modern Art! They preside over one of the greatest collections of modernist art in the world—perhaps *the* greatest—yet nowadays it seems to give them nothing but nightmares. Indeed, a kind of collective nightmare seems to have descended upon all the curatorial departments at MOMA as one after another the curators struggle and compete to free themselves of the onus of—well, of modernism.

At modernism's once-proud citadel, modernism is now the big bogyman—or should one say, in keeping with the new mind-set, bogyperson? To be suspected of a secret allegiance to modernism is now, for every ambitious curator at the museum, to be deeply compromised. The aesthetically correct thing to be associated with is, of course, postmodernism. That is the new orthodoxy to which all curatorial assent is now directed. That is the new party line at MOMA, and meeting it with the requisite dedication and enthusiasm inevitably entails a mighty effort of deconstruction. Hence the nightmares.

We were given a glimpse of what this effort means in practice when, as part of last fall's *Dislocations* show at MOMA, we were offered in lieu of certain paintings in the permanent collection—Seurat, Modigliani, et al.—some idiotic words *about* these pictures written on the walls where the pictures themselves normally hang. Earlier on, an even more ambitious example of this deconstructivist program was given to the public when the late Scott Burton was allowed to dismantle certain Brancusi sculptures in order to exhibit their pedestals as autonomous works of art—an idea that would have certainly given Brancusi some nightmares.

The truth is, wherever one turns at MOMA these days, there is evidence of this impulse—this itch to deconstruct and desecrate and mock the legacy of the modernist art that is the museum's principal reason for existence. Sometimes this impulse takes the form of a stupid little joke— e.g., hanging a self-portrait by Frida Kahlo next to a framed mirror so that visitors to the permanent collection can be made to feel that their

reflected images in the mirror are just as important as the artist's image of herself. This is the kind of thing that now passes for curatorial initiative at MOMA.

More and more often, however, this deconstructivist impulse takes the form of big stupid exhibitions and their catalogues. The latest of these shows now occupies a good deal of space on three floors of the museum under the title *Allegories of Modernism*. Organized by Bernice Rose, senior curator of MOMA's Department of Drawing, it is a show that cheerfully bids farewell to the whole idea of drawing and substitutes in its place the usual inventory of postmodernist inanity. There are paintings here that aren't drawings. There are objects here that aren't drawings. There are photographs, comic strips, and other printed materials that aren't drawings. There are even some drawings here that aren't really drawings but badly failed attempts to make something that may or may not resemble a drawing. As a drawing exhibition, *Allegories of Modernism* is a fraud and a shambles. As a guide to the new orthodoxy at MOMA, however, it is highly instructive, and there is this, too, to be said for the show: It doesn't assault the ears with the kind of noise that had to be endured in the *Dislocations* exhibition. We are allowed to suffer through this inventory of failed art in silence.

For this overscale massacre of the art of drawing Ms. Rose has rounded up all the usual suspects. Jean-Michel Basquiat, Jonathan Borofsky, Mike Kelley, Jenny Holzer, Julian Schnabel, David Salle, Nancy Spero, Francesco Clemente, Sherrie Levine, Doug and Mike Starn are here along with sundry fashionable Germans and the ubiquitous Bruce Nauman, who seems to be every curator's favorite these days at MOMA. At times, it seems, Ms. Rose has gone to great effort to single out precisely those artists who are manifestly devoid of any real talent for drawing—Basquiat and Schnabel, for example—or to bring us items that are wholly removed from drawing itself—Mr. Nauman's *Model for Animal Pyramid II*, which is a rather silly collage made of cut-and-taped photographs. The more we look at the work that Ms. Rose has assembled for this *Allegories of Modernism* show, the more we come to realize that it should really have been called *Allegories of Drawing*, for the show as a whole does tell a sad tale about what has happened to the very idea of drawing under the authority of postmodernist ideology.

To understand the real meaning of this show and what it signifies for the museum, however, it is necessary to consult the catalogue, and that is itself a very melancholy task. Ms. Rose is no newcomer to MOMA.

She has been around for some years, and it is clear that the mental labor involved in the need to effect her conversion to the new postmodernist program has not been easy for her. For one thing, this postmodernist orthodoxy requires of a curator the mastery of a new language. The old lingo, you see, is tainted—just like modernism itself. Its clarity is now thought to be sort of repressive, so you are obliged to muddle up the language with a lot of jargon and other obstacles to clear thinking in order to qualify as a fully emancipated postmodernist.

For this purpose Ms. Rose has gone to a good source for her postmodernist models—to the contributors to *October*, a journal that can always be counted upon to be reader-proof, so to speak. Some of us can remember a time when Ms. Rose wrote perfectly intelligible prose, but now under the imperatives of the postmodernist program she writes things like this:

"The 'iconography,' or lexicon, of postmodernism is the abstraction and reworking—the 'personification'—of modernist style itself, so that style is read through style, with the body of modernism serving as the original text. Remembrance of the past is iconographically integral to the new language age of art. Within this general area of agreement, there is an enormous range of play inherent in the new mode, and drawing, with its enormous potential for overwriting, has become a primary vehicle for this postmodern allegory."

Somehow as we read along in this catalogue, though we may doubt that "overwriting" has much to do with the art of drawing, it does seem to have something to do with Ms. Rose's new prose style. Where it will all end—Ms. Rose's text, I mean—we can more or less divine, too, and she does not disappoint us. In the last paragraphs she brings on the big guns—Terry Eagleton, the English Marxist literary theorist, and Theodor Adorno, the German Marxist philosopher. This, I suspect, is foreign intellectual territory to Ms. Rose, but she has tried hard to learn her lessons well. And so on page 113 of this (postmodernist?) parody—or allegory?—of an exhibition catalogue, she leaves the last word to Mr. Adorno, believing that "out of his negativity," as she writes, "comes affirmation," a neat postmodernist formation. "Perspectives must be fashioned that displace and estrange the world, reveal it to be, with its rifts and crevices, as indigent and distorted as it will appear one day in the messianic light": this is the message that Mr. Adorno, a Marxist lapsing into the language of Christian theology, has for connoisseurs of postmodernist drawing.

It would all be very comical if it did not portend a ghastly future for the Museum of Modern Art. We were given a warning of things to come a couple of years ago when Kirk Varnedoe, the then newly installed chairman of MOMA's Department of Painting and Sculpture, published *A Fine Disregard*, his deconstructivist assault on the thought of Alfred H. Barr Jr., the founding director of MOMA, and Clement Greenberg, our leading modernist critic. And since then we have seen one department after another fall into line with the new orthodoxy. Peter Galassi, the new director of photography at MOMA, has already announced a post-modernist extravaganza to come—one that will revise the definition of photography to conform to postmodernist doctrine. And Ms. Rose has meanwhile rushed in to dismantle the definition of drawing along the same lines. She has done her job well in *Allegories of Modernism*, for as the result of this show just about everything in the world can now be considered a "drawing"—or maybe a "text," since according to postmodernist doctrine there is no real difference between a drawing and a text.

I could not help but wonder what Paul Sachs, the great Harvard connoisseur whose name used to adorn the Department of Drawings galleries at MOMA, would have thought of this debacle. Appropriately, however, his name was removed from the Drawings galleries in the 1980s—a more symbolic act, it now seems, than we could have appreciated at the time.

In the early decades of the Museum of Modern Art, the enemies of modernism were all on the outside, shaking their fists and lavishing their anathemas. Nowadays they occupy the curatorial offices, quietly deconstructing from within. This is the real allegory of modernism in our time.

[1992]

Fairfield Porter, a Master Long Ignored

At the time of his death in 1975 at the age of sixty-eight, Fairfield Porter had been a conspicuous and well-connected figure on the New York art scene for many years. Admired and influential as a painter, he

also commanded great respect as an art critic, first as a writer for *Art News* and then as the critic for *The Nation*. Yet, though Porter's paintings were often praised by painters, poets, and other critics, there was a distinct reluctance in New York art circles to grant him the status of a master, which was what in the end he certainly was.

The museums paid him no attention, and his work remained unknown to the public that knew—or thought it knew—all about Jackson Pollock, Jasper Johns, and Andy Warhol. He was never a big name. Among the curators who were then responsible for the making and breaking of contemporary reputations, Porter's paintings were often regarded—to the extent that they were regarded at all—as too agreeable to be important. There was the story, which I know to be true, of the Whitney curator who had to be dragged to see a private collection of Porter's paintings. He had put off the dreaded visit for months even though the collection was hanging in an apartment only a block or two away from the museum. When at last he finally had a look at them, he pompously announced to the lucky collector of those paintings that "This is too tame for us." That's the way it often was for Porter.

I am reminded of this curious history by the excellent exhibition, called simply *Porter Paintings*, that has now been organized at Hunter College, and reminded, too, of some of my own experiences of that history. When I first wrote about Porter's work in the *Times*, in the late sixties, one of my colleagues on the paper—a critic in another field who lived in a state of acute anxiety lest he be caught missing out on the latest trend—took me aside to warn me that I would ruin my reputation if I continued to write about such boring, conventional stuff.

Then there was the day, a few years later, when my wife and I took Henri Cartier-Bresson to see an exhibition of Porter's paintings at the Hirschl & Adler Galleries. We were having lunch, and Henri was returning to Paris at the end of the day. He had time to see only one exhibition that afternoon, and he asked us what he should see. Simultaneously, we both instantly said: "Fairfield Porter!" The name, of course, was unknown to him. As soon as he began to look at the paintings, however, Henri was beside himself with excitement—and Henri Cartier-Bresson, I should add, is a man difficult to please in artistic matters. As it happened, an old friend of Henri's—the late Monroe Wheeler, for decades one of the senior members of the Museum of

Modern Art hierarchy—walked in while we were looking at the Porters. In his characteristically abrupt manner, Henri rushed over to Wheeler and, without any preliminary greeting, said to him: "Monroe, what kind of a friend are you? All these years I have been coming to New York, and you never told me about Fairfield Porter!" But then, I cannot recall ever seeing a Porter painting hanging in the MOMA galleries.

When the time came in the early eighties to mount a Porter retrospective, it was well known that no New York museum wanted it. The show was organized by Kenworth Moffett at the Museum of Fine Arts in Boston, and took even that museum by surprise by turning out to be one of the most popular shows in its history. When the Whitney was finally persuaded—or coerced, really—into taking a severely abridged version of the Boston retrospective, which was enormous, the staff hung the paintings against brightly colored walls that nearly killed them—an act of revenge, I suppose, for the humiliation of having to handle such boring, conventional stuff. Or did they feel that the paintings needed a little pepping up? Who knows? To this day New York has never seen a comprehensive Porter retrospective.

The show that William C. Agee has organized at Hunter College with three of his students—Malama Maron-Bersin, Sara Rosenfeld, and Michele White—is not, of course, intended to be a retrospective. The 23 paintings in the show are all drawn from the magnificent gift of 250 works that Porter's estate made in 1979 to the Parrish Art Museum in Southampton, where the artist had lived for many years. Still, as the organizers of the show point out in the splendid catalogue, the result gives us "an overview of [Porter's] art. There is at least one painting from each decade of his working career, with the first dating from 1938, and the last from 1963, two years before his death." It was from around 1951 that Porter really got going as a painter, however, and the bulk of the show is happily concentrated on the period from 1952 to 1973.

One of the things that made it difficult for Porter's contemporaries to place him, or to place themselves in relation to Porter's painting, was the fact that while he painted in a very accessible representational style, he belonged in fact to the Abstract Expressionist generation. He readily acknowledged the influence of Willem de Kooning, whom he met in

the late thirties and whose work he bought long before the art world even knew the name. Yet Porter himself always looked a little askance at the idea of abstraction. The other great influence on his painting was Vuillard, whose paintings he saw at the Art Institute of Chicago in 1938. "I looked at the Vuillards," Porter said, "and thought that maybe they were just a revelation of the obvious, and why did one think of doing anything else when it was so natural to do that."

Yet more than a decade elapsed before Porter could fully realize his own version of this "revelation of the obvious," and it was de Kooning's handling of the medium in his paintings of the late forties and early fifties that made it possible, oddly enough, for Porter to follow through on what he had seen in Vuillard years before. The influence of Vuillard is easily seen—from the wonderful painting of *Laurence Typing* (1952) to the more problematic pair of paintings called *Lizzie, Guitar, and Christmas Tree* (1973)—but throughout Porter's later painting de Kooning nonetheless remained a presence. Or, as the authors of the catalogue essay put it, "Porter's procedure was to fuse Vuillard's world of direct observation with the broad and physical paint handling of de Kooning and Abstract Expressionism."

There are some outstanding paintings in this show—the two portraits of the artist's wife Anne (1965 and 1967) are both amazing pictures, as indeed are most of the portraits here. I would like to have seen some of the small flower paintings included in the show, for among them are some of the best things Porter painted. The landscape called *Penobscot Bay with Peak Island* (1966) is fine, too, but it would have been nice to see more of the Maine landscapes, which are such an important part of Porter's oeuvre. No matter. This is still one of the best painting exhibitions in town, and Mr. Agee and his students are to be congratulated on a job well done—and a job all the more welcome because of the fate Porter's work has suffered at the hands of the New York museums. Their catalogue, too, is first-rate, with a fine introductory essay and good selections from Porter's own writings and from the critics of his work. What a pleasure it is to read a publication coming from the academy that is completely untouched by the ghastly jargon and odious politics that nowadays tend to dominate academic discourse on art. Bravo!

[1992]

Hoving's Biteless Barking

Everyone who was around at the time (1967–1977) has a favorite memory of Tom Hoving's years as director of the Metropolitan Museum of Art. Mine is the story of his performance at an off-the-record luncheon with the top brass of the *New York Times* toward the end of his tempestuous tenure at the Met. For this story to be fully understood, however, something must be said about the special relationship he had with the *Times* while he was the director of our greatest art museum. For latecomers to this saga, it should also be mentioned that in the first years of Mr. Hoving's directorship of the Met, I was the *Times*'s art news editor, and in the later years its chief art critic.

The *Times* loomed very large in Mr. Hoving's career at the Met. It couldn't have been otherwise, for as a self-confessed "publicity hound," he was peculiarly dependent upon the *Times* to gratify his single most ardent desire, which was to see his name continuously and conspicuously in the news. From the perspective of a publicity hound like Tom Hoving, it hardly mattered whether the news was good or bad. He well understood that in the magic world of publicity, even a knock can sometimes be a boost, and in the early days at least, there were many more boosts than knocks. In respect to the attention that was lavished on his every word and deed and misdeed, the *Times* rarely let him down. It was the *Times*, more than any other branch of the media, that made Tom Hoving a New York celebrity—which is to say, a person who is famous for being famous.

On the other hand, it was also the *Times* that published the most damaging criticism he ever received as director of the Met, and in the end the *Times* played a significant role in causing Mr. Hoving to resign his position at the museum. Hence his intensely conflicted, love-hate relationship with the paper he so tirelessly courted and so shamelessly attempted to manipulate by fair means and foul. Hence, too, the space that Mr. Hoving now devotes to the *Times* in the book he has written about his troubled tenure at the Met—*Making the Mummies Dance*. The bulk of the *Times*'s coverage of Mr. Hoving's activities at the Met does not, to be sure, receive any mention at all in *Making the Mummies Dance*. In keeping with

the self-aggrandizing tenor of the book, most of the critical stuff the *Times* published about the Hoving era at the Met has been dropped down the memory hole. But even so, some eighteen lines of the book's index list references to the *Times*, more lines than are devoted, for example, to the Met's acquisitions during Mr. Hoving's ten years as director of the museum—itself an interesting index of what still looms largest in his retrospective assessment of his achievements as the Met's director. It is for this reason, as well as others, that a more accurate title for the book would have been: *Confessions of a Publicity Hound*. But accuracy, alas, has never been one of Mr. Hoving's cardinal concerns.

It certainly wasn't his principal concern on that day in the late 1970s when he came to the *Times* as the guest of honor at the "publisher's lunch." In those days, the publisher's lunch at the *Times* was a highly formalized "informal" ritual to which well-known figures in public life—the secretary of state, say, or the president of Lincoln Center, or some visiting foreign statesman—were invited for an off-the-record discussion of current problems with the paper's senior editors and executives. Staff writers like myself were invited to attend these lunches, which were held in the publisher's private dining room, only when their journalistic responsibilities were directly related to the professional field of the guest of honor.

While it was understood that the purpose of these lunch discussions was to provide "background," it was also expected that they would generate exclusive news stories for the *Times*. Either way, the rule prohibiting direct attribution was strictly enforced. Thus it was in the nature of this journalistic ritual for the advantage to lie with the guest of honor, who was in a position to disclose the kind of confidential information, real or imaginary, that would reflect favorably on himself and unfavorably on his adversaries, and to do so without risk to himself. The whole process was, in effect, a high-level form of leaking, and like most journalistic leaks, it gave the leaker a marvelous opportunity to inflict damage on his rivals while enjoying complete anonymity.

I attended a number of these lunches during my tenure at the *Times*. The most hilarious was the one given for Michel Guy when he was the French cultural minister. The editors were expecting some grave reflections on the French political situation, but all Mr. Guy wanted to talk about was the sculpture of Mark di Suvero, which he had just installed in the Tuileries in Paris, and the choreography of Merce Cunningham, which he also adored. The meeting was not considered a success. The

most lugubrious of the lunches I attended was the one given for the loathsome Armand Hammer, who was then making use of his position in the art world—as a collector, dealer, and museum benefactor—to advance the interests of his company, Occidental Petroleum, in Mexico. As a result of that lunch, I was assigned to review a tenth-rate exhibition of Mexican art that Hammer had brought to Washington and New York. I panned it, of course, which (I was told) made Hammer very angry, but there were no other repercussions. Neither the publisher nor the editors of the *Times* ever interfered with anything I wrote about art events—or, indeed, anything else that I wrote.

This was true, by the way, even in the case of my criticisms of Mr. Hoving and the Met. Although the publisher of the *Times* was a member of the museum's board, I was never asked to change a single word that I wrote about the Met. On the rare occasions when I saw the publisher, who always treated me with great courtesy, he would simply say something like, "Boy, am I going to catch hell at the next board meeting for what you guys are writing about the Met!"

It seemed to me at the time that it was an odd moment for the publisher of the *Times* to invite Mr. Hoving to speak at one of these lunches. Everyone in the museum world and in the media knew that Mr. Hoving's days at the Met were already numbered, and as a member of the Met's board, the publisher was in an even better position than the rest of us to know the extent to which the board's confidence in its current director had been shattered beyond repair. My guess at the time was that Mr. Hoving, either directly or (more likely) through an intermediary, had requested the invitation—perhaps in the hope of generating some sort of *Times* story that might save his neck. As it turned out, I had quite underestimated how far Tom Hoving was prepared to go in the misinformation game.

Conversation at lunch that day got off to a slow start, partly because Mr. Hoving seemed to be in a particularly dispirited state of mind and partly because Charlotte Curtis, who had risen from her position as chatelaine of the paper's women's pages to become editor of the Op-Ed page, derailed the discussion by trying to get Mr. Hoving to agree that New York was losing its preeminent position as the art capital of the nation. (In her invincible ignorance, Charlotte cited Georgia O'Keeffe's fame as a resident of New Mexico, and it was crushing news for her to learn that O'Keeffe's reputation had actually been made as a member of

the Stieglitz circle in New York.) So it wasn't until the coffee was served that Mr. Hoving dropped his bombshell.

Suddenly sporting that smarmy smile that always signified some noxious mischief in the making, Mr. Hoving let drop the "news" about an agreement that was being negotiated between the Museum of Modern Art in New York and the National Gallery of Art in Washington. Surely we must all know about it, he said. In an instant, all eyes at the table were turned to me. I was the only person present who was supposed to know about such things, and I had to admit that I knew nothing about this alleged negotiation or agreement. It was a nice moment for Tom Hoving and a bad one for me, for I had been the most vocal of his critics and it was perfectly clear that the assembled editors were furious at the thought that I might be responsible for the *Times* missing out on a major art story.

Then, with all the sangfroid that Mr. Hoving had learned to muster in tight situations, he allowed himself to be persuaded to tell the following tale. The Museum of Modern Art, he said, was in grave financial peril—graver than was known, and so grave, indeed, that it might have to be permanently shut down. The National Gallery, however, was then in the process of promoting its new East Building, which was planned to be the site of a new program in modern and contemporary art. The problem, according to Mr. Hoving, was that the National Gallery had "nothing" to put into its new facility. What could be simpler, he suggested, than for MOMA to close up shop and transfer its great collections to the National Gallery? This, we were told, was the nature of the agreement then being negotiated by Paul Mellon and the Rockefellers.

It was all the sheerest baloney, of course—and instantly recognizable as such by anyone who had Mr. Hoving's number. And yet, despite the Niagara of misinformation that had flowed from the Met in the Hoving era, the editors inevitably found the story electrifying—as, of course, Mr. Hoving knew they would. The publisher's lunch was hurriedly concluded, and within minutes a major investigation was set in motion in the newsroom of the *Times* to confirm the story from other sources. Needless to say, it could not be confirmed because it was a complete fabrication, and so the story never ran. Like so many of Tom Hoving's ill-judged initiatives, it caused a lot of commotion and produced nothing but hot air.

Why, it will be asked, would a man in Mr. Hoving's position pursue such a foolhardy course? The main reason, of course, is that he is basically an extremely foolish man—at heart, despite his age and experience, still an unruly adolescent out to shock his elders and embarrass his benefactors. But there was also the immediate hope of avenging himself on the two institutions—MOMA and the National Gallery—that, in his view at the time, he had ample reason to resent. MOMA had stood in the way of realizing his ambition to make the Met's twentieth-century department a major player in the field of modern and contemporary art, and the National Gallery had often stolen his thunder in the field of blockbuster exhibitions. (See, in this connection, his unlovely remarks about Carter Brown, then the director of the National Gallery, in *Making the Mummies Dance*.) Then, too, if he could also have caused the *Times* a major embarrassment by getting this phony story into the paper, that would have added to the fun. And there was always the outside chance that the story, if published, would have caused so much fuss and confusion elsewhere that the Met's board might not have thought it a propitious moment to dump its own wayward director.

We shall be a long time assessing the full impact of Tom Hoving's directorship of the Met on our art museums, and on their place in American cultural life. Yet in a way that its author hardly intended, the publication of *Making the Mummies Dance* makes that assessment a lot easier. For this is an egregiously shallow and mean-spirited book, and a book, moreover, that has absolutely nothing to say about the life of art in our time. For serious thought it substitutes malicious gossip and the tiresome rituals of self-promotion. It thus reminds us of the intellectual void that was always at the center of Tom Hoving's tenure as director of the Met. It spells out in gruesome detail what happens to a great art institution when it passes into the hands of a spoiled smarty-pants whose principal success was to gull a lot of important people (who should have known better) into believing that money, politics, publicity, and what Tom Hoving liked to call "flash" and "fun" would serve as an adequate substitute for vision and leadership. In *Making the Mummies Dance*, the momentous affairs of one of our greatest cultural institutions are reduced to the level of talk-show scuttlebutt, which is the only level on which Tom Hoving has ever excelled.

[1993]

A Wretched Nauman Show

Masochists of the art world! Your hour has come at last. No longer are you to be denied the stupefying levels of tedium, torture, disgust, humiliation, intimidation, and victimhood that constitute your greatest artistic pleasures. If a programmed mental regression accompanied by an unrelenting assault on the senses is what you need in order to experience high pleasure in art, then your fondest desires are about to be gratified: the Bruce Nauman show has opened at the Museum of Modern Art, and it is indeed a masochist's delight.

Whereas other contemporary exhibitions merely pretend to offer a radical quantum of pain, insult, and degradation sufficient to the needs of the most jaded art-world tastes, this one really delivers. Your aural faculties are horribly assaulted. (Bring earplugs if you are unduly sensitive to high levels of incessant, repulsive noise.) Your sense of delicacy is repeatedly and pointlessly violated. (Leave the kids home if you don't want to have to explain the effigies of dead animals, the sexual mayhem on the videos, or the masturbation joke in *Manipulating a Fluorescent Tube*.) After the Nauman show, the next *Oprah* will look like a rerun of *Rebecca of Sunnybrook Farm*, and the most nerve-jarring police sirens will sound to your beleaguered ears like the anodyne strains of Vivaldi.

Bruce Nauman's language—for he uses a lot of words in his work— is coarse or stupid or unintelligible where it is not actually obscene, which it often is. His admirers, however, regard Mr. Nauman's use of language as quite profound, though they appear to be in some disagreement about the exact character of this alleged profundity. Robert Storr, the curator of painting and sculpture at MOMA, believes that "Nauman's method . . . has much in common with that of Ludwig Wittgenstein," whereas Kathy Halbreich, the director of the Walker Art Center in Minneapolis, finds a more appropriate comparison in the writings of "the great 17th-century metaphysical poet John Donne."

But preposterous claims of this sort represent nothing more than a kind of *deformation professionnelle* that nowadays is a common affliction among curators of contemporary art, who are routinely obliged to de-

fend the indefensible and confer meaning where none exists. The fact is, Mr. Nauman's amateur wordplay bears no resemblance whatever to Wittgenstein's work, and neither does the adolescent fixation on body parts bear any resemblance to Donne's poetry. You'd have to be either a fool or a curator of contemporary art to believe otherwise.

I haven't myself seen, or have any wish to see, the Nauman video called *Black Balls*, which Ms. Halbreich cites as a Donne-like work. But from the still reproduced in the catalogue of the current exhibition and Ms. Halbreich's own account of the work ("Eroticism is frustrated, frozen, even when the artist applies theatrical makeup to his own testicles," etc.), it can reasonably be assumed by anyone familiar with Donne's poetry that her memory of it is less than perfect.

What, then, is really going on in this huge exhibition, which alternates between extreme tedium and extreme nastiness? The show is divided into two parts, with the early work—beginning in the 1960s—confined to the museum's basement galleries, and the later work occupying an immense amount of space on the third floor. The course traced by the artist's development is from a kind of graduate-school version of Dada to what must now be called bureaucratic Dada—the kind of overscale video and/or installation art that requires large art bureaucracies like the Walker Art Center and the Museum of Modern Art to serve as its accomplices and an agency like the National Endowment for the Arts to provide a certificate of respectability.

Graduate-school Dada is little more than a familiar rehearsal of Duchampian jokes and stunts that, owing to the success of Jasper Johns, have been commodified as "avant-garde" bourgeois entertainments. Bureaucratic Dada, however, is art-world show business, requiring expensive production facilities and an audience of determined masochists. What unites the smaller-scale graduate-school Dada and overscale bureaucratic Dada is an expanding atmosphere of boundless, adolescent narcissism, which the hapless art public is invited to scrutinize for signs of deep cultural significance.

I shall have to leave it to the psychiatrists to explain exactly why, in Mr. Nauman's case, this unrelieved narcissism is, as Mr. Storr writes in the catalogue accompanying the exhibition, "increasingly prone to brutal fun." Certainly there is a great deal in the exhibition, especially in the third-floor galleries, that is exceedingly brutal. Whether it is also fun depends, I suppose, on whether you delight in the imagery of dead animals,

as in the installation called *Carousel*, or in the spectacle of slapstick sexual violence in the video sequence called *Violent Incident*, or in the disgusting details of another sequence called *Clown Torture*.

Far from finding it fun myself, I thought this exhibition the single most repulsive show I have seen in the nearly fifty years I have been going to MOMA. It is also one of the biggest. At a press conference the other day, Mr. Storr proudly pointed out that the Nauman retrospective is, after the great Picasso and Matisse retrospectives, the third largest in MOMA's history. Why a great institution like the Museum of Modern Art should take such great pride in showing such nihilistic rubbish on such a grand scale is, in the end, a far more interesting question than any raised in the exhibition itself. We know, of course, that Bruce Nauman has won a great many prizes, that in Europe he is considered one of our greatest living masters, and so on. Yet the work remains nihilistic rubbish all the same. Why taxpayers should be called upon to support an event of this kind— and why indeed a supporter of conservative causes like Ronald S. Lauder should help finance it—needs to be explained. These are more compelling questions than any to be found in the mind of Bruce Nauman.

[1995]

How Long Will Curators Ignore the Great Nerdrum?

The strangest painter exhibiting new pictures in New York at the moment is undoubtedly a fifty-one-year-old Norwegian artist by the name of Odd Nerdrum. He isn't exactly new to New York. He has been exhibiting here since the 1980s, and in certain circles—not the most fashionable, to be sure—he may even be said to have become something of a cult figure. He has remained unknown, however, to the public that takes its cues from the museums specializing in contemporary art. Indeed, he seems to represent everything that our curators of contemporary art most despise—a highly accomplished reactionary technique combined with an attitude of extreme moral gravity.

All the same, my guess is that before the end of the decade, we shall be seeing Mr. Nerdrum's paintings in our museums. We may even get to see a retrospective. For he is a force to be reckoned with. Which is why his current exhibition at the Forum Gallery is not to be missed. When you see the work, you may very well dislike it intensely. But you will not soon forget it, and you will certainly not remain indifferent to it. Afterward, you may even find that a lot of contemporary painting looks perfectly trivial by comparison.

Mr. Nerdrum is that rare thing—a deeply disturbing artist. I mean genuinely disturbing, not merely irksome or cleverly provocative. He is disturbing in ways that pose more questions about his art—and about art itself—than can be easily answered. His pictures do not seem to belong to the contemporary world at all. Yet they don't quite belong to the past, either—despite the resemblances they obviously bear to the work of certain Old Masters. They reject the present and exploit the past in favor of a realm of pictorial fable, allegory, and myth that offers the viewer a grim symbolic account of the human condition in extremis.

This is not the kind of task that we look to the art of painting to perform for us nowadays, and a large part of Mr. Nerdrum's appeal is that his art is so resolutely indifferent to contemporary conventions. In everything but his view of human nature, which is as bleak and unforgiving as anything to be found in Nietzsche, Freud, or Heidegger, Mr. Nerdrum is a radical anti-modernist. His pictorial style, with its swaggering obeisances to Rembrandt, Brueghel, and Caravaggio, consigns the whole realm of modernist practice to oblivion. This is an art deeply rooted in the twilight chiaroscuro of the northern latitudes—an art that is premodern rather than postmodern in its fundamental loyalties.

All of this—the contrived fables, the emotional violence, the atmosphere of primeval menace—would be a matter of indifference or mere curiosity if Mr. Nerdrum did not bring to his art such a formidable command of his medium. Painting at this level of ambition requires exceptional technical powers, for it invites comparison with the great painting of the past at every turn, and it is one of the astonishments of Mr. Nerdrum's art that it so consistently meets this challenge with such unflagging virtuosity.

In addition to his mastery of the figure and of landscape, moreover, Mr. Nerdrum brings to his painting a first-rate dramatic imagination. With paintings like *Man with a Horse's Head* or *Girl with a Fish* or the

sensational *Woman Killing an Injured Man*—all dating from the last two years—the only appropriate comparisons that come to mind are not with other contemporary painters, but with artists in other fields. It is in relation to certain films by Ingmar Bergman or with the poetry of the English writer Geoffrey Hill that Mr. Nerdrum's accomplishment is best understood. In that company, the spiritual turmoil that lies at the center of Mr. Nerdrum's pictorial vision may be more clearly perceived. And in that company, Mr. Nerdrum's visionary ambitions for art no longer look quite as anomalous as they would if we limited our perspective to the spiritually destitute conventions of contemporary painting. Seen in relation to Bergman and Hill, moreover, Mr. Nerdrum no longer appears quite so isolated or orphaned as a late-twentieth-century artist. He turns out to be our contemporary, after all.

Something that another fine poet, William Logan, recently wrote about Geoffrey Hill comes to mind in attempting to place Mr. Nerdrum's art in the cultural life of our time. "Critics who would pigeonhole Hill all too conveniently as a conservative," wrote Mr. Logan, "fail to understand the radical nature of his mistrusts, from which no complacent sentence is safe." In Mr. Nerdrum's case, the "radical nature of his mistrusts" encompasses just about all of modernist art, which makes it very convenient indeed to pigeonhole him, too, as a "conservative." And insofar as it gives us a key to a keener understanding of Mr. Nerdrum's painting, I see nothing wrong with regarding him as a conservative—though I think myself he is more of a radical reactionary in his attempt to reconstitute a lost tradition in his art.

It would be a mistake, however, to view Odd Nerdrum as just another offbeat novelty that has been tossed up by the carnival of the contemporary art scene. He is more important than that and, I am sure, he will be seen more and more as important. Frankly, I don't think the future of painting lies in his direction. He is too much of an individual and his art is too closely bound to the eccentricities of his own sensibility for him to become the leader of a "school." (Not to mention the fact that few artists today are technically or spiritually equal to the challenge of following his lead.) But I do think that the future of painting will be affected by his example, if only because of the profound reexamination of modernist practice it demands. And from the perspective of Mr. Nerdrum's art, this includes postmodernist practice as well.

It is going to take a while for the implications of Mr. Nerdrum's audacious innovations to be fully grasped. Meanwhile, the ten paintings on view at the Forum Gallery constitute an excellent introduction to his work.

[1995]

Best-kept Secret in Art? Stettheimer

The paintings of the American artist Florine Stettheimer (1871–1944) have long been one of the best-kept secrets in the art of this century. Those who were in on the secret during her lifetime—Marcel Duchamp, Virgil Thomson, Henry McBride, and Carl Van Vechten, among other eminences of the period—held her work in high esteem, and they were right to do so. For Stettheimer is a very remarkable artist. Yet except for her participation in a single avant-garde event, she remained unknown to the public. That event was the 1934 premiere of the Virgil Thomson–Gertrude Stein comic opera, *Four Saints in Three Acts*, for which Stettheimer designed the sets and costumes. But even that event, though it garnered a good deal of public attention, still left her paintings unknown.

It was Stettheimer's wish, moreover, that they remain unknown. In her will, she stipulated that all of her pictures were to be destroyed upon her death. Fortunately for us, this harsh sentence—born, I think, of her belief that her paintings were too private to be understood by anyone outside her immediate circle of family and friends—was never carried out. Instead, her sister Ettie set about the task of placing as many of the pictures as she could in important museum collections.

That task was made somewhat easier than it otherwise might have been by the fact that immediately following Stettheimer's death, her well-connected friends went to work organizing a memorial exhibition of her paintings. It took place at the Museum of Modern Art in 1946. Marcel Duchamp selected the pictures, and Henry McBride wrote the

catalogue. If the show didn't exactly put Stettheimer on the map—1946 wasn't a good year for an art as esoteric as hers was thought to be at the time—it at least saved the work from oblivion. It couldn't save it from obscurity, however. Notwithstanding the imprimatur of MOMA, Stettheimer's pictures remained in private hands or in the storerooms of the museums to which they had been donated. Occasional attempts to revive an interest in them were unavailing.

The exhibition called *Florine Stetheimer: Manhattan Fantastica*, which Elisabeth Sussman and Barbara J. Bloemink have organized at the Whitney Museum of American Art, is the first New York museum show devoted to the artist in nearly half a century. I am happy to say that it is a very good show. It concentrates on the work of Stettheimer's artistic maturity, which dates from around 1917, when the artist was in her forties. It was only then that she broke loose from her academic training—she had studied at the Art Students League in New York and the academies of Berlin, Munich, and Stuttgart—to follow a course of her own.

That course consisted of the development of a style that compounded a very personal wit and an aestheticism that concentrated its attention on the *mise en scène* of the artist's life—a life bounded by art, money, and the rituals of a privileged bohemia. It was a style decisively shaped by Stettheimer's extensive knowledge of art in Europe, where she lived with her mother and sisters for a part of each year from 1898 to 1914, but it was wholly devoted to New York subjects.

Stettheimer's New York was indeed as personal as her style, and in her art she treated it as comic exotica. Its center was the elegant salon she established for her artist and writer friends, almost all of whom were better known than she was, and the country entertainments she organized for their amusement. This was a society of sharp wits, intellectual dandies and worldly aesthetes, and Stettheimer's depictions of it were, as the critic Paul Rosenfeld once wrote, "tinged with irony and merriment."

Yet if there is a lot of comedy in these pictures—as there certainly is—there is also an element of inventive aesthetic artifice that places Stettheimer's painting at a great distance from the art of her American contemporaries. The elongated stylized figures in her paintings clearly owe a good deal to the art of Aubrey Beardsley and to Jugendstil illustration, though the affectionate mockery they convey is often closer in spirit, if not in form, to the drawings of Max Beerbohm. There is, in any case, a lot of nineties "decadence" and aestheticism in Stettheimer's art.

It is also much influenced by the Russian ballet and the American circus. Nijinsky's dancing and Léon Bakst's sets for Diaghilev's Ballets Russes, which Stettheimer saw in Paris in 1912, constituted one of the central aesthetic experiences of her life, and one of her paintings—*Beauty Contest* (1924)—is dedicated "To the Memory of P. T. Barnum." The gestures traced by the figures in her group scenes and portraits are indeed "choreographed" to resemble those of ballet dancers, mimes, and circus acrobats. Often her canvases are divided into separate, simultaneous scenes like those of a pantomime or the rings in which circus artists perform. But every figure in these paintings is a specific personality drawn from Stettheimer's circle of family and friends. It is autobiography turned into harlequinade.

The most distinctive painterly feature of Stettheimer's art, however, is its extraordinary coloristic invention—that palette of hot reds and purples, magenta pinks and theatrical blacks, often set in an icy white light and embellished with yellow and gold, is like nothing else in the American art of her time. This she owed principally to Bakst and the tradition of Byzantine-Russian design that Bakst drew upon in his sets for the Ballets Russes. It is the kind of color you often find in the early paintings of Marc Chagall, who studied with Bakst in Russia, and in some of the Russian Symbolist painters. In appropriating this chromatic convention for her own pictorial purposes, Stettheimer adapted it to her own interest in cosmetics and theatrical *maquillage*, especially in the portraits of the 1920s, thus making it an instrument of contemporary feeling.

Beginning in the late twenties, with her *Cathedrals of Broadway* (1929), and continuing into the early forties with the *Cathedrals of Art* (1942), Stettheimer expanded her subject matter to include satires of the New York social and cultural scene. These comic tableaux are also delightful pictures, and are in some respects, I suppose, Stettheimer's aesthetic "answer" to the heavy-handed and badly painted social realist painting of the period. But upon revisiting them on the occasion of this exhibition, I found them a lot thinner in substance and style than the more private group scenes and portraits of the twenties. Even among the paintings of the thirties, they aren't in the same class with the wonderful *Family Portrait No. II* (1933).

Stettheimer was a true original, and the current exhibition at the Whitney at last does justice to her achievement. Since we live in an imperfect world, however, it wasn't to be expected that this event would

escape the kind of ideological packaging that is now the fashion at the Whitney and elsewhere on the museum scene. So in the catalogue accompanying the current show, Stettheimer is made out to be some sort of radical feminist with a discernible political agenda. This turns Stettheimer's career into a comic opera of a very different sort, and is tone-deaf to the entire spirit of her work. But it's a small enough price to pay—if pay it we must—to have Stettheimer's paintings given their due.

[1995]

Reintroducing Nadelman

Although he was one of the most accomplished sculptors of his generation—a great generation—and some of his drawings are among the best of their time, Elie Nadelman (1882–1946) remains an elusive figure for many people on the New York art scene. Part of this has to do with the fact that with every passing season the New York art scene becomes more and more amnesiac, if not simply ignorant, about its own past. And part of it has to do with the fact that Nadelman's art requires a certain sensibility—a certain cultural depth—to be fully appreciated.

You have to know something about the art of the past—sources as diverse as Greek sculpture and American folk art—to understand the impulses and traditions that shaped Nadelman's vision. It helps, too, to know something about his "take" on American culture and the ways in which this mandarin European talent transformed himself into an authentic American artist during the last three decades of his life, which he spent in New York.

These are all things that were better known in the past than they are today. In 1973, Lincoln Kirstein published a big, brilliant, beautifully written study of the artist, and in 1975 the Whitney Museum of American Art—hard as it may now be to believe such a thing—devoted a marvelous exhibition to his work. Long before that, in 1948, the Museum of Modern Art had organized a show of his sculpture, and even longer ago

than that, in 1915, Nadelman was one of the few "new" sculptors whom Alfred Stieglitz favored with an exhibition in his gallery. Yet despite this impressive history—and the fact that some wonderful examples of his work can be seen in the museums—Nadelman still, or again, needs an introduction to an art public that seems at times to have the attention span of a gnat.

We are fortunate, therefore, that in one quarter at least—the Zabriskie Gallery—we have been given some salutary reminders of Nadelman's artistic importance in exhibitions that are always intelligent introductions to the artist's oeuvre and yet can be counted upon to come up with some surprises even for aficionados. The current Nadelman exhibition, which Virginia Zabriskie has organized to open her new space in the Fuller Building, is the sixth show she has devoted to the artist. It is the kind of small, perfectly judged, utterly delightful exhibition that is nowadays one of the rarest pleasures on the New York art scene, and it has the additional interest of calling our attention to the fact that the Fuller Building, on the northeast corner of 57th Street and Madison Avenue, is itself the site of a Nadelman architectural commission. The clock flanked by a sculptural relief of *Construction Workers* that adorns the 57th Street façade of the building above the main entrance was created by Nadelman in the early 1930s. Ms. Zabriskie's new gallery space is, appropriately, on the forth floor directly behind this Nadelman work, which the many art lovers who frequent the galleries in the Fuller Building are nowadays scarcely aware of.

The show itself consists of seven sculptures, seven drawings, and— the real surprise—eleven early photographs of Nadelman sculptures, many of which have been lost and presumed to have been destroyed. These photographs, all but one taken by Mattie Edwards Hewitt around 1922, are themselves very beautiful. The earliest—Eugène Druet's photograph of a lost *Plaster Head* (circa 1909)—is a real knockout. Druet was the art dealer who gave Nadelman his first one-man show in Paris in 1909—a show that caused a considerable stir at the time. Druet was also an accomplished photographer whose pictures of Rodin sculptures are, like the Nadelman photograph in the current exhibition, works of art in themselves.

The earliest of the sculptures in the show—the *Semi-Seated Tubular Nude* (circa 1909–1910), in carved wood, and a marble *Head* (circa

1910)—date from the period when the exhibition at the Galerie Druet had made Nadelman something of a sensation on the Paris art scene. Even before that exhibition, in 1908, Leo Stein took Picasso to Nadelman's studio, and scholars of the period have long believed that the bronze Cubist *Woman's Head* that Picasso created in 1909—the first of his Cubist sculptures—owed a good deal to what he saw on that visit. (Druet's photograph of Nadelman's *Plaster Head* in the current show seems to confirm that link.) It will be interesting to see what, if anything, John Richardson will have to say about the Nadelman-Picasso connection in the forthcoming second volume of his Picasso biography.

Small as the Zabriskie exhibition is, it nonetheless touches upon the whole range of Nadelman's accomplishment. His art is at once very classical in its formal loyalties, and very modern in its range of feeling. It is an art of great elegance, wit, and character—a character that owes as much to the style of the American musicals that Nadelman adored as to the exalted European traditions he revered. Nadelman was himself a connoisseur and collector of considerable distinction. His most important discovery, when he settled in the United States around the time of World War I, was American folk art, which was then very little understood in "high art" circles in this country, and he promptly set about amassing a major collection of it. When the Wall Street crash of 1929 left him and his family in need of money, he attempted to interest New York City in acquiring the collection for a folk-art museum, but nothing ever came of the proposal—and the collection was dispersed. Today you couldn't buy a single major work from that collection for what the whole collection would have cost the city in the 1930s.

Born in Warsaw when it was still a province of the Russian Empire, Nadelman studied at the Warsaw Art Academy, then continued his studies for six months in Munich before settling for a time in Paris. He seems never to have been an avant-gardist, however. In 1912 he quarreled with Marinetti, the leader of the Futurists, whose *Manifesto* famously called for the destruction of the museums. For Nadelman, a speeding motorcar was never thought to be more beautiful than the *Victory of Samothrace*, and his art reflected that prejudice in favor of tradition. Yet he found in America—the kind of civilization the Futurists clearly envied—a whole new impetus for his art.

Elie Nadelman is still a bigger and better artist than he is now commonly thought to be—when he is thought about at all—and in this ex-

quisite exhibition at the Zabriskie Gallery, we are once again reminded of his quality.

[1995]

Alex Katz Blossoms

This year the American painter Alex Katz observes his sixty-ninth birthday. And this season, as it happens, he is having the best exhibition he has had in his long career—the best, anyway, that I have seen in the four decades or so that I have been familiar with his work. The show on view at the Marlborough Gallery is large, ambitious and beautiful. Not all of it is of uniform quality, to be sure. I have often had my doubts about Mr. Katz's large-scale figure paintings, and the examples there—though they are not without a good deal of interest—do not persuade me to allay those doubts. But the big new landscape and cityscape pictures achieve a level of quality that seems to me to be well beyond even the finest of Mr. Katz's earlier paintings. For that reason alone, this show is something of an event.

Even very good painters do not necessarily get better as they get older. Some do, some don't. Some lose their nerve, some suffer losses of energy and momentum, some merely repeat themselves with diminishing effect. It is given to others, however, to achieve an almost preternatural clarity and concentration as they reassess their goals and their means of achieving them. Mr. Katz appears to belong to that lucky class of painters to whom age brings not only an increase in fluency, confidence, and ambition but something else as well: a certain gravitas.

In this exhibition you see the evidence of it in the landscapes and cityscapes—paintings in which the bright, voluble, insouciant spirit of the artist's earlier work has been supplanted by something less sociable and more austere, something timeless and impersonal. The weight of the artist's interests—which is to say, the emotions that inspire his gravest efforts—seems to have shifted from society to nature. No longer does the social milieu of the young, the hip, and the immaculately dressed

command the kind of priority in Mr. Katz's painting that it once did. It is still vividly represented in the figure paintings, of course—but these cool young mannequins of the downtown Manhattan scene are no longer drawn from the artist's own generation. Nowadays they tend to be drawn from his son's generation, which inevitably makes them actors in someone else's play.

Is it for this reason, too, that the backgrounds in the figure paintings tend to be more interesting, *as* painting, than the figures themselves?

Nature has, in any case, overtaken society as Mr. Katz's principal subject, and is now the locus of his finest endeavors. Landscape has always been one of the artist's interests, of course, but it hasn't in the past assumed the kind of priority or claimed the kind of scale that it enjoys today. Does this mean that Maine, where Mr. Katz has spent his summers for some decades now, has supplanted Manhattan as his primary inspiration? To some extent, it obviously has. When you walk into the Marlborough Gallery and see the mural-size canvas of light filtering through the spring foliage in the distance—the painting called *May* (1996) is twenty feet wide and ten feet tall—you are certainly made to feel that you are a long way from the streets of downtown Manhattan.

This painting may be the single finest thing Mr. Katz has ever done, and it ought to go straight into some museum collection, though given the taste of our museums today, the chances of this happening are not terrific. *May* and certain other paintings in the current show—*Coleman Pond III* (1995), *10 A.M.* (1994), *Dark Reflection* (1995), *Poplars* (1994), and *Yellow Morning* (1996)—suggest, moreover, that in the Maine landscape and nightscape Mr. Katz has found his Giverny, the kind of "late" subject that allows for the maximum expansion of imaginative energy.

Indeed, it is of late Claude Monet that one often thinks in looking at these overscale paintings of nature—not as a direct influence, perhaps, but as a premise that has lodged itself in the minds of several generations of American painters, both realists and abstractionists, since the rediscovery of the Giverny murals in the 1950s found them to be among the most radical paintings produced in the early decades of the twentieth century. It is worth recalling, too, that prior to his total absorption in his water garden at Giverny, Monet had also been a painter of the modern urban scene.

So decisive has been this shift to nature in Mr. Katz's work that it now does much to determine the way even his urban subjects are pic-

torially conceived. Another of Mr. Katz's major efforts in the current show is the mural-size *City Landscape* (1995), which, if not for the city lights in the night sky shining like scattered moons, could easily be mistaken for a depiction of the Maine woods after dark. Without their titles, certain other paintings in the show—*Manhattan Evening* (1995), for example—might also be mistaken for Maine subjects. Which suggests that Maine is now less a discrete subject for Mr. Katz's painting than it is a realm of pictorial fantasy to which he has ready access wherever he finds himself.

Many years ago—in 1960, in fact—the late Fairfield Porter, an excellent critic as well as a fine painter himself, said of Mr. Katz, "He is not overwhelmed by nature but stands outside it; it is outside him and includes his subjectivity." Like almost everything else Porter wrote about painting, it was a sharp observation. Yet as Mr. Katz has developed over time, I think he has tended to remain less "outside" the subjects he has drawn from nature, and that nature itself has come to occupy a larger and larger place in what Porter called "his subjectivity." Again, one thinks of Monet at Giverny.

[1996]

Welcome, Professor Forge

Painters who are wonderfully articulate about painting—their own as well as others'—are often regarded with a certain suspicion. What they are suspected of is being better at talking a painting than at painting one. The suspicion is quickly elevated to a certainty, moreover, if the painter in question is also known to be a first-rate writer on art. By and large, the art world tends to be more comfortable with talents that are nicely segregated, and trespassers are sometimes punished.

Yet despite the fact that the art world is full of clever people who are better at talking than at painting, the suspicions I speak of cannot invariably be relied upon to place an artist's work. Chore though it may be for some overburdened souls, we are still obliged to examine pictures

before we pronounce judgment on them—to look at them, as I heard someone say the other night, "one at a time." This is a phrase that made a deep impression on me as soon as it passed the speaker's lips, for it had never before occurred to me that painting could be looked at any other way. Well, we learn something every day, especially at exhibition openings.

I was thinking of all this when, a few days ago, I went up to New Haven—not, I must admit, one of my favorite cities—to see the Andrew Forge retrospective at the Yale Center for British Art. Everyone in the art world either knows Mr. Forge, or knows of him. But not as a painter. He is known as a teacher, a lecturer, and a writer. He taught first in London, then in New York, then for twenty years at the Yale University School of Art, where he also served as dean. He has been one of our best teachers of painting—and a much beloved figure in that capacity. For almost as long as I can remember, he has also been one of our best writers on art—author of, among much else, two marvelous books on Pierre Auguste Renoir and Claude Monet.

Yet it is no exaggeration to say that *as a painter* Andrew Forge has remained a largely unknown talent on both sides of the Atlantic. Unless you had the good fortune over the last two decades to be closely involved with the Yale School of Art or the New York Studio School, where Mr. Forge has also been a teacher and lecturer, you are unlikely to have seen his pictures. It is for this reason that *Andrew Forge: A Retrospective* at the Yale Center for British Art is something of an event—a bigger event, indeed, than the artist's small circle of admirers may have expected it to be.

With this exhibition, Mr. Forge, who was born in 1923 and first studied painting with William Coldstream, Kenneth Martin, and Victor Pasmore at the Camberwell School of Art in London, is now seen to be something more than a very good painter. He must now be regarded—in my view, anyway—as one of the most accomplished painters of his generation anywhere. This is the kind of exhibition that requires us to make a revision in the way we think about the achievements of painting since the 1970s, for in any serious account of the subject, Mr. Forge will henceforth have to be afforded a significant place.

Be warned, however, that Mr. Forge's paintings are not the sort that can be taken in by a hasty glance. They really do have to be looked at "one at a time." Or, as Mr. Forge has said of his own pictures, "They are

a long time in the making; they also take a long time to look at." This is painting that seems to begin in a realm of unstructured painterly abstraction and only gradually, by way of small poetic increments, discovers through a visual memory and association its ostensible "subject" or motif. What begins as a lyrical improvisation of luminous touches (or "dots") of color reveals a wealth of perceived experience—the fugitive experience of nature as it reposes and recomposes itself in a pictorial imagination alert to its every visual nuance.

Certain paintings seem to address the subject of seasonal change, and are on that account named after months of the year. Others may or may not be phantom cityscapes or evocations of a nude torso, but what is never in doubt is the nearly flawless pictorial command. This is painting of tremendous virtuosity and tact—the kind of painting that requires years of experience with the medium, and with life, to achieve.

The paintings I speak of—which, for want of a better term, may be described as postabstract neo-impressionist—all date from 1973 to the present. Several were completed this year, and it is painting of this persuasion that dominates the current retrospective. The exhibition commences, however, with a very northerly *Winter Landscape* from 1951 and a series of cold-climate nudes and landscapes from the later 1950s and '60s. What is remarkable about these earlier paintings is their command of and sheer affection for the medium, and they leave us in no doubt that it was in this period that Mr. Forge discovered his true vocation.

Then there is a hiatus of a decade, 1964 to 1973, that is not represented in the exhibition. It was in 1973 that Mr. Forge came to New York to teach, first at Cooper Union, and this change of venue seems to have provided the artist with the impetus—and, I suspect, the time—that his talents needed for their full realization. It is, in any case, for the paintings he has produced since the 1970s that he has now won a place for himself in the history books. A few years ago, Mr. Forge wrote something about Monet that I believe offers us an important clue to his own pictorial endeavors, for at the time of writing he was also hard at work on many of the paintings in this exhibition. "To paint," he observed, "is as necessarily sequential as to play chess. Meanwhile, somewhere between time 'out there' in the changing light and time 'here' in the sequence of changes on the canvas, there is another unfolding in time, the gradual movement toward understanding in which the evolving painting reveals its nature."

For the viewer, too, a good deal of the pleasure to be derived from this exhibition comes from that "gradual movement toward understanding" the nature of Andrew Forge's achievement.

[1996]

The Somber Brilliance of Braque's Late Work

It may sound odd to suggest that an artist as famous as Georges Braque (1882–1963) is nowadays underappreciated—or even, perhaps, unduly neglected. His celebrated collaboration with Picasso in creating Cubism is, after all, universally recognized as one of the pivotal events of the modern movement. But of Braque's artistic achievements after that historic collaboration, the public—on this side of the Atlantic, anyway—has rarely taken an excited interest.

Braque was never the kind of artist who was supported in the public mind by a compelling personal myth. There were no sexual scandals or political outrages associated with his name. He had but a single wife, to whom he remained devoted, and he played no role in public life. To be interested in Braque—in Braque after Picasso, so to speak—you had to be interested, really interested, in painting rather than the things that sometimes surround it, and that is often a rarer interest for the art public than is commonly acknowledged.

For people of so-called avant-garde taste, moreover, post-Picasso Braque represented another kind of problem—the problem of Late Cubism, which in the period immediately following World War II was often thought to represent the academicization of a once revolutionary style. This, like a good many other avant-garde illusions of the period, is an aesthetic prejudice that is nowadays somewhat abated. But in its day, it no doubt contributed something to a disinclination to comprehend the magnitude of Braque's pictorial achievement in the later decades of his life. As a result, Braque came to be regarded as a master who could

be taken for granted, an artist assured of his place in history but without a compelling appeal for contemporary tastes.

For all of these reasons, it is especially regrettable that the exhibition called *Braque: The Late Works*, which has just opened at the Royal Academy of Arts in London, will not be coming to New York. For myself, anyway, this exhibition has proven to be something of a revelation. It is at once deeply serious and deeply moving. For this is a very somber exhibition in which we are made witness to a great painter's attempt to come to terms with the gravity of feeling generated by war, conquest, and their aftermath—meaning, of course, the condition of France in the 1940s and '50s—and yet remain faithful to the purely aesthetic demands of his art.

What these late works of Braque constitute, in effect, is a series of elegies or meditations on the experience of enduring that catastrophe. At the same time, these paintings are also a series of meditations on the nature of painting itself, about its capacity to encompass a world that resists fixity and settled definition. They are not what in any conventional sense could be called history paintings. Yet, they must now be seen to have a place among the relatively few works of genius—beside, that is, the sculptures of Alberto Giacometti and the plays of Samuel Beckett, especially *Waiting for Godot*—that still have more to tell us about the spiritual history of the war and its aftermath than almost anything else produced at the time.

"People don't take sufficiently into account the dark forces that impel us," Braque remarked in 1939, and that observation could easily have served as an epigraph to the *Late Works* exhibition. What makes Braque's artistic success so extraordinary in the difficult endeavor he set for himself in this period is the self-imposed restrictions he rigorously observed in pursuing it. For this is largely an exhibition limited to still lifes and studio interiors, which are not genres traditionally associated with the elegiac mode—not in modern painting, anyway. Unlike Picasso and Matisse, Braque was never primarily a painter of the figure, and he didn't become one in the late works. He had begun as a landscape painter, and, as this exhibition reminds us, he returned to landscape in his very last years. But it was in the paintings of objects and the space they occupy that Braque concentrated his elegiac vision of "those dark forces that impel us," thus transforming the still life and the studio interior into vehicles of tragedy.

To encompass the "dark forces" that haunted him in this work, Braque's palette grew progressively darker as he explored his restricted themes. Though there are moments of light and occasional forays into vivid color, the late paintings are largely executed in greys, blacks, and earth colors. And what an amazing range of greys and blacks Braque was able to summon to his purpose in these paintings! He had always, of course, been one of the consummate painterly craftsmen of his time, a painter with a total command of his medium who was also deeply suspicious of his own facility and determined to resist it. The discipline he had acquired in this regard was put to magnificent purpose in the late works, where every temptation to an easy appeal is resisted and the reigning temper of his art is governed by an elevated and deeply pondered austerity.

From the first masterpiece we encounter in the Royal Academy show—the *Large Interior with Palette* (1942)—to the marvelous room in which we are surrounded by the black *Atelier* paintings of the late 1940s and early '50s, and the *Billiard Table* pictures that immediately precede them, to the last room that contains not only the last, very melancholy landscapes but an utterly astonishing painting, from 1960, of a rusted-out plow reposing in a field of bright sunshine, we are shocked into discovering, or rediscovering, what a great painter Braque was in these years. Even where color is allowed, on occasion, to assert its prerogatives—as in two of the most ambitious of the paintings of the 1950s, *Atelier VIII* (1954–1955) and *The Echo* (1953–1956)—the mood remains somber, and the elegiac spirit unbroken. As for all the old arguments of Late Cubism, if we remember them at all after seeing this exhibition, they are bound to seem faintly ridiculous.

Braque: The Late Works is not, to be sure, one of those overblown blockbuster exhibitions of the type that is nowadays devoted to Picasso—and, for that matter, to the likes of Jasper Johns and Andy Warhol. It numbers a mere forty-five pictures that are hung in four ample galleries: one could wish that it were somewhat larger than it is, that the walls of the galleries containing it hadn't been painted a hideous green for the occasion, and so on. But the show itself has been splendidly organized by John Golding, who has also contributed an excellent essay to its catalogue. And it would not have been wise, in any case, to make the exhibition very much larger than it is, given its emotional tenor. If it succeeds in making us wish to see a good deal more of late Braque in the future, that too is all to the good. My principal regret is that the show will not be seen in

New York, where I think serious painters are more and more in need of such an exhibition.

[1997]

Richard Diebenkorn at the Whitney

Few painters of his generation in America are more highly esteemed today—esteemed, that is, as painters—than the late Richard Diebenkorn (1922–1993). Yet visitors to the Diebenkorn retrospective that Jane Livingston has now organized at the Whitney Museum of American Art will quickly discover much that is new to them. Few of us have seen as many examples of the artist's Abstract Expressionist paintings from the 1950s as Ms. Livingston has brought together in this show. There are also some rarely seen landscapes, figure paintings, and still lifes, shown in the company of Diebenkorn's best-known representational paintings. And if only for its stunning selection of paintings and drawings from the artist's Ocean Park series—surely Diebenkorn's crowning achievement—this exhibition would be a capital event. So there is a lot to look at in this retrospective, at least for that surviving remnant of the art public that still takes a serious and knowledgeable interest in the fine art of painting and in the kind of drawing that sustains it. There is also a lot of art history packed into this exhibition. I don't mean the history of reputations and publicity and shocks to the solar plexus, but the history in which we can trace an artist's thinking as he attempts to comprehend both the artistic past and the art of his own contemporaries for whatever may be usable in extending the range of his creative endeavors. Every artist carries in his head—which is to say, his imagination—certain touchstones of quality and achievement that are felt to have a direct bearing on his own developing vision of what at any given moment may be possible in art, and Diebenkorn wasn't shy about acknowledging and acting upon such models. He clearly considered himself to be part of a tradition—a modernist tradition, in his case—that he hoped to advance at something like the same level of quality that he admired in the masters he favored.

He thus set a very high standard for himself, and for many of his contemporaries as well—a standard that invites us, too, to see his work in relation to the tradition he aspired to uphold. In large part, it was an American standard, and in an even larger part, perhaps, it was a School of Paris standard. But this conjunction of American experience and Parisian modernism is itself the tradition that has so often produced the best American modernist art in this century.

It is for this reason that on the basis of this retrospective alone one could almost write a comprehensive chronicle of the aesthetic relationships that have tethered the fate of American modernist painting in the last half of the twentieth century to the precedents and standards of modernist painting in Paris in the early decades of the century. In what other American pictorial oeuvre do we find the ideas of such diverse talents as Edward Hopper and Willem de Kooning, Piet Mondrian and Henri Matisse, so deeply pondered, so openly acknowledged, yet so delicately assimilated and so triumphantly transcended?

At the same time, there is something else in Diebenkorn's art that is important for us to take account of—its West Coast, Californian character, which gives to even his most abstract paintings the look and feel of something pastoral. This is true even of Diebenkorn's California cityscapes, in which the man-made urban environment dissolves into a pastoral patchwork of California light and shadow. In this exhibition the Californian accent announces itself straightaway in the Abstract Expressionist paintings of the 1950s. De Kooning is clearly a central influence in these paintings, and there are hints of Franz Kline and even Mark Rothko. Yet the light in these paintings is not the light of the New York School, and in these paintings, too, the forms are more suggestive of pastoral pleasures than of urban anxieties.

This may be one of the reasons why it took a while for Diebenkorn's painting to be accepted by critical opinion in New York. In his Abstract Expressionist period, he didn't seem "tough" enough to meet the New York—or perhaps I should say, the Tenth Street—macho standard. And then when he started painting figures in the California landscape, the partisans of the New York School hastened to nail him as a provincial, after all. It was all a part of conventional art-world wisdom of the period. (And it wasn't only to Californian figurative painting that it proved to be prejudicial; Fairfield Porter's paintings of Maine and Long Island were treated with the same condescension.) Forty years later, many of

those overrated Tenth Street reputations are forgotten, and Diebenkorn has emerged as an underrated master.

There are certain moments in this retrospective in which we are given such a clear glimpse of the artist rethinking the very basis of his art that they have the quality of high drama. One of these moments comes in the group of small painterly still-life pictures from the early 1960s that occupy an entire wall of the exhibition. Suddenly we are transported back in time to Manet, or some memory of Manet, in paintings that seem to sever all connection with the abstractions and even the landscapes and figure paintings that occupy adjacent galleries. One is reminded of the way Matisse often shifted his ground backward, so to speak, before undertaking his next radical departure.

But it is in the paintings that register Diebenkorn's most fateful encounter with Matisse's art that the most dramatic moment in this exhibition occurs. When Diebenkorn finally got to see the Matisses in the Hermitage collection in Leningrad (as it was then called) in the 1960s, it was clearly the most decisive moment of his career. From that moment, everything shifts onto a higher plateau of painterly aspiration. You see it first in such pictures as *Recollections of a Visit to Leningrad* (1965), which should really have been called *Recollections of Seeing the Matisses in Leningrad*, and the magisterial *Large Still Life* of 1966. Yet the greatest artistic consequence of that encounter with Matisse in Leningrad was the heroic Ocean Park series, which Diebenkorn commenced to create shortly thereafter.

Going through this extraordinary retrospective, what came to mind more than once was that remarkable passage in the text that Matisse wrote for *Jazz* in which he warned that an artist should never become a prisoner of his own style, a prisoner of his own reputation, or a prisoner of his own success. Then he recalls that the Goncourt brothers wrote of certain Japanese artists that they even changed their names in the course of their careers in order to pursue new departures. "I like that," Matisse wrote, "they wished to safeguard their freedom."

Few artists of our time have made more of that kind of "freedom" than Richard Diebenkorn—which is why this retrospective is such an absorbing event. It needs to be remembered, however, that you do have to bring a certain interest in the art of painting to fathom what, in Diebenkorn's case, that kind of freedom made possible.

[1997]

Arthur Dove at the Phillips Collection

"Americans are supposed to paint as if they had never seen another picture." That disheartening observation was made in a moment of exasperation and despair by the American painter Arthur Dove (1880–1946) sometime in the 1930s—a decade that was not an easy period for an artist of his persuasion. By the mid-1930s, Dove had for a quarter of a century been creating pictures that are both remarkably original and yet very much akin to the paintings of certain other modern masters. Yet pictures of the kind he favored, which were either completely abstract or tending toward abstraction even when openly addressed to subjects drawn from nature, were still regarded as an alien presence on the American art scene. There was not yet much of an awareness in the public mind that modernism, while still castigated by academic realists, social realists, regional muralists, and sundry other champions of "tradition," was now itself a vital tradition that an artist like Dove could continue to draw upon for inspiration and support. For many benighted souls, modern art was still thought to be a hoax perpetrated by people who "had never seen another picture."

With what ardor, invention, and lyric grace Dove did indeed continue to work in this modernist tradition in his later years is made wonderfully vivid for us in the superb retrospective of his work that has now been organized at the Phillips Collection in Washington. *Arthur Dove: A Retrospective* is quite the best exhibition of this artist's work I have ever seen—and I think I've seen all the major Dove shows of the last forty years. Beginning with a *Still Life Against Flowered Wallpaper* (1909) and ending with *Flat Surfaces* (1946), his last major painting, this retrospective does full justice to every phase of Dove's development. There are things in this exhibition that I, at least, do not remember seeing before, and even the most familiar paintings and assemblages are seen in a new light in a survey that encompasses some seventy-eight objects.

It has become the custom in discussions of Dove's work, owing to the small oils he called *Abstractions* in 1910–1911, to make much of his status as a pioneer of abstract painting—even, perhaps, the pioneer, superseding the claims made for Vasily Kandinsky, as Debra Bricker Balken

puts it in the catalogue of this show, "by maybe a year." But as Ms. Balken also points out, the question of what Dove knew or did not know about Kandinsky at that early date remains unresolved and is probably unresolvable. It is exacerbated, moreover, by the attempt made by Dove's dealer and patron, Alfred Stieglitz—who really was familiar with Kandinsky's ideas—to capitalize on Dove's early abstractions in order, as Ms. Balken writes, "to buttress his [Stieglitz's] growing claims for America's artistic parity with Europe."

In my view, however, "America's artistic parity with Europe" did not then exist, and to claim otherwise places an aesthetic and historical burden on those early abstractions of Dove's which the work itself cannot support. To my eyes, anyway, those pictures read more as symbolist paintings based on motifs drawn from nature than as abstract paintings that abjure all reference to recognizable objects. It is no insult to Dove, either, to be reminded that in 1910–1911 he was not yet an artist in Kandinsky's league. Alfred Stieglitz had many admirable qualities, as we see illustrated in his early support of Dove, but it is worth remembering that as a dealer he was no stranger to what later came to be called hype. In the New York art world, he was indeed one of its pioneers.

It isn't, in any case, in the early work in this Dove retrospective that the artist's finest achievements are to be found. Dove doesn't really hit his stride as a modernist painter of remarkable originality until the 1920s when, for the first time, almost every object he produces—collage and assemblage as well as well as paintings—is wholly individual in conception and beautifully realized in the execution. Still largely based on nature, the paintings move in and out of the realm of abstraction so consistently that the distinction often made between abstraction and representation in his work hardly matters.

The most audacious of his pictures in the 1920s are undoubtedly the assemblages that make use of unconventional materials—which have, alas, become all too conventional in our own day—and the paintings that are similarly executed in mixed media. *Rain* (1924), for example, is an assemblage composed of twigs and rubber cement on metal and glass. *Starry Heavens* (also 1924) is a painting executed in oil and metallic paint on the reverse side of a glass plate backed with black paper. The most famous of the assemblages—*Goin' Fishin'* (1925)—uses bamboo and the sleeves and buttons of a blue denim shirt, while the extraordinary painting called *Hand Sewing Machine* (1927) applies oil pigment, cut and pasted linen, and graphite to a sheet of aluminum.

Oddly enough, it is in this period, too, that Dove produced his most Kandinskyish abstract painting—*George Gershwin*—*"Rhapsody in Blue," Part II* (1927), which has the look of the kind of "Improvisation" that Kandinsky himself had abandoned more than a decade earlier. The connection probably had more to do with the parallels both painters believed united abstract painting and classical music than with any conscious effort on Dove's part to imitate Kandinsky—but the resemblances are nonetheless striking.

By the 1930s the assemblages and the unconventional materials are largely abandoned as Dove, whose health had begun to deteriorate, concentrates exclusively on the art of painting. In this retrospective, "late" Dove emerges as the primary Dove, for it was in his last years that he created his greatest abstract paintings—*Naples Yellow Morning* (1935), the three *Sunrise* paintings (1936), *Flour Mill II* (1938), *Rain or Snow* (1943), *Sand and Sea* (1943), *Roof Tops* (1943), *That Red One* (1944), and the final *Flat Surfaces* (1946).

What William Agee says about *Flat Surfaces* in the catalogue of this retrospective—"It is a singularly personal variant of abstract art of the time, while closely paralleling the work of Robert Motherwell, and within a few years, of David Smith and Ellsworth Kelly"—might also be said of certain other late abstractions in the exhibition. My own favorite is *That Red One*, which I think is a finer, deeper painting than anything I know of in the oeuvres of either Motherwell or Kelly.

The extent to which Dove was consciously working within the tradition of modernist abstraction during this late period is well documented for us by Mr. Agee in the catalogue. "In April 1936, while visiting New York," he writes, "Dove had seen and commented favorably on the landmark exhibition Cubism and Abstract Art at the Museum of Modern Art. A week later, on April 23, he visited A. E. Gallatin's Gallery of Living Art at New York University, where he would have seen a broad group of important abstract and nonobjective paintings, including work by Mondrian. . . . Two months later, Dove went to the trouble of translating an article by Mondrian, most likely Mondrian's response to an inquiry into the state of modern art published in a 1935 issue of *Cahiers d'art*." And so on. Dove, who spent time in Paris before the First World War, knew what the standards of achievement were for the kind of art he aspired to create, and in the late work he met those standards more consistently than at any other time in his life. It was a considerable

achievement, and it is our good luck that this retrospective does it such justice.

[1997]

Richard Pousette-Dart at the Met

Among admirers of the late Richard Pousette-Dart, the exhibition of his paintings that has now been organized by Lowery Stokes Sims at the Metropolitan Museum of Art is likely to elicit some mixed emotions— on the one hand, gratitude and delight that this still underrated and often misunderstood modern master has at last been accorded official recognition by the greatest of our museums; yet, on the other hand, disappointment that the exhibition has come so late and is so woefully unequal in scale to the actual dimensions of the artist's achievement. Richard Pousette-Dart was one of the youngest and most precocious painters of the New York School. He was also one of the most productive, enjoying a career that was far longer than almost any of his contemporaries in the Abstract Expressionist movement. He came to his vocation as an abstract painter earlier than most, and in the painting called *Symphony No. 1, The Transcendental* (1941–1942), he produced at the age of twenty-six what may very well be the first large-scale masterwork of the New York School. And he continued to create paintings of remarkable quality, variety, and size for another fifty years.

Yet it is a fact of cultural life in the 1990s that this artist's work still remains more or less unknown to the many people in the New York art world who fancy they know everything there is to know about the art of the New York School. All of this might have definitively changed had the marvelous retrospective organized by Joanne Kuebler in 1990 at the Indianapolis Museum of Art come to New York. But it didn't, and so an entire younger generation in the New York art world—including some of its critics—has been left in ignorance about a body of work never actually seen in all of its amazing variety and depth.

It is no criticism of Ms. Sims, who has devoted many years to the study of the artist's work, to report that the exhibition she has now organized in *Richard Pousette-Dart, 1916–1992*, is not a retrospective on the scale of the Indianapolis exhibition. Consisting, as it does, of thirty-three paintings from the years 1939–1990, plus some early drawings, a few sketchbooks, and a display of brass objects, the current exhibition at the Met is more in the nature of an introduction to the artist's oeuvre than a full-scale account of it. As such, it serves its purpose well, and it has the additional virtue of bringing us certain pictures that few of us are likely to have seen before. The scandal is that an artist of Pousette-Dart's accomplishment still needs an "introduction" to our increasingly amnesiac art public.

It needs also to be said, however, that Pousette-Dart's paintings do not easily conform to certain ideas that have come to be identified with the art of the New York School. There is little in his painting, for example, that resembles the kind of athletic improvisational gesture that characterizes certain works of Jackson Pollock, Willem de Kooning, and Franz Kline, and there is even less that conforms to the hard-edge geometrical forms we find in Ad Reinhardt or the fields of unbroken color in Barnett Newman. From the outset, Pousette-Dart was a painter who brought a more deliberate, painstaking concentration to the physical realization of the painted surface. While many of his contemporaries in the New York School worked toward simplifying their forms and thinning their facture to a watercolorlike transparency, Pousette-Dart remained committed to working by means of a slow accretion of dense painterly touches that brought to his pictures a visual richness and complexity that could not be achieved by any other means.

The miracle is that a pictorial method so dependent upon the working and reworking of the painting's material density should result in an imagery of such extraordinary spiritual radiance. But this is the miracle we encounter in all of the artist's most successful pictures. It is all the more remarkable when we see, as we are able to do in the current exhibition, that this essential impulse in Pousette-Dart's work has its origins in an art immersed in nocturnal shadows—not only in *Symphony No. 1* but in *Figure* (1944–1945), *Fugue No. 4* (1947), and certain other early pictures—and only slowly found its way toward celebrating a kind of celestial light in *Path of the Hero* (1950), *Chavade* (1951), and in so many of the paintings that follow in the remaining decades of the artist's life.

It was in the pursuit of that celestial light, which gave expression to the artist's mystical beliefs, that Pousette-Dart's pictorial imagination was most deeply engaged throughout his long career. Lest it be thought peculiar that painting of this abstract persuasion should owe so much to mystical belief, it is worth recalling that the principal pioneers of abstract painting—Piet Mondrian, Vasily Kandinsky, and Kazimir Malevich—were all similarly disposed to identify their pictorial innovations with a variety of mystical ideas. Far from being an eccentric in this respect, Pousette-Dart may be said to have carried forward one of the central traditions of modernist painting in allying his art with the realm of mystical thought.

For nonmystics like myself, however, this inevitably raises the question of exactly how we are to respond to the "content" of an art so deeply immersed in a mode of mystical belief. The best answer to that question that I know of is to be found in one of the essays of Wallace Stevens, written around 1937, in which this great poet offered some reflections on the problem of "the irrational" and "the unknown."

"The irrational bears the same relation to the rational that the unknown bears to the known," wrote Stevens. "In an age as harsh as it is intelligent, phrases about the unknown are quickly dismissed. I do not for a moment mean to indulge in mystical rhetoric, since, for my part, I have no patience with that sort of thing." But then, Stevens reverses his course by observing: "That the unknown as the source of knowledge, as the object of thought, is part of the dynamics of the known does not permit of denial." And further: "We accept the unknown even when we are most skeptical. We may resent the consideration of it by any except the most lucid mind; but when so considered, it has seductions more powerful and more profound than those of the known."

This may be a useful thought for visitors to the Pousette-Dart exhibition at the Met to bear in mind as they encounter some of the artist's statements that are inscribed on the walls of the show and quoted at greater length in Ms. Sims's contribution to its catalogue. As Stephen Polcari also makes clear in his essay for the catalogue, to ignore such questions in relation to the art of the New York School is to ignore something essential about the ideas that shaped the early course of the Abstract Expressionist movement. It is certainly to ignore something essential about the ideas that governed the art of Richard Pousette-Dart.

But in regard to our understanding of that art, the current exhibition at the Met must be regarded more as a beginning than a culmination.

There is far more to be discovered in Pousette-Dart's oeuvre than the public has ever been shown or the critics have ever written about.

[1997]

Gustave Courbet at Salander-O'Reilly

Late Courbet? It's my impression that, unlike late Monet or late Cézanne, late Courbet is not a subject commonly given special attention, even by the artist's admirers. Gustave Courbet (1819–1877) has long been recognized as one of the greatest masters of nineteenth-century French painting, yet much of the last decade of his often turbulent career was—in everything but his painting—a debacle that ended in humiliation and disgrace. It began, to be sure, with the clamor of acclaim. With characteristic bravado, Courbet had mounted a mammoth retrospective of his own work—it consisted of more than one hundred pictures exhibited in a private pavilion—at the time of the Paris World's Fair in 1867, and it proved to be a triumph. The painter who had earlier on been mocked as an oaf and an upstart was now embraced as a living master. As Jean-Jacques Fernier, curator of the Musée Courbet in Ornans, writes in the catalogue accompanying the exhibition of *Gustave Courbet: Later Paintings*, which has now been organized at the Salander-O'Reilly Galleries, "During the late 1860s, Courbet was as famous in Frankfurt, Montpellier, Munich, and Deauville as Picasso was on the Côte d'Azur, or Andy Warhol was in New York. Courbet was a 'star.'" In 1870 he was even offered the Legion of Honor, which he grandly refused—though a year earlier he had readily accepted a decoration from the King of Bavaria, where his work had won the esteem of the leading German painters of the day.

Then came the Franco-Prussian War, in which France suffered a devastating defeat. Always something of a political radical, Courbet joined the revolutionaries of the Commune that temporarily attempted to govern the city of Paris. When the Commune fell, he was arrested and given a short prison term. Upon his release in early 1872, he found the official art

world closed to him. Then a vindictive French government imposed an enormous fine for Courbet's alleged role in the destruction of a public monument while a member of the Commune. Never a teetotaler, he was also drinking too much, and his health was failing. He fled to Switzerland, where he set up a new studio in a small town on the Lake of Geneva. It was there that he died an invalid on the last day of 1877.

Yet, being Courbet—which is to say, a painter of irrepressible energy, ambition, and genius—he continued in those last years to work like the inspired monomaniac that he was. According to Mr. Fernier, "Courbet's production after 1870 is vast," and it includes some of his loveliest and most original paintings. Most of these are devoted to subjects drawn from nature—landscape, water, and sky—which are painted with a mastery that is all the more breathtaking when we come to understand the ordeal that Courbet was enduring at the time of their execution. It is only in certain of the "darker" paintings of the late period, in which storm clouds may be seen to portend a menacing fate and mountain peaks loom as symbols of an insurmountable destiny, that we may be tempted to see evidence of Courbet's troubled state of mind. On the other hand, it is more likely that he was drawn to these subjects because they offered a fresh challenge to his pictorial powers.

In the exhibition at the Salander-O'Reilly Galleries, which brings together thirty-four paintings from museum and private collections here and abroad, the earliest of these "later" pictures is the spectacular *Fox in the Snow* (circa 1860), from the Musée Courbet. Considering some of the nonsense that has recently been written about Courbet's animal pictures, it is a salutary experience to be reminded that Courbet was, above all, a virtuosic painter of realistic subjects drawn from nature and not at all a harbinger of the kind of late-twentieth-century postmodern art theory that has now made the study of painting such a farce in our universities.

It is still another virtue of the current exhibition that it includes two splendid portraits, both painted in 1862, to remind us of Courbet's debt to a pictorial tradition that he continued to venerate even in the course of the many radical changes he brought to it. There is also the wonderful *Portrait of Jo, the Beautiful Irish Girl* (1866), from the Nelson-Atkins Museum in Kansas City, which was last seen here in the *Courbet Rediscovered* exhibition at the Brooklyn Museum in 1988. And lest we forget that Courbet was also one of the great painters of the female nude, there is the terrific *Bather* (circa 1865).

Yet the primary focus of this *Later Paintings* exhibition is inevitably on the landscapes and seascapes, and among them are three extraordinary examples of the so-called wave paintings that must be counted as some of the most moving and original of Courbet's late masterpieces: *The Wave, Stormy Weather* (1869), *Waves* (1869), and *The Black Rocks* (1872). Seeing this *Stormy Weather* painting, I could not resist wondering if Marsden Hartley had ever had a glimpse of this remarkable picture, for between it and some of the stormy-sea pictures that Hartley painted in Maine in the early 1940s there are many striking resemblances. Even more haunting, in some respects, is *The Black Rocks*, with its clouds, which seem to be illuminated by an unearthly fire that is reflected in delicate touches on the black rocks in the foreground. That Courbet was able to create so fine a painting at a moment when his worldly fortunes had sunk so low is astounding. But then, of course, Courbet went in for astounding his public. He was the very archetype of the impudent genius—a terrible showoff, in fact, who had the irritating habit of always producing something worth showing.

One of the latest and gloomiest of the paintings in the show—one of the toughest as well—is a small canvas called *Landscape in the Alps* (1874), from the Art Institute of Chicago. If only for the brute force with which the mountains in this picture have been laid in with the palette knife, this painting, too, is an unforgettable experience. I don't ever recall seeing this picture on public view at the Art Institute, but there are a number of other pictures in this exhibition that will be equally unfamiliar to most of us.

Need I add that *Gustave Courbet: Later Paintings* is an exhibition not to be missed?

[1998]

Jinny and Bagley Wright Collection at the Seattle Art Museum

There are times when one has to travel a certain distance to acquire some perspective on the recent history of the New York art scene. It's

not that travel is likely to alter our judgment of artists whose work is already well known to us. That—in my experience, anyway—rarely occurs. The true believers remain secure in their faith; the skeptics remain skeptical. Yet a change of venue—and the kinds of changes in the conversation about art that is its inevitable accompaniment—often does give us a vivid sense of how such work is perceived when it comes to rest in collections far from the milieu of its initial reception. In other words, when the work ceases to be contemporary and becomes historical. Or, as we say now, when it enters the canon of established taste. I have been thinking about this experience since returning earlier this month from Seattle—a city I had not visited since the 1980s—where I had gone to attend the opening of the Virginia and Bagley Wright Collection of Modern Art exhibition at the Seattle Art Museum. While I was delighted to see Seattle again, it was mainly to artistic developments and shifts of taste in New York over the last fifty years that the exhibition of the Wright collection turned my attention.

Among the earliest works in the show are Willem de Kooning's *Woman* (1943), Arshile Gorky's *How My Mother's Embroidered Apron Unfolds in My Life* (1944), David Smith's *Royal Incubator* (1949), and Mark Rothko's *Number 10* (1952). Among the most recent are Anselm Kiefer's *The Wave* (1990) and Katharina Fritsch's *Man and Mouse* (1991–1992), which are also among the largest works in the show. Thus the course that has been traversed on the New York scene from the heyday of the New York School in the 1940s and '50s to the German incursions of the '80s and '90s is well documented in this exhibition, and so are all the best-known intervening developments—hard-edge abstraction, Color-field painting, Pop Art, Minimalism, Neo-Expressionism, and sundry escapades claiming to be postmodern.

Opening at the same time as the show at the Seattle Art Museum, which numbers about one hundred works, was a new public exhibition space in the city devoted to other works in the Wright Collection. Although smaller in scale than the museum show—a mere twenty-two items—the artistic and historical mix was similar, ranging from de Kooning's *Warehouse Mannequins* (1949) to Tony Cragg's *Eroded Landscape* (1998). Taken together, then, both shows had the effect of confronting the visitor with the problems that are inherent in current thinking about the canon of modernist art.

Only the other day, it seems, many of the artists represented in the Wright collection exhibitions were still looked upon as contemporary—meaning, among much else, that their artistic importance was still in contention. Yet in these exhibitions they are presented to the public as exemplars of modern art—which, if it means anything in a period more and more eager to be seen as postmodern, means that the artists in question are believed to occupy a place in a tradition deriving from Cézanne, Matisse, Picasso, Braque, Mondrian, Miró, Kandinsky, Brancusi, and certain other modern masters. That, however, is a very stiff standard for most of yesterday's contemporaries to meet, and in my view very few of them do in fact even come close to meeting it.

Yet I believe the Wrights are correct in calling theirs a collection of modern art, for every work in these two exhibitions derives its aesthetic sanction from one or another aspect of the modernist movement. If inspiration is drawn from Duchamp rather than from Mondrian, that is certainly no reason to regard the result as postmodern, for it is only within the boundaries of a modernist sensibility that Duchamp's readymades have any meaning at all. The whole notion of postmodernism is little more than a critical fiction, a strategy designed to escape the standards and strictures of modernism itself when it is not simply a polemical ploy designed to discredit the ideas of Clement Greenberg.

What is nowadays advertised as postmodernism would more accurately be described, I think, as late modernism or even low modernism—modernism engaged in a fierce polemic with itself. Polemics of that kind have been a constituent strain of the modernist movement from the outset, however, and it doesn't advance our understanding of anything that has occurred in the art of the 1980s and '90s to call it something else. As we are all, perforce, the creatures of a modernity we cannot escape, so is our art of every persuasion a modernist art of one variety or another.

It is indeed the primary interest of the Wright collection that it embraces that variety without attempting to resolve its many conflicts and contradictions. The story of how the collection was assembled is recounted by Bagley Wright in a wonderful essay for the catalogue of the museum show called "Our Lives as Collectors." In the early 1950s, Jinny Wright, fresh from studying art history at Barnard, was working at the Sidney Janis Gallery. Bagley Wright, just out of Princeton, where he had majored in English, was working on the night shift of the *New York Mir-*

ror, a long defunct tabloid he describes as "the last of the spit-on-the-floor dailies."

"What a marvelous time it was to be a collector," he writes, "when only a few collected and the best paintings being done anywhere in the world were available for a few hundred or at the most a few thousand dollars. From this period came the de Kooning, Guston, Rothko, and Pollock that formed the foundation of our collection." About acquiring the Rothko, he tells the following story: "The first really important large painting Jinny acquired was Mark Rothko's *Number 10*, but she got it only after a protracted negotiation. The problem wasn't the price ($1,200), it was Jinny. Was she worthy, in Rothko's judgment, to own one of his masterpieces? His dealer at that time, Betty Parsons, arranged a meeting. Rothko was charmed by Jinny. With certain restrictions—no exhibitions, no photos—she was allowed to have it. I doubt that Rothko had sold more than a dozen paintings in his life, but like all the Abstract Expressionists, he had a high opinion of himself and his calling."

In this memoir, Mr. Wright also gives us a shrewd and affectionate account of Clement Greenberg and pays tribute, too, to the dealer Dick Bellamy, both of whom he acknowledges as important influences on the collection. Especially in his evocation of the New York art world in the 1950s and early '60s, he has a very engaging story to tell, and he tells it well. He doesn't hesitate to recount the kind of resistance the Wrights' efforts on behalf of some of their favorite artists have sometimes met with, either. When the Virginia Wright Fund commissioned a Mark di Suvero sculpture for the campus of Western Washington University, it was assumed it would be a great hit. Instead, however, "They denounced his unpainted steel construction as the detritus of a military-industrial society. Only after it was painted red did they grudgingly accept it as art."

It was even worse with a Richard Serra commission. Failing to find an admiring public, Mr. Wright writes, "It has become a maintenance problem, the target of graffiti and scurrilous pamphlets plastered on its surface." All of which is a reminder that not all the criticism that is directed at the varieties of modernist art in the Wright Collection is what is written in the papers.

[1999]

Honoré Daumier at the Phillips Collection

There are retrospective exhibitions of well-known artists that ought to be accompanied by a warning label that would read: Do not understand this artist too quickly! In other words, what you know, or think you know, may not be all there is to know. The French painter, sculptor, and caricaturist Honoré Daumier (1808–1879), whose work is currently the subject of a large and wonderful exhibition at the Phillips Collection in Washington, D.C., is an artist who would certainly benefit from such a cautionary injunction, especially on this occasion. For this is, astonishingly, the first ever retrospective to give the public a comprehensive account of the entire range of Daumier's achievements. Famous he is, of course, and rightly so, for Daumier is an immensely appealing and accomplished artist. In every aspect of his work, he brings us closer to the life of his time at every level of society and culture than any other visual artist of his period, which was one of the greatest periods in the history of French culture. It is for this reason that his oeuvre has often been compared to Balzac's. Yet Daumier's fame mainly derives from but one aspect of his copious and many-sided endeavors: the pungent and abundant caricatures of contemporary social and political life that made him something of a culture hero in the middle and later decades of nineteenth-century France. That he might also have been a painter of considerable consequence, a sculptor of distinction, and a draftsman of genius are not matters that, until now, anyway, the public has been in much of a position to appreciate.

It is one of the many virtues of this Daumier retrospective that it accords to all of the artist's accomplishments the kind of concentrated attention they merit. The caricatures that made him famous are by no means neglected or diminished. They did indeed occupy a very large part of Daumier's life. He produced nearly five thousand of these satirical prints over the course of a fifty-year period, and for one of them— his horrific and hilarious *Gargantua* (1831), a scatological caricature of the French monarch Louis-Philippe—he was arrested and even served a brief prison term. The labor of study and selection that enabled the cu-

rators of the exhibition to reduce this enormous corpus of prints to a representative sampling of seventy-four lithographs for this show is impressive, to say the least, and does much to explain why such a retrospective had not been attempted before.

Even in this aspect of Daumier's oeuvre, which is the most familiar to most of us, there are many revelations to be savored. For they contain a range of subjects and sympathies, of irony and indignation, comedy and pathos, that is not customarily associated with the art of caricature. There is also a technical virtuosity that confers on each of its subjects, from the most repulsive to the most sympathetic, a finely judged emotion that is totally devoid of cant or sentimentality. No profession or social class is exempted from Daumier's undeceived comprehension of the human comedy, and every comic touch is accompanied by a mordancy that can make us shudder even before we have stopped laughing. It is no wonder that Baudelaire compared Daumier's caricatures to the plays of Molière.

In this exhibition, however, this classic corpus of caricatures shares attention with no less than seventy-five paintings, fifty-seven drawings and watercolors, and thirty-nine sculptures. It is the paintings that are likely to be the greatest revelation in this retrospective, for we have never before seen so many of them assembled in a single exhibition. Painting was anything but a sideline for Daumier. It was in fact the medium in which he made his most profound contribution to the art of his time. That he appears to have been entirely self-taught as a painter makes his achievement in this medium all the more remarkable.

As a painter he is usually classified as a Realist, but with a contemporary Realist like Courbet he had little in common. Daumier's is a much darker sensibility than Courbet's, a sensibility that is closer to that of the "black" paintings of Goya than to the sunlit world evoked in Courbet's landscapes. Daumier's is also a more urban, more cosmopolitan vision than Courbet's. The solitude that is Daumier's most powerful subject in his paintings is an urban solitude. The virtuosic attention to detail that is one of the glories of the artist's lithographs is often abandoned in the paintings in favor of a pictorial drama of light and shadow, with shadow the dominant element. Not always, to be sure. In a painting like *A Third-Class Carriage* (circa 1862–1864), in which a subject explored in the artist's lithographs is carried over into painting, certain details remain. But even there they are enclosed in a pictorial structure of shadow and silhouette. And in the later masterpieces like *Two Sculptors* (circa 1872–1875) and the

first version of *The Painter at His Easel* (circa 1870–1875), detail is radically occluded as we are plunged into a maelstrom of painterly dusk.

With these late paintings, which were produced when Daumier had abandoned caricature and was living in impoverished circumstances, it hardly makes any sense to consider him a Realist. He had in fact become a kind of Expressionist *avant la lettre*, and this was what he was seen to be by the very few connoisseurs of modern painting in the early decades of the twentieth century who were drawn to his work in this medium. One of the most perceptive of these connoisseurs was indeed Duncan Phillips, who, in founding the Phillips Collection in 1921, created the first museum of modern art in the United States. Phillips understood better than most that Daumier had created something distinctly modern in his painting. Which is why some of the greatest of Daumier's paintings, including the two late paintings already mentioned, were acquired early on for this distinguished collection of modern art.

No doubt this is also why the Phillips Collection is the only American venue for this marvelous Daumier retrospective, which has been organized by the Phillipses in collaboration with the National Gallery of Canada and the Réunion des Musées Nationaux in France.

[2000]

Thomas Eakins at the Philadelphia Museum

For a large part of the American art public, the Philadelphia painter Thomas Eakins (1844–1916) stands alone and unrivaled as the classic American representative of the Realist style. With subjects ranging from water sports and baseball to affectionate scenes of domestic life and portraits that are penetrating character studies of his Philadelphia contemporaries, Eakins created a corpus of American types and pastimes that, for sheer quality, gravity, and intelligence, no subsequent champion of the Realist style has been able to match.

That his career was also marked by scandal, rejection, and outright character assassination only adds to the luster of a fame that has elevated Eakins to the status of a national icon. We like our artist-heroes to be fiercely independent and disruptive, and Eakins leaves little to be desired in this respect, too. He made it a habit to offend established taste, not only in painting but in the realm of public morals as well, and this has also endeared him to posterity. Not that offending established taste was a difficult thing to accomplish in the Philadelphia of his day, which was nothing if not staid in its standards of respectability. Eakins even dressed for the role, affecting the kind of shabby attire that polite society looked upon as impermissibly "bohemian," especially for a teacher at the remorselessly respectable Pennsylvania Academy of the Fine Arts.

Thus, while Winslow Homer was undoubtedly more beloved, and both William Merritt Chase and John Singer Sargent were far too eager to please to be cast in a heroic role, Eakins remains a singular figure in the American art of his time—and indeed, in ours as well. Which is one reason why the comprehensive retrospective that has now been organized at the Philadelphia Museum of Art—*Thomas Eakins: American Realist*—is bound to be a huge success. Another reason, of course, is that Eakins brought a powerful, if narrow, talent to an oeuvre that is wonderfully accessible to every level of public perception. This is pictorial Realism unburdened by the modern appetite for ambiguity, irony, or obscurity. It is an art in which easily recognized sentiments and actions are clearly expressed in a manly, robust style that commands attention without challenging the boundaries of the mainstream imagination.

That the aesthetic elements in Eakins's art were deeply conservative, with affinities closer to academic tradition than to avant-garde innovation, has seldom been held against him. In fact, it is seldom even acknowledged. Owing to his reputation as a rebel and martyr at the Pennsylvania Academy, Eakins has been transformed in our literature into a kind of honorary modernist révolté, yet this is a classification that is denied in every square inch of painted canvas Eakins ever put his hand to. In every respect but one—his unremitting and incorruptible candor in registering the impact of his personal response to the American life of his time—Eakins remained a votary of academic tradition.

Yet this radical candor—which was abetted in Eakins's case by his keen interest in scientific standards of objectivity, and which was itself a

spur to clarity of expression—was sufficiently rare and sufficiently af-
fecting to set him apart from his contemporaries. Yet it was a candor ex-
pressed in an academic mode. No one understood the academic roots of
Eakins's art better than his widow, Susan Eakins, who was herself a gifted
painter, very much influenced by her husband's pictorial practice. Thus,
when Lloyd Goodrich's pioneering study of the artist, *Thomas Eakins,
His Life and Work*, was published in 1933, she was appalled to find that
Goodrich had "disregarded Eakins' roots in the French academic tradi-
tion," as Carol Troyen writes in the catalogue accompanying the current
retrospective.

Susan Eakins understood that, far from being a painter "little influ-
enced by others," as Goodrich had insisted, Eakins had been deeply
influenced by his period of study in Paris under Jean-Léon Gérôme, a
retardataire Academician whose work, as Goodrich surely understood,
commanded nothing but contempt in advanced art circles in the 1930s.
Susan Eakins thought otherwise, of course, observing that "when a man
cannot understand the greatness of Gérome I cannot think he under-
stands Eakins." To what extent Susan Eakins came to understand that her
husband had been a far greater painter than Gérome—and greater by
virtue of his radical candor in rendering the look and feel of contem-
porary life—must remain a matter of speculation.

In the current exhibition we are given a glimpse of the kind of ac-
ademic painter Eakins might have remained absent that candor in an
ambitious painting of a conventional religious subject, *The Crucifixion*
(1880), which—in my view, anyway—is the least persuasive of all of the
artist's major canvases. Compare it to the intensity of concentrated at-
tention in *The Gross Clinic* (1875) or the pathos of *The Concert Singer*
(1890–1892) or the controlled passion of the rowing pictures, and you
see the difference between an artist attempting to conform to conven-
tion and an artist inspired by the depth and complexity of his own re-
sponse to life.

In no other Eakins exhibition that I've seen have we been given
such a detailed account of the intellectual and aesthetic labor that
Eakins invested in perfecting his Realist masterpieces. In addition to the
expected drawings and oil sketches in the Philadelphia retrospective, we
are also given a plethora of his sculptural studies and the photographs
that were used in the preparation of his major paintings. Indeed, there

may be a few too many photographs in the current show for most viewers, for they are not all invariably interesting, and the sculpture, too, is mainly of interest as preparatory studies for the paintings. The sculpture, certainly, can leave no one in doubt about Eakins's academic loyalties.

It is in the paintings—and in the paintings alone—that Eakins's genius was fully developed. And it is in the paintings, too, that he remains an isolated figure in the history of American art. No painter before Eakins was as audacious as he was in his account of American experience, and none that came after was in a position to resist with impunity the innovations of the modern movement. In his lifetime, Eakins paid a high price for his singularity of purpose—the singularity of a radical conservative—yet it's hard to believe that he could have achieved what he did without the social resistance he met with at almost every stage of his career. It is in this respect that he can be said to resemble one of his idols, Walt Whitman, who was the subject of one of his finest portraits.

[2001]

The Thaw Collection at the Met and the Morgan Gallery

Of the many intellectual faults that have plagued the study of art in recent decades, one of the least forgivable has been the campaign to discredit the idea of connoisseurship. At the outset, about a quarter-century ago, it was a campaign largely confined to university art history departments, where training in connoisseurship—which concentrates on aesthetic distinctions—came to be more and more disparaged, at times even vilified, in favor of sociological and political standards in assessing artistic achievement. Inevitably, this campaign spread to the museums and the media as our academic institutions turned out cadres of

art history graduates to serve as curators and critics. Since their training disposes many of these graduates to regard the study of art as a branch of the social sciences—if not, indeed, as a political science—this is the primary intellectual perspective they bring to their curatorial and critical endeavors. As a consequence of this folly, it's not uncommon to find curators and critics in high places who are simply incapable of making an independent assessment of the aesthetic quality of the works of art they address. Hence their abject reliance on the reputations and fashions of the moment.

The good news, however, is that connoisseurship is alive and flourishing elsewhere—most conspicuously among independent collectors, who, through patient study and analysis of the specific objects that interest them, have proven again and again to be fully capable of distinguishing aesthetic quality from its absence. These independent collectors are the unsung heroes and heroines of the art world, and not only because of their exemplary judgment but also because they remain the principal donors of great works of art to our museums.

I have been vividly reminded of all this once again by two current exhibitions: *The Thaw Collection: Master Drawings and Oil Sketches, Acquisitions Since 1994* at the Morgan Library, and *Nomadic Art of the Eastern Eurasian Steppes* at the Metropolitan Museum of Art. From the collections of drawings that have been assembled by Eugene and Clare Thaw since the 1950s and donated in stages to the Morgan Library, we have come to expect both top quality and remarkable scope, and the latest survey of their acquisitions adds something new: some forty-nine oil sketches on paper and canvas dating from the eighteenth and nineteenth centuries.

Outstanding among them is a superb landscape by the English master John Constable, *A View of Hampstead Heath* (circa 1821–1822), with its breathtaking masses of clouds in a brilliantly illuminated sky. The biggest surprises, however, are likely to be found among the many drawings and oil sketches by German and Scandinavian artists. Museumgoers who have lately discovered the work of Danish artist Vilhelm Hammershoi (1864–1916) will be pleased to find an exquisite pencil drawing by him, *Study for Interior of San Stefano Rotondo, Rome* (1902); and admirers of the German painter Adolph von Menzel (1815–1905), who now enjoys something akin to a cult status, will be thrilled by the undated drawing, *Sleeping Youth, His Head and Arm Resting on the Back of a Sofa.*

Nor have Italian, French, and Dutch masters been neglected in this latest selection of the Thaws' drawings, for strongly represented, too, are works by Vittore Carpaccio, Ingres, Delacroix, Degas, Pissarro, Redon, Mondrian, Morandi, Seurat, Corot, and Rembrandt. It all adds up to a tremendous feast for the eye and the mind—and a feat of connoisseurship that is without equal in recent times.

The sheer scope of the Thaws' artistic interests has long been recognized in the art world; Mr. Thaw is also a recognized authority on the work of Jackson Pollock. But nothing could have prepared us for his latest collecting project: the more than two hundred objects, largely drawn from his collection, in the exhibition of *Nomadic Art of the Eastern Eurasian Steppes* at the Met. Dating from the tenth century B.C. to the second century A.D., these small, sometimes miniature sculptural objects in bronze, gold, silver, and jade were produced to serve as horse harnesses and chariot fittings, belt ornaments, garment plaques, weapons, and vessels. Dominated by animal imagery, which at times is highly realistic but also given to fantastic stylization, they are certain to be a revelation to visitors of the exhibition.

According to James C.Y. Watt, chairman of the Met's Department of Asian Art, "The present-day knowledge concerning the art of the nomadic world is insufficient for a systemic art-historical exposition." Undaunted by this lack of documentary literature, Mr. Thaw has assembled a dazzling collection of these bizarre and often enchanting objects, and the Met has responded to still another of his feats of connoisseurship by mounting this exhibition in an installation that is exemplary both for its design and its discreetly informative wall texts.

One of these days, when training in connoisseurship is restored to its rightful position in the academic study of art history, collectors like Eugene and Clare Thaw and institutions like the Morgan Library and the Metropolitan Museum will be remembered for upholding appropriate standards while the tenured radicals in the universities betrayed their academic responsibilities. Meanwhile, for anyone who wants lessons in connoisseurship, *The Thaw Collection: Master Drawings and Oil Sketches* is on view at the Morgan Library, and *Nomadic Art of the Eastern Eurasian Steppes: The Eugene V. Thaw and Other New York Collections* remains on view at the Met.

[2002]

Lois Dodd at Alexandre Gallery

Let's face it: There's a class of highly accomplished American painters whose work has been consistently rejected by the New York museum establishment when it comes to mounting full-scale retrospective exhibitions. Although otherwise diverse in style and spirit, these painters can generally be characterized as representational but not confrontational. They deal with recognizable subjects but do not set out to shock or dismay; on the contrary, their work offers us aesthetic delight and intellectual probity. They shun the so-called cutting edge and give us instead a deeply pondered personal vision of a world we can recognize as our own. These painters are not discriminated against according to generation. I'm old enough to remember a time when Milton Avery (1885–1965) and Fairfield Porter (1907–1975) were both relegated to the class of talents denied museum retrospectives. Why? They were apparently considered insufficiently avant-garde by doctrinaire modernists and yet too modern to be embraced by doctrinaire traditionalists. So it was left to posterity: The museums granted them posthumous recognition.

The exhibition of paintings by Lois Dodd at the Alexandre Gallery is a reminder that at the age of seventy-five, she too now belongs to this class of neglected talents. For close to half a century, Ms. Dodd's work has been seen and admired in more than fifty solo exhibitions. One of her recent shows (*Women at Work*, at the Caldbeck Gallery in Rockland, Maine), a rare (for Ms. Dodd) and often hilarious survey of naked female figures performing common household tasks, was a runaway sensation. It was the kind of show that visitors returned to again and again—as I did. The show was great fun as well as an experience of high-octane painterly virtuosity.

It's unlikely, however, that a single New York curator ever bothered to see it, even though Ms. Dodd has been a presence on the New York art scene for decades. She studied at Cooper Union in the 1940s; she was one of the founders of the Tanager Gallery in the '50s; and she taught at Brooklyn College for many years. Like a great many other New York painters, past and present, she has found some of her best subjects in rural Maine.

As is often the case in New York these days, the galleries provide what the museums overlook or deny. While the exhibition at the

Alexandre Gallery is hardly the Dodd retrospective we needed, it does have the great virtue of giving us a concentrated account of one of the artist's most inspired inventions: the complex, highly poetic pictorial compositions based on the structures and settings and shifting light to be seen in and around the windows and doorways of old Maine houses.

To these pictorial inventions, Ms. Dodd brings a commanding mix of realism and abstraction. Fidelity to exact observation is tempered and elevated by the discipline of formal rigor. If there are identifiable affinities or sources for such a style, they are likely to be found in the precisionism of Charles Sheeler and certain other varieties of American Cubism, as well as the geometric abstraction of Piet Mondrian. Yet nature, too, is given its due, especially in the depiction of foliage and seasonal change. And it's in her brushy, fragmented renderings of nature—often seen reflected in rectangular window panes—that Ms. Dodd also reminds us that she came of age as an artist in the era of Abstract Expressionism.

It's interesting to observe how this range of abstractionist conventions and styles is adapted to the spatial ambiguities of her window and doorway subjects. Is there an allusion, perhaps, to the all-black abstract paintings of Ad Reinhardt or even the early abstractions of Malevich in the series of black rectangles to be seen in the painting called *Barn Window with White Square* (1991)? Probably not, but the comparison nonetheless leaps to mind.

On the other hand, there is certainly something Hopperesque in the haunting *Night House* (1975), even though Ms. Dodd's use of realism differs in many respects from Edward Hopper's vein of anecdotal melancholy. (In an essay for the catalogue of the current show, John Yau makes a strong case for Ms. Dodd as "Hopper's heir," but I remain unpersuaded; the complexities in every development of her oeuvre are too distant from Hopper's dour, unforgiving realism. No heir of Hopper's could have possibly conceived of a show like *Women at Work.*) It is, in any case, in a painting like *Falling Window Sash* (1992) that the artist's stunning combination of realism and abstraction is most elaborately developed.

Well, it's clearly going to take a while for the New York museums to catch up with Lois Dodd's fast-paced development—and it may not happen in her lifetime, or mine. But when such a retrospective does come to New York, it will be a smash.

[2003]

Christopher Wilmarth at the Fogg Museum

The American sculptor Christopher Wilmarth (1943–1987), whose draw-
ings are the subject of a splendid exhibition at Harvard University's Fogg
Art Museum, was one of the most remarkable artists of his generation. He
was remarkable not only for extending the aesthetic frontiers of sculpture
and drawing but for the subtlety and depth of thought he brought to their
creation. The materials he favored—steel and glass—obliged him to mas-
ter the crafts of a seasoned factory worker. Yet from the outset of his ca-
reer as an artist, Wilmarth's closest affinities were with certain aspects of
Matisse and then, in his later work, with the sensibility of the nineteenth-
century French poet Stéphane Mallarmé. Wilmarth's description of his
own work as "physical representations of states of mind, reverie, interiors,
spirits" is itself reminiscent of Mallarmé's most celebrated dictum: "De-
scribe not the object itself, but the effect it produces." Until now,
Wilmarth's sculpture—large, highly poetic constructions of steel, etched
glass and steel cable—have been better known to the art public than the
drawings that were central to everything he aspired to achieve as an artist.
That perception is now likely to be altered, however, by the exhibition
called *Christopher Wilmarth: Drawing into Sculpture*, which Edward Saywell
has organized at the Fogg. This enchanting exhibition, together with Mr.
Saywell's illuminating catalogue, establishes beyond doubt the crucial role
that drawing occupies in the Wilmarth oeuvre. Indeed, we are reminded
that certain works that we might have regarded as sculpture—the small,
exquisite wall constructions made of etched glass and steel cable—were
actually entitled *Drawings* by the artist.

About these particular works, Mr. Saywell writes: "Most extraordi-
nary is the group of drawings that [Wilmarth] made in the early 1970s,
not with pencil and paper but with etched glass, which acts as the draw-
ing layer, and steel cable, the calligraphic surrogate for the graphite mark."
Hence the title of this exhibition: *Drawing into Sculpture*. Yet the bulk of
the drawings in the exhibition are indeed on paper, usually graphite on
gesso-prepared off-white wove paper; and the graphite is sometimes
combined with graphite wash, as it is in *Invitation #1* (1976). The draw-

ings on paper encompass a broad range of function, style, and expression. Some are diagrammatic drawings for future sculptures while others are highly finished drawings of sculpture made earlier. As Mr. Saywell also writes: "For the most part drawing was a retrospective activity for Wilmarth, a means for him to return to and assess specific aspects of existing sculptures, occasionally years after their completion. Acting almost like an appendix or index to the sculptures, his drawings helped mediate the transition from one sculpture, or group of sculptures, to the next."

Standing quite apart from the many abstract drawings in the show are a knockout figurative drawing of a female nude, *Shifrah* (1964), in which Wilmarth made the most explicit acknowledgment of his debt to Matisse; and a related drawing, *Yolande* (1965), in which the Matissean forms, though still explicitly legible, are in the process of being transmuted into something more identifiable as Wilmarthian.

In some respects, however, the most haunting works in the show are the abstract drawings of heads, and the *Breath* series that recorded Wilmarth's aesthetic and spiritual response to Mallarmé's poetry. In the late 1970s he was asked by the American poet Frederick Morgan to recommend an artist to illustrate his translations of seven poems by Mallarmé. As soon as Wilmarth read these translations, he felt he had found something like a soul mate in Mallarmé and undertook to create the illustrations himself. Immersing himself in a study of Mallarmé, Wilmarth came to the realization that "this is a guy who just lives in his head," and this proved to be the key to his Mallarmé drawings and the blown-glass sculptures of heads that followed. As Mr. Saywell observes of this encounter: "Using that metaphor as the key, Wilmarth settled on the image of an oval sphere to translate the poetry of Mallarmé. For each of the seven poems, he took advantage of the many metaphorical connotations of the oval as heart, soul, or mouth, to make a series of drawings first in charcoal, then in pastel." These and the watercolor-and-graphite drawings in the *Breath* series constituted Wilmarth's own homage to the poet's vision.

Near the entrance to the Wilmarth exhibition at the Fogg, a wall text quoting a passage from the artist's writings underscores the extent to which he had embraced this Mallarméan vision in his own art. It reads: "Light gains character as it touches the world; from what is lighted and who is there to see. I associate the significant moments of my life with the character of the light at the time. . . . My sculptures are

places to generate this experience compressed into light and shadow and return them to the world as a physical poem." Wilmarth's drawings are also an integral part of that poetry.

[2003]

Max Beckmann at MOMA

In a rare collaboration between two elite art dealerships, Richard L. Feigen and Co. and the Jan Krugier Gallery have joined in organizing an exhibition devoted to a pair of major artists—Pablo Picasso (1881–1973) and Max Beckmann (1884–1950)—whose works, though they belong to the same generation of European modernists, are rarely seen in close, comparative proximity. The result, on view at the Feigen gallery, is Beckmann-Picasso/Picasso-Beckmann, a show that is not to be missed. It's not only of compelling interest in itself, but it explores a relationship in the history of modern painting that, as far as I know, has not heretofore been closely studied.

Picasso needs no introduction; he has long enjoyed a fame that's universal in scope. This doesn't mean that his work is universally understood, however: in Picasso's case, it has often meant the opposite. What many people think they know about Picasso has far more to do with his public persona—his sex life, his politics, his longevity, his fecundity in creating a variety of styles in a variety of media, and his unembarrassed love of the limelight—than with his artistic achievements. Such has been his celebrity that his name is now synonymous with the very idea of the artist-genius, even among people who remain baffled by his work.

Max Beckmann, on the other hand, has never enjoyed a celebrity on this scale, even in America, where he lived and worked as an émigré in the last years of his life and as a teacher, first in St. Louis and then in New York, influencing an entire generation of American painters. Moreover, Beckmann's private life, which was centered on a long and happy marriage, remained private, and his politics—insofar as he can be said to have

had any—were limited to his opposition to the Nazi regime in his native Germany, which famously declared art of his persuasion degenerate.

Yet, despite Beckmann's opposition to the Nazi regime, his German background has been a problem for many art lovers. This has less to do with politics than with style and aesthetics. The fact is, for a majority of the art public in this country, the school of Paris—Picasso, Matisse, Leger, Bonnard, et al.—is greatly favored over that of the modern German school, which for tastes nurtured on Parisian aesthetics is often found to be too harsh, too strong, too naked in feeling.

Even if you reject this criticism of modern German art as a caricature, as I do, it has to be acknowledged that it exists, and it has sometimes proved damaging to Beckmann's reputation. In the presence of a powerhouse talent like Picasso's, however, Beckmann's strengths as a draftsman and painter show to great advantage, and he emerges in the current exhibition as a powerhouse himself—and does so without the presence of a single example of his finest work, the great triptychs of the climactic years of his maturity.

In this connection, it has to be said that it's one of the downsides of this Picasso-Beckmann standoff that it's mostly limited to smallish paintings and works on paper. (The few sculptures hardly seem to be part of the show.) By the same token, it's one of the upsides of the exhibition that it makes us all the more eager to see a Picasso-Beckmann show on a far grander scale. Not until we have an opportunity to see *Guernica* (1937) and other Picasso paintings on a similar scale in the same space as some Beckmann triptychs will we be in a position to make a definitive judgment of their respective pictorial achievements.

Meanwhile, in the show that we've been given at Feigen, Beckmann more than holds his own. In the very first room, Beckmann's *Oyster Eaters* (1943) commands a painterly sensuousness that triumphs over Picasso's schematic *Bouquet* (1969), just as his radical *Crouching Woman* (1930) renders Picasso's more delicate *Femme Dormeuse* (1937) almost mute. For this viewer, anyway, even Picasso's more powerful *Femme Assise en Robe Grise* (1943), with its emphatic black structure, has too formulaic a look to be persuasive.

The really big surprise in this exhibition is its revelation of Picasso's keen interest in Beckmann's paintings, which seems to have had a longer history than any of us suspected. Once we've been alerted to this connection and its implications, both Beckmann and Picasso emerge

somewhat changed for us—changed, that is, from powerful individualists into comrades in pursuit of very similar goals.

[2004]

Manet at the Art Institute of Chicago

The French artist Édouard Manet (1832–1883) is often said to have been the first modernist painter—the father, as it were, of Impressionism and the great succession of avant-garde movements that followed in its wake. In fact, there's just enough truth in the claim to render it plausible, even at this distance in time. But it was never the whole truth about Manet—who could scarcely touch a brush to a canvas without recalling the Old Masters—and it has frequently led to a misunderstanding of the artist's relation to the tradition whose lofty standards the nineteenth-century reactionaries in the French Academy accused him of violating. By their lights—not always the brightest—the champions of the academy undoubtedly had a point: though Manet clearly made a close and sympathetic study of certain Italian and Spanish masters, it was a study that resulted in a determination to modernize his medium and thus bring it into close alignment with contemporary experience. The benighted exponents of "tradition" could not forgive him for this audacity, which made him a hero to the newly emergent avant-garde.

Two provocative figure paintings of 1863—*Le Dejeuner sur l'Herbe*, based on Giorgione's *Fête Champêtre*, and *Olympia*, based on Titian's *Venus of Urbino*—provoked famous scandals. And it is mainly for his figure compositions—of which, in my view, the greatest is the *Bar at the Folies-Bergère* (circa 1882)—that Manet is widely admired today.

But in the exhibition called *Manet and the Sea*, currently at the Art Institute of Chicago, the focus is on a very different aspect of the artist's achievement. For most of us, Manet's interest in marine painting has remained a more or less marginal subject, but it turns out to have been a major one for the artist himself. Although we were recently given a

glimpse of Manet's initial foray into marine pictorial subjects (a battle scene at sea in a show called *Manet and the American Civil War* at the Metropolitan Museum), the exhibition in Chicago is a far more ambitious production, with nearly one hundred marine works, including paintings, watercolors, and drawings by Manet and his contemporaries—among them Delacroix, Courbet, Whistler, Monet, Renoir, Jongkind, Boudin, and Morisot.

While it would be going too far to suggest that with *Manet and the Sea* the artist emerges as a radically changed painter, energetic engagement with marine subjects does seem to have unleashed an impulse in Manet that we do not find in his earlier work—an impulse to confront the untamed forces of nature. In this respect, too, Manet was once again in the avant-garde, for as John Zarobell reminds us in his catalogue essay for *Manet and the Sea*: "There was, in fact, something like an explosion of marine painting in the 1860s among artists not connected with the Academy or bound by official commissions. . . . As the behemoths of official marine painting declined in artistic importance, the field was left open to experimental artists who did not much care about their relationship to the artistic establishment in Paris and who sought, in the sea, a means of furthering their inquiries into the relationship between the self and the natural world."

Manet was in one respect better qualified to deal with the subject than many of his contemporaries: At the age of sixteen, he had gone to sea as a sailor, spending three months on a ship bound for Brazil in order to qualify for a career as a naval officer. But he wasn't much good at passing the requisite exams for such a career, and it's our good fortune that he fell back on pursuing an artistic career as an alternative.

As a consequence of his experience as a sailor, Manet was on more intimate terms with the sea and its manifold mysteries than most of the other painters of the time—and far less daunted by it. Courbet, especially in his wave paintings, often responded to the challenge of sea painting as exercise in physical combat, in which he was determined to subdue an unruly antagonist; Renoir remained utterly undaunted, painting his ocean waves with the same brushy delicacy he brought to the depiction of bourgeois ladies' frilly dresses; and Monet appears to have been steadfastly faithful to his direct observation of the sea and its seaside visitors. But Manet seems to have made no distinction between observation and invention in rendering a subject he knew by heart, so to speak.

What lends still another layer of interest to *Manet and the Sea* are the many glimpses it gives us of those visitors to the seaside who, either as swimmers or leisurely observers, inaugurated a pastime so familiar to us today. Between paintings like Manet's *On the Beach at Boulogne* (1868) or the *Departure of the Folkestone Boat* (circa 1868–1872) and the steady production in our time of similar seaside scenes at Provincetown, the Hamptons, and Cape Ann, there's an obvious connection—despite vast differences in aesthetic quality. The sea may be eternal, but the social uses that are made of it bear the stamp of period sensibilities, and that's another part of our history that's illuminated in this dazzling exhibition.

[2003]

The Matisse Collection at the Met

The late Pierre Matisse (1900–1989), the younger son of the French master Henri Matisse, was one of the most illustrious art dealers of his day. For the art public of my generation, his gallery in the Fuller Building at 41 East 57th Street was as much a fixture on the modern art scene in New York as the Modern, Guggenheim, and Whitney museums, and its opening in 1931 actually preceded that of the Guggenheim by six years. For some sixty years, the Matisse Gallery remained one of the centers of contemporary art life in New York. This is one reason why the current exhibition of the Pierre and Maria-Gaetana Matisse Collection at the Metropolitan Museum of Art is a significant event. Another is that the Met's acquisition of the Matisse Collection is itself an important chapter in the history of the museum's ongoing effort to accord the masterworks of modern art a status akin to that of its celebrated collections of the Old Masters. It should be remembered that in the early years of the Matisse Gallery, it was the policy of the Met—and, indeed, most of the older museums—not to acquire or exhibit the work of "untested" living artists.

If this policy now strikes us as bizarre, it should also be revealed that as late as 1950, when E. H. Gombrich published the first edition of his

classic history, *The Story of Art*, the chapter devoted to the great flowering of modernist art in the first half of the twentieth century was called "Experimental Art"—in other words, art that had not yet proven to be of permanent interest. That's not the way we think about art today, of course, but I wonder if I'm alone in feeling a certain nostalgia for this discredited policy. It would certainly have saved us from having to wade through a lot of the fashionable trash that has glutted museums in recent years.

Fashionable trash was never of much interest to Pierre Matisse. His principal mission as a dealer was to bring the controversial achievements of the Paris avant-garde of his own generation to the attention of the American art public. His own favorites in that generation were Balthus, Dubuffet, Giacometti, and Miró—especially Miró, to whose work the Matisse Gallery devoted an astounding thirty-seven exhibitions.

The works of these artists are now blue-chip investments on the international art bourse, but some of them were a hard sell when they were first exhibited in New York—Balthus because of his concentration on erotic subjects, and Miró because his work was often found to be incomprehensible. (Often, to fully understand Miró, you have to have a sophisticated sense of humor.) In one of Miró's letters to Pierre Matisse—I quote from memory—the painter thanked him for his support, adding that he sometimes thought it must require as much courage for the dealer to exhibit such paintings as it took him, the artist, to create them.

In some quarters even the beloved Giacometti was controversial—but for an opposite reason. Hard-core Surrealists could never forgive Giacometti for abandoning the orthodoxies of their movement in favor of what they regarded as the more traditional style of his sculptural figures and still-life paintings. Oddly enough, it was the so-called Art Brut of Jean Dubuffet that was an instant hit with the Upper East Side collectors, who still favored the work of the School of Paris over anything produced by the burgeoning New York School of Abstract Expressionism.

And yet, the exhibitions that the Matisse Gallery devoted to Miró and Giacometti in the late 1940s proved to be landmark events—but again, for opposite reasons. Miró exerted an enormous influence on the Abstract Expressionists while Giacometti's figurative sculpture, drawings, and paintings were a source of inspiration and moral support for a younger generation of American painters determined to resist the temptations of

abstractionism. For both of these opposing camps, the Matisse Gallery provided a standard of achievement.

The exhibition of the Matisse Collection at the Met is the first in a series of three consecutive shows over a yearlong period designed to bring us highlights of the collection. In addition to examples of the artists already mentioned, it also includes some excellent works by Matisse père that Pierre Matisse inherited from his father's estate. Of lesser interest are paintings by René Magritte and Paul Delvaux and sculpture by two British artists, Raymond Mason and Reg Butler. Of great interest, however, are two powerful paintings by André Derain—a still life, *The Table* (1911), and a flamboyant full-length painting of a woman called *The Black Feather Boa* (1935). These two monumental pictures leave one yearning to see a full-scale Derain retrospective, but that's probably too much to hope for—Derain is so utterly unfashionable today. Both for artistic and biographical reasons, Balthus's portrait of Pierre Matisse (1938) is a must-see painting.

[2004]

John Walker at the Center for Maine Contemporary Art

For the many people, whether tourists or natives, whose favorite memories of paintings of Maine are largely defined by the work of Winslow Homer in the nineteenth century and the Wyeth clan in the twentieth, the art of John Walker is bound to come as something of a shock. Everything traditionally associated with the beloved imagery of the Maine coast and its weather-beaten landscape—the illustrational clarity, the crystalline light, and the abundant detail of a down-home naturalism—is totally absent from Mr. Walker's paintings. Inducements to nostalgia are nil.

What one encounters instead in the artist's latest exhibition—*John Walker: A Winter in Maine, 2003–2004*, at the Center for Maine Contemporary Art in Rockport—are huge, sprawling expressionist canvases and

smaller oil sketches on paper that give the observer what's best described as the clamdigger's view of the Maine landscape. In this view the terrain tends to be muddy, the atmosphere overcast, the sky a distant band of mottled light, and the boundaries separating land from sea all but overwhelmed by a painterly virtuosity that's easily mistaken for outright abstraction. Yet as the eye habituates itself to these bold, highly charged depictions, what comes into focus are some of the most extraordinary landscape paintings of the modern era. Not since John Marin burst upon the American art scene in the 1920s and '30s have paintings of Maine succeeded to a comparable degree in setting a new standard for pictorial innovation in the art world at large.

Like many Maine painters, Mr. Walker is, as Mainers say, "from away"—in his case, originally from Britain; he was born in Birmingham in 1939 and studied at the Birmingham College of Art in the 1950s. Then came Paris, where he studied at the Académie de la Grande Chaumière in the 1960s, and New York, where he came under the sway of the regnant Abstract Expressionists.

Nowadays Mr. Walker divides his working life between a coastal property in South Bristol, Maine, the *mise en scène* of his current work, and Boston University, where he's a member of the art faculty. (He often brings his students to Maine as part of their course of instruction.) In New York his work can often be seen at Knoedler & Company.

It's sometimes said of the Abstract Expressionist painters that they could be divided into two classes: those who put everything—which is to say, more than merely enough—into their pictures, and those who left out as much as possible while still giving us something to look at in what remained.

Mr. Walker unquestionably belongs to the first category, for his appetite for overloading his canvases is unstinting, and he has found in the dour attractions of a muddy bay in South Bristol a correlative in nature that allows him to create a landscape art in a medium that is not only reminiscent of the viscous facture often seen in the work of the Abstract Expressionists but at times actually incorporates mud itself— or what's sometimes called "sea cake" in the titles of his paintings— into the painted surface. What Mr. Walker's "sea cake" paintings recall for me are the lines from the "Little Gidding" section of T. S. Eliot's *Four Quartets*: "Dead water and dead sand / Contending for the upper hand."

For Mr. Walker, mud has clearly acquired an aesthetic, if not indeed a mystical significance. In a recent interview, Bruce Brown, one of the curators of the current exhibition, asked him, "Technically, how do you get the mud to stick to the canvas and why do it?" This was Mr. Walker's response: "I've experimented with mixing various mediums with the mud. Basically dirt turns into cement, really. The fact that I take in these beautiful surroundings—the muddiest, smelliest, dirtiest cove to paint in—allows me to get beyond the beauty of the tourist sort of Maine. Mud has been a reoccurring theme in my paintings for years. . . . I have certainly always thought of paint as being colored mud. As you know, while I was involved with the first group of landscape paintings, I was concurrently painting my father's recollections of the First World War where mud was the theme—not only his recollection, but almost everyone's from that war. I like the fact that mud is dirty. If I'm painting and a clammer comes along and digs those big, dirty holes right in front of me, I truly believe that what I'm doing on canvas is just a pastiche. I really am moved when I see that his is the artwork and mine is just an impression. It always shocks me that these people come along and dig great holes and walk away from it and it looks just wonderful."

Well, as I say, this is no longer the Maine of Winslow Homer and the Wyeths.

[2004]

R. B. Kitaj at Marlborough Gallery

The career of R. B. Kitaj, whose work is the subject of a very large exhibition at the Marlborough Gallery, is like no other in the annals of American art. For one thing, no other American artist in recent memory has accorded to literary and historical subjects so large a role in shaping his pictorial ideas. For another, none has devoted so much attention—and so much writing—to serving as a mythographer of his own life and work. Then, too, there's Mr. Kitaj's "obsession" (his word) with the "Jewish Question," which he insistently identifies as the principal focus of his

work. It's important to understand that Mr. Kitaj's interest in Jewishness has everything to do with history and almost nothing to do with religion. Neither prayer nor piety—never mind religious orthodoxy—comes to mind in studying his work and his many commentaries on it, but rather a kind of intellectual combat addressed to enemies real and imagined. He is the most autobiographical of living artists (hence the title of the show at Marlborough: *R. B. Kitaj: How to Reach 72 in a Jewish Art*) and the most unforgiving in responding to the adverse judgments of his critics.

Owing to his appetite for polemic and public controversy, moreover, Mr. Kitaj has often cast himself as a kind of art-world adversary or outlaw. And yet his career has been a resounding success since he first caused a stir as a student at the Royal College of Art in London in the early 1960s. The very scale of the show at Marlborough—fifty-four paintings and thirty-four works on paper, plus a selection of prints and a large-format catalogue running to nearly ninety pages—is further testimony to that success.

This is not to say that Mr. Kitaj has been spared harsh attacks on his work. Far from it. No sooner had he been elevated to stardom by the London critics—who compared him with T. S. Eliot and Ezra Pound—than those same critics turned against him when his subsequent work failed to meet their extravagant expectations. Never one to settle for half-measures, Mr. Kitaj responded to this censure by denouncing the London art scene—in terms guaranteed to offend—and promptly left town. He now makes his home in Los Angeles.

In his fury at the London critics, Mr. Kitaj has been guilty of some remarkably intemperate outbursts. Not only did he accuse them of anti-Semitism but he also suggested that their negative response to his work in London had somehow been the principal cause of his wife's unexpected demise. Grief over the untimely death of a spouse is certainly understandable, but an unfounded charge of murder is nonetheless an outrage—and only one example of Mr. Kitaj's many rhetorical excesses.

Given all this uproar—so much of it provoked by the artist himself—it's a mercy that Mr. Kitaj draws as well as he does, for a highly accomplished draftsmanship remains the fulcrum of his art. Indeed, one sometimes has the impression that for him—especially in dealing with literary subjects (Kafka is a special favorite)—drawing is a form of writing by other means, a medium in which the literary and the graphic are in perfect accord.

At the risk of inspiring yet another wave of invective from Mr. Kitaj's pen, I am obliged to observe that in many of the paintings in the current exhibition I do not find a comparable accord. Drawing remains the strongest component in his paintings, but it's unmatched by any comparable command of chromatic invention. More often than not, Mr. Kitaj's draftsmanship tends to be coarsened by its intercourse with color; and color in his work, where it's not simply illustrational, has the character of something added to the armature of the artist's draftsmanship. Though Mr. Kitaj's palette can be said in some respects to be Matissean, its application remains devoid of Matissean subtlety and control. Here color is at once hectic, nervy, breathless, and undisciplined, often suggesting that it's struggling to keep ahead of a draftsmanship that has already outpaced it.

R. B. Kitaj: How to Reach 72 in a Jewish Art remains on view at the Marlborough Gallery. The press release reminds us that Mr. Kitaj's work is "in the permanent collections of fifty-five museums throughout the world"—not bad for an artist who continues to regard himself as a rebel and an underdog.

[2005]

Marvin Bileck and Emily Nelligan at Alexandre Gallery

Some years ago I began hearing about the drawings of the American artist Emily Nelligan, and it was mostly other artists who were talking up her work. I soon discovered that it was these other artists who were also buying Ms. Nelligan's drawings. The mainstream galleries hadn't yet heard of Emily Nelligan, and neither had most of the critics and collectors. When I finally did get to see a rather modest gallery show of her drawings, they were a revelation of a remarkable talent. This was soon followed by a show in which Ms. Nelligan's drawings were exhibited with the prints of her husband, Marvin Bileck, a renowned printmaker

and illustrator. It was in 2000 that the first full-scale exhibition of Ms. Nelligan's drawings was organized at the Bowdoin College Museum of Art in Maine. Now the Alexandre Gallery in New York has mounted a splendid survey of the drawings and prints devoted to the subject that inspired both artists over a period of fifty years: the landscape of Great Cranberry Island, off the cost of Maine near Mount Desert.

Emily Nelligan and Marvin Bileck met in the 1940s, when both were art students at the Cooper Union in New York. For many years they divided their time between their home in Connecticut, where they spent winter and spring, and Great Cranberry Island in summer and fall. Sadly, Bileck died in April at the age of eighty-five while preparations were in progress for the current exhibition.

While both artists devoted their principal endeavors to works on paper depicting the visual enchantment of this isolated landscape, they brought very different sensibilities to their graphic accounts of it. Ms. Nelligan's medium is unfixed charcoal on white paper, which she transforms into virtuosic varieties of shadow and light. The sea, the sky, and the fog-misted earth are devoid of sharp contours in these drawings, and seem instead to have an apparitional character. From every smudge and erasure of charcoal dust she has been able to wrest subtleties of coastal light unlike anything that has heretofore been seen in pictures of Maine or any other coastline. In contrast to those images we carry in our memories from paintings of Maine by Winslow Homer and John Marin, Ms. Nelligan's drawings are nocturnes in which light is more fugitive than shadow and a velvety darkness dominates every prospect.

Bileck's forte was close-up, linear observation of nature in decay. Fallen trees, tangled underbrush, and lonely rock formations were frequent subjects for both his graphite drawings on paper and his etchings. The sky all but disappears as the artist concentrates his attention at ground level, where a once-vital jumble of roots and stumps and broken branches has weathered into a baroque phantasmagoria of seasonal decomposition. Bileck's command of detail in depicting such profusion, especially in the etchings, is worthy of comparison with the finest tradition of Northern Europe graphic art.

For readers—and aspiring printmakers—who are curious to know more about Bileck's working methods, the essay for the catalogue of the current show, written by Alison Ferris, provides some useful information. "Bileck," Ms. Ferris writes, "works on his plates over the course of

a number of years. As a result, one print might be very different than a previously made print even though they were made from the same plate. Additionally, each print varies and is determined by how wet the paper is, how much pressure Bileck decides to put on it, and if and how he might burnish the back side of the paper before it's dry. Sometimes he even considers one of his counter prints the finished product. All this indicates that Bileck is perfectly correct when he says that no one else could print his work. The copious amount of time that Bileck spends on his prints instills in them a complexity that distinguishes them from the spontaneity of his drawings, some of which are completed in a day or so."

For connoisseurs of drawing and prints, the Marvin Bileck and Emily Nelligan exhibition is clearly an event not to be missed.

[2005]

Oscar Bluemner at the Whitney

There are artists who, despite their abundant gifts, seem destined to endure a melancholy fate, and one of them was Oscar Bluemner (1867–1938), the subject of a fine exhibition at the Whitney Museum of American Art. Bluemner was too "advanced" for the traditionalists at a time when modernism was still a contentious issue, and he was too tactless and outspoken in his relations with the modernists of the Alfred Stieglitz circle to benefit from their support. He remained an archetypal outsider in whatever milieu he frequented.

He was born in Germany, where he was trained as an architect, and it was as an architect that he initially established himself in New York. In 1904 he designed the Bronx Borough Courthouse, but this remained his only major completed work in architecture, which he then abandoned in favor of painting.

In 1910, Bluemner met Stieglitz, whose 291 Gallery was already an established haven for the American avant-garde. Bluemner's first solo exhibition at 291 came in 1915—a series of eight landscape paintings—and

this further confirmed his commitment to painting. So, too, did his con-
tributions to the prestigious Forum Exhibition of Modern American
Painters.

Yet a variety of vexations continued to make both art and life ex-
tremely difficult for Bluemner. Money had always been a problem for
him, and it was a problem that became more acute over the course of his
career. When he could no longer afford to live in New York, he settled
in the New Jersey countryside; and when he could no longer afford the
materials he needed for his oil paintings, he turned to watercolor as an
alternative. Yet his slide into penury proved irreversible.

Then, too, there was the problem of Bluemner's German identity.
This became especially acute in 1917, when the United States declared
war against Germany, which inevitably provoked a terrific wave of anti-
German sentiment. This added considerably to Bluemner's woes. In every
respect but one—his painting—he was in the wrong place at the wrong
time. And even as a painter, he was in some respects ahead of his time.
Had he come of age as an artist in the era of color-oriented abstraction,
he would very likely have been acclaimed an avant-garde master. The se-
ries of paintings called *Suns and Moons*, which Bluemner created in
1926–1927, are virtual prototypes for a kind of color abstraction that later
became commonplace in American abstract painting.

The show that Barbara Haskell has organized in *Oscar Bluemner: A
Passion for Color* thus has an interest for us that extends well beyond
Bluemner's personal misfortunes. It's an exhibition that anyone curious
about American modernism will want to see. And Ms. Haskell is to be
congratulated, also, for the accompanying catalogue. She has tri-
umphantly succeeded in rescuing an ill-fated painter from the tragedies
of his life in a way that will allow posterity to appreciate his accom-
plishments.

[2005]

I V
Modernism and
Its Institutions

Modernism and Its Institutions

I couldn't portray a woman in all her natural loveliness. I haven't the skill. No one has. I must, therefore, create a new sort of beauty, the beauty that appears to me in terms of volume, of line, of mass, of weight, and through that beauty interpret my subjective impression. Nature is a mere pretext for a decorative composition, plus sentiment. It suggests emotion, and I translate that emotion into art. I want to expose the Absolute, and not merely the factitious woman.—Georges Braque, circa 1908

Subject, with her, is often incidental.—Wallace Stevens, on the poetry of Marianne Moore, 1935

Content is a glimpse of something, an encounter like a flash. It's very tiny—very tiny, content.—Willem de Kooning, 1963

Although we have lately been advised that "the days when one could sit down with an easy mind to write an account of something called modernism are over,"[1] there nonetheless remains very little in our experience of the arts even in this first decade of the twenty-first century that can be separated from the traditions that were established by what used to be called the modern movement but that nowadays tend to be known collectively as modernism. As I shall be using the term here— that is, modernism as a movement in literature as well as the visual arts—it was never monolithic in style, ideas, or impact. In its heyday,

1. Paul Mattick, *Art in Its Time: Theories and Practice of Modern Aesthetics* (New York, 2003), p. 9.

which by my reckoning dates from the 1880s to the 1950s, it encompassed a broad range of styles, from realism and symbolism to pure abstraction, and a variety of anti-styles we associate with the legacy of Marcel Duchamp and Dadaism.

In many respects, modernism is identified as much by the traditions it rejects as by the innovations it embraces. In his *Histoire de la littérature française de 1789 à nos jours* (1936), the French historian Albert Thibaudet highlighted the radical nature of the modernist enterprise when he spoke of the commitment to the idea of "indefinite revolution," of

> a right and duty of youth to overturn the preceding generation, to run after an absolute. If the poets were divided into "normal," or "regular," and free-verse, literature was divided into normal literature, and literature of the "avant-garde." The chronic avant-gardism of poetry, the "What's new?" of the "informed" public, the official part given to the young, the proliferation of schools and manifestos with which these young hastened to occupy that extreme point, to attain for an hour that crest of the wave in a tossing sea—all this was not only a new development in 1885 but a new climate in French literature. The Symbolist revolution, the last thus far, might perhaps have been definitively the last, because it incorporated the theme of chronic revolution into the normal condition of literature.

Thibaudet's announced subject was Symbolist literature; but his diagnosis of the way a commitment to "chronic revolution" had become "the normal condition of literature" pertains equally to the whole project of modernism. The ultimate aesthetic and spiritual fruitfulness of this chronic revolution differed sharply among genres. In the pictorial arts, revolution first of all entailed rejection of the moribund conventions of nineteenth-century academic instruction, which had elevated a narrowly conceived mode of depicting the observable world to the status of an aesthetic and cultural absolute.

What modernism rejected in architecture was ornament, decorative embellishments, and explicit references to historical precedent. The Viennese architect Adolf Loos put the case against ornament with histrionic astringency in his 1908 essay "Ornament and Crime." "The evolution of culture," Loos wrote, "is synonymous with the removal of ornament from utilitarian objects." According to Loos, "freedom from ornament is a sign of spiritual strength." In the modern world, "art has taken the place of or-

nament," and a hankering after ornament is, for Loos, a sign of spiritual backwardness or criminality. "Anyone who goes to the *Ninth Symphony* and sits down and designs a wallpaper pattern is either a confidence trickster or a degenerate."

Loos may have written with tongue at least partly in cheek, but he nonetheless summed up a cardinal element in the brief of classic architectural modernism. We are now perhaps in a position to question how fruitful the rejection of ornament really was as an aesthetic desideratum: what seemed terribly brash and exciting in 1908 looks rather different when it succeeded in transforming whole cities into monotonous rows of rectangular glass and steel plinths.

As far as painting and sculpture are concerned, modernism introduced a radical revision in the very concept of representation, the implications of which are admirably summarized in George Heard Hamilton's introduction to his classic history, *Painting and Sculpture in Europe, 1880–1940* (1967):

> In the half-century between 1886, the date of the last Impressionist exhibition, and the beginning of the Second World War, a change took place in the theory and practice of art which was as radical and momentous as any that had occurred in human history. It was based on the belief that works of art need not imitate or represent natural objects and events.
>
> Therefore artistic activity is not essentially concerned with representation but instead with the invention of objects variously expressive of human experience, objects whose structures as independent artistic entities cannot be evaluated in terms of their likeness, nor devalued because of their lack of likeness, to natural things.

But revolution and rejection do not tell the whole story of modernism. As I argued long ago in my essay "The Age of the Avant-Garde" (1972), the impulse to wage war on the past had a constructive as well as a rebellious side. What was most conspicuously embraced by modernism in the literary arts were so-called free verse (*vers libre*) in poetry, which entailed an abandonment of traditional rhyme and meter, and the "stream of consciousness" technique in fiction, which was introduced to literature in English by James Joyce but was made more accessible to public comprehension by the popularization of Freudian psychoanalytical therapy.

These innovations entailed a rejection of nineteenth-century narrative conventions in favor of more hermetic literary structures based on myth, symbolism, and other devices more commonly found in poetry, especially modern poetry, than in prose fiction.

Moreover, owing to the resolute and often vindictive resistance that such innovations met with in the arena of public taste, it was probably inevitable that ways would be sought to circumvent that resistance. It was, in any case, in direct response to such prohibitions that the modernist impulse was driven to create institutions of its own in order to safeguard the survival and prosperity of its aesthetic initiatives. It was probably inevitable, too, that in the early history of these institutions, an attempt would be made to minimize the sometimes controversial content of modernism—not only its sexual explicitness but its political provocations as well. After all, in a period when even as blameless a book of short stories as Joyce's *Dubliners* met with refusal by its first printers on the grounds that certain passages were deemed to employ improper language, and a masterpiece like *Ulysses* was legally banned in the United States, there was ample reason to be cautious about publicizing the content of certain modernist works.

On the large and thorny question of modernism's content and its relation to modernist form, however, it must also be said that certain modernists have themselves been complicit in minimizing its content even under conditions where prudence was no longer required, as the epigraphs quoted above from Georges Braque, Wallace Stevens, and Willem de Kooning suggest. For anyone who was present on the New York art scene in 1953, for example, when de Kooning exhibited the first of his sensational *Women* paintings at the Sidney Janis Gallery, the much-quoted claim made ten years earlier, obviously in reference to abstract painting, that the content in the creation of a work of art is "very tiny," would have sounded absurd. The ferocity with which de Kooning attacked his subject in the *Women* series left no one in doubt about the importance of its content—both for the artist and viewer—and the unraveling of de Kooning's talent in the aftermath of the *Women* paintings, when he returned to a mode of abstraction that was sadly depleted of both form and content, only underscored the point.

Similarly, Wallace Stevens's observation that in the poetry of Marianne Moore, "Subject . . . is often incidental," may indeed apply to some of the poet's minor later work, but elsewhere Moore's poetry positively

bristles with difficult subjects. In the early masterpiece from the 1920s called *Marriage*—a work that, in my view, occupies a place in Moore's literary oeuvre akin to that of *The Waste Land* in Eliot's—the intensity and indignation prompted by the subject of matrimony is anything but "incidental." Its treatment is ferocious, as the poem's opening lines attest:

> This institution,
> perhaps one should say enterprise
> out of respect for which
> one says one need
> not change one's mind
> about a thing one has believed in,
> requiring public promises
> of one's intention
> to fulfill a private obligation:
> I wonder what Adam and Eve
> think of it by this time,
> this fire-gilt steel
> alive with goldenness;
> how bright it shows—
> "of circular traditions and impostures,
> committing many spoils,"
> requiring all one's criminal ingenuity
> to avoid!

In a new edition of *The Poems of Marianne Moore*, edited by Grace Schulman, *Marriage* runs to eight and a half pages, and remains to its very last lines one of the most caustic poems in the language—one of the scariest, too.

Georges Braque was a far gentler soul than either Willem de Kooning or Marianne Moore, and it was characteristic of his moral delicacy to wrap his statement about the artist's subject in a mantle of modesty, only to disclose in the end that, like so many other modernists, his too had been a pursuit of the Absolute. Braque's version of the Absolute no doubt differed from that of the true firebrands of modernism—among them, Piet Mondrian, Mies van der Rohe, Ad Reinhardt, and Donald Judd— yet where would any of them have been without the prior existence of Cubism, the creation of which was owed to Braque's collaboration with

Picasso? It might even be said that Braque created the foundation upon which these firebrands were able to take their stand.

The great irony, as I pointed out in "The Age of the Avant-Garde," is that this effort to place tradition under the pressure of a constant revaluation had an unexpected effect. It resulted in the virtual dissolution of any really viable concept of tradition. And this sense of dissolution—of the muteness or sterility of tradition—is at the heart of the situation in which we find ourselves today. Without the bulwark of a fixed tradition, modernism found itself deprived of its historic antagonist. Much to its own embarrassment, it found that it had itself become a tradition—albeit one without obvious progeny. With its victory over the authority of the past complete, its own raison d'être had disappeared, and it had, in fact, ceased to exist except as an imaginary enterprise engaged in combat against imaginary adversaries.

In fact, in its most fruitful manifestations, the modernist attitude toward tradition was as much a distillation or transformation as a rejection of tradition. Indeed, a revaluation of the past is precisely what the modernist masters were forcing upon the official guardians of taste. One thinks in this context of T. S. Eliot, himself a modernist pioneer, who outlined in "Tradition and the Individual Talent" (1919) a vision of originality in which "not only the best, but the most individual parts of [a poet's] work may be those in which the dead poets, his ancestors, assert their immortality most vigorously." "No poet, no artist of any art," Eliot wrote in one of the most famous passages of that famous essay,

> has his complete meaning alone. His significance, his appreciation is the appreciation of his relation to the dead poets and artists. You cannot value him alone; you must set him, for contrast and comparison, among the dead. I mean this as a principle of esthetic, not merely historical, criticism . . . [for] what happens when a new work of art is created is something that happens simultaneously to all the works of art which preceded it. The existing monuments form an ideal order among themselves, which is modified by the introduction of the new (the really new) work of art among them.

Eliot's effort was not to subvert tradition but, on the contrary, to salvage it from the sclerotic imperatives of an exhausted antiquarianism or impotent gentility. To what extent Eliot succeeded may be open to question—his conception of an "ideal order" of "existing monuments"

may in the end have been too purely aesthetic to bear the existential burden of vitality with which he invested it. Nevertheless, Eliot's example illustrated the apparently unavoidable paradox that the advent of modernism brought with it the seeds of its own perpetual renovation: the anti-institutional impulse of modernism would ultimately be brought to bear on the seemingly unassailable institution that was modernism itself. The question that confronts us today is to what extent the institutions of modernism can survive the consuming effects of their own self-immolation—survive, I mean, as vital sources of cultural renewal, not simply as vacant bureaucratic placeholders.

What are the institutions that either created or were commandeered to accommodate modernism's battle of the Absolutes? Some of them have become so well established as fixtures of our cultural landscape that we can hardly imagine a time when they didn't exist—among them, the art galleries, with their one-man shows of new art; the art museums that vie with each other for the privilege of being the first to embrace what is certain to be controversial; the "little magazines," literary quarterlies, and small presses without which modernist literature would never have prospered; the more problematic writers' "workshops," which seem now to have degenerated into an academic racket (one recalls Kingsley Amis's remark that much of what was wrong with the twentieth century could be summed up in the word "workshop"); and the Armory Show type of large international exhibitions that grew out of the various "independent" and "secessionist" modernist movements of a century or more ago.

Virtually all of these institutions were created by artists working in collaboration with amateur, noninstitutional collectors, just as the little magazines, small presses, and literary quarterlies were created by poets and critics who understood that mainstream publishers were not in a position to respond to the challenges of modernist literature without the kind of spadework that only noninstitutional amateurs could provide. As Lionel Trilling wrote in his essay "The Function of the Little Magazine":

> To the general lowering of the status of literature and of the interest
> in it, the innumerable "little magazines" have been a natural and
> heroic response. Since the beginning of the [twentieth] century,
> meeting difficulties of which only their editors can truly conceive,
> they have tried to keep the roads open. From the elegant and brilliant
> *Dial* to the latest little scrub from the provinces, they have done their

work, they have kept our culture from being cautious and settled, or merely sociological, or merely pious. They are snickered at and snubbed, sometimes deservedly, and no one would venture to say in a precise way just what effect they have—except that they keep the new talents warm until the commercial publisher with his customary air of noble resolution is ready to take his chance, except that they make the official representatives of literature a little uneasy, except that they keep a countercurrent moving which perhaps no one will be fully aware of until it ceases to move.

Now, nearly sixty years after Trilling wrote "The Function of the Little Magazine" to mark the tenth anniversary of *Partisan Review*, the kind of "little magazine" he described in that essay is virtually extinct—as, of course, is *Partisan Review*. Some literary quarterlies have survived but have diminished in number and—with the shining exception of *The Hudson Review* and (if I may say it) *The New Criterion*—in quality, too, as the blight of deconstructionist, poststructuralist, and other varieties of anti-literary "theory" has triumphed over literary intelligence. When we look back today on the much-maligned New Criticism, which was largely the creation of modernist poets—among them, T. S. Eliot and Ezra Pound—it looks like a Golden Age compared to the kind of academic obscurantism and political shadow-boxing that have supplanted it.

As for the fate of literature itself in the hands of the mainstream book publishers, we find that virtually all of the major houses in this country are now wholly owned subsidiaries of foreign conglomerates whose standard of achievement has less to do with literary quality or innovation than with access to media promotion, movie and television tie-ins, prize-winning, and other coefficients of high profitability. Mercifully, we can still count on a number of smaller presses and some of the better university presses to save the situation, but the downside of this benefit usually entails significantly reduced royalties for the worthy writers who do get published.

Exactly how it came to pass that a nation as prosperous as ours could not summon the resources to resist the takeover of its book publishing industry by an ailing Europe remains to be explained, but that takeover is now a *fait accompli*, and we shall be obliged to suffer its consequences for a long time to come.

In some respects the institutions that serve the visual arts—especially the museums and the galleries—might seem to present a much rosier prospect, for even in periods of low economic growth they have continued to prosper. Indeed, headlong and often heedless expansion of both collections and exhibition space and the funds required to support them has been the rule in the art museums for some years now. Modernist art of various persuasions has been the driving force as well as the principal beneficiary of this very expensive expansiveness as museums have hastened to respond to new artistic developments while at the same time attempting to catch up on the earlier innovations they missed out on. This museological scenario is now so familiar to us that we sometimes forget that the compulsion on the part of museums to keep abreast of radical innovations in contemporary art—and even, when possible, to anticipate and assist in creating a demand for them—was itself a momentous innovation in the way museums come to identify their interests and responsibilities. For this compulsion obligated the museums to become, in effect, not only collectors but also promoters of the art in which they were seen to have a vested interest—a vested interest, that is, in both the objects acquired for their collections and in the careers and celebrity of the artists who created them.

Hence the elements of hucksterism and entrepreneurial cynicism that have coarsened the character and spirit of so much museum activity today. Consider the advent of the museum called Tate Modern in London. Born in a blitz of publicity the like of which had formerly been reserved for pop stars and consumer gadgets, Tate Modern was the huge spin-off from the venerable Tate Gallery (now rebaptized Tate Britain). Housed in a gigantic renovated power plant on Bankside across the Thames from the original Tate Gallery, Tate Modern is ostensibly devoted to modern art. In fact, as the Tate's chief commissar Sir Nicholas Serota put it when announcing the bifurcation of the original Tate Gallery, Tate Modern is really devoted to "new narratives" of art—"new narratives," alas, in which the energy and seriousness of modernism is trivialized and distorted in order to accommodate its repackaging as a postmodernist exercise in chic cultural shallowness.

When we enter a monstrosity like Tate Modern in London, we are straightaway put on notice by the noise, the crowds, the theatrical lighting, and the general atmosphere of vulgarity and tumult that art has been used as bait to attract a segment of the public—free-spending

youth—for which aesthetic achievement is, if not a matter of indiffer-
ence, certainly not a compelling priority. And to assure a steady supply
of the only kind of new art that is guaranteed to be a turn-on for this
public, there are the proliferating productions of Charles Saatchi's gang
of YBAs—Young British Artists—and the Tate's own atrocious Turner
Prize–winners, who can be counted upon to maintain the requisite
standard of titillation.

Unlike the old Tate Gallery, our own Solomon R. Guggenheim Mu-
seum has not had to change its name but only its character to adjust to
the new entrepreneurial standard. I wonder how many of the people
who went to ogle Matthew Barney's freak show at the Guggenheim
have any idea that this museum, with its once incomparable collection
of paintings by Vasily Kandinsky, was founded in 1930 as an institution
devoted to the achievements of abstract painting? (Its original name was
the Museum of Non-Objective Painting.) Yet, just as its influence in that
respect was contributing something important to the emergence of Ab-
stract Expressionist painting in New York—the young Jackson Pollock,
among other artists, worked there as a guard in its early days—the
Guggenheim initiated the first of its ongoing efforts to reinvent itself.
This project of reinvention has left the museum stripped of anything that
can be called an identity and has required, among other depredations, the
sale of a great many of its Kandinsky holdings and works by other mod-
ernist masters. Today it is an institution better known for its exhibitions
of Norman Rockwell and Harley-Davidson motorcycles and its branch
museums abroad than for anything that advances an understanding of
modernist art.

Two of the other New York institutions that were founded to serve
the interests of modernist art—the Museum of Modern Art and the
Whitney Museum of American Art—are also at a crossroads that will de-
termine their future course, but for very different reasons.

MOMA is now in the throes of yet another of its periodic expansion
plans, one of the biggest in its history. When the expansion is completed
in 2005, it is expected to provide the museum with far more space for
showing its permanent collection as well as for its temporary exhibitions
program. Meanwhile, the museum and its public are making do with an
abridged, unappealing facility in Long Island City, MOMAQNS, for a re-
duced exhibition schedule, and a theater on East Twenty-third Street in
Manhattan for its popular film program.

At this point, we can only speculate about what this expansion will bring in the way MOMA's permanent collection—and thus modernism itself—is to be presented to the public for the remainder of the twenty-first century. If there is good reason to be hopeful about this outcome, it is mainly because John Elderfield—no doubt one of the most qualified senior curators in the field today—has been called upon to head the curatorial committee that will oversee the installation of MOMA's permanent collection in its new building. If there is also good reason to be anxious about the outcome, it is owing to the debacle of the museum's *MOMA2000* exhibitions, which radically recast the history of MOMA's permanent collection to conform to a "new narrative" emphasizing social content at the expense of aesthetic innovation. This was a shift in perspective that, among other losses, had the effect of consigning the history of abstract art—one of the central developments of modernist art—to the sidelines. Given the theme-park character that governed the organization of *MOMA2000*, there was no way that the aesthetics of abstraction could be given its due. It thus remains to be seen whether Mr. Elderfield will have sufficient authority to rectify such disastrous errors of judgment in the newly expanded MOMA.

About the future of the Whitney Museum, too, we can only speculate. Its recent history, marked by a succession of incompetent directors and a board of trustees that seemed at times to have lost its mind, has been so dismal that almost any change is likely to be a change for the better. The good news is that the Whitney's plan for a harebrained expansion of its own has been canceled for financial reasons. The appointment of Adam D. Weinberg, a former curator at the Whitney, as the museum's new director also gives us reason to expect significant improvement. It will not be easy, however, for the Whitney to win back the respect it has lost among artists as well as the critics and the public. A good place to start would be either the overhaul or the outright abandonment of the Whitney's Biennial exhibitions, which in recent years have gone from being merely ludicrous to wholly contemptible.

As for the international exhibitions like Documenta in Germany and the monster Biennials in Venice and São Paulo, they have now become cultural dinosaurs with no useful functions to perform and therefore no reason to exist. There was a period, of course, when exhibitions like the 1910 Post-Impressionism exhibition in London, the 1913 Armory Show in New York, and the 1938 International Exposition of Surrealism in

Paris really did bring the public news of important avant-garde developments in modernist art. But the age of the avant-garde is long gone. Its celebrated scandals and audacities have passed into the possession of the academic curriculum, to be catalogued, codified, and otherwise processed for doctoral dissertations and classroom instruction. The pathetic attempts at artistic insolence, mostly having to do with sexual imagery and political ideology, that turn up in the Whitney's Biennial exhibitions and the art departments of colleges and universities are better understood as efforts to attract publicity and what in the business world is called "market share" than as anything that can be regarded as avant-garde. In a culture like ours, in which, alas, everything is now permitted and nothing resisted, the conditions necessary for the emergence of a genuine avant-garde no longer exist. It doesn't change anything, either, to adopt the term "trangressive" as a substitute for "avant-garde," for where boundaries no longer exist it is impossible to violate them. "Transgressive" is a term that belongs to the history of publicity rather than the history of art. Today there is no avant-garde, and the big international shows are mainly devoted to marketing and politics. Modern systems of communication have, in any case, rendered the big international shows irrelevant.

Far more important to sustaining the aesthetic vitality of modernist art, however, has been the institution that we do not usually even think of as an institution: I mean the commercial art gallery. The art gallery as we know it today is, after all, a modern creation, barely a century old, and it performs a service for art unlike that of any other institution. It keeps the public in constant touch not only with current developments on the art scene but also with revivals of the work of earlier artists that the museums and the critics may have overlooked or underrated, and it does so at no financial cost to the viewer. More often than not, it is the gallery dealer, not the museum curator, who discovers significant new talent, for nowadays most curators make their "discoveries" in the dealers' galleries.

This is a cultural service more often enjoyed than acknowledged, but for many of us the art galleries have been a fundamental part of our aesthetic education. In this connection it is worth recalling Clement Greenberg's tribute to the late Betty Parsons, whose gallery introduced Jackson Pollock, Hans Hofmann, Mark Rothko, Barnett Newman, and Richard Pousette-Dart, among other artists, to gallerygoers of my gen-

eration. In 1955, on the tenth anniversary of the Betty Parsons Gallery, Greenberg wrote:

> Mrs. Parsons has never lacked for courage. It is not a virtue signally associated with art dealers (or, for that matter, with art critics or museum directors either), but then she is not, at least for me, primarily a dealer. I have seldom been able to bring her gallery into focus as part of the commercial apparatus of art (I am not sneering at that apparatus); rather, I think of it as belonging more to the studio and production side of art. In a sense like that in which a painter is referred to as a painter's painter or a poet as a poet's poet, Mrs. Parsons is an artist's—and critic's—gallery: a place where art goes on and is not just shown and sold.

Just as modernist art in America was, initially, an extension and appropriation of European modernism, so was a gallery like Betty Parsons's in a tradition that grew out of the precedents set by Vollard and Kahnweiler in Paris and Alfred Stieglitz's "291" gallery, which introduced Cézanne and Matisse as well as Marsden Hartley and John Marin to the New York public even before the Armory Show and long before the museums awakened to the achievements of modernism. The same could be said of the Weyhe Gallery's efforts on behalf of Gaston Lachaise and Alfred Maurer and the exhibitions devoted to Stuart Davis at Edith Halpert's Downtown Gallery. At every stage in the history of modernism in America, it was the galleries that set the pace in recognizing artistic achievement. This is not to suggest that all of our art dealers are sainted figures, but merely to point out that in New York, anyway, we are blessed with an extraordinary number of galleries that are places "where art goes on," and they should be given their due in any account of modernism and its institutions.

Finally, it is inevitable—or at least expected—in any discussion of modernism that the question of postmodernism will rear its ugly head. Or should I say, its wrongheadedness? For the entire concept of postmodernism is based on a fundamental misconception—a belief that the modernist era in art and culture is over and has been supplanted by something radically different. What we find this usually means when we get down to specific cases is a mode of art or thought in which some element of modernist sensibility has been corrupted by kitsch, politics, social theory, gender theory, or some other academic, pop-oriented,

anti-aesthetic intervention. Modernism has aged, to be sure, as modernity itself has aged, and in the process modernism has undeniably lost its capacity to shock or otherwise disturb us. But except for the short-lived antics of Dada and Surrealism, shock was never the essence of modernism. It was, rather, an inspired and highly successful attempt to bring art and culture into an affective and philosophical alignment with the mind-set of modernity as we know it in our daily lives. Modernism endures, and does so, in part, anyway, by virtue of the institutions it has created to serve the needs of a public that is today more enlightened intellectually and aesthetically than at any other time in our history. Postmodernism, in contrast, has created no institutions of its own, largely because postmodernism is nothing but a mind-set of deconstructive attitudes in search of a mission.

As I have noted elsewhere, we are far more aware than earlier generations of the many divisions, contradictions, and countervailing tendencies within modernism. We are more aware, too, that what goes under the name "postmodern" is really only modernism gone rancid—modernism with a sneer, a giggle, modernism without any animating faith in the nobility and pertinence of its cultural mandate. At any rate, it is a crowning irony that much that modernism in its original formulations took as essential to its identity should now appear just as dispensable as representation, narrative, ornament, and other traditional aesthetic accoutrements once did to the early modernists. It turns out that no style or genre has a monopoly on the modernist spirit. Its core is not synonymous with abstract art or plotless novels or Miesian glass boxes. On the contrary, the core of modernism lies in an attitude of honesty to the imperatives of lived experience, which means also an attitude of critical openness to the aesthetic and moral traditions that have defined our culture. The problem with postmodernism is not that it embraces architectural ornamentation or representational painting or self-referential plot lines. The problem is postmodernism's sentimental rejection of the realities of modern life for the sake of an ideologically informed fantasy world. In this sense, modernism is not only still vital: it remains the only really vital tradition for the arts. It is, in many ways, a broken or fragmented tradition, a tradition bequeathed to us not in a perfectly legible script that guarantees our continuity with the past but in the hieroglyphic syllables of a past that must be continuously redeciphered in order to shed intermittent light on our half-plotted itinerary. We see, then, that what modernism requires is not

a commitment to "chronic revolution" but rather permanent restlessness. It yields insights but not finality. The traditions it recovers are partial, fragmentary, but also forthright and nourishing: "these fragments I have shored against my ruin."

Looking back on the history of modernism in the twentieth century, what is especially striking is the violence that was directed against its achievements by the most horrific totalitarian regimes in recorded history: the Nazis in Hitler's Germany and the Communists in Stalin's Russia. And if we ask the question of what it was about modernist art that prompted such a massively destructive response, I believe the answer is clear: modernist art was seen to provide a spiritual and emotional haven from the coercive and conformist pressures of the societies in which it flourished. Modernism represented a freedom of mind that totalitarian regimes could not abide. It is in this sense, perhaps, that the infamous *Degenerate Art* exhibition that Hitler devoted to modernist art in Munich in 1937 may now be seen to have marked the beginning of the "postmodernist" impulse. And just as modernism survived the determined efforts of Hitler and Stalin to impugn and destroy its artistic achievements, so, I believe, will modernism and its institutions continue to prosper in the face of the nihilist imperatives of the postmodernist scam.

[2004]

Has Success Spoiled the
Art Museum?

Of all the institutions of high culture that have undergone significant change in recent decades, none has been more radically transformed than the art museum. In every aspect of its function, its atmosphere, and its scale of operations, in the character and number of the events that it encompasses, in the nature and size of the public it attracts, and in the role it plays in codifying—and at times deconstructing—our ideas about what art is, the museum has been so dramatically altered in our lifetime that in many important respects it can no longer be said to be the same institution we came to in our youth. And of all the changes that have overtaken the art museum in our time, the most crucial has been the elevation of change itself to the status of a governing principle.

In the past we looked to the art museum for our touchstones of artistic quality and achievement. It was in the museums that we learned to become connoisseurs of artistic accomplishment—to become intimate with and knowledgeable about works of art over the long term; to acquire a sense of judgment and discrimination about their special attributes, about their differences and resemblances, and their complex relation to one another and to ourselves. It was through this process that our pleasure in art was deepened and our understanding of it enlarged, and this was as true for the amateur public, which we are all a part of at the outset, as for the professional. "The Louvre," wrote Cézanne, "is the book in which we learn to read," and it was understood that learning of this sort could not be hurried by crash courses, superficial entertain-

ments, or overnight conversions. Like all learning that is serious, that becomes a personal and permanent acquisition and thus a part of our lives, it required time and application, and one of its essential preconditions was a certain stability in the museum itself—the kind of stability that precludes precipitous change and a fickle, continual tampering with the objects of our scrutiny. We did not look to the art museum for news but, on the contrary, for what remained vital and enduring after it had ceased to be news.

Nowadays, however, we expect of our museums that they will be dynamic rather than stable, that they will no longer be guided by fixed standards or revered traditions, but just the reverse—that they will shed convention, defy precedent, and shatter established values as often and as eagerly as the most incendiary avant-gardist of yesteryear. We demand of our museums that they bring us news as regularly as the media itself, and this inevitably entails a shift of attention from the permanent to the temporary—a shift now everywhere in evidence in the museum world and officially codified in the name of the museum facility in Los Angeles that calls itself the Temporary Museum of Contemporary Art, or the Temporary Contemporary, as it is better known. It is thus one of the paradoxes of the art museum as a cultural force that as the reign of the avant-garde has drawn to a close as far as the creation of new art is concerned, its program of incessant and omnivorous change has been enthusiastically embraced—some would say promiscuously embraced—by the institution that was long thought to be the principal counterweight to the restless avant-garde spirit.

The art museum thus finds itself at the end of the twentieth century in the curious position of having supplanted art itself as the leading advocate and agency of innovation in our artistic affairs. What was formerly a highly individualistic impulse has now become an established bureaucratic practice, and there can be no question that the museum's adoption of this radical role has been accompanied and indeed accelerated by widespread approbation and applause. There are dissenting voices, of course, but if the command of money, resources, publicity, prestige, and sheer numbers of people is a measure of success in the life of an institution, the transformation of the art museum into a vehicle of headlong cultural change must be pronounced a resounding success.

Yet, just as Braque once observed that in the making of art every acquisition involves an equivalent loss, it may be appropriate to ask what

this huge success has cost us. While there is little likelihood that the momentum that has propelled our museums on their present course will soon be reversed, it nonetheless behooves us to see as clearly as we can where this course is taking us and what further sacrifices are to be exacted as the price of developments still to come. For certain sacrifices have already been made, as almost anyone whose experience of museums goes back a few decades will readily attest, and we may be sure that an institution that has so irreversibly tethered its fate to the principle of dynamic change will be called upon to make a good many more.

One thing is beyond dispute. As a result of the immense growth of museums and their embrace of the principle of dynamic change, more people than ever before have been induced to take some sort of interest in art, or induced at least to take an interest in matters that have the appearance of being somehow related to art. It must also be said that this new multitudinous public has access to a program of events, exhibitions, entertainments, publications, etc., far more various and far more numerous than any that was offered by museums in the past. Many of these activities are not, to be sure, what I have heard described by museum officials as "object-oriented."

That is, they are not concentrated on specific art objects. But then, museums have long ceased to be places that people visited solely or primarily for the purpose of looking at works of art. They are now the venue of all sorts of other activities that can be described as museum activities only in the sense that they take place under the roof, or at least under the auspices, of the museum. Yet with serious artistic matters, with learning or intellectual improvement or aesthetic enlightenment of any sort, these activities often have little or nothing to do. They come under the general heading of social diversions.

We now take it for granted that the art museum is an appropriate place in which to order lunch or dinner, buy something to wear, do our Christmas shopping, see a movie, listen to a concert, attend a lecture on anything under the sun, possibly even art, and also on occasion participate in a wedding party, a cocktail party, a charity benefit, a business reception, a fashion show, or some other lavish social event for which the museum is deemed a suitably prestigious facility. In the museums that now offer such services and distractions, it is still possible, of course, for people to look at works of art, and many do. Yet except in the highly publicized special exhibitions that draw the crowds, the galleries con-

taining works of art are likely to be emptier of visitors, even on weekends, than they were a generation ago. This is no doubt some consolation to the beleaguered connoisseur looking for a quiet corner in which to have an unimpeded view of a favorite masterwork, but it is not exactly a happy index of the museum's interest in cultivating a loyal public for its greatest treasures. The overall atmosphere in our big museums, anyway, does not really lend itself to the cultivation of such a public, which cannot be expected to prosper in an environment of hubbub and hucksterism. In lieu of this public the museum now has members, who avail themselves of the social diversions and add to the hubbub without in any way constituting a serious public for art.

This development is no longer to be regarded as a peculiarly American phenomenon, by the way. We may have pioneered the move toward a broad diversification of the art museum's interests and functions, but the phenomenon itself is now widespread. When we enter the Louvre nowadays through the famous glass pyramid, we descend by escalator into a vast, bright, sprawling space that resembles, more than anything else, the interior of a huge international airport in the busy holiday season. There are lines everywhere—a line to enter the pyramid itself, and then more lines at the cloakroom, the washrooms, the ticket booth, and the cafeteria. (Except in the immediate vicinity of the famous tourist attractions—the Victory of Samothrace, the *Mona Lisa*, et al.—the crowd is considerably thinner in the galleries, where most of the art is.) And at this "new" Louvre or Grand Louvre, as it is now to be called, there is worse yet to come. According to an interview with Michel Laclotte, the director, "in the future, a shopping mall and a substantial underground parking lot will complete the new underground areas of the Louvre." We are assured that despite this vast expansion of the Louvre's functions and facilities, "in Michel Laclotte's mind, no concessions have been made to mere trends or fashions"—a statement which, if it means anything, can only mean that the director of the Grand Louvre is oblivious to what is going on under his own authority.[1] For at every turn in the labyrinthine sprawl of the new Louvre we are in the grip of every trend and fashion that has beset the art museum for several decades now.

1. See Raoul Ergmann's interview with Michel Laclotte in *The New Louvre: Complete Guide* (Paris, 1989).

Adding a huge underground shopping mall to the airportlike entrance to the new Louvre will have the virtue, I suppose, of carrying the logic of the new museology to its ultimate conclusion. Martin Filler, writing in the London *Times Literary Supplement*, gave us an excellent account of where this logic was heading even before the Grand Louvre was on the drawing boards. "I. M. Pei's East Building for the National Gallery of Art in Washington, completed in 1978," wrote Mr. Filler, "is dominated by a vast, glass-roofed atrium—replete with escalators and potted ficus trees that give it the aspect of an upmarket shopping mall—while the oddly shaped galleries relegated to three towers on the periphery of the central courtyard and the subterranean changing-exhibition spaces seem like grudging afterthoughts. Intentional or not, the architect's adaption of the imagery of the contemporary market place reinforces the notion of museum-going as yet another consumer activity." In this respect, at least, it must be acknowledged that the French, albeit with some help from us—Mr. Pei is also, of course, the architect in charge of the Grand Louvre—have outdone even American efforts in this direction by uniting the shopping mall and the art museum in a single gargantuan facility. Alas, one is reminded that Andy Warhol's joke about the many things that department stores and museums have in common is turning out, as so many of Warhol's jokes have, to be a deadly prophecy.

It would be difficult to say whether this rampant commercialization and consumerization is only a symptom or a primary cause of the altered relationship that now obtains between the art museum and its public, but there can be no question that this relationship is now the main issue facing the art museum as an institution. It determines much of its budget, its program, its choice of personnel, and its general ethos. To a larger extent than is commonly supposed, the museum has become a captive of its own success, and what is so striking now about its relation to its public is the extreme degree of anxiety and uncertainty that has come to characterize every aspect of it. Often the problem comes down to catering—in every sense—to a public that does not know exactly what it has come to the museum to do or see. This public wants, at one level or another, to be amused, instructed, gratified, edified, or otherwise diverted. Nowadays, too, with the toxin of multiculturalism threatening the intellectual integrity of arts institutions of every kind, the public may also come to the museum in search of political satisfaction. The experi-

ence of art is likely, in all too many cases, to be entirely peripheral to what is looked for in the museum.

With museumgoing now separated in this way from a genuine interest in art—and by this I do not mean only a professional interest, for it is the amateurs of art who have traditionally constituted the true museum public—it was inevitable that the art museum would be obliged to devise new stratagems for attracting its public and retaining its loyalty. That these stratagems have, for the most part, less to do with education than with marketing is a reflection of the museum's low estimate of the public it has won for itself with such great effort. Hence the sometimes extreme measures that even great museums are driven to in their quest for the high attendance figures that are now needed to justify the expense of major events. When, a few years ago, I heard the radio commercials for the Caravaggio exhibition at the Metropolitan Museum of Art—commercials that attempted to make the show sound as much as possible like an X-rated movie—I knew that we had entered a new period in the relation of the museum to its public. This was, after all, advertising aimed at the "educated" segments of the public, and it was not only the appeal to a prurient interest that was obnoxious. It was also the cynicism implicit in the whole endeavor, for the museum officials responsible for this advertising campaign surely knew that the exhibition they were touting in this unseemly manner was incapable of satisfying the kind of sexual curiosity the ads were designed to arouse. As a result, the art was demeaned, the public misled, and the institution degraded. This was not an isolated case, either. The same advertising strategy was used by the same museum to promote a showing of Balthus's paintings, too. In other words, a policy had been established to cope with a pressing need—the need to entice a public in whose artistic judgment the museum has no confidence whatever.

This low estimate of the public's interests and appetites, with its corollary reliance on marketing rather than education as a means of recruiting new constituencies, is even more vividly in evidence in the kinds of new museum architecture that have been created at such vast expense in recent decades. The field of museum architecture has in fact emerged in this period as a cultural battleground of considerable significance, for in the debates that the new museum architecture has prompted, as well as in the particular buildings it has produced, virtually

all the most contentious issues concerning the future of high art in our democratic society have been broached, and in them we have been given a glimpse of the way these issues are likely to be resolved, or left even more conflicted and unresolved, for many years to come.

The first thing we notice about a great deal of the new museum architecture—and this is as true of the refurbished Los Angeles County Museum of Art as it is of the new Louvre or the East Building of the National Gallery in Washington—is that the palace-of-art, or temple-of-art, ambience has been dramatically supplanted by the atmosphere of an emporium, a recreational facility, or a transportation center. This isn't the whole story of the new museum architecture, to be sure—the Kimbell Art Museum in Fort Worth and the Picasso Museum in Paris afford a very different order of experience—but it is the largest part of the story, and the part most likely to be emulated in the future. The grandest of the new museum spaces tend to be allotted not to the contemplation of art objects but to the activity of the crowd—*as* a crowd. The debate that has attended the creation of the new museum architecture is, moreover, almost wholly shaped by this shift from an environment of reverence, as it may be called, to an atmosphere of activity and consumption. And while it is less a debate about the philosophy of art than about the philosophy of leisure, it nonetheless has grave implications for the place to be accorded high art in our culture.

Like all cultural questions these days, this debate about museum architecture also has an important political dimension. In the policy disputes governing the new museum architecture, no less than in other branches of the arts today, we have been witnessing the struggle—sometimes it seems as if it were the final struggle—between those who, on the one hand, believe that the future of our civilization depends on safeguarding the integrity of high art from the leveling imperatives of popular culture and populist politics, and those who, on the other hand, are dedicated to destroying—in the name of democracy and equality, of course—all sense of hierarchy and all distinctions of quality in the life of culture itself. The latter have been especially concerned to discredit the idea of the museum as a "temple" or "palace" of art, which in their view is not only an outmoded museological paradigm but a politically vicious one, and they argue in favor of the kind of design, the kind of program, and the kind of technology that will shatter forever the entire range of museum practices traditionally used to reinforce the sense of hierarchy

and the distinctions of quality they so intensely despise. Needless to say, connoisseurship at any level is dismissed as an interest identified with the odious elitism of the past. In the brave new world of the new museum— the populist museum, as it may be called—every interest, including a lack of interest in art, is to be on an equal footing with every other interest. The art object is thus to be denied its traditionally "privileged" place in the institution that was originally created to preserve and celebrate its existence.

The most respectable exponents of this populist museum model— Mr. Pei is, I suppose, the outstanding example among the architects— bear no grudge against art objects, of course, but they tend, all the same, to favor the kind of consumerist museum plan described by Martin Filler and so enthusiastically embraced by Michel Laclotte. But there is also a more radical faction in this debate that takes as its primary goal the downgrading—or, as they say, the desanctifying—of the art object in favor of technological simulacra that can now make images of the art object instantly accessible to ever larger numbers of people. Not the experience of art but the consumption of "information," not the ideal of high culture but the easy, ephemeral pastimes of entertainment, are what now, in this view, should be made the museum's priority.

It is from this perspective—best described, perhaps, as that of a technocratic populism—that we have lately been given a glossy book called *The Museum Transformed.* Its author is Douglas Davis, who was for many years a writer for *Newsweek*; its subtitle is "Design and Culture in the Post-Pompidou Age"; and its foreword is by Jack Lang, the French cultural minister, who is himself a champion of the technocratic populism Mr. Davis espouses. *The Museum Transformed* is, as an intellectual artifact, a perfect example itself of the way the appeal to fashionable consumption is nowadays combined with the denigration of the art object and the advocacy of radical cultural policy in discussions of museum matters. The format of the book is that of the upscale coffee-table picture book, with its many color plates and its lavish use of decorative typography, yet in the nearly two hundred illustrations to be found in *The Museum Transformed,* which surveys a good many of the art museums that have been recently built or significantly altered, we are afforded very little sense of what it is like to look at works of art in these structures. You can turn many pages of this big book without having a glimpse of an art object, and this, I think, tells us most of what we need to know about the author's view of

the museum's real function today. It is scarcely a surprise, then, that Mr. Davis's allegiance turns out to be clearly committed to what he calls the "post-object" role of the museum, which, owing to what he also calls the "post-contemporary condition" of our culture, is—or at least ought to be—in the happy position of dispensing with the traditional obligation to provide, as he says, "first-hand access to the sacred object."

While it may still be necessary for the museum to provide such access to the art object, it is Mr. Davis's view that "the evolving museum must see itself as a medium of information and pleasure." This, in any case, is the direction in which "the audience and the program of the museum" are said to be moving, and ought to be moving, and an institution that remains "committed to posing as the cathedral of the irreplaceable object" is merely pursuing a lost cause. Instead of a concern for what Mr. Davis calls "unique totems sanctified by scholars and historians"—one of the author's many sneering epithets for the accumulated aesthetic achievements of an entire civilization—museums are advised to look to technology and the theories of Walter Benjamin for proper guidance in these matters. Why should the actual art object matter, anyway, when technology has already rendered its physical presence obsolete? He thus invokes "the presentation of information about the world's authentic treasures, now easily recalled for our eyes and minds by electronic media or by holography, in media varying from the television set to the home computer . . . or to monitor terminals installed in the museum itself," and this development is acclaimed as the happy realization of Benjamin's theory of the desanctified art object.

> Long ago [Mr. Davis writes] the German critic Walter Benjamin
> prophesied that the mechanical reproduction of works of art through
> photography and film would diminish our insistence on confronting
> the "aura" of art only in its original state. . . . Now we have the means
> to "move" any treasure in a matter of seconds from the vault of the
> Louvre to a terminal in Columbus, Ohio, before a viewer conditioned
> by now to intuit the lost "aura" of a work of art in its duplicate state.

But is it really the "aura" of the work of art that we go to a museum to have an experience of, or is it something else, something far more concrete that cannot be experienced in "its duplicate state"? This refusal to make a distinction between aesthetic experience and what is now called "information" is central, of course, to this utopian—or should I say

dystopian?—vision of the museum of the future. In his chapter on "The Museum in the Next Century," Mr. Davis writes:

> Because the possibilities for instantaneous transmission of visual and textual information are now almost limitless thanks to computer systems of instantaneous retrieval . . . each museum is now potentially every museum.

The awful thing is that Mr. Davis is by no means alone in believing in this chimera—nor alone, either, in his eagerness to see this museum of the future quickly and fully realized. Almost nothing that the new museum architects have so far produced for us comes close enough to the ideal he envisions. The Pompidou Center in Paris is the closest approximation, but its futuristic mission has been subverted, in Mr. Davis's view, by old-fashioned curators who persist in their benighted attachment to the art object and to devising sympathetic ways of exhibiting it—admittedly, an uphill task at the Pompidou Center. Certainly the art object is nowhere mentioned in Mr. Davis's evocation of what the "next" museum will ideally offer us:

> The grand staircase, the broad walkable corridors, the honeycombed asymmetrical galleries, and of course the elegant theaters and restaurants are the obvious interior elements that define the potential of the "next" museum.

The curious thing is, except for the remaining presence of those "unique totems sanctified by scholars and historians," this sounds to me a lot like the museum buildings we have lately seen erected, but Mr. Davis is apparently the kind of purist who will not be satisfied until the museum is entirely object-free.

Is that day close at hand? I frankly doubt it. The art object is not going to be eliminated from the museum, but what is already upon us in the museum is an altered attitude toward the work of art. It is no longer trusted to speak for itself. It needs, so to say, to be brainwashed. It must now be seen to speak for, or about, something else. The way in which the art object is presented in the museum, the way in which it is interpreted, deconstructed, "contextualized," politicized, and otherwise de-aestheticized, reflects a loss of confidence on the part of museum professionals in art itself.

It is also a reflection of the shift that has taken place in the academic study of art—the shift from connoisseurship to theories and methodologies derived from the social sciences. The immense influence of structuralist and poststructuralist theory has also played a crucial role in this trend among museum professionals to de-aestheticize the interpretation of art and treat the art object as if it were just another artifact in what is now called material culture. Aesthetic categories are now shunned in the museum in favor of sociological and political categories. The charge of "formalism" is now almost as dreaded in the museum world as it used to be in the Communist world. While militant Marxists remain a small minority among museum professionals, the Marxist notion of relegating art to the so-called superstructure, where it is seen to be an embodiment of social and economic forces more profound than itself, has now become part of the conventional intellectual wisdom of a great many curators who have never read a line of Marx himself.

Often entire exhibitions are now organized on the basis of such ideas. The show called "The West as Art," which caused such a furor at the National Museum of American Art in Washington last season, was but one of many recent examples, and most of them cause no furor at all. And this changed attitude toward art is also beginning to be reflected in the way museums present their permanent collections to the public. This summer at the Whitney Museum of American Art in New York, for example, the seasonal "Selections from the Permanent Collection" exhibition was mounted under the title "American Life in American Art, 1950–1990," and it was billed as a survey of "postwar paintings and sculpture exploring themes from prosperity to critiques of the American Dream." When one ascended to the third floor of the museum to see what had been selected to represent this documentation of "prosperity" and "critiques of the American Dream," there were familiar paintings by Milton Avery, Richard Diebenkorn, and Lee Krasner, and sculptures by David Smith, among many other objects, that had nothing whatever to do with these subjects.

I don't suppose that most visitors to the Whitney were even aware that these and the other works of art in the exhibition were intended by the museum staff to be "read" as social documentation and criticism. But that will change. With the announcement in July that Benjamin H. D. Buchloh, a left-wing stalwart of the *October* magazine circle, has been appointed to a position that makes him, in effect, the Whitney's chief po-

litical ideologist, you may be sure that we shall be seeing a good many more "critiques" of this sort far more aggressively pursued. According to David A. Ross, the new director of the Whitney, Mr. Buchloh "will have a key role in providing an environment that encourages critical study and theoretical inquiry into the practices, institutions and discourses that constitute the field of culture." This, you may be sure, sounds the death knell to whatever remained of a remnant of a serious and disinterested attitude toward art at the Whitney. From now on it will be more and more politics and less and less art, though the politics will be presented, of course, in the name of art.

And this political, anti-art course at the Whitney will be pursued in tandem with a revivified emphasis on consumerism at the museum. Mr. Ross's other big initiative this summer was the refurbishment of the Whitney's restaurant and the installation of a new chef. If you think that consumerism and political radicalism represent conflicting polarities in the new museum world, you are mistaken. Nowadays they live on very easy terms with each other, for each conforms to a fashion of the moment, and they are alike in diverting the museum from its real function. Neither contributes anything whatever to our understanding of art. That is what makes them so attractive to the new breed of museum director. You will see the same program of consumerism and left-wing ideology in command at the expanded Guggenheim Museum whenever its director gets around to reopening it. In the new museum there is no need to eliminate the art object. You may instead render it socially and intellectually invisible.

Of the art museum at the end of the twentieth century it may truly be said that nothing has failed like success.

[1991]

Tate Modern Inside and Out:
The Museum as Culture Mall

Absence of heart—as in public buildings—
Absence of mind—as in public speeches—
Absence of worth—as in goods intended for the public,

Are telltale signs that a chimera has just dined
On someone else; of him, poor foolish fellow,
Not a scrap is left, not even his name.
 —W. H. Auden, in "The Chimeras"

Of the late, lamented Tate Gallery in London it can be said that only a name is left, but now clipped of its definite article and divided into dubious duplicate, Tate Modern and Tate Britain—a reminder, if we need one, that two negatives cannot be expected to produce a positive result. Yet this ill-conceived project clearly represents the spirit of the age, which in art and in life is besotted with an appetite for destroying what is good by enlarging it to a scale of extinction. It puts us on notice that in the twenty-first century we shall need no wars to devastate our monuments to the past. Our cultural bureaucrats have shown themselves to be fully capable of performing the task for us.

At the outset of these melancholy reflections on Tate Modern, I must acknowledge that I put off visiting this bizarre creation—or should I say bazaar creation?—for a longer time than was, perhaps, appropriate for a professional critic of art and its institutions. Yet I had my reasons. The publicity campaign preceding the breakup of the old Tate Gallery into

two new museums—Tate Britain, which is now to be devoted to British art, and Tate Modern, which ostensibly provides London with its first museum of modern art—was not of a sort that inspired confidence in the entire enterprise. Whether we call it hype or spin or (as we used to say) false advertising, it was clearly a campaign to prepare the public for an art museum that was to be something other than a traditional art museum. What this other thing might be remained a little vague, but one somehow had the impression that the advancement of an aesthetic understanding of works of art would not be its top priority.

The announcement of the Tate's breakup coincided, moreover, with the Blair government's promotion of a policy called Cool Britannia, which cheerfully promised to extirpate all signs of Britishness from the UK's institutions and their symbols—a campaign of self-annihilation that, in my view, is a death warrant for much that I have cherished in Britain during my frequent visits over the course of some four decades. Suddenly the very words "British" and "English" were being stigmatized as "racist" by wacko members of the Blair government—a sure sign that "New Labour," as the Blair government bills itself, was launching a far-reaching *Kulturkampf* bound to affect the art museums, which in Britain (as in most of Europe) are state institutions.

My mounting feeling of dread was further advanced when, shortly before the opening of the new Tates, I attended a lecture at our own Museum of Modern Art in New York by the mastermind of this project, Sir Nicholas Serota, who outlined his program of "new narratives" for these institutions. Sir Nicholas spoke like a man who had lately emerged from a conversion experience somewhere in the vicinity of Disneyland or some other American theme park. Themes, themes, and more themes were now to determine every aspect of the museums' "new narratives," while historical chronology and the presentation of art according to periods, styles, and movements were to be consigned to oblivion as outmoded, if not indeed—perish the thought—elitist.

Thus distinctions between past and present, never mind the very idea of tradition in art, were to be abandoned in favor of something like a boundless eternal present in which an anaesthetic populist ideology would trump every other intellectual imperative. Thinking back now about Sir Nicholas's talk at MOMA that evening, it occurs to me that his only remaining attachment to tradition of any sort is to be found in his acceptance of a knighthood from Her Majesty's government. Was this

a sign of hypocrisy? Perhaps. But as it was also a sign of power, it was deemed to be acceptable. All of which I took to be a dour augury, and I was in any case fully occupied elsewhere. I was in no hurry to visit the ruins of what I had for so long regarded as a beloved embodiment of the civilization that had successfully survived the punishing wars and revolutions of the twentieth century with its democracy, its civility, and many of its cultural traditions intact.

By March, however, I felt I could no longer defer this professional obligation, and I set off for London with a heavy heart. Arriving at night, I had my first encounter with the new, dumbed-down BBC—another sign of the times—when I attempted to find a news broadcast on the television set in my hotel room. What I found was a dispiriting variety of tabloid journalism, delivered in a distinctly downmarket accent, that was determined to whip up hysteria over the spread of foot-and-mouth disease in the countryside while exploiting the already rampant cynicism over the sleaze-scandals of the Blair government. The obvious correlatives that obtained between the Blair government's hype and the Tates' spin strategy were ominous indeed.

Still, London looked beautiful the next morning as I set off on foot from my hotel in Knightsbridge to see "The Genius of Rome" exhibition at the Royal Academy in Piccadilly. Spring comes earlier to London than to New York, and the parks were already ablaze with daffodils and primroses in bloom. The sun was shining, the skies were blue, and "The Genius of Rome" show proved to be every bit as marvelous as I had expected it to be. It was a pleasure to be able to revisit this exhibition twice again during my week in London. Marvelous, too, was the big exhibition of Rembrandt's etchings at the British Museum.

I was less thrilled—appalled, in fact—by the new, horribly overscale entrance to the British Museum, which now encloses the museum's legendary Reading Room in a faceless structure of monstrous height and girth. No matter how well acquainted we may be with the many examples of execrable museum architecture in our time, atrocities of this magnitude have not lost their power to shock when we first encounter them. It therefore seemed prudent to put off my initial visit to Tate Modern for another day.

That day, too, was bright with sunshine and blue skies, which made the taxi ride to Bankside, across the Thames, a very pleasant journey. Despair descended, however, immediately upon entering the vast ascending

ramp, fully wide enough (it seemed) for two-way truck traffic, that serves as the principal pedestrian entrance to Tate Modern. This unwelcoming space in what was once a power station seems deliberately to embrace the featureless brutality of an underground parking garage. Until then I had thought that the lugubrious Hayward Gallery, designed in the 1960s in what its creators were happy to call the Brutalist style, was the worst museum building in London, but that distinction now has been won by Tate Modern. It was almost enough to make one lapse into nostalgia for the kinder and gentler horrors of the Museé d'Orsay in Paris, which was originally built to serve as a major railway terminal and still feels like one.

I had only just entered this behemoth, but it was already enough to make one experience a profound sense of loss—a loss not only of beauty and amenity but of civilization itself. This was an experience that was to be repeated many times as I began to make my way through the organized chaos of the place, for upon ascending to the top of the unlovely entrance ramp, the visitor to Tate Modern suddenly encounters a somewhat different prospect: the gloom of an underground parking garage dissolves into something resembling a gigantic airport arrivals terminal, where crowds, confusion, and commercialism reign and the only work of art to be seen is what I suppose must be called a sculpture constructed of discarded office furniture. This turned out to be one of Damien Hirst's nonzoological inspirations, and it prompted me to wonder if this minimonument to Neo-Dada was meant to represent some sort of farewell to the Tate Gallery of old—a memento mori, as it were. Or was it, perhaps, to be construed as a symbolic portrait of Sir Nicholas himself—a portrait of the museum director as deranged bureaucrat? When I put this question to a harried clerk at the Information counter, he was unable (or unwilling) to shed any light in the matter. Given the unrelieved din that made even a brief exchange of words something of a feat, I could hardly blame him.

Then it became a question of what to attempt to see first: the reinstallation of the Tate's modern art collection or its mammoth inaugural theme exhibition—"Century City: Art and Culture in the Modern Metropolis." Given the museum's chaotic layout, there was no consecutive way of seeing either without skipping floors and doubling back. For the sections of "Century City" devoted to London and Bombay were right there on the first floor, behind the Information counter, while the sections devoted to other cities in this mad mélange of what it pleased its

sizable cadre of curators to call art and culture but was often neither—
Paris, Rio, Vienna, Moscow, New York, and Lagos—were on the fourth
floor, sandwiched in between the two floors, three and five, devoted to
a reinstallation of the museum's collection.

In the end, the order in which the visitor to Tate Modern looks at
anything—whether walls festooned with words or rooms in which mag-
azines and newspapers vie for attention with works of art—hardly mat-
ters. For every object and every wall text is manacled to its assigned
themes and classified according to its subject and sub-subject. In the
"Century City" show, each metropolis was also strictly confined to a
specific time frame. This was lucky for Paris, which was assigned the
years 1905–1915, and for Vienna, which was given 1908–1918, and so
some art worth looking at was actually on the walls. The way it was pre-
sented, however, was another story—a "new narrative."

You might think it impossible to devote even a thematic show to the
art and culture in Paris in the years 1905–1915 that could reduce its high
artistic achievement to a tedious, incoherent jumble. Yet Serge
Fauchereau, the curator of the Paris section of "Century City," somehow
managed to pull off this unimaginable feat without a hitch. A few of Pi-
casso's and Braque's finest Cubist collages, for example, were hung in a
narrow corridor in which they could hardly be seen if three or four peo-
ple were present at the same time. And remember, "Century City" was
designed to draw huge crowds—and did. The sound track—Stravinsky, I
think—didn't help matters, either. It only added to the din.

New York, to be blunt about it, was given the shaft in "Century
City." To provide even a foreshortened glimpse of art in New York in the
twentieth century, what period would commend itself? The years before
and during World War I when Alfred Stieglitz was showing John Marin,
Marsden Hartley, Arthur Dove, Paul Strand, et al., and publishing *Cam-
era Work*? Or the period in the 1940s and '50s when the Abstract Ex-
pressionists captured the attention of artists and critics on both sides of
the Atlantic, and New York itself became the art capital of the Western
world?

Forget it. The geniuses who organized "Century City" were clearly
determined to cut New York down to size—the smallest possible size. So
the New York section of the show was limited to a five-year slot,
1969–1974—compared, say, to the fifteen-year period, 1955–1970, as-
signed to Lagos, and the fourteen years, 1950–1964, given to Rio de

Janeiro. The point, apparently, was to find a time when New York in particular and the United States as a whole could be depicted as a society on the skids.

The iconic object here was the silk-screen print of a demonic Richard Nixon which Andy Warhol produced for the George McGovern campaign in 1972. And to underscore an alleged absence of significant art in New York in this half-decade period, the curator of the New York section—Donna de Salvo—featured the work of Lynda Benglis, Hannah Wilke, Vito Acconci, and Gordon Matta-Clark. The creepiest thing of all, perhaps, was the first wall text that greeted visitors to the New York section of "Century City": a quotation from that celebrated connoisseur of urban amenity, the late Nikita Khrushchev, whose statement deplored the absence of "greenery" in Manhattan. Apparently nobody took the trouble to show him Central Park when he made his famous foray to New York to announce that the Soviets would "bury" us.

Does all this suggest that "Century City" was, in its principal focus and energy, more of an exercise in left-wing political pieties than a serious inquiry into the worldwide achievements of art and culture in the twentieth century? You bet. Hence the exuberant attention lavished upon the Moscow section of "Century City," which focused on the years 1916–1930. Did anything even vaguely unpleasant happen to the modernist movement in Russia in this period? Well, sort of. Lutz Becker, the curator of the Moscow section of the show, does very briefly acknowledge that "Mayakovsky's suicide and Malevich's three-month imprisonment as a suspected spy in 1930 were for many a signal of the beginning of Stalin's terror." But that's the last we hear of such unpleasantness, and even this less than satisfactory reference to the Terror that vanquished the Soviet avant-garde is quickly followed by a statement that is patently false. "Throughout the 1920s," writes Mr. Becker, "artists had contributed to the new society voluntarily and with enthusiasm, with a minimum of Party interference." The fact is, you either had to give up your artistic freedom in favor of party hack work or leave the country to survive. Which is why Rodchenko, Stepanova, Lissitzky, and other true believers in the Revolution became, in their graphic art, apologists for Stalin's Terror, and also why, by 1923, Kandinsky, Chagall, Gabo, Pevsner, and many other talents had already fled to the West.

What was finally even worse than the political slant of "Century City" was its pervasive contempt for art itself—a contempt that refused

to acknowledge that works of art do not, in the character and quality of the experience they afford, differ from any other variety of material culture. As a consequence, it was only as a variety of material culture that works of art were presented to the public in this "new narrative" of social ideology.

Alas, it cannot be said that the reinstallation of the Tate's collection of modern art fared much better. In this "new narrative," an elaborate system of classifying objects according to themes reduces all of the art to four basic categories: "History/Memory/Society"; "Nude/Action/Body"; "Landscape/Matter/Environment"; and "Still Life/Object/Real Life." Except for the artists who are given the privilege of having rooms largely devoted to their work—Bruce Nauman and Louise Bourgeois among the Americans, and Richard Deacon and Ben Nicholson among the Brits—the idea seems to be to pit unlike talents against each other in a game of survival-of-the-strongest. Thus a Richard Long mud wall is pitted against a water lilies painting by Claude Monet in the "Landscape/Matter/Environment" section. The most horrific of these confrontational installations is the room in the "Nude/Action/Body" section in which several really grim paintings by Lucian Freud and Christian Schad are pitted against a single exquisite work by Bonnard—*The Bath* (1925), the first of the many paintings Bonnard devoted to the subject of his wife lying full length in a bathtub, and a picture that was much beloved by an earlier generation of English painters. This grotesque abuse of a masterpiece ought really to be called museum rape, and it tells us everything we need to know about Sir Nicholas's "new narratives." In one of the installations at Tate Britain, by the way, Lucian Freud is similarly pitted against a Whistler portrait of a girl in a white dress.

Why, one is finally left wondering, this persistent, pernicious imperative to degrade art of superior subtlety and delicacy—Monet, Bonnard, et al.—by means of incongruous juxtaposition with the kinds of art that are blatantly inimical to its spirit? We can only guess at the motives governing this malign impulse, which is as pervasive in the installation of the Tate's permanent collection of modern art as it is in so much of the art selected for the "Century City" installations. My own guess is that it may be an attempt by a younger generation of curators to reduce the masterworks of modern art to the debased levels of feeling which dominate the so-called Young British Artists—think "Sensation," which came to

the Brooklyn Museum by way of the Royal Academy and the Charles Saatchi collection. The current London art establishment has so much invested (in every sense) in the international prosperity of these YBAs that it was probably inevitable that their supporters would make an attempt to bring everything else down to their level. From this perspective, it makes perfect sense, then, that the first work which the visitor to Tate Modern encounters is that construction of discarded office furniture by Damien Hirst.

It makes the same kind of sense for the New York section of "Century City" to be dominated by some overscale urban debris—no doubt rescued from the demolition of a New York building—by Gordon Matta-Clark and by Lynda Benglis's photograph of herself in the nude sporting a sizable dildo—a picture that once served as an advertisment in *Artforum*. If items like these were meant to signify that New York art in the early 1970s is only of interest to London now as a kind of prelude to the Brits' own YBAs, the point is well made. But for most of us in New York, Gordon Matta-Clark and Lynda Benglis were entirely marginal to what art in New York was up to in that period. At every turn at Tate Modern, a line remembered from William Hazlitt seemed to sum up the whole spirit of the place: "People who lack delicacy hold us in their power." Is this really the way to run a museum?

The truth is, Tate Modern isn't an art museum at all. It's something else—a culture mall in which bits and pieces of twentieth-century art, culture, and politics are deboned and prepackaged for quick and effortless consumption. It is the function of this culture mall to reduce the achievements of high art to the sensation levels of tabloid journalism and pop entertainment. It addresses itself not only to a pop sensibility but to a pop attention span, and with a similar need for interminable hubbub. Is it any wonder, then, that it has proved to be a tremendous success, especially appealing to the young? But this success has been purchased at what is also a tremendous price. *Absence of heart, Absence of mind, Absence of worth*: Tate Modern has them all.

[2001]

The Man Who
Created MOMA

*A work of art is an infinitely complex focus of human
experience. The mystery of its creation, its history, and the rise
and fall of its esthetic, documentary, sentimental, and commercial
values, the endless variety of its relationships to the other works
of art, its physical condition, the meaning of its subject, the
technique of its production, the purpose of the man who made
it—all these factors lie behind a work of art, converge upon it,
and challenge our powers of analysis and publication. And they
should be made accessible to other scholars and intelligible to the
man off the street.*—Alfred H. Barr, Jr., 1946

Of the many museums that were founded in the United States in the
course of the last century, none has exerted a greater influence on pub-
lic taste, on American intellectual life, and on the life of art itself than the
Museum of Modern Art, which made its debut in New York in 1929 un-
der the directorship of Alfred H. Barr, Jr. With one exception, more-
over—the Phillips Collection in Washington, D.C., founded by Duncan
Phillips in 1921—none was so clearly the creation of a single governing
intelligence.[1] The ideas and the aesthetic judgments that shaped the for-

1. The same might be said of the Barnes Foundation, founded by Albert C. Barnes in
Merion, Pennsylvania, in 1925, but for one crucial difference: the Barnes Foundation was
specifically created to function as a school, not a museum. Its subsequent transformation
into a public art museum, resulting from dubious court decisions, openly contravened its
founder's purposes and program.

mation of MOMA in the early decades of its existence were primarily Barr's. They were the ideas and judgments of a man who was not yet thirty years old when the museum opened its doors to a wary, uninformed public in the first year of the Wall Street crash.

In his own generation the young Alfred Barr was uncommonly well prepared to undertake the daunting task that had been offered to him. His intellectual history actually began in high school when, as Sybil Gordon Kantor writes in her forthcoming biography, *Alfred H. Barr, Jr. and the Intellectual Origins of the Museum of Modern Art*, "Barr's interest in history was already piqued . . . when his Latin teacher, William Serer Rusk, awarded him Henry Adams's *Mont-Saint-Michel and Chartres* as a prize."[2] It was in his sophomore year at Princeton, however, in Charles Rufus Morey's course in medieval art, that Barr decided on a career in art scholarship.

Morey's teaching methods prompted Barr's interest in the sources, patterns, chronology, and spread of a style—an approach that he would apply to modern art, first in his teaching modernism at Wellesley in 1926–1927, and then in the very structure of the Museum of Modern Art and its multidepartmental organization. Barr later attributed his famous 1929 plan for the establishment of the various curatorial departments at the Museum of Modern Art to Morey's course.

After Princeton, in his graduate studies at Harvard with Paul J. Sachs—himself a collector and connoisseur—the now legendary Museum Course gave Barr his first practical training in the aesthetic and administrative aspects of museum work. It was a mark of Sachs's esteem for Barr that he also provided him with the funds he needed for further study in Europe.

Modern art was not yet, of course, an accepted subject for study in the universities. The pioneering course in modern art that Barr initiated at Wellesley is said to be the first of its kind in the American academy. It became a subject of lively public discussion when Barr's remarkably comprehensive "Modern Art Questionnaire"—an entrance exam he devised to screen students for his Wellesley course—was published in its entirety as a feature in *Vanity Fair*, a magazine then widely read in literary and art circles.

2. Sybil Gordon Kantor, *Alfred H. Barr, Jr. and the Intellectual Origins of the Museum of Modern Art* (Cambridge, Mass.).

By the time he came to occupy the first directorship of the Museum of Modern Art in 1929, Barr had succeeded in establishing himself as the country's leading authority on the modern movements in both Europe and the United States. From the outset, his approach to the study and presentation of modernism was wide-ranging and ecumenical. It went beyond painting, sculpture, and the graphic arts to embrace architecture, industrial design, theater, movies, and, at least in principle, literature and music. Thus, among the subjects to be identified in his Modern Art Questionnaire, which was an inquiry into what we should now call cultural literacy, were James Joyce and Arnold Schönberg as well as Henri Matisse and Frank Lloyd Wright—though not, oddly, either T. S. Eliot or Pablo Picasso. But then, the fame already enjoyed by Eliot and Picasso may have disqualified them for the purposes of the questionnaire as too easy.

Barr's ecumenical view of modernism was similarly to be observed in the concentration he lavished upon painting, sculpture, and the graphic arts, which inevitably, then as now, have been MOMA's central focus. This was a more unorthodox approach to modernist art in the early decades of the twentieth century than it may appear to be today, for we are all now, albeit in varying degrees, ecumenical in our understanding of what constitutes modernism in the visual arts. In the United States no less than in Europe, however, every avant-garde movement tended to be absolute in its dismissal of aesthetic alternatives. In Paris the Surrealists regarded Matisse as a bourgeois lightweight while the votaries of pure abstraction looked with horror upon the literary and erotic subject matter of the Surrealists. And in New York in the 1930s, the first decade of MOMA's existence, the art scene was deeply riven by a political as well as an aesthetic factionalism. The political left favored social realism, the populists promoted regionalism, aesthetic conservatives condemned every deviation from the conventions of realism while the underdog abstractionists struggled against all of these currents to establish their aesthetic validity.

It was Barr's distinction that as MOMA's first director he refused to be drawn into this factional warfare, preferring instead to search out aesthetic merit and historical significance in whichever variety of modernist endeavor he encountered. From his study trips abroad in the 1920s he was already well versed in the politics as well as the aesthetics of the principal avant-garde movements in France, Germany, the Netherlands, and Russia. Indeed, he witnessed at firsthand the political suppression of modernist art first in the Soviet Union in the 1920s and then in Nazi

Germany in the early 1930s, and wrote eloquently about these baleful developments at the time. In politics he remained an old-fashioned liberal, as immune to every totalitarian temptation as he was to the absolutism that virtually every faction of the avant-garde made claim to.

In 1949, in a contribution to a symposium on "The State of American Art," Barr made a clear statement of his liberal distaste for what he dubbed the "battle of styles." Observing that "Abstraction and realism are crude and ambiguous terms but they have a present usefulness as indications of polarity," he issued a salutary warning against the politicization of art which had again become an issue in the late 1940s, owing to some stupid congressional denunciations of modernism as "Bolshevik."

> An actual "battle of styles," as for instance between realism and abstraction, is desirable only to those who thrive on a feeling of partisanship. Both directions are valid and useful—and freedom to produce them and enjoy them should be protected as an essential liberty. There are, however, serious reasons for taking sides when one kind of art or another is dogmatically asserted to be the only funicular up Parnassus or, worse, when it is maliciously attacked by the ignorant, the frightened, the priggish, the opportunistic, the bigoted, the backward, the vulgar or the venal. Then those who love art or spiritual freedom cannot remain neutral.

For his rejection of political attacks on modernism, Barr won much praise, of course, in the liberal press. But for his refusal to be drawn into the aesthetic factionalism of the art world, Barr was roundly attacked by all sides. Lincoln Kirstein denounced him and MOMA itself for promoting the work of Matisse, of all people, and Clement Greenberg criticized him for his allegedly laggard support of the Abstract Expressionists, while Meyer Schapiro condemned what he characterized as Barr's "essentially unhistorical" account of the origins of abstract art.[3] Yet in retrospect

3. Meyer Schapiro's criticism of Barr was occasioned by the latter's catalogue essay for one of the most important exhibitions on MOMA's early history, *Cubism and Abstract Art* (1936). Writing as a Marxist in those days, Schapiro decried Barr's refusal to discuss the social and political aspects of abstract art. Yet Barr himself had already addressed those issues in his early writings: see, for example, "The LEF and Society Art," published in *Transition* in 1928, and reprinted in *Defining Modern Art: Selected Writings*. For my own analysis of Schapiro's political perspective on modern painting, see "The Apples of Meyer Schapiro," in my book *The Twilight of the Intellectuals* (Chicago, 1999).

Barr's disinterested and unhurried concentration on aesthetic achievement in a wide range of modernist art proved to be a key to MOMA's success in creating the single greatest collection of modern art in the world. This was itself a considerable intellectual feat.

Yet it is one of the curiosities of Barr's pivotal career—a career largely responsible for establishing modern art as a subject for serious critical and institutional attention in this country—that he has rarely, if ever, been acknowledged to have made a major contribution to American intellectual life. This is owing, in part, to the fact that for much of the twentieth century the principal chroniclers of American intellectual life did not take much of an interest in the visual arts. But it also has something to do with Barr's lifelong refusal to become a public personality. Both in his voluminous writings on art and in his public statements about the place of art in our democratic culture, he was seen—by his own design—to be speaking for the museum rather than for himself. And as he was neither an academic nor a journalist nor a charismatic public speaker, it rarely occurred to the chroniclers of twentieth-century intellectual life to accord Barr any attention in their historical surveys of its achievements. More often than not, it was Barr's critics in the academy and in the press who were assumed to occupy the intellectual high ground—and thus worthy of historical analysis—while Barr himself was relegated to the faceless ranks of the museum bureaucrats. It didn't help matters, either, that no collection of his writings on art was published in his lifetime. The splendid volume called *Defining Modern Art: Selected Writings of Alfred H. Barr, Jr.*, edited by Irving Sandler and Amy Newman, was published posthumously in 1986, five years after Barr's death.

Given this curious history, in which Barr's achievements have somehow been allowed to eclipse our understanding of the man himself, the publication of Ms. Kantor's intellectual biography must be considered something of an event. For this is the first extended account we have been given of Alfred Barr as an intellectual force not only in the art world but also in the larger cultural life of his time. Its focus is emphatically upon ideas and their consequences rather than on the private life of its subject. It examines the conflicts, both personal and institutional, which strongly held beliefs are bound to generate in the arena of cultural debate, but this is not the kind of biography that goes on the prowl for scandal or psychoanalytic revelation. This is not to say that Barr fails to emerge as a distinct personality in this book. Far from it. Ms. Kantor

concentrates on character, intellectual development, and the acquisition of skills—in Barr's case, not only the critical skills needed for making a wide range of difficult and often controversial aesthetic judgments but also the political and diplomatic skills essential to professional survival in a milieu as highly charged with oversize egos, big money, conflicting tastes, contending ideas, and the fierce competition for power, influence, and preferment, as MOMA was in the first decade of its existence.

That Barr succeeded for as long as he did in imposing his vision of modernism, which was essentially but not exclusively the vision of an aesthetic formalist, is an amazing story, and Ms. Kantor tells it well within the limits of the scope of her study. For this intellectual biography comes to an end in 1943 when Barr was precipitously fired by the chairman of MOMA's board of trustees, Stephen Clark. As Ms. Kantor writes:

> Barr had been having difficulties for the preceding six years on a variety of fronts: his tastes were running ahead of the trustees, his writings were always behind schedule, and, in the area of administration (which he disliked), competing forces were undercutting his efforts. . . . His enemies ranged over a broad front of staff members, hostile critics of modern art in general, or adherents of one mode of art or another.

Barr had never been physically robust, and he was increasingly subject to nervous collapses, insomnia, and other ills of the body and spirit. Yet he faced down his adversaries in the museum and outside the museum with an extraordinary display of tenacity and conviction. Although he had been fired from the directorship of the museum, he refused to acknowledge that he had been booted out of the museum itself. He continued to turn up at his office and pursue his curatorial tasks.

> Without fanfare or argument—never mind such a thing as a lawsuit— he simply stayed on and on, continuing to meet his writing commitments, advising on acquisitions and exhibitions until, amazingly enough, in 1944 he was appointed chairman of MOMA's Modern Painting and Sculpture department, which had always been his principal interest anyway.

There are, of course, many ways to write the history of modern art, and one of the most important, certainly, is to write its intellectual history. It is to the intellectual history of modern art that *Alfred H. Barr, Jr. and the*

Intellectual Origins of the Museum of Modern Art makes an indispensable contribution. It is also timely, for with MOMA currently undertaking the largest expansion in its history, Ms. Kantor's disabused account of its past gives us a needed perspective from which to judge the museum's future.

About the future of MOMA we can only speculate, of course, but certain auguries have already alerted us to what might be expected of the greatly expanded MOMA that awaits us. One, certainly, was the break with MOMA's past—in effect, a decisive rejection of Alfred Barr's carefully formulated conception of modernism—that was mounted in the series of exhibitions and catalogues called *MOMA2000* (October 1999–January 2001).[4] An even earlier augury was the publication of *A Fine Disregard: What Makes Modern Art Modern* (1990) by Kirk Varnedoe, the current director of MOMA's Department of Painting and Sculpture, which grandly promised to bring us "an entirely new vision of modern art's origins and its subsequent meanings." Still further portents may be found in the kinds of changes in programs and exhibitions that have lately been attempted in a number of other museums ostensibly devoted to modern and contemporary art—at Tate Modern in London, for example, and at the Solomon R. Guggenheim Museum and the Whitney Museum of American Art in New York.

Notwithstanding certain differences in emphasis and in sheer intellectual competence, what all of these developments have in common are some sweepingly revisionist attitudes toward art and history: 1) a distaste for the fundamentals of historical chronology; 2) a refusal to accord the aesthetics of style a priority over the subject matter or "content" of works of art; 3) a bias that favors tendentious sociology at the expense of connoisseurship; and 4) an appetite for populist appeal. It is this nexus of ideas and attitudes that united such otherwise disparate exhibitions as "High and Low: Modern Art and Popular Culture," which Kirk Varnedoe and Adam Gopnik organized at MOMA in 1990, as well as large tracts of *MOMA2000*, "The American Century" at the Whitney Museum, "Century City: Art and Culture in the Modern Metropolis" at Tate Modern, and the Guggenheim's ill-fated turn to exhibiting motorcycles, haute couture, and the pictures of Norman Rockwell.

4. For two views of *MOMA2000*, see Karen Wilkin's "Rethinking Modernism" in *The New Criterion*, January 2000, and my own essay "Telling Stories, Denying Style: Reflections on 'MOMA2000'" in *The New Criterion*, January 2001.

All but the Rockwell exhibition have been large and ambitious projects, encompassing hundreds of objects and occupying vast quantities of exhibition space as well as many hundreds of pages of catalogue text. They have been hugely expensive, too. Yet their net effect has been to render the aesthetic history of modern art incomprehensible to anyone coming to them without a firm command of the subject. Intellectually they represent the same corruption of scholarship that has led to the teaching of art history in the universities as, in effect, a branch of the social sciences. For a broad public—Barr's "man off the street"—they virtually guarantee historical confusion and a corruption of taste. That some of these monster exhibitions have been box-office hits is not surprising. To package art for the public on the basis of its alleged subject matter is always an easier "sell" than an attempt to instruct the public in aesthetic distinctions, for it turns every work of art into an easily apprehended illustration of something other than itself. Yet if the term "modernism" in art is to mean anything other than a strictly period classification of objects, an aesthetic comprehension of the art object itself and its relations to other objects of a similar class must be seen to be central to our experience of the art. When such objects are presented to us as illustration, however, it is no wonder that museums are tempted to embrace authentic illustration—e.g., Norman Rockwell—as a substitute for the real thing. As H. L. Mencken famously said, no one has ever lost money underestimating the intelligence of the American people.

Alfred Barr's conception of modernism, in his installations of MOMA's great collections and in many of the museum's major exhibitions during his tenure, provided a coherent account of both the master currents of modern art and its minor tributaries. It was a conception that was bound to be modified, augmented, or otherwise revised in the course of time, especially in relation to subsequent developments in modern art itself and in the literature of criticism and scholarship that they have generated. Yet none of the attempts to overturn the basic tenets of Barr's conception of the aesthetic and intellectual morphology of modernism have proved to be persuasive. Kirk Varnedoe's attempt to provide "an entirely new vision of modern art's origins" foundered on the debacle of "High and Low," while Robert Storr's attempt to rewrite the history of modernism in the section of *MOMA2000* called "Modern Art Despite Modernism" was obliged to ignore the fact that much of what he was concerned to reclaim for modernism had long before been

encompassed by Barr's ecumenical embrace of modernism's diversity of style. Even worse, the decision to deny the history of abstract art a section of its own in *MOMA2000* and then consign actual examples of abstraction to various categories of subject matter—thus once again demoting abstract art to the realm of illustration—meant that the public for Barr's 1936 exhibition of "Cubism and Abstract Art" was in a better position to understand the aesthetics of abstraction than the much larger public for *MOMA2000* two-thirds of a century later.

The truth is, the greatest monographic exhibitions at MOMA in recent decades—among them the 1980 Picasso retrospective organized by William Rubin, the 1992 Matisse retrospective organized by John Elderfield, and the current retrospective devoted to Alberto Giacometti—have all had a close kinship to Barr's pioneering exhibitions. Yet at a press briefing in November for MOMA's forthcoming *Matisse Picasso* exhibition in 2003, neither Glenn Lowry, MOMA's current director, nor either of the MOMA curators involved in the organization of this big show—Kirk Varnedoe and John Elderfield—thought it appropriate to make a single reference to the definitive exhibitions and scholarly monographs that Barr devoted to Matisse and Picasso during his long association with the museum. They spoke of MOMA's long-standing commitment to the achievements of Matisse and Picasso, but of the man who initiated, nurtured, and institutionalized that commitment they said nothing. For some of us in the audience at that press briefing, this startling omission said more about MOMA's current attitude toward its own history than anything that was actually said about the forthcoming exhibition.

About what the new mammoth MOMA now under construction will bring—it is expected to open in 2005—we hear many things, and we can hope that some of them are true. One is that *MOMA2000* will *not* be a model for the reinstallation of the museum's permanent collection. That would be good news, indeed. But we also hear that the entire first floor of MOMA's expanded quarters will be devoted to contemporary art, and if true this is not such good news. For in practice—if the present and the recent past are any guide to the future—this is likely to mean a wholesale transfer of the contents of the more trendy galleries in Chelsea to MOMA's midtown facilities. And the present is not, after all, a period that has produced artists who can be claimed to rank with the masters of modernism. Even the few exceptions to this judgment that come to mind are not, for the most part, the artists in whom MOMA's

curators take much of an interest. The very thought of a mammoth new exhibition space devoted to the overscale detritus of a post-Duchampian folly and its allegedly "postmodern" explorations of "transgressive" subjects is chilling.

My own guess is that what MOMA will do best in the future is what it has done best in the past: pay homage to the masters of modernist achievement, and thus face up to the fact that its principal mission lies in sustaining the tradition that it did so much to establish. And in the execution of that mission, the challenge will still be to meet the standards of the man who created MOMA.

[2001]

Does Abstract Art
Have a Future?

It is hard to tell if abstract painting actually got worse [after the 1960s], if it merely stagnated, or if it simply looked bad in comparison to the hopes its own accomplishments had raised.
—Frank Stella, *Working Space*, 1986

It must be acknowledged at the outset of these observations that the question of whether abstract art has a future is anything but new. The question of abstraction's future has been raised many times in the past. Historically, the question of abstraction's future is as old as abstraction itself, for the birth of abstract art some ninety years or so ago immediately prompted many doubts about its artistic viability. No sooner did abstract art—particularly abstract painting—make its initial appearance on the international art scene in the second decade of the twentieth century than the doubts about its future course began to be heard.

Many good minds have raised such doubts, and many benighted minds have done so as well. There are highly accomplished artists and critics who have taken sides on the question, as well as respected museum curators, art collectors, and art dealers. Over the course of time, in fact, debate about the future of abstract art has been an equal-opportunity enterprise to which the smart and the dumb, the advanced and the reactionary, the informed and the misinformed have all been eager to make a contribution.

I have a particularly vivid memory of an evening in 1954 at the Artists Club in New York when no less an eminence than the late Alfred

H. Barr, Jr., the founding director of the Museum of Modern Art, announced that the age of abstraction was drawing to a close and would now be succeeded by, of all things, a revival of history painting. The occasion was a panel discussion on what was then called the "New Realism." It was organized by John Bernard Myers, the irrepressible director of the Tibor de Nagy Gallery, which represented a number of the painters under discussion—among them, Larry Rivers, Fairfield Porter, and Grace Hartigan.

The Artists Club had been founded, of course, as a forum dedicated to the advancement of Abstract Expressionism. It was therefore inevitable that Barr's provocative pronouncement—and indeed, the very subject of the panel—would be greeted with a vociferous mixture of skepticism and hostility. It had clearly been Johnny Myers's intention to create such a stir on that occasion, for he knew very well that public controversy would have the effect of making some of the figurative painters he represented better known to the art world. He also knew that Barr had just acquired Rivers's *Washington Crossing the Delaware*, a modernist version of Emanuel Gottlieb Leutze's well-known nineteenth-century history painting in the Metropolitan Museum, for MOMA's permanent collection, and could therefore be counted upon to acclaim Rivers's picture as a significant development on the contemporary art scene.

To discuss this controversial development, however, Myers had deliberately convened a panel that could be relied upon to be evenly divided about the significance of Rivers's painting. Joining with Barr in extolling the virtues of *Washington Crossing the Delaware* and the shift in direction it was said to represent was Frank O'Hara, already well established as a poet and art critic. Opposing this view, not surprisingly, was Clement Greenberg. Although he had praised Rivers's earlier work, Greenberg clearly had a low opinion of both *Washington Crossing the Delaware* and Barr's claims on its behalf. Relations between Greenberg and Barr had never been anything but icy, and Greenberg remained, in any case, firm in his often-stated belief that abstraction represented what he characterized as the "master current" of the modernist era.

I was the fourth member of the panel, a newcomer to the art scene whose sole claim to attention on that occasion was an essay I had recently published in *Partisan Review* that was highly critical of Harold Rosenberg's theory of "Action" painting, then a hot topic in the art

world. This criticism of Rosenberg, then an arch rival of Greenberg's for the critical leadership of the New York School, had the effect of allying me on the panel with Greenberg even though some exhibition reviews I had lately contributed to *The Art Digest* were unmistakably sympathetic to a wide range of contemporary figurative painting. I didn't think much of Rivers's *Washington Crossing the Delaware*, however, and much as I admired Alfred Barr, I didn't believe that a revival of history painting was either imminent or even possible. Like many first-rate art historians, critics, and connoisseurs, Barr was better at codifying the past than at predicting the future.

I mention all this as a reminder that some of the harshest criticisms of abstract art, and some of the direst predictions of its demise, have come from within the ranks of the modernists themselves. In the 1950s, few living persons could rival Alfred Barr in his knowledge and understanding of abstract art, yet he seems genuinely to have come to believe that its end was nigh—and indeed inevitable. In the 1960s, Philip Guston, after winning considerable acclaim as a convert to Abstract Expressionism, won even greater acclaim for loudly denouncing abstraction in favor of a pictorial style derived from comic-strip and other populist images. Then in the 1980s came Frank Stella's Charles Eliot Norton Lectures at Harvard, *Working Space*, with its litany of contemporary abstraction's repeated failures to produce an art that we had any reason to admire. Stella, too, looked to populist imagery for inspiration—in his case, urban graffiti—with results that are depressingly familiar.

Given this checkered history, in which so many gifted people have said so many foolish things about abstract art—and we haven't even mentioned the openly declared enemies of abstraction—why does one feel compelled to raise the question of its future yet again? I think there are several good reasons for doing so. One is that by any objective measure, the place occupied by new developments in abstract art on the contemporary art scene—what we see in the galleries and museums and read about in the mainstream press and in the art journals—by this measure, the place occupied by new developments in abstract art is now greatly diminished from what it once was.

In this country, certainly, you have to go back to the 1950s and 1960s to recall a time when new developments in abstract art had shown themselves to have the effect of transforming our thinking about art itself. This is what Kandinsky, Mondrian, Malevich, and oth-

ers accomplished in the early years of abstract art. It was what Pollock, Rothko, de Kooning, and others in the New York School accomplished in the 1940s and 1950s. And, for better or for worse, it was what Frank Stella, Donald Judd, and certain other Minimalists accomplished in the 1960s.

I don't myself see anything comparable to this group impact on aesthetic thought happening at the present moment. I haven't observed anything of comparable magnitude occurring in the realm of abstract art since the 1960s. Let me underscore here that I am speaking about group impact on aesthetic thought, about art movements and not about individual talents. I am speaking about the impact of abstract art—or more specifically, abstract painting—on cultural life. That kind of impact on cultural life can rarely be achieved by an individual talent working in isolation from a group of like-minded, or similarly minded, talents.

I think there is a reason why the place occupied by abstract art is now so radically diminished not only on the contemporary art scene but in cultural life generally. At least I have an hypothesis as to the cause or causes of the diminished power and influence that abstraction has suffered since the acclaim it met with and the spell it cast in the 1960s. And let me be clear once again about what I mean in speaking of abstraction's diminished powers. I mean its power to set the kind of agenda that commands the attention of new and ambitious talents—and at times, indeed, even the emulation of established talents.

Before speculating about the causes of this diminution in what may be called, for want of a better name, movement abstraction, I think it important to recall something that has been central to the aesthetic history of abstraction itself—specifically, its inevitably symbiotic relation to representational art. As all of us know (but sometimes forget), abstract art—especially abstract painting—derives, aesthetically, from representational painting. Whatever the degree of purity abstraction can be said to attain, it cannot make claim to a virgin birth. If abstract painting could be said to have a genetic history, its DNA would instantly reveal its debt to some representational forebear. Whether abstraction derives from Cubism or Impressionism or Fauvism or Neo-Impressionism or Expressionism or some combination of these developments, its antecedents are traceable to the aesthetic vitality of representational painting. This is true of abstract sculpture, too—for abstract sculpture comes out of abstract painting—specifically, Cubism and Cubist collage.

In my own speculations about the fate that movement abstraction has suffered in our own day, two specific developments seem to nominate themselves as the cause or causes of our current impasse. The larger and more general cause is the fate of painting itself—its fate as a factor in cultural life generally as well as in the life of art. If we look back on two recent developments—the series of exhibitions at the Museum of Modern Art called *MOMA 2000* and the transformation of the Tate Gallery in London into two really bizarre institutions—Tate Britain and Tate Modern—we are obliged to recognize two things: 1) that on both sides of the Atlantic, abstract art has been marginalized by the institutions that were formerly in the vanguard of its public support and presentation, and 2) that painting itself is well on its way to being similarly marginalized.

It was certainly striking that in the vast logistical planning that went into the organization of the *MOMA 2000* exhibitions, no place was accorded to the birth and development of abstract art. There were plenty of examples of abstract art in the separate little shows that constituted *MOMA 2000*, but those examples were in every case presented to the public on the basis of their subject matter, their so-called content, and not on the basis of their abstract aesthetic. John Elderfield, one of the curators involved in the organization of *MOMA 2000*, at least had the decency to acknowledge this perverse treatment of abstraction as a failure of thought, but elsewhere in the voluminous texts that accompanied *MOMA 2000* the aesthetic history of abstraction was consigned to oblivion.

At Tate Modern in London there was also a discernible hostility to all aesthetic considerations, for painting and sculpture of every persuasion were similarly presented to the public on the basis of their thematic "content." And in the Tate Modern's initial blockbuster exhibition—a real horror called *Century City: Art and Culture in the Modern Metropolis*—painting could scarcely be said to have been given even a marginal status. In the section devoted to New York, for example, the twentieth century was represented by work from the period 1969–1974 with the principal focus on Andy Warhol, Lynda Benglis, Vito Acconci, Adrian Piper, Gordon Matta-Clark, and Mary Miss. There were no paintings, abstract or otherwise. Even in the sections devoted to Vienna 1908–1918 and Paris 1905–1918, where paintings could not be avoided, they were presented as a kind of tribal art of interest for its social content and political imagery.

In my own thinking about this fateful shift of priorities away from the aesthetics of painting, both abstract and representational, in favor of a political, sexual, and sociological interest in art-making activities, two historical developments—one within the realm of art itself, the other in the larger arena of intellectual and cultural life—appear to have shaped the situation in which we find ourselves. In the art world, the emergence of the Minimalist movement, which has been so central in determining the fate of abstract art since the 1960s, went so far in diminishing the aesthetic scope and resources of abstraction that it may in some respects be said to have marked a terminal point in its aesthetic development. At the same time, in the larger arena of cultural life, the fallout from the 1960s counterculture left all prior distinctions between high art and pop culture more or less stripped of their authority. It was hardly a coincidence that Minimalism and Pop Art made their respective debuts on the American art scene at the very same moment. However they may have differed in other respects, they were alike insofar as each constituted a programmatic assault not only on the Abstract Expressionism of the New York School—their initial target—but also on the entire pictorial tradition of which the New York School was seen to be a culmination.

It was left to Donald Judd, the most militant of the Minimalists, to spell out exactly what was at stake in this project to sever all ties to the cultural past. About what Judd contemptuously called "the salient and most objectionable relics of European art," he was nothing if not explicit: "It suits me fine," he said in a radio interview in 1964, "if that's all down the drain." He clearly meant it, too, for what was needed, in his view, was an art that would radically occlude all connection not only with the great traditions of the distant past but also with the kind of latter-day modernism that he had come to regard as the depleted remnants of a moribund culture. For Judd, art itself had become a utopian project.

There is a passage in an essay by Lionel Trilling—"Aggression and Utopia," published in 1973—that neatly defines the spirit that came to govern this utopian project and so much else in the Minimalist movement. Never mind that Trilling was writing about a Victorian utopian romance—William Morris's *News from Nowhere*. His admonitory analysis of its utopian vision applies with uncanny accuracy to the Minimalist project. This is the key passage:

> . . . the world is an aesthetic object, to be delighted in and not
> speculated about or investigated; the nature and destiny of man raise

no questions, being now wholly and finally manifest. . . . [I]n Morris's vision of the future, the judgment having once been made that grandiosity in art is not conformable with happiness and that Sir Christopher Wren had exemplified radical error in designing St. Paul's, the race has settled upon a style for all its artifacts that is simple and modestly elegant, and no one undertakes to surprise or shock or impress by stylistic invention.

This, in my view, is the Ground Zero from which the aesthetics of abstraction has not yet recovered.

[2002]

Index

A NOTE ON THE AUTHOR

Hilton Kramer was born in Gloucester, Massachusetts, and attended the public schools there. He received a bachelor's degree from Syracuse University and studied at Columbia, Harvard, and Indiana universities before teaching at the University of Colorado, Bennington College, and the Yale School of Drama. Mr. Kramer became editor of *Arts Magazine* in 1955 and art critic of *The Nation* seven years later. In 1965 he was appointed art news editor of the *New York Times*, then its chief art critic, a position he held until 1982, when he left to found *The New Criterion*, of which he is now co-editor and co-publisher. He was also art critic of the *New York Observer* from 1987 to 2005. Mr. Kramer's other books include *The Twilight of the Intellectuals*, *The Age of the Avant-Garde*, and *The Revenge of the Philistines*. He lives in Damariscotta, Maine.